As the lad grew older, he learned to his delight that he could hurdle skyscrapers...

... Leap an eighth of a mile...

... Raise tremendous weights...

... Run faster than a streamline train --

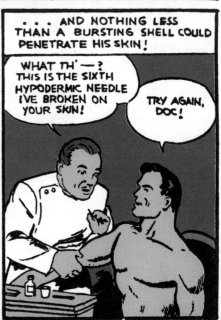

... And nothing less than a bursting shell could penetrate his skin!

WHAT TH' — ? THIS IS THE SIXTH HYPODERMIC NEEDLE I'VE BROKEN ON YOUR SKIN!

TRY AGAIN, DOC!

The passing away of his foster-parents greatly grieved Clark Kent. But it strengthened a determination that had been growing in his mind.

Clark decided he must turn his titanic strength into channels that would benefit mankind. And so was created--

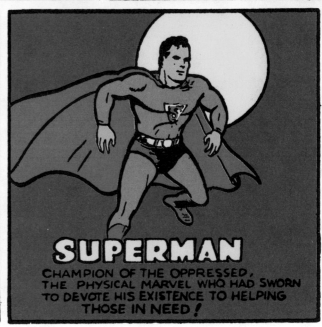

SUPERMAN

Champion of the oppressed, the physical marvel who had sworn to devote his existence to helping those in need!

DCCO

MICS

Sixty Years
★ of the ★
World's Favorite
Comic Book Heroes

by Les Daniels

**Introduction by
Jenette Kahn
President, DC Comics**

A Bulfinch Press Book
Little, Brown and Company

Boston New York Toronto London

PROJECT DIRECTOR:
Judy Fireman

DESIGN:
Our Designs, Inc.

ART DIRECTION:
Natasha Lessnik

EDITOR:
Steven Korté

ARCHIVAL PHOTOGRAPHY:
Marc Witz

First Edition Second Printing

Library of Congress Cataloging-in-Publication Data

Daniels, Les.

 DC Comics : sixty years of the world's favorite comic book heroes / Les Daniels.
 p. cm.
 "A Bulfinch Press book."
 Includes index.
 ISBN 0-8212-2076-4
 1. Comic books, strips, etc.—History and criticism. 2. DC Comics. I. Title.
 PN6725.D193 1995
 741.5'0973—dc2095-7243 95-7243

Bulfinch Press is an imprint and trademark of Little, Brown and Company (Inc.).
Published simultaneously in Canada by Little, Brown & Company (Canada) Limited.

TEXT SET IN MINION FROM ADOBE SYSTEMS; CAPTIONS SET IN FRANKLIN GOTHIC DEMI FROM ADOBE SYSTEMS;
TITLES SET IN CHAMPION GOTHIC FROM THE HOEFLER TYPE FOUNDRY.

PRINTED IN THE UNITED STATES OF AMERICA

—————————————— Back Jacket Art Credits (clockwise from upper left) ——————————————

BATMAN: Cover of *Detective Comics* #600. Pencils by Denys Cowan and inks by Malcolm Jones III.

GREEN LANTERN: From *Green Lantern* #26. Pencils by M.D. Bright and inks by Romeo Tanghal.

PLASTIC MAN: DC Comics style guide.

SWAMP THING: Painting by Michael Zulli.

WONDER WOMAN: Cover of *Wonder Woman* #72. Art by Brian Bolland.

CATWOMAN: Michelle Pfeiffer as Catwoman in *Batman Returns*, 1991.

AQUAMAN: Cover of *Aquaman* #13. Pencils by Chris Schenck and inks by Bob Dvorak.

JOKER: Cover of *Batman Adventures* #3. Pencils by Ty Templeton and inks by Rick Burchett.

SANDMAN: Art by Marc Hempel.

Acknowledgments

This book could never have been completed without the aid and encouragement of many, many people. Chief among them are the following talented individuals who have been associated with DC over the years and who generously shared their memories with me for this project: Karen Berger, Steve Bissette, John Byrne, Mike Carlin, Lynda Carter, Irwin Donenfeld, Kevin Dooley, Neil Gaiman, Bob Haney, Andy Helfer, Jenette Kahn, Bob Kane, Gil Kane, Joe Kubert, Paul Levitz, Jack Liebowitz, Dwayne McDuffie, Alan Moore, Noel Neill, Denny O'Neil, Joe Orlando, George Pérez, Christopher Reeve, Jack Schiff, Julius Schwartz, Dick Sprang, Vin Sullivan, Curt Swan, Mark Waid and Marv Wolfman.

My gratitude also goes to the following individuals for quotations, most of them previously unpublished, that were drawn from interviews conducted before this book was envisioned: Tim Burton, Dean Cain, Danny DeVito, Anton Furst, Michael Gough, Peter Guber, Teri Hatcher, Carmine Infantino, Michael Keaton, Val Kilmer, Jack Kirby, Roy Lichtenstein, Sheldon Mayer, Frank Miller, Grant Morrison, David Newman, Peter Pastorelli, Michelle Pfeiffer, Joel Schumacher, Joe Shuster, Jerry Siegel, Len Wein and Adam West.

Special thanks also to DC President Jenette Kahn for her spirited introduction, and to Chantal d'Aulnis, Vice President of Business Affairs, for overseeing everything with unflagging courtesy. Words fail concerning my editor at DC, Steve Korté. He's got some great toys in his office, and without his endless enthusiasm and constant contributions, it would have been nearly impossible to get this big book done. A tip of the hat to Charles Kochman, who got things started and stayed interested; to Ann Goetz for heroic work in keeping track of all the illustrations; and to Scott Sonneborn for his sharp eye.

Still more gratitude is extended to Project Director Judy Fireman, for her patience and perseverance and for bringing everyone together in the first place; to Natasha Lessnik at Our Designs for the handsome look of the book; and to Marc Witz for his fine photography of most of the images printed on these pages. The cover art by José García-López is just super.

Allan Asherman, DC Librarian and all-around media expert, spent weeks guiding me through the company archives, and also kindly contributed a number of rare items from his private collection. Special contributions were also made by Steve Geppi and Bill Schanes of Diamond Comic Distributors, who provided a number of rare covers; and by Ed Fuqua and The Mad Peck Studio Archives, both of whom offered treasure troves on semi-permanent loan. Other selfless people who provided precious pieces from their collections include Bill Blackbeard (the newspaper strip's best friend), Bob Booth (pulps), Mike Chandley, Joe Desris (Batman's best buddy), Fred Ganczar, Bob Greenberger, Jim Hambrick (super stuff), Chuck Harter (classic TV pix), Mike Heisler, Eddie Ortiz (Superman cartoon images), Margery Peters, Bob Rozakis, Diana Schutz, Anthony Tollin and Bobby Yeremian.

Everyone at DC seemed happy to be helpful, and I must mention all I can recall who offered valuable advice or selfless service: Valerie Atlas (permissions), Pat Bastienne (who set up interviews and gave me the grand tour), Lillian Laserson and Jay Kogan (the law), Arlene Lo (proofreading), Dean Motter, Scott Peterson, Neal Pozner, Sandy Resnick (who helped set things up), Cheryl Rubin (Vice President of Licensing), Stuart Seltzer (who knows the deal on cards), Rob Simpson (hidden heroes), Rick Taylor (arcane knowledge), Martha Thomases (publicity) and Jeanette Winley (Manager of the DC Film Library). Helpful advisers outside DC included Richard Morrissey, Larry Shirley and Mike Tiefenbacher.

Even in a book of this size, it is not possible to pay tribute to everyone who has contributed to the hundreds of thousands of pages that DC has published. My regrets to those who are not mentioned. Please be assured that no slight was intended. While we have endeavored to identify all the artists whose work appears in this book, we apologize to any person misidentified or not identified, and invite them to inform us of the error.

Finally, all this would have been in vain without Lindley Boegehold and Sarah Kirshner of Bulfinch Press, and all of this might have been in limbo without copy editor Amy Handy. Some valuable supplementary photos were taken by Eliot Brown and Judy Roberts.

And the last gleam of gratitude goes to my big sister, for lots of stuff. This one's for her.

TABLE OF CONTENTS

Introduction by Jenette Kahn

12

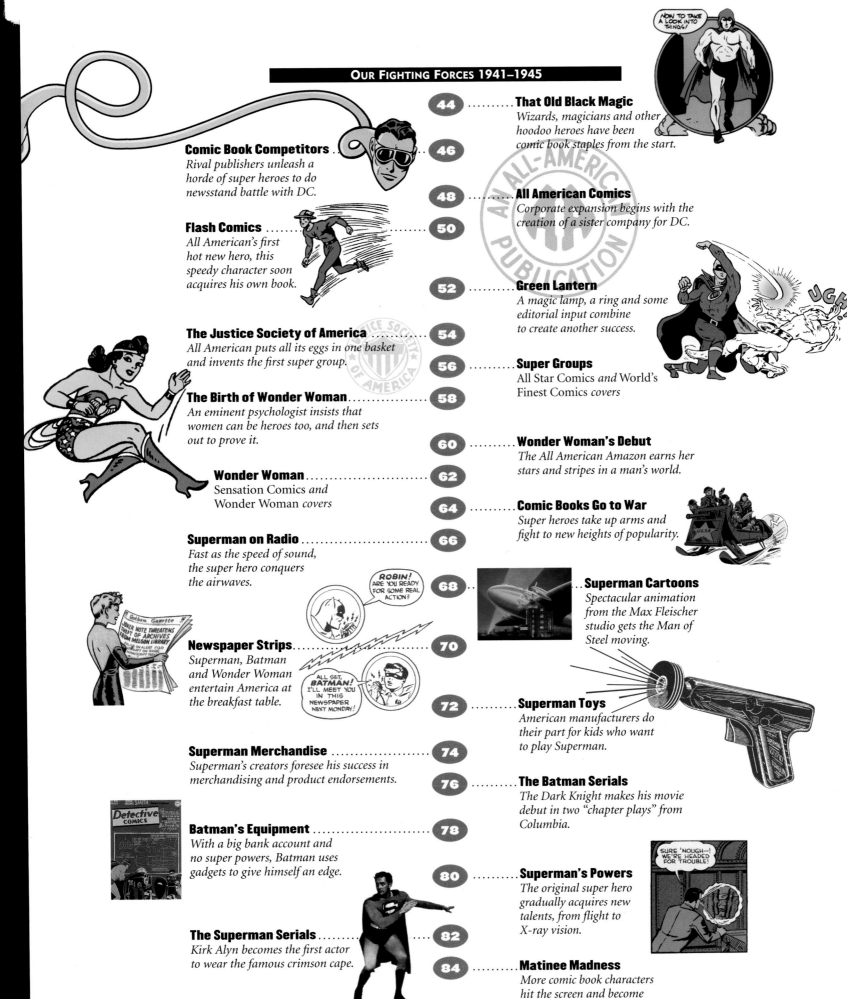

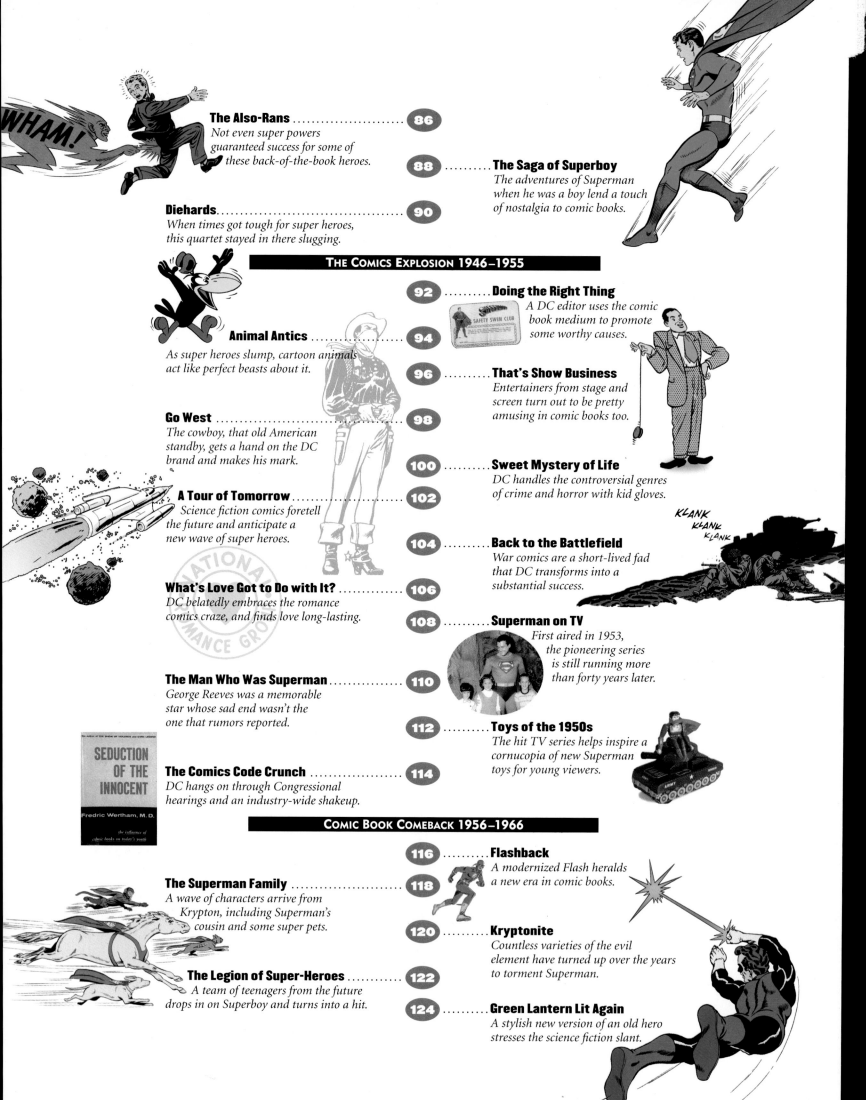

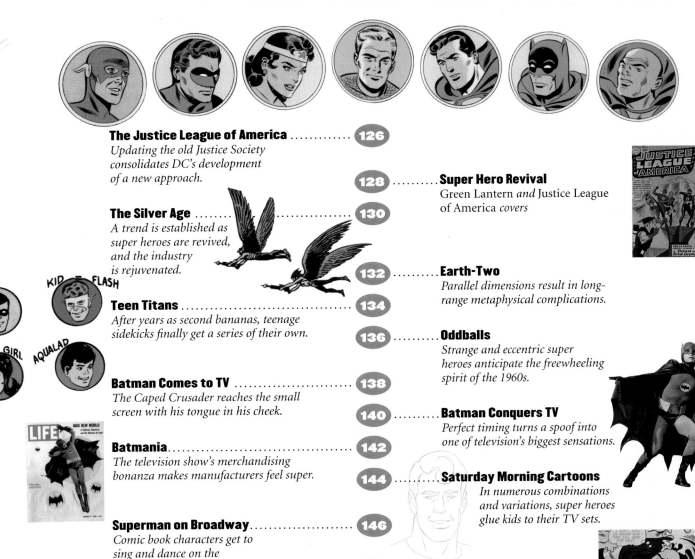

BEYOND POP 1967–1984

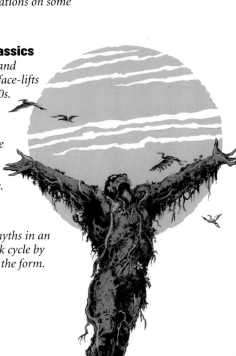

INTRODUCTION

Unless your parents were prison wardens, or you had a completely benighted childhood, there probably isn't one of you under the age of sixty-five who, upon picking up this book, isn't flooded with memories of the joy comics brought you in those mined fields of childhood. For my older brother and me, reading comics in the 1950s (oblivious to the words "mint condition" and the very existence of Mylar storage bags), finding our favorite books, reading and rereading them again and again was a totally gratifying pleasure.

Of course there were no comic book stores in those days, so we'd bicycle down to the ice cream store or Kresge's Five and Dime. There we'd flip through as many pages as we could until some clerk would insist we either pay or leave. With as many comics as we could afford, we'd race home to lie face down on the living room floor to relish our cache. We read our comics everywhere: in the bathroom, in the back seat of the car, under the covers at night with a flashlight. We couldn't get enough of them.

These magical books that had originated in the thirties were the brainchild of printers casting about for additional material to keep their presses rolling more hours a day. Actually, the first comic books were simply reprints of existing newspaper comic strips. In 1935, DC Comics changed popular culture forever when it published the first-ever book of all new comic material. This is why in 1995 we celebrate the sixtieth anniversary of both DC Comics and the modern comic book.

In 1938, DC made history again with the introduction of Superman, the wondrous creation of two teenagers from Cleveland, Jerry Siegel and Joe Shuster. Superman's success initiated a whole new genre—the super hero, and launched a horde of followers. There was Batman, who, lacking any super powers, nonetheless honed himself into an awesome athlete, an unrivalled detective and a terrifying symbol of justice. There was the Flash, The Fastest Man Alive, Green Lantern, wielding his genie-like power ring, and Captain Marvel, who, in his secret identity as a boy named Billy Batson, uttered the word *Shazam!* to become not only an adult but The World's Mightiest Mortal. And of course there was Wonder Woman, a courageous, compassionate and beautiful woman created by psychologist William Moulton Marston in order to give young girls a role model of their own.

Comic book characters like these have been too often dismissed as the boyish fantasies of men still young in years and wet behind the ears. Yet nearly six decades later, all these heroes flourish, claiming a vibrant hold on the imaginations of millions of kids and grown-ups alike.

These characters are popular not only because they embody childhood dreams, but because they provide us a way of fulfilling fundamental human yearnings that we carry with us no matter what our age. The original Clark Kent is Everyman, mild-mannered and unprepossessing. But he is also Superman, a demi-god with "powers beyond those of mortal men." We all embrace the wish that no matter how ordinary we might seem, underneath we are each capable of the extraordinary.

Batman is fabulously rich, but the fantasy is much larger than that. While we pity him for the horror he suffered at seeing his parents murdered, we experience through him the wish to be independent and free, with no one telling us what to do with our resources or time.

And of course who among us doesn't remember how desperate we were as children to be older, bigger, stronger? Billy Batson has only to say *Shazam!* to gain all this and super powers too. And what child or adult wouldn't love to have Green Lantern's power ring? What little girl or woman wouldn't like to be, as Wonder Woman is, admired most for her power, her values and her open heart?

Comic books provide heroes, stories and dreams not just through words but through whole worlds of enthralling pictures. Even before the proliferation of television in the 1950s, comic books were like movies on tape—decades before VCR's and CD-ROM's were a

gleam in anybody's eye. You can read them anytime you want, you can fast-forward or reverse, and you can freeze-frame for as long as you like. Yet comics are tactile, personal and private in a way that stories on screens can never be.

It is fascinating to note that the evolution of comic book art in sixty years has mimicked the development of western painting over the past six hundred years. Fresco painters Giotto and Masaccio, followed by the early Renaissance painters, were concerned with articulating the weight and mass of their figures; they wanted to paint people who could actually exist in space. As the Renaissance reached its apex, mastery of perspective became an all-consuming passion, which reached perfection in Michelangelo's combination of verisimilitude and dy-namism. Once these goals had been achieved, succeeding artists took figural painting in new directions. Some pur-posefully distorted the body for emotional effect; others flattened or skewed perspective in order to emphasize elements of composition and design.

The movement in comics art is exactly parallel. Comics moved from the strong volumes of Joe Shuster's Superman art to the masterful pyro-technics of Neal Adams in the late sixties and early seventies to the formal design emphasis in Marshall Rogers' work in the late seventies. Today there are a multiplicity of styles of DC art; our books have branched out to include the suggestive, painterly style of Bill Sienkiewicz and the evocative, con-structed collages of artist Dave McKean.

In the meantime, the contents of DC comics have followed suit. The diversi-fication in the nature of the stories and the editorial style in which they are told began primarily with Denny O'Neil and Neal Adams' highly political Green Lantern/Green Arrow series in 1970. In the 1980s, DC broke the comics industry wide open by publishing two watershed books by Frank Miller, *Ronin* and *The Dark Knight*. These dark, complicated comics were followed by a number of other dramatic and seminal books, including *Watchmen*, *Hellblazer* and *Sandman*. By 1990, there were ten new formats in the comic book world, and DC had invented nine of them.

DC's ability to publish enormously sophisticated books for an adult audience is attributable to a major change in the methods of comic book distribution.

In the late 1970s, as small mom-and-pop stores disappeared and as newsstands grew disenchanted with carrying low-ticket comics for kids who weren't big-spending customers, a fledgling market of comic book specialty stores began to crop up, and DC enthusiastically supported its growth. The strip-mall location of most of these specialty stores and the fact that they were owned and operated by grown-up comic book fans encouraged a substantially older readership to visit the stores. DC could now create different kinds of comics for this newly identified market of young adult readers.

Today DC continues to develop comics for many different interests and tastes. DC not only constantly reinvents its classic heroes, but also continues to create new kinds of books: the Vertigo imprint stresses adult horror; Paradox Press emphasizes the experimental; and with Milestone Media, DC has launched the very first comic book line of multicultural heroes.

The average DC reader is now twenty-five years old; the regular audience includes directors, producers, book editors, artists and musicians. Newspapers and magazines review the best of our comics, and there is growing respect for comics as a legitimate art form.

And yes, people are speculating financially in the comic book market, stockpiling hund-reds of new titles in the misguided hope that they'll be able to send their kids to college when they finally put their stash on the market. No such luck. Too many people are doing it.

Are you one of the millions of people whose mother threw your comics away? You've probably been seized by filial rage every time *Detective* #27 or *Action* #1 commands $50,000 at auction. However, these unimaginable prices occur only because *everybody's* mother threw her kids' comics away; the few left in existence can be traded for bullion at Fort Knox.

Even if you can't get rich on the comics being published today, there is one major compensation. It may be the old-fashioned way, but reading DC comics without regard for their future value is a pleasure that nothing can duplicate.

Stay tuned for the next sixty years.

JENETTE KAHN,
PRESIDENT, DC COMICS

A MAJOR INNOVATION
New Comics for a New Medium

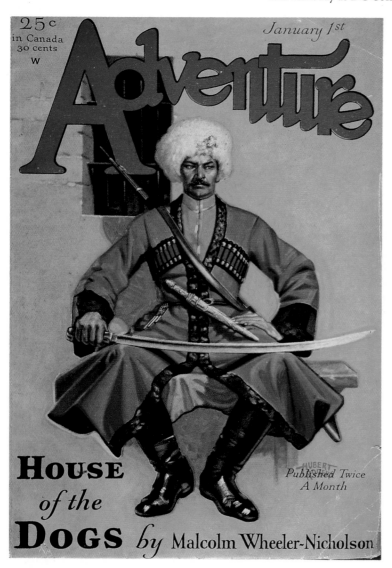

Major Malcolm Wheeler-Nicholson, the founder of DC Comics.

In February 1935, a writer known as Major Malcolm Wheeler-Nicholson determined the destiny of the American comic book when he launched a publication called *New Fun*, subtitled "The Big Comic Magazine." And big it was, measuring ten by fifteen inches, but the size turned out to be one of the major's mistakes. Another was printing the interior pages in black and white. What he did right was to publish "all new, all original" comics. Reprints of popular newspaper comic strips had been around in one form or another for decades, and had recently come into their own with the regular monthly appearance of Eastern Color's *Famous Funnies*, introduced in 1934. Its imitators soon included *Popular Comics* and *King Comics*, but only Wheeler-Nicholson had much faith in the idea of creating new material for a new medium. The major was right, however, and by sticking to his guns he created the New York company— known today as DC Comics—that defined the modern comic book, inspired countless imitators, and exerted an immeasurable influence on popular culture.

Major Wheeler-Nicholson's decision to go against the grain was undoubtedly astute, but in fact he had little choice in the matter. Licensing popular characters from the newspaper strips cost money, and the biggest mistake the major made was to start up his company, National Allied Publishing, without sufficient capital. So he was obliged to gamble with untried talent, but by 1935 he was used to taking risks.

Born in 1890 in Greenville, Tennessee, Malcolm Wheeler-Nicholson had been a cavalry officer and, according to an autobiographical article he wrote, had served everywhere from France to the Philippines, from Siberia to the Mexican border. "I don't know whether all those things are true or not," says Vin Sullivan, who started as a cartoonist and soon became one of the new company's key editors. "He was quite a character. He was a fiction writer, so that may account for the many stories about his activities. He married his wife on top of the Eiffel Tower, I think that was the story, and she was some sort of royalty." Wheeler-Nicholson's military career ended, and his literary career began, when he attacked his superior officers in a letter written to President Warren G. Harding. The resultant controversy led to his separation from the U.S. Army in 1924, and he worked for the next decade as an author for pulp magazines.

A powerful influence on comic books, offering fast-paced fiction and larger-than-life heroes, the pulps were not demanding in terms of literary style, and the major sold stories to the most prestigious publications in the field. *Adventure*, where much of his work appeared, prided itself on narratives with authentic backgrounds, and his varied experiences proved useful for tales with titles like "Dark Regiment," "Honors of War" and "Lost Legions." *Adventure* would later lend its name to one of DC's longest-lasting comic books.

As a publisher, Wheeler-Nicholson had more ambition than expertise. Ten months after introducing the faltering *New Fun*, he followed it up with *New Comics* (December 1935). Then, to avoid confusion, he changed the titles to *More Fun* and *New Adventure Comics*. Eventually the adjective dropped off and the new title became *Adventure Comics* (November 1938), but by then the major was out of the business. Debts to printers, distributors, artists and writers had caused him to lose control of his company.

This January 1929 pulp magazine cover by Hubert Rogers heralded one of Wheeler-Nicholson's popular yarns about soldiering in far-off lands.

"He wasn't a very good businessman," says Vin Sullivan. "It was a new industry and the books just hadn't caught on. We were struggling all the time." Artist Bob Kane, who had contributed a number of short humor pieces and would later create Batman, recalls his efforts to collect "about 300 dollars, which was a fortune to me in the late '30s." Promised full payment by Wheeler-Nicholson, Kane arrived at the office "one rainy Friday" and found it empty. "He flew the coop," says Kane.

More experienced publishers took control of the company, which soon became the leader of the industry, but it might never have happened except for the major's vision. An adventurer, an author, a teller of tall tales, a dreamer and perhaps a bit of a rogue, Major Malcolm Wheeler-Nicholson was the individual who created the comic book as we know it today. He died, all but forgotten, in 1968.

The first issue of the company's first comic book even had comics on the cover, which was the only part of *New Fun* printed in color. Jack Woods, the cowboy who got the place of honor on this historic publication, was drawn by Lyman Anderson.

The company's second comic book had a more conventional cover, with emphasis on comedy, although the contents were varied. The cartoonist, Vin Sullivan, was also the infant industry's first great editor.

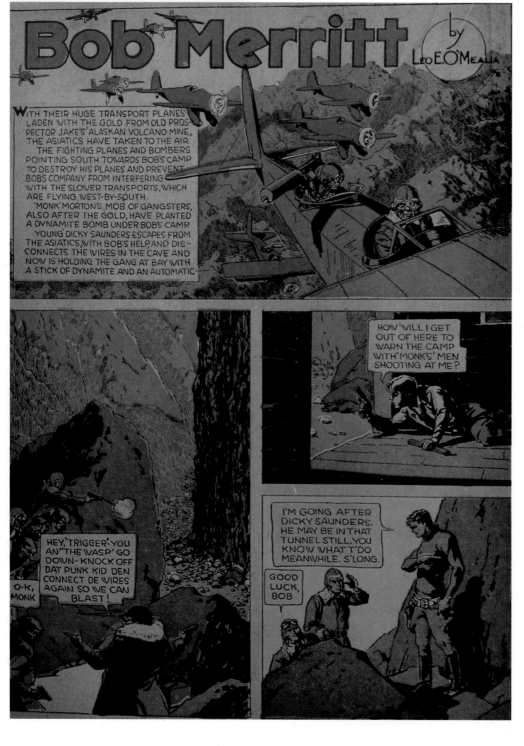

New Fun became *More Fun* with its seventh issue (January 1936), but comics on the covers continued. Little Linda was the brainchild of Whitney Ellsworth, who later became DC's editorial director.

In Search of a Hero
The First Comic Book Characters

Cartoonists came from everywhere to fill the pages of Major Wheeler-Nicholson's new comic books. Most of them were young and inexperienced, but they were willing to try anything. The notion that each feature should take up only one page, a holdover from newspaper comics, meant that a single issue required dozens of original characters. The first issue of *New Fun Comics* contained everything from spies ("Sandra of the Secret Service") to science fiction ("Don Drake on the Planet Saro"), from prehistoric comedy ("Caveman Capers") to a serialized adaptation of Sir Walter Scott's *Ivanhoe*.

The most significant debut in *New Fun Comics* came in its sixth and final issue, in the improbable form of "Henri Duval of France, Famed Soldier of Fortune." This black-and-white swashbuckler about an irritable swordsman was unimportant in itself, but it marked the first professional publication of work by two young men from Cleveland: a writer named Jerry Siegel and an artist named Joe Shuster. Their real ambition was to move into the more established field of newspaper strips, and to that end they were holding back their favorite feature, something about an alien with amazing powers. Still, they needed work, and Siegel recalled forty years later that "as soon as we saw a comic book, we took to that immediately." In fact, the same issue of *New Fun* contained another of their one-page stories, an adventure of one "Dr. Occult," which they signed pseudonymously as "Leger and Reuths."

When *New Fun Comics* became *More Fun Comics*, its oversize pages were shrunk down to something approaching the standard format we know today, in keeping with its new sister publication *New Comics*. The reduced size was a real improvement because it was easier to display on newsstands. The publisher claimed in advertising that the change came "in response to thousands of requests," but editor Vin Sullivan says "that was probably because of financing. With the small size, you wouldn't be using as much paper." Some of the money saved seems to have been used to add color, which was certainly a plus.

Leo E. O'Mealia, a trained artist with years of experience on newspaper strips, drew beautifully rendered pages like this one from *More Fun Comics* #27 (December 1937). Believe it or not, this elegant but slightly old-fashioned adventure series was originally called "Bob Merritt, Gentleman Adventurer and Inventor, and His Flying Pals." Like other heroes of the era, Bob and his pals rated only two pages per issue, hence the lengthy synopsis that opens this serialized episode.

Vin Sullivan and Whitney Ellsworth, cartoonists who had become the company's editors, continued to draw humorous covers, as well as strips about kids like Sullivan's "Spike Spalding" and Ellsworth's "Little Linda." The readers seemed to prefer action, however, and they soon got more, with adventure stories gradually expanding to four, six or eight pages; this was enough space so that eventually serialization became unnecessary. The most polished artist for this sort of material was Leo O'Mealia, a generation older than his colleagues, who illustrated the exploits of "Barry O'Neill" in a richly detailed style.

Still, Siegel and Shuster were the ones to watch. They introduced a strip about modern police methods, which soon changed its name from "Calling All Cars" to "Radio Squad," in the July 1936 *More Fun*; they also promoted law and order with "Federal Men," starting in the second issue of *New Comics* (January 1936). These were better than average features, with enthusiastic scripts from Siegel and simple, appealing art from Shuster, but the team's real interests lay elsewhere. "Jerry and I were both science fiction fans from way back," said Joe Shuster, and even while they were trying to interest newspapers in their idea about a visitor from space, they couldn't keep futuristic menaces like giant robots out of "Federal Men." They even did a story called "Federal Men of Tomorrow," but it wasn't enough to get the company out of the red. It would require publishers with experience to keep this experiment alive.

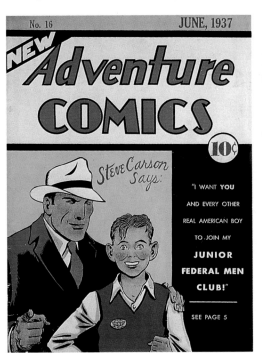

By June 1937, when this cover appeared, *New Comics* had become *New Adventure Comics*, and artist Joe Shuster was drumming up members for the Junior Federal Men Club.

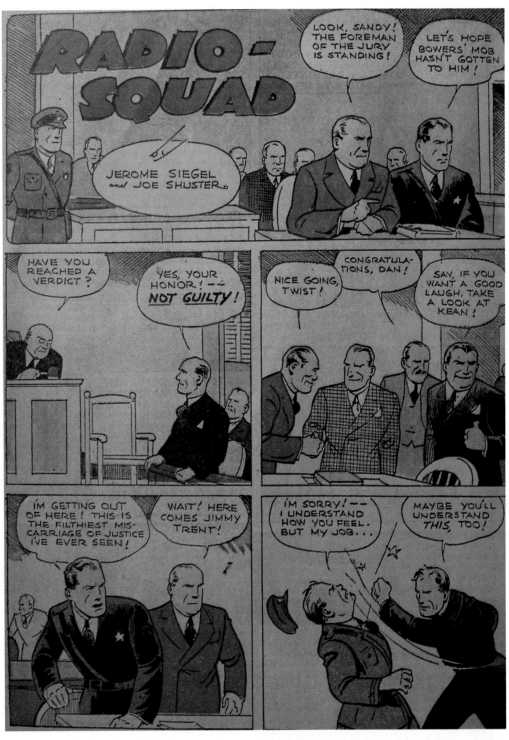

Sharing space in the same comic book with "Bob Merritt," this offering from Siegel and Shuster looks comparatively crude, but the simpler style turned out to be what readers wanted. Shuster's cartooning was expressive and appealing, while Siegel's story of crime and corruption in urban America prompted more direct reader involvement than was inspired by fanciful tales of gold mines and "Asiatic" aviators. This entire page, instantly understandable, contains fewer words than just the synopsis required to get "Bob Merritt" moving. From *More Fun Comics* #20 (May 1937).

Harry Donenfeld

Jack Liebowitz

UNDER NEW MANAGEMENT
Taking Care of Business

What kept Major Wheeler-Nicholson's new comic book company from drowning in a sea of red ink was the infusion of new blood provided by two astute businessmen named Harry Donenfeld and Jack Liebowitz. Donenfeld has been described as the senior partner and Liebowitz as his accountant or business manager, but as Liebowitz now says, "We didn't bother with titles in those days." The pair got involved with the major's comics early on, printing the glossy covers that were wrapped around the newsprint pages, and sending the books out through their Independent News Company, which became, notes Liebowitz, the country's "largest distributor of magazines and paperbacks."

The partners advanced the major money to keep *More Fun Comics* and *New Adventure Comics* afloat, and then went into partnership with him on a third title, *Detective Comics* (March 1937), the first successful comic book with a single theme, and the one which gave the company the name by which it has been known ever since. By 1940, a circular logo containing the letters "DC" (short for Detective Comics, Inc.) was appearing on the covers of the firm's publications; from then on readers called them DC Comics, although decades would pass before the change became official.

Detective Comics doubtless sounded like a good idea to Harry Donenfeld, who, in addition to his other activities, published a line of pulps that included *Spicy Detective*. This magazine is remembered for the often-reprinted adventures of Dan Turner, a tough-talking private eye whose hilarious prose was created by Robert Leslie Bellem. No character in the early issues of *Detective Comics* had such lasting impact, although Jerry Siegel and Joe Shuster's energetic "Slam Bradley" showed promise. The pair were still saving their idea of a science fiction hero for the newspapers, but Siegel has said that the athletic Slam Bradley included "some of the impact we planned to use later in Superman."

It wasn't enough. Sales continued to be slow, and by 1938 Wheeler-Nicholson was bankrupt. Donenfeld and Liebowitz might have thrown in the towel themselves, but instead they stuck it out. "I had a feel for it, that it was a good field," says Liebowitz. "I went down to the court at the time and bought the two titles *More Fun* and

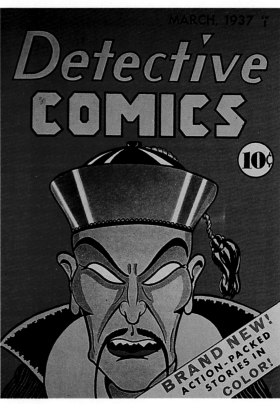

Vin Sullivan's cover for the first issue of *Detective Comics* featured a villain called Chin Lung.

New Adventure. We bought out Wheeler-Nicholson's interest in *Detective Comics*, so we had three comics to start with."

"Whitney Ellsworth decided to seek greener pastures in California, and I was the only one left," says editor Vin Sullivan. "I was the company, I guess. I had a small office, and the artists and writers would come to me." The outgoing Harry Donenfeld spent time on the road creating a distribution network, while Jack Liebowitz supervised the comic books. "Jack was in house as commander in chief, so to speak, so all the cartoonists got to know Jack better than Harry," recalls artist Bob Kane.

"I had an idea that I wanted to start another magazine, which I had the title for," says Liebowitz, "*Action Comics*." Donenfeld was less enthusiastic: "He thought three magazines in the field were plenty." With Donenfeld eventually won over, Liebowitz wondered where to get stories, since "in those days there were very few people in the field." Liebowitz called a friend at a newspaper syndicate, who sent over several comic strips that had been rejected for publication. "And that," says Liebowitz, "was the beginning of Superman."

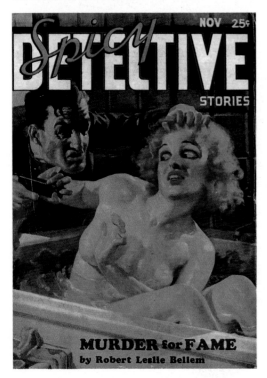

"From a bedroom, a roscoe said: '*Whr-r-rang!*' and a lead pill split the ozone past my noggin," wrote Robert Leslie Bellem in one overheated tale. "There was a bullet-hole through his think-tank. He was as dead as a fried oyster." Bellem's zany prose and covers like H. J. Ward's made *Spicy Detective* the most notorious of Harry Donenfeld's pulps. This is the November 1934 issue.

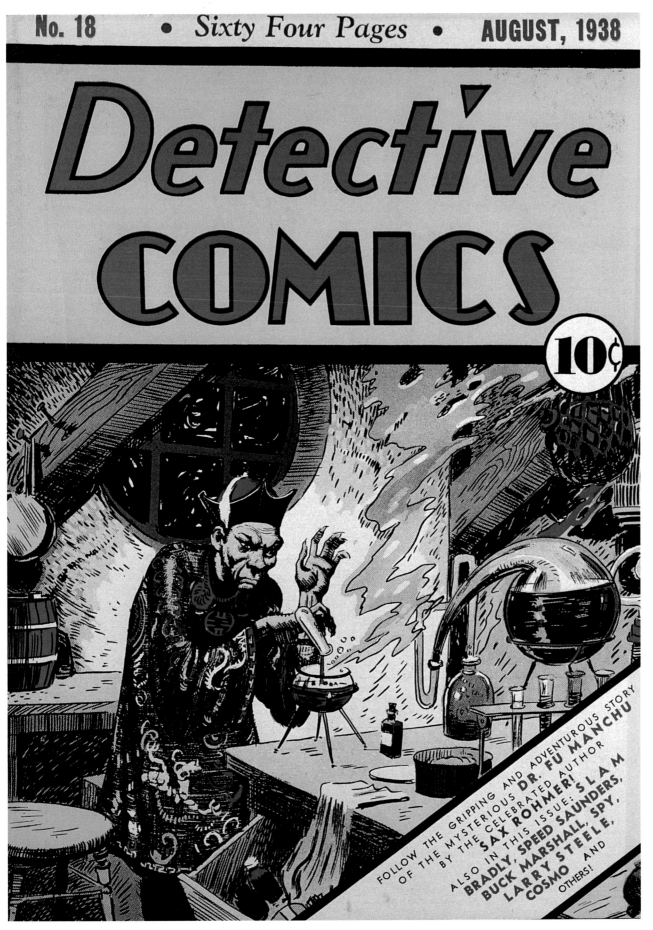

No. 18 • Sixty Four Pages • AUGUST, 1938

Detective COMICS

10¢

FOLLOW THE GRIPPING AND ADVENTUROUS STORY OF THE MYSTERIOUS **DR. FU MANCHU** BY THE CELEBRATED AUTHOR **SAX ROHMER!** ALSO IN THIS ISSUE: **SLAM BRADLY, SPEED SAUNDERS, BUCK MARSHALL, SPY, LARRY STEELE, COSMO** AND OTHERS!

The one well-known character from the early days of *Detective Comics* was Dr. Fu Manchu, depicted by Creig Flessel on the cover of the eighteenth issue (August 1938). The first of author Sax Rohmer's Fu Manchu books had appeared in 1913, and they continued for decades, inspiring film, radio and television adaptations along with his DC appearances. Rohmer made so much money that he began signing his name as "$ax," but DC got tired of paying him royalties and dropped Fu Manchu a few issues after his debut in July 1938. There was undoubtedly racism in the depiction of the era's Asian villains, but at least they were portrayed as masterminds.

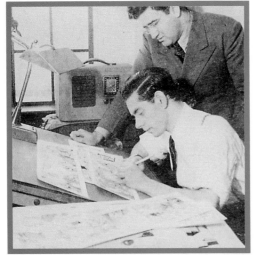

Jerry Siegel and
Joe Shuster

THE BIRTH OF SUPERMAN
The Hero Who Saved Comic Books

If the comic book was invented by executives in New York, it was kept alive by two teenagers from Cleveland. Starting in 1933, writer Jerry Siegel and artist Joe Shuster were engaged in what Siegel later called a "process of evolution," one that eventually led to the most famous comic book character of all. Superman not only inspired a host of imitators, he virtually defined the new medium and, through his popularity and influence, guaranteed its survival.

"Jerry and I were both science fiction fans from way back, ever since I can remember," recalled Joe Shuster. The two had met at the age of sixteen, when Shuster moved into Siegel's neighborhood. They both worked on the high school newspaper, but their real love was the mimeographed magazine they created called *Science Fiction*. Its third issue, dated January 1933, contained a story by Siegel about a man with enhanced mental powers; he called it "The Reign of the Superman." Shuster's illustration showed a malevolent baldy hovering over a futuristic city, in keeping with the pulp magazine tradition that advanced beings were bound to be menaces. It was a reasonable extrapolation, for 1933 was also the year when a failed artist named Adolf Hitler became chancellor of Germany and announced a reign of "supermen" like those predicted by philosopher Friedrich Nietzsche. Yet Siegel eventually decided that a benevolent superman would make a more attractive and effective character, and this creation of two Jewish-American boys would soon be battling the Nazis in his comic book adventures; all he owed to Nietzsche was his name.

Siegel and Shuster's second shot at a Superman character came later the same year, when the first continuously published comic books were launched and the team caught the fever. They put their new version of Superman (not a bald villain, but a hero with hair) into a full-length comic book story, prepared for a fly-by-night publisher who then turned it down and went out of business shortly thereafter. Joe Shuster was so upset that he ripped up his art, and only the cover of this early version was saved. Still, the partners didn't lose heart for long. "We felt that we had a great character," Shuster remembered, "and we were determined that eventually it would be published." Their hero's next incarnation, however, was intended to bypass comic books and go into newspaper syndication.

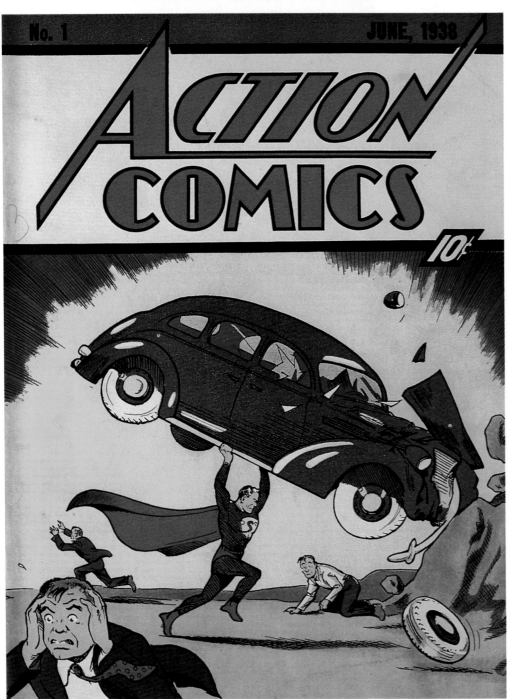

This cover by Joe Shuster kicked the comic book business into high gear, but the legend goes that publisher Harry Donenfeld nearly vetoed it because the image of a man lifting a car was so utterly unbelievable. Worth a dime in June 1938, a mint copy of *Action Comics* #1 recently sold for $137,500.

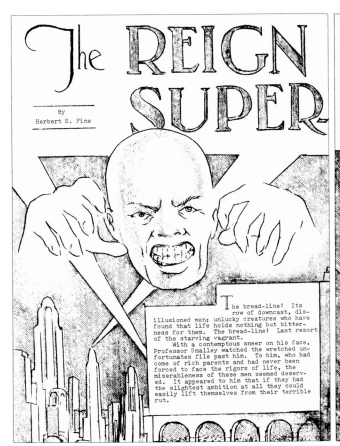

The REIGN of the SUPERMAN

By
Herbert S. Fine

Another Thrilling Story By The Writer
of "Snaring The Master"

The bread-line! Its
row of downcast, dis-
illusioned men; unlucky creatures who have
found that life holds nothing but bitter-
ness for them. The bread-line! Last resort
of the starving vagrant.

With a contemptous sneer on his face,
Professor Smalley watched the wretched un-
fortunates file past him. To him, who had
come of rich parents and had never been
forced to face the rigors of life, the
miserableness of these men seemed deserv-
ed. It appeared to him that if they had
the slightest ambition at all they could
easily lift themselves from their terrible
rut.

But while he eyed them with a world
of condescension, he was busy scanning
their faces, searching for the man he
sought. Time and time again he seemed
on the point of reaching out and putting
a restraining arm on the hand of one of
the men. But ever he hesitated at the
last moment and allowed the fellow to
file past.

At last, however, he gave up his
search in despair and resignedly claim-
ed the attention of the raggedly-dressed
person who happened to be before him
at that moment. "How would you like
to have a real meal and a new suit?"
he inquired.

The resentment in the vagrant's
face died as he saw that Smalley wore
costly apparel. "I'd like nothing
better, mister." Then, suddenly sus-
picious—"What do you want me to do
for you? Nothing crooked,
I hope?"

Professor Smalley lau-
ghed. "I assure you my in-
tentions are purely human-
itarian. But if you doubt
........"

The ultimate version of Superman was born one night in 1934, when Siegel found new ideas coming so fast that he couldn't sleep. He wrote several weeks' worth of newspaper strips, then rushed over to see Shuster, who spent the day drawing with the writer by his side. In the space of twenty-four hours, the job was done. Unlike the previous versions, the new Superman came from outer space. Siegel was one of the first to portray such a being as benevolent, and because he wanted his brainchild to be "glam-orous and unique," considerable care was taken with the costume. Tights seemed vaguely futur-istic and in fact were often used in science fic-tion illustration; Shuster added a cape to help give the effect of motion. Thinking of the color in Sunday comics, they used the primary hues, which Shuster called "the brightest colors we could think of."

Another vital element in the mystique of the new Superman was the idea of a dual identity. Both Siegel and Shuster were shy, bespectacled young men who longed to be admired, and it tickled them to imagine that they might have marvelous powers that nobody suspected. They made Superman's alter ego a newspaper reporter and named him Clark Kent after actor Clark Gable, who, Siegel noted, was "tremen-dously popular at the time."

The combination of unique abilities, flashy costume and secret identity created a new kind of character to which Superman gave his name: the super hero. To say this was a great idea would be putting it mildly, but publishers were unanimous in their lack of interest. Siegel and Shuster offered it everywhere for four years and got nowhere. They began to sell comic book stories to DC, but held Superman back while they made the rounds of the newspaper syndicates. The strips were on the desk of Sheldon Mayer, an editor at the McClure Syndicate, who had been unable to convince his boss, M.C. Gaines, that Superman might fly. When DC's Jack Liebowitz called Gaines, searching for material to put in his new *Action Comics*, the strips were sent to DC editor Vin Sullivan. Taking credit for no more than "just good luck, or maybe a little bit of foresight," Sullivan bought the character nobody wanted. "It looked different," he says.

Superman first streaked across the sky in *Action Comics* #1, dated June 1938.

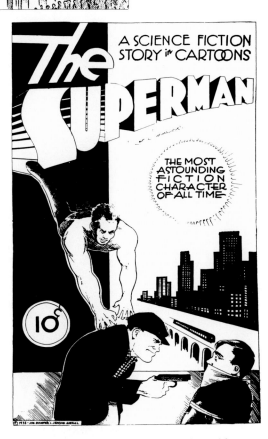

A SCIENCE FICTION STORY in CARTOONS

The SUPERMAN

THE MOST ASTOUNDING FICTION CHARACTER OF ALL TIME

10¢

The second version of Superman was planned for a comic book that never got published. The hero didn't have his costume yet, but by now he was fighting crime instead of causing it.

SUPERMAN'S DEBUT
The Battle for Truth and Justice

Superman #1 represented the first time a character created for comic books was successful enough to earn his own title.

Once DC decided to publish Superman, who had been originally designed for newspapers, he had to be tailored to fit the comic book page. "I had Jerry Siegel and Joe Shuster cut the strips apart," says editor Vin Sullivan. "Sometimes they had to add a panel." There wasn't time to draw a whole new version of the sample story the team had been peddling unsuccessfully for years, so it was simply chopped up, retouched and pasted down. This casual approach may horrify today's collectors of original art, but nobody in the company knew they had history in their hands. Publisher Jack Liebowitz calls the decision to run the feature "a pure accident," based on what was available as the deadline neared for the first issue of a new title. Still, Liebowitz says, "I picked the first cover of *Action Comics*," which meant discarding a previously advertised generic drawing in favor of a scene from the first Superman story.

"We put out a first run of 200,000 copies," Liebowitz remembers. "Dealers called up and wanted more copies. I kept the print run tight, and didn't increase it for three or four issues." In fact, Superman didn't appear on the cover again until the seventh issue, and by that time *Action Comics* was selling half a million copies a month. Before long, the figure would be close to a million. A survey revealed that Superman, not the other characters, made *Action Comics* so popular, so summer 1939 saw the debut of *Superman #1*. Although the first issues of this unique solo comic book relied largely on reprints from *Action Comics*, it sold even better. Superman had turned comic books into a big business.

The only people who had even imagined such success were Siegel and Shuster, who predicted it at the end of their first published story. "You'll note that in the very last panel we say, 'And so begin the startling adventures of the most sensational strip character of all time,'" Siegel observed in 1976. "And that may sound a little conceited, but actually that's the way we felt about the character."

The obvious appeal of Superman was that he could do almost anything; the obvious problem for writer Jerry Siegel was deciding exactly what the character should do. It almost went without saying that he would catch crooks, prevent disasters and impress women. What was remarkable about Superman, however, is that Siegel gave this fantasy figure a serious social conscience. In his earliest adventures, Superman was a reformer.

The Superman story in *Action Comics #1* was thrown together so quickly that its initial pages were dropped to save space. When the more complete version appeared in *Superman #1*, it was revealed that the first good deed performed by the world's first super hero was to rescue a prisoner from a lynch mob. Lynchings were still a real problem in the 1930s, and there was an implied condemnation of capital punishment in Superman's efforts to prove that someone had been unjustly sentenced to die in the electric chair. Covering this story got Clark Kent his job on a newspaper, at that time called the *Daily Star*. All this accomplished in a few pages, Superman casually dropped in on a wife beater and taught him the error of his ways.

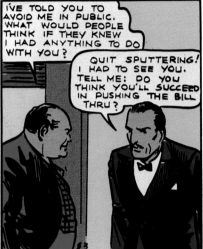

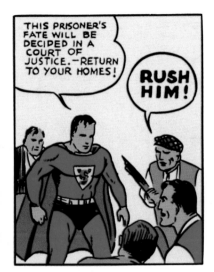

Superman vs. lobbyist

Superman vs. lynch mob

The first Superman appearance ended abruptly with the hero embarked on an even more radical campaign: fighting corruption in the United States government. In a continued story that may remind readers of recent events in the real world, Superman discovers that a lobbyist and a corrupt senator are engaged in a deal to sell arms to one side in a Latin American war. The munitions manufacturer behind the plot reforms after Superman forces him to fight in the front lines. Siegel's favorite story of this socially conscious type concerns a greedy mine owner whose workers are forced to labor under unsafe conditions. When a disguised Superman traps him in the mine, the terrified owner realizes that improvements are mandatory. Amazingly, Superman appears in costume in only one panel

of this adventure from *Action Comics #3*, yet issues like this one were catapulting him to the top. Obviously Siegel and Shuster were not the only children of the Great Depression to embrace progressive causes.

Other tales from Superman's formative period found him involved with crooked labor unions, drunk drivers, and gamblers attempting to influence college sports. Yet the trend toward reform didn't really last, and eventually the world's first super hero found himself facing challenges that were more impressive physically but less interesting politically. Still, the seeds had been sown, and in years to come young writers would sometimes again use comic books to express their more serious concerns. As usual, Superman had been there first.

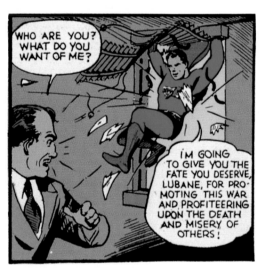

Superman vs. profiteer

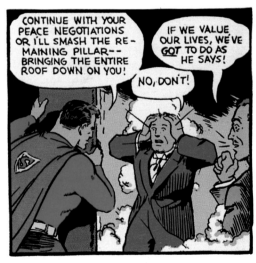

Superman's peace conference

Superman vs. wife beater

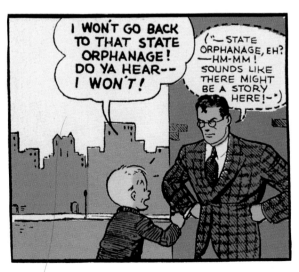

Clark vs. orphanage

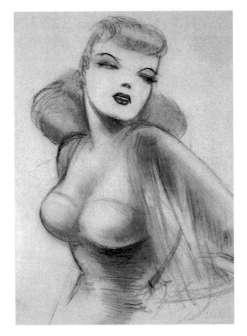

Joe Shuster's lovingly rendered pencil drawing of a sloe-eyed Lois helps explain why Superman put up with her.

THE LIBERATION OF LOIS LANE
Role Model or Just a Role?

Lois Lane has been a lightning rod since her debut in the first Superman story. Perhaps the most controversial character in comics, Clark Kent's colleague is also very likely the best known woman (her only rival is Wonder Woman, who has the advantage of super powers). As the female star in the prototype of comic book features, Lois Lane set the pattern for hundreds of imitators, and she has been analyzed by hundreds of commentators. Somehow, she has come to symbolize the problems of women in the modern world, and to serve as a prism through which we view shifts in the battle of the sexes. Although she exists in a world of outright fantasy, people sometimes seem to forget that she is an imaginary character.

Reportedly, Lois Amster was bright and attractive, but she was, after all, just a student, not the renowned reporter that Lois Lane became. And it's doubtful that she treated anyone the way Lois Lane frequently treated Clark Kent, with a naked contempt that is in itself rather contemptible (in the first published story, she called him "a spineless, unbearable coward"). Fortunately, most women are not as brutal as Lois Lane, but neither are they beautiful celebrities. The dream Lois and the demon Lois are both male projections.

The relationship between Lois Lane and Superman has become so well known over the years that many women have come to identify with Lois, sharing her frustration with the nerd

Scenes of Superman flying with Lois in his arms are so familiar today that the impact of their sexual symbolism has faded, but this dreamlike, evocative underwater rescue has some of the same Freudian overtones. From *Action Comics* #33 (February 1940).

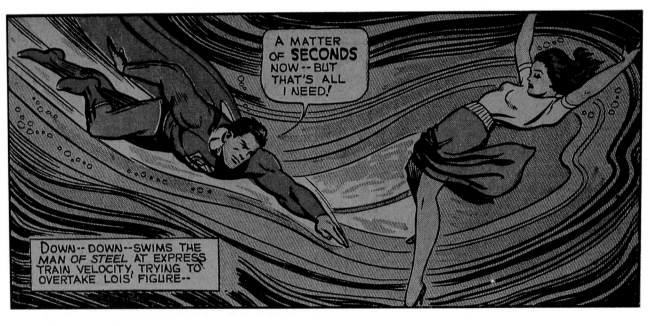

Lois was created by young males for an audience composed largely of young males, and she reflects something of a boy's illusions and delusions about women. Writer Jerry Siegel has stated repeatedly that the inspiration for Superman's dual identity grew out of his own frustration as a high school kid who wasn't "glamorous" and felt uneasy around girls.

Was there one girl in particular who made Siegel wish he had secret powers to impress her, one who might have been the inspiration for Lois Lane? When the question arose years later, Siegel's partner Joe Shuster had no trouble supplying an answer: "Oh, Lois Amster." And Siegel reluctantly concurred. "I don't like to talk too much about that. It is true that I did have a crush on the girl, but it was just a passing juvenile thing of the past."

who wants her and the paragon who doesn't. The irony, of course, is that they are the same person, just as the good Lois and the bad Lois are. And impressive as Lois Lane's credentials may be, there is something questionable about her conviction that no human being is good enough for her, and only a Superman will do. Meanwhile Superman presents an image of perfection while simultaneously demanding, as Clark, to be loved for faults he doesn't even have.

The tension between the characters may not have been entirely healthy, but it seemed to be a vital component of the Superman saga. And girls who encountered Lois in their formative years did learn valuable lessons. For decades she offered the image of a woman as a competent professional making her way in the world, and the idea of self-sufficiency had an impact. Actress Noel Neill, who played Lois for years in

movies and on television, learned this while making public appearances. "A lot of the gals working at radio or television stations said that they were inspired by Lois to go and do it," she reports. Of course, comics are not real life, and no reporter can count on an inevitable rescue from peril courtesy of Superman, nor can she always get her way by sheer force of personality. Lois even bossed around Perry White, editor at the *Daily Planet*, the newspaper where she and Clark ended up working. "No use arguing with her, Kent," declares a minor character in 1941, "I can see she's bound to have her way."

Lois Lane mellowed in the years after her debut, developing more tolerance for Clark, and trading in her inital thrill over Superman's powers for a desire to domesticate him. In 1958 she got her own comic book (even if its full title was *Superman's Girl Friend Lois Lane*), where her obsession with marriage came to the fore. Still, what other DC "girlfriend" had her own title? And after all, men were still writing the stories.

Another interesting aspect of the tale of the "courageous girl reporter" lies in the existence of another "real" Lois Lane. Her name was Joanne Carter, a Cleveland girl who worked as a model for artist Joe Shuster when he was trying to create the definitive Lois Lane. They went their separate ways after a while, but they continued to correspond, and years later she met Siegel and Shuster again at a costume ball in New York. This time Joanne Carter caught Jerry Siegel's eye, and they were married in 1948. "She was tremendously helpful to us," Siegel said. For this "Lois Lane," who saw past Superman to the man behind him, there was a happy ending.

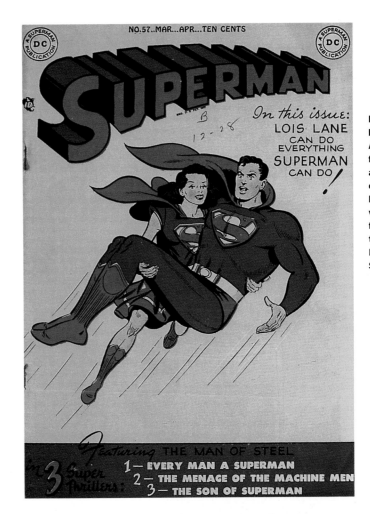

Role-reversal stories like this one (March–April 1949) appeared frequently. In her attempts to juggle career and romance, Lois was a "super-woman" years before feminists took up the term. Pencils by Wayne Boring and inks by Stan Kaye.

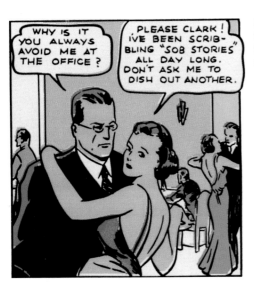

Love's labors lost, from Superman's first published adventure.

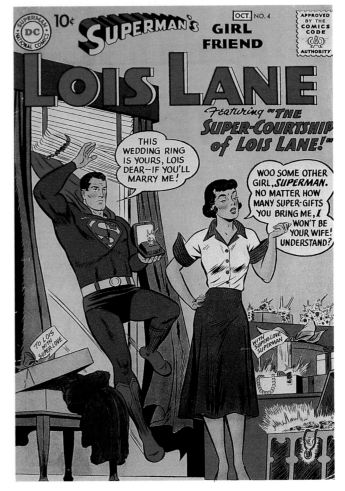

Another switch, and a bit of wish fulfillment for Lois fans as Superman pines after her for a change. After all, it was her own comic book (October 1958). Pencils by Curt Swan and inks by Stan Kaye.

The Superman Villains
Who Can Beat the Unbeatable?

The trouble with writing Superman stories, as Jerry Siegel soon discovered, was that there were very few challenges for a hero who could do almost anything. Omnipotence was obviously a big part of the character's appeal, yet Siegel and his partner Joe Shuster knew there was drama in conflict, and made at least half-hearted efforts to keep Superman vulnerable. They may have succeeded in the beginning, but Siegel acknowledged that "as the strip went on we made him more and more powerful." That didn't matter in the early adventures when Superman dealt with social problems, but he soon needed opponents who could really put his powers to the test.

The Ultra-Humanite, a "mental giant" who was Superman's first great foe, keeps on plotting even after an invisibility gimmick has gone sour. From *Action Comics* #14 (July 1939).

Luthor teams up with perennial pests the Toyman and the Prankster in this Wayne Boring drawing from *Superman* #88 (March 1954).

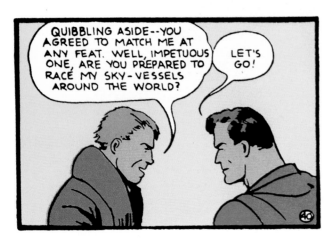

Lex Luthor, nearly unrecognizable on his first appearance, challenges Superman to a contest of science against super powers in *Action Comics* #23 (April 1940).

One obvious solution was sending him into battle against big ugly monsters, so in his first few years he fought giant men and beasts, but they didn't have much personality. Since Superman was going to be around for the long haul, his opponents would have to have staying power equal to his.

Since Superman had a science fiction background, mad scientists seemed a sensible solution. They could invent things to give him trouble, just as Siegel and Shuster did. The first major character of this type, the first one interesting enough to be brought back again and again, was called the Ultra-Humanite. He looked like the menacing, hairless "Superman" that Siegel and Shuster had experimented with back in 1933, but Ultra, as he was sometimes known, was confined to a wheelchair and exhibited only mental powers. Bent on conquering the planet, Ultra concentrated on Superman's home base, Metropolis, at one point unleashing a "purple plague" on the city. His struggles against Superman (1938–40) involved devices like hypnotism, robots and diamond-tipped drills. His most amazing feat was switching sexes by transplanting his brain into the body of a beautiful movie star, but by the time he/she died in a fiery volcano, Siegel and Shuster were building a better baldy.

The most famous Superman villain is undoubtedly Lex Luthor. Introduced in *Action Comics* #23 (April 1940), he sported a full head of red hair, but by 1941 the hair was gone, and the man described by Superman as "the mad scientist who plots to dominate the earth" was clearly a stronger and smarter clone of the Ultra-Humanite. Hiding out in locations ranging from underground to outer space, Luthor began with modest inventions like death rays, but before long he was creating earthquakes, starting wars and causing economic collapse by drugging financial leaders. Pressing on, he evaporated the world's water, blocked out the rays of the sun, and by 1947 discovered a way to give life to inanimate objects. In 1963, his ingenuity made him the hero of a dying planet, whose grateful inhabitants named it Lexor. In recent years he has appeared as a tycoon more often than as a scientist, but in any guise he remains the Mr. Big of comic book bad guys.

Since nobody could compete with Luthor's grandiosity, many of the early Superman villains decided to underplay instead. At least a little silly, these popular foes were more like gadflies than genuine challenges, but they provided some welcome humor. The Prankster, dubbed "crime's

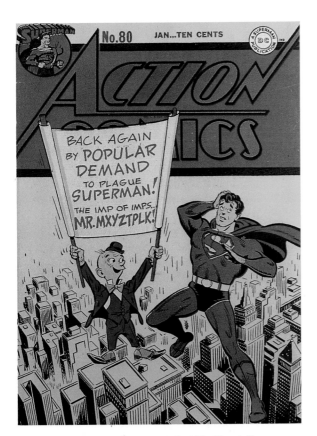

The only way to vanquish the magical Mr. Mxyztplk was to make him pronounce his name backwards (no mean trick). This January 1945 cover has pencils by Wayne Boring and inks by Stan Kaye.

comedy king," was a gap-toothed, pencil-necked geek with a penchant for pulling people's legs. He first appeared in 1942 and had his greatest moment in 1943 when he tricked Superman into knocking himself out. The Toyman, who made his debut in 1943, was a pudgy, bespectacled, long-haired crook whose ingenious if impractical schemes involved the use of sinister playthings. His most annoying caper involved committing crimes with the aid of miniature mechanical figures of Superman.

The most maddening menace Superman faced, however, was undoubtedly Mr. Mxyztplk, who showed just how infuriating he could be by later changing his name to Mr. Mxyzptlk. Described in his 1944 debut as a "sappy supernatural sprite," the little man in the purple derby was a visitor from "the fifth dimension" who had apparently limitless magical powers and employed them with no other motive than pestering people, especially Superman. "If it weren't for guys like me," he reasoned, "super-guys like you would be out of a job."

Creating foes like this was a constant struggle, as Jerry Siegel acknowledged in a strange story about a one-shot villain called Funnyface (*Superman* #19, November 1942). Hidden behind a goofy mask, Funnyface brings villains from other comic strips to life so they can battle Superman. When his real face is revealed on the last page, it is clearly Jerry Siegel's.

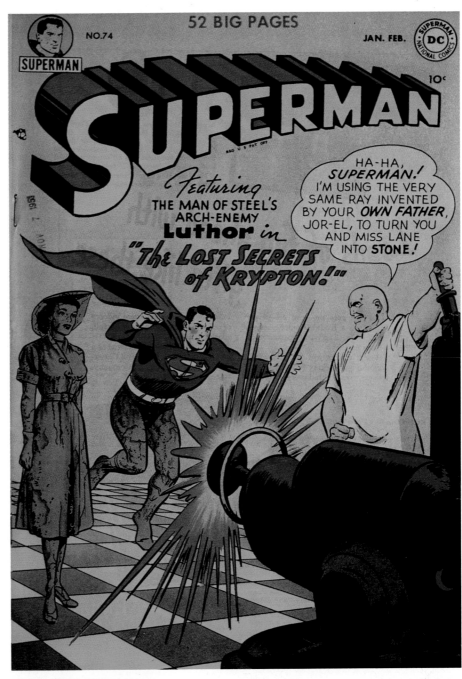

The classic image of Luthor, complete with gleaming dome and crazy ray, was firmly established by January 1952 when this cover by Win Mortimer appeared. Luthor is making use of devices invented by Superman's father Jor-El, unaware that one of them has been booby-trapped and will defeat him.

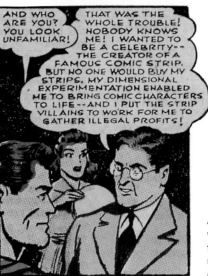

Artist John Sikela drew writer Jerry Siegel as the villain for this 1942 story about a frustrated creator of comics.

THE SUPERMAN STYLE
Refining the Man of Steel

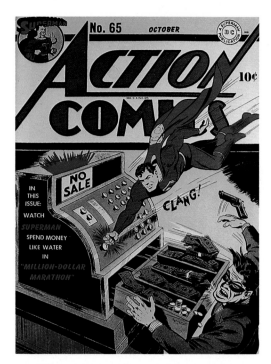

Jack Burnley, hired by DC when Shuster's staff could no longer handle the workload, drew this cover from October 1943.

Pencil roughs by Joe Shuster show his emphasis on construction, using simple shapes to create the impression of a three-dimensional character on a two-dimensional surface.

Success changed Superman. It's not that popularity spoiled him, but it put demands on the character that could no longer be handled by a two-man team working quietly in Cleveland. One story was needed for each issue of *Action Comics*, and four for each issue of *Superman*, not to mention covers. Artist Joe Shuster recognized the problem and responded by setting up a small studio and hiring assistants; the key man among them turned out to be Wayne Boring. Shuster drew with his left hand and could letter with his right, yet despite this facility the work was never easy for him. His eyesight was so poor that he confessed to working with his face an inch from the page, and the demands of deadlines forced him to skimp on details. Yet Shuster's work was solid and full of energy; if it seems unsophisticated by modern standards, it was well above average in the pioneer period of comic books, and Shuster stayed true to his vision. Even as he came to rely on other artists, he insisted on drawing the face of every Superman that emerged from his studio.

The stories became more of a team effort, too. Superman's original editor, Vin Sullivan, left at the end of 1939 to start his own company; publisher Jack Liebowitz replaced him with an enlarged staff headed by Whitney Ellsworth, who had worked at DC during its earliest days. Two more editors, Mort Weisinger and Jack Schiff, were recruited from the pulp magazines. Weisinger, known as a tough taskmaster, was soon called away by World War II, leaving Schiff as managing editor for the duration. "I wanted to get more of the plotting that we had in the pulps," recalls Schiff. Both he and Weisinger were accustomed to making contributions to story lines, and gradually the editors increased their influence. A number of well-known science fiction authors, including Edmond Hamilton, Alfred Bester and Manly Wade Wellman, were brought in to work on scripts. "Times do change," said original writer Jerry Siegel, "and people and literary characters have to grow with the times."

The first artist outside the Shuster shop to work on Superman was Jack Burnley, assigned to draw covers and then stories in 1940. Burnley's version of Superman was taller and more muscular; it seemed to make sense, even though Superman's powers came from differences between Earth and his home planet Krypton, and his size was essentially irrelevant.

The image of Superman that eventually became preeminent was Wayne Boring's. By 1942 the former assistant to Joe Shuster was working on his own for DC, turning out pencilled and inked pages for *Action Comics*

Wayne Boring, whose initial work emulated Joe Shuster's style, gradually developed a distinctive look for the Man of Steel. Its mature form is on display in this cover for *Action Comics* #182 (July 1954).

and *Superman*. His ability had increased since the days when he was admittedly copying other artists; now his technique was polished and his figures less cartoonish than what had been seen before. Massive and magisterial with a suggestion of middle age, Boring's Superman was a paternalistic hero distinctly different from the exuberant character of a few years earlier. Wayne Boring drew the Man of Steel for over a quarter of a century, and in the process he defined the world's first super hero for a generation.

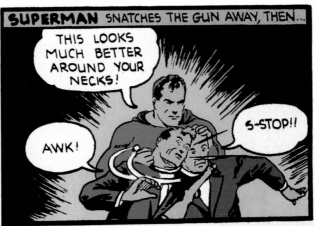

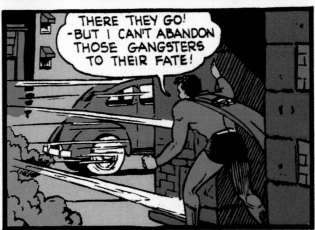

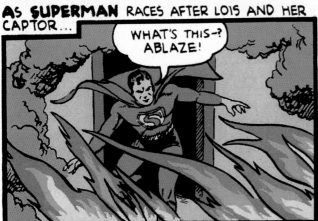

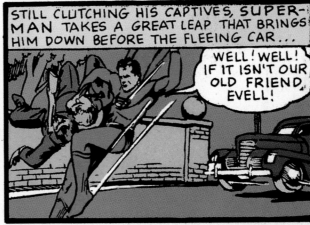

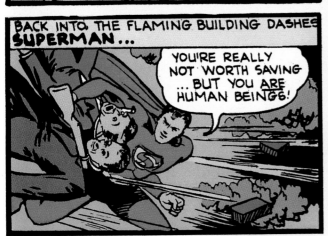

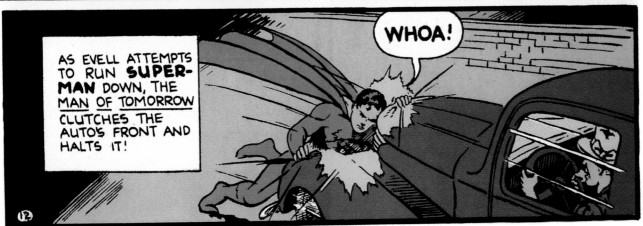

By the publication of *Superman* #5 (Summer 1940), the character was becoming a big business, and Joe Shuster needed a staff to produce all the drawings required. He still tried to work on the layouts and the characters, while other artists did the backgrounds and the inking. This page shows the Shuster shop at its dynamic peak, as Superman runs through his repertoire of stunts by defying bullets, flames and onrushing cars. A standard layout of the time was likely to be divided into eight panels of identical shape, but pages like this one showed a growing interest in experimentation.

The complex romantic triangle of Clark Kent, Lois Lane and Superman fueled many a story; some commentators believe it was the key to Superman's success. This September–October 1944 cover introduces an especially convoluted variation: Trying to defend Lois after she's involved in a fender-bender, Clark gets himself knocked down and Lois says, "I'm ashamed of you, Clark Kent." Bemoaning his fate of "always acting like a weakling around Lois," Clark is encouraged by a colleague to have Superman dress up in his clothes and do something impressive. Lois overhears, but Clark suspects as much and drops the pointless scheme, only to be forced into it when Lois catches him changing from one identity to the other. From then on it's the old "I know that she knows that I know" game, carried to the brink of insanity. As Clark says, "Wouldn't she feel silly if she knew I'd fooled her into thinking I tried to fool her—when I didn't?" The two of them went on torturing each other like this for years and years. Pencils by Jack Burnley and inks by Stan Kaye.

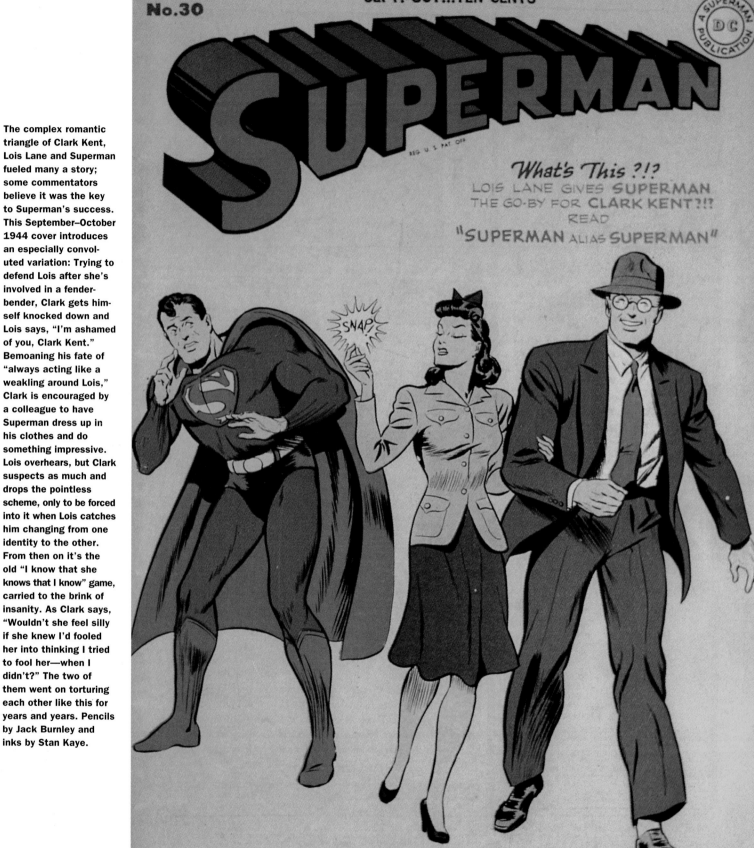

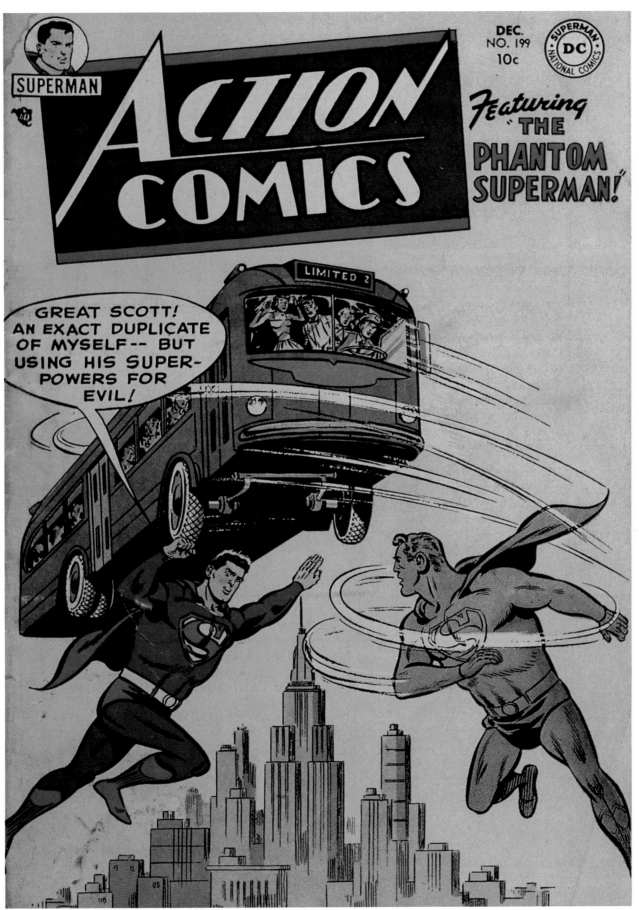

German fantasy writers of the nineteenth century popularized the term doppelgänger, later adopted by psychologists, to describe a menacing double that is a mirror image of the self. The symbolic meanings of such an evil twin are myriad, but for comic books the main significance lay in the chance to oppose a super hero with a villain possessing identical powers. In this story from *Action Comics* #199 (December 1954), the gray "Phantom Superman" has been created by mad scientist Lex Luthor's use of such devices as a "three-dimensional materializer." The process duplicates every characteristic of a subject except color, creating the impression that Superman has been challenged by a living statue of himself. Luthor is defeated when Superman declines to duke it out and instead uses his intelligence to reverse the process that created his dark double. Meanwhile, the striking image of two omnipotent beings tossing a bus around Metropolis anticipates scenes from the 1980 film *Superman II*. Pencils by Wayne Boring and inks by Stan Kaye.

THE BIRTH OF BATMAN
A Hero by Design

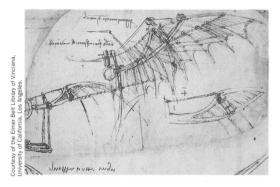

Renaissance man Leonardo da Vinci's proposed flying machine was called the ornithopter, and his drawings inspired cartoonist Bob Kane to create the second great hero of comic books. The design may not have been practical, but it sure looked great.

Batman, the company's second major character, was inspired by visual images from sources that included a Renaissance master and a Hollywood villain, but the immediate inspiration was the success of Superman.

As editor Vin Sullivan recalls, a young cartoonist named Bob Kane was looking for more work. "He was one of the many young fellows who came in, and while we were talking he mentioned something about Superman, who was starting to catch on at the time." When Kane, who says he was making "about forty dollars a week, doing little fill-ins," heard about the soaring incomes of Jerry Siegel and Joe Shuster, he decided at once to abandon humor and create a costumed hero. "For that kind of money," he told Sullivan, "you'll have one on Monday."

Today, many fans believe that Batman began with a plot idea about a boy whose parents were killed by a criminal, but that story line was not created until months after the character's debut. What concerned Kane was coming up with a memorable image. "If you notice," he says, "almost every famous character ever created had a kind of simplistic, definitive design that was easily recognizable, and that's what I was striving for with Batman. Of course the first sketches were very crude."

Racking his brains for something suitable, Kane recalled the design for a batlike flying machine drawn by the Italian artist and inventor Leonardo da Vinci. This Kane combined with a phantasmagoria of figures who had fascinated him in the films he loved as a boy. "I should have been a director," says Kane. "I really love film. I'd go into these little Bijou theaters on Saturday around noon and I wouldn't leave until seven o'clock at night when my mother came in yelling."

The image of a masked man battling evil with extravagant displays of acrobatics came from the 1921 movie *The Mark of Zorro*, starring silent screen legend Douglas Fairbanks. The Zorro character, playboy by day and avenger by night, was created by novelist Johnston McCulley and made Fairbanks the hero of millions of boys. Yet bad guys played their part in the look of Batman too. Kane had been struck by *The Bat Whispers* (1930), the second

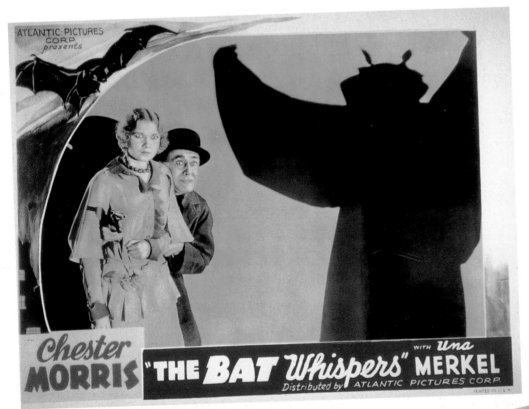

ATLANTIC PICTURES CORP. presents

Chester MORRIS "THE *BAT* Whispers" with Una MERKEL

Distributed by ATLANTIC PICTURES CORP.

This influential melodrama from the early days of sound film was shot in a pioneering wide screen format, and featured effective camera work by director Roland West. Bob Kane was so impressed with the villain's costume that he adapted it for Batman, thus giving the hero an edge of menace.

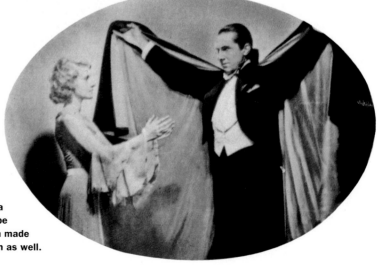

Bob Kane picked up some of his moody lighting and expressionistic angles from the horror films of the 1930s. Bela Lugosi's way with a cape when he played Dracula made an important impression as well.

screen version of Mary Roberts Rinehart's mystery play *The Bat*. Chester Morris was the star, and as Kane notes, "he was the villain but he wore a bat costume." Further inspiration came from the atmospheric horror films of the era, notably the 1931 *Dracula* starring Bela Lugosi.

Kane took his first sketches to writer Bill Finger, who had previously worked with him on a minor feature called "Rusty and His Pals." Today Kane calls Finger "the unsung hero" in the development of Batman, and has expressed regret that Finger's name never appeared on the stories beside his own. Finger not only wrote the best Batman scripts for decades; he also made some helpful contributions to Batman's appearance. He suggested exchanging the stiff bat's wings Kane had drawn for a billowing dark cape with scalloped edges, and also added the ominous touch of leaving Batman's eyes as blank white spaces behind his mask. "When I first drew him I had eyes in there and it didn't look right," admits Kane. "Bill Finger said 'Take them out.'" Among Finger's other contributions was naming the hero's alter ego Bruce Wayne. The similarity to the artist's own name was no coincidence, for Finger had noticed that Bob Kane had not only based the character on his own appearance, but also shared his hero's fondness for keeping late hours. "Oh yeah," says Kane. "I *am* Batman."

Years later Kane met Walt Disney, who compared Batman's memorable design to that of another instantly identifiable character, Mickey Mouse. The look of the lovable mouse was created with circles, but Batman was based on another basic shape: the triangle. The repeated motif of these pointed, slightly menacing shapes defines the character, from the tips of his ears to the bottom of his cape.

"I thought it looked pretty good," said editor Vin Sullivan when the first Batman story appeared on his desk. "It seemed like an interesting character. I don't think anybody realized that it would develop into what it has become today. In fact, I'm sure they didn't." In any case, Sullivan snapped it up as he had Superman, and in the process laid claim to a reputation as one of the most astute editors in publishing history. Batman, known for a few issues as the Bat-Man, first stalked the night in *Detective Comics* #27, dated May 1939.

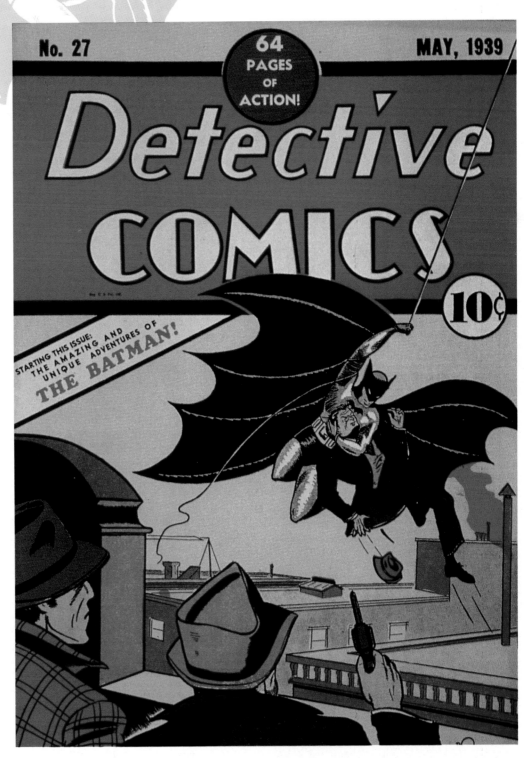

Inside the pages of this first comic book appearance he was the "Bat-Man," complete with quotation marks, but on the cover he was just the Batman. His potentially awkward wings were soon traded in for a more manageable cape. The artist signed the story "Rob't Kane."

BATMAN'S DEBUT
The Man Who Lived in Shadows

Bob Kane

Bill Finger

It wasn't safe to be around Batman in 1939. In his first adventure, "The Case of the Chemical Syndicate," and in those that followed it each month in *Detective Comics*, criminals who battled against the masked man showed a disturbing tendency to fall from rooftops or go up in flames. Batman might not have consciously caused these mishaps, but they didn't make him bat an eyelash. He was angry, and this attitude as much as anything kept the series going in the early days, while its creators decided how much of a menace the hero should be.

Bob Kane's drawings and Bill Finger's scripts showed almost childlike simplicity; the most remarkable thing about them was how quickly they got better. "I really improved fast with Batman," Kane says, adding that it took "about a year" to get the character looking right. In the same period, Finger progressed from patchworks of old pulp plots to tight little mysteries with grandiose visual elements, earning himself a reputation as perhaps the best comic book writer of his era. Both Kane and Finger felt the pressure almost at once. "I used to get nosebleeds from working on it sixteen hours a day at the beginning," says Kane, who supplied pencils, inks and lettering. And Finger's stories were good, according to Kane, because "he sweated over them. That was the main reason he never got them in exactly on time."

One of editor Vin Sullivan's last decisions before leaving DC was to recruit Gardner Fox, a friend from grammar school days. "He became a lawyer," says Sullivan, "but he never practiced. He liked to write." Fox, who went on to become one of the most popular and prolific writers in the business, helped Finger by contributing a two-part story that began in September 1939. For a fill-in, it proved to be fraught with implications.

Fox sent Batman to a castle in Hungary, where he discovered that the villains were vampires; he promptly shot them with silver bullets. Fox's Gothic atmosphere would linger, if in a less European style, but the gun was a problem. When Bill Finger included

another shooting shortly thereafter, the company's new editorial director called a halt.

"Whitney Ellsworth said to take the gun out," recalls Kane. Most readers were kids, and DC had begun to develop a sense of responsibility about what was appropriate. Forbidding heroes to kill was just one of the restrictions that would give DC a reputation for avoiding excess. The tone of the Batman series became lighter, and the door was opened for bad guys to return again and again.

While the vampire story was running, Bob Kane hired an assistant. At a tennis court, he spotted Jerry Robinson wearing a jacket covered with his own drawings and offered him a job on the spot. Although he was about to enter college, Robinson got caught up in the Batman saga. He began with lettering and backgrounds, but gradually his contributions became more significant. As Kane's pencil drawings improved and Robinson took more control of the inking, the two achieved a polished combination of cartoon and illustration. Kane had assembled a superb team with Robinson and Finger, but it was broken up when DC hired Robinson to work separately. "He was a better artist than I," says Kane, "but he never emulated my style."

Along the way came a little two-page piece for *Detective Comics* #33 (November 1939) that proved to be the most famous Batman story of all. "Bill Finger and I decided to give Batman an

Bad guys rarely survived in early stories like this one from *Detective Comics* #29 (July 1939).

Unlike Superman, Batman was vulnerable, which may have accounted for his merciless approach. Bruce's bullet wound came courtesy of Dr. Death.

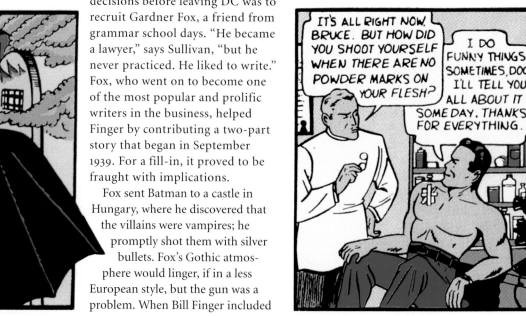

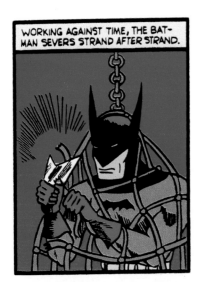

By *Detective Comics #31* (September 1939), escaping from traps was a Batman tradition. Art by Bob Kane.

origin," Kane recalled. "I suggested that maybe he should be an orphan because it would evoke sympathy for him. Then Bill and I discussed it and we figured there's nothing more traumatic than having your parents murdered before your eyes." When Superman's parents were killed he was adopted by the kind, comfortable Kents, but after Bruce Wayne's parents are shot down by a cheap thug (identified in 1948 as one Joe Chill), subsequent panels show the boy entirely alone. His bitter quest for vengeance is often characterized as the mainspring of the series, but the fact is that it was an afterthought.

A favorite film of the Batman staff was Orson Welles' classic *Citizen Kane* (1941). Its dramatic lighting and camera angles struck a responsive chord, as did its hero's surname; less obvious is the fact that this film and their comic book share a similar plot. Psychologists say that it's a common if transient daydream among children to be rid of their parents, but having it actually come true is the stuff of nightmares. Neither Charles Foster Kane nor Bruce Wayne ever recovered, perhaps in part because they experienced survivor's guilt over the price they paid for wealth and power. We're told that Batman adopted his dark disguise to scare criminals, but there could be other reasons why he felt compelled to dress as "a creature of the night, black, terrible." Consumed by guilt and grief, this was a fellow who needed a friend. He was just about to get one.

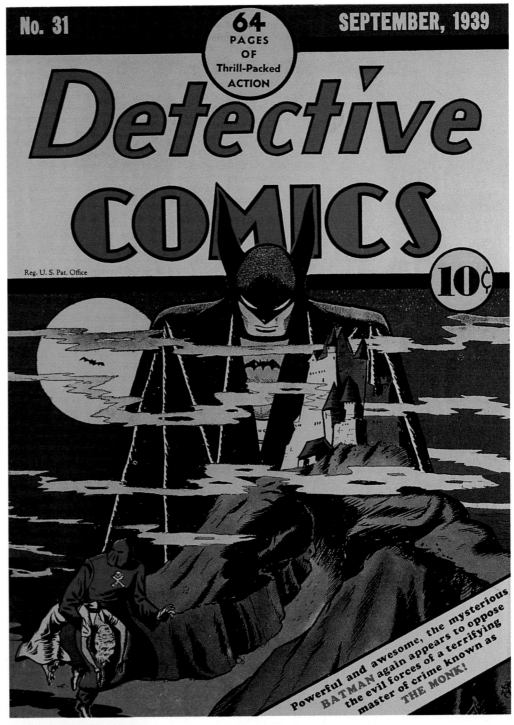

Nothing demonstrates the ominous nature of the early Batman more than this cover from *Detective Comics #31* (September 1939), by Bob Kane. That's the evil Monk in the foreground, but a casual glance would suggest that Batman is the menacing vampire of the castle.

Batman's gun showed up briefly in publicity in late 1939, but soon it was gone for good.

RECRUITING ROBIN
The Boy Who Laughed in the Dark

"What sort of adventure would this be if Batman or Robin didn't swing on a rope at least once?" By 1942 an ebullient Batman could ask this question as a matter of course, mocking his once obsessive quest for vengeance while simultaneously acknowledging that he was now part of a team. Robin, billed as "The Boy Wonder" starting with his debut in *Detective Comics* #38 (April 1940), represented a major step in altering the tone of the series.

"The laughing young daredevil" was born of a writer's frustration and an artist's ambition. Bill Finger complained about the difficulty of creating scripts for a protagonist who had nobody to talk to, and Bob Kane responded with the idea of introducing a kid into the series. He thought it might improve sales, and discovered with satisfaction that in fact they nearly doubled. Kane believes that hordes of younger readers took to Robin not because they were too inhibited to identify with the adult Batman, but because they liked the idea of becoming a costumed hero without waiting to grow up. Only on rare occasions did Batman tell Robin, "You can't come with me—you've got homework to do." Kane personally preferred the solo Batman stories, but he, his staff and DC's executives were all caught up in the quest to gain the broadest possible audience for Batman. And Robin was so popular that kid sidekicks became almost obligatory for the next generation of super heroes.

Robin's origin story echoed Batman's own. His parents were trapeze artists murdered by extortionists seeking protection money from a

Robin was armed with a sling for a few issues, but it rapidly went the way of Batman's pistol.

circus owner. Batman approaches the boy to promise him justice. "I guess you and I were victims of similar trouble," he says, then gives in to young Dick Grayson's pleas to be taken into the super hero business. Already a skilled acrobat, the boy is easily trained and soon equipped with a bright red, green and yellow costume that by its mere appearance altered the tone of the stories. Kane's assistant Jerry Robinson says he suggested Robin's name, which of course echoes his own but also suggests a flying creature. There were also references to the boy as a "young Robin Hood of today," and Kane designed his outfit with medieval embellishments. The colorful, roguish attire matched his personality; he was an orphan like his mentor, but he was hardly traumatized. He viewed crime-fighting as a lark, and soon developed a fondness for bad jokes. Perhaps the difference was that Robin had not been left to grow up alone.

Dick Grayson became the ward of wealthy playboy Bruce Wayne, but in a sense Robin was Batman's guardian too. By the time the two of them caught up with the killers of Robin's parents atop a construction site, Batman wasn't knocking people off buildings anymore. Instead the gang's ringleader pushed off an underling who wanted to confess, and Robin caught the crime with a camera. Batman's angst was dissipating, and a reader could follow the action for years without ever suspecting that Batman and Robin were catching crooks for any reason but the fun of it.

Batman looms over the action (August 1940) the way he did on another cover eleven months earlier (see page 35). However now he is a benevolent, avuncular presence, looking on with approval as Robin goes into action. His ears have been trimmed as well. Cover by Bob Kane and Jerry Robinson.

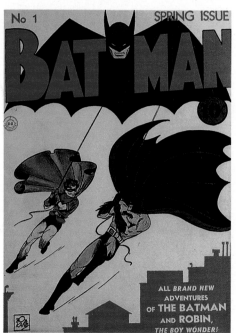

By the time the first issue of *Batman* appeared (Spring 1940), the Dynamic Duo was a going concern.

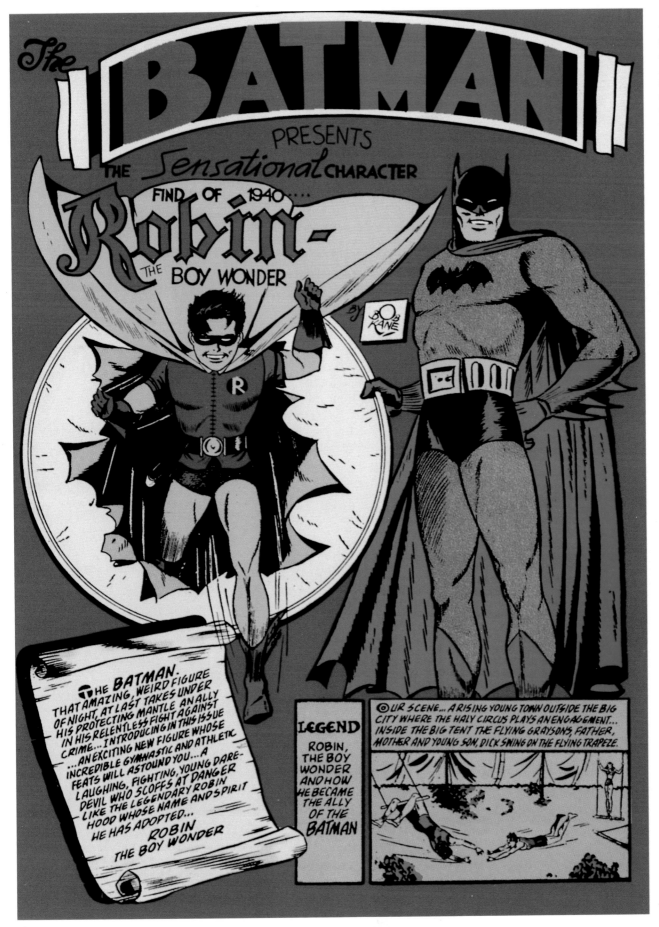

This splash page, the first thing a reader saw on opening *Detective Comics #38*, was a more elaborate version of the issue's cover design by Bob Kane and Jerry Robinson. Only rarely did two such pieces of art duplicate each other, but clearly the plan was to make an indelible impression when introducing Robin. There was duplication in Robin's origin story too: the murder of his parents echoed the shocking event that had created Batman. It took Batman until 1948 to find the killer who orphaned him, but Robin only had to wait till the end of his first appearance.

THE BATMAN VILLAINS
A Gallery of the Grotesque

Gotham City played host to the most colorful cast of criminals in comic books. Bob Kane envisioned his version of New York as a maze of concrete canyons where the full moon cast black shadows behind a man with a cloak; Batman all but demanded fantastic foes. Jack Schiff, who wrote several scripts for Batman and became his principal editor from the 1940s to the 1960s, says, "I wanted to get good opponents for Batman, somebody powerful to fight against so the kids could get interested."

Gangsters in gaudy suits had their place in Kane's urban jungle, but bizarre bad guys were better. A mad scientist named Doctor Death showed promise in two stories, but then he was history, and the vampire called the Monk didn't last any longer. Conditions for villainy improved immeasurably with the premiere issue of *Batman* (Spring 1940). Batman's lethal leanings were under control; the last story where he used a gun was in this issue only because it had been bumped from *Detective Comics* to make room for the introduction of Robin. So the villains survived in three stories from *Batman #1*, including two about a man named the Joker and one about a woman named the Cat.

The Joker arrived with the impact of a pie in the face, and more than half a century later he remains Batman's most notorious nemesis. Later dubbed "The Clown Prince of Crime," he appeared with a hideous grin spread across his dead-white face; his lips were ruby red and his hair emerald green. Originally a ruthless killer without much humor, he employed a poison that caused his victims to expire smiling. He was destined to die in his second story, but was rescued by editorial director Whitney Ellsworth, who declared him too wonderful to waste. By 1942, he had stopped killing and become a practical Joker who would pave his escape route with banana peels to prevent pursuit. He set death traps, but didn't seem to care if Batman and Robin survived them since he took such pleasure in their battles. More than once he turned down the chance to unmask his adversaries and expose their secret identities.

Bob Kane's assistant Jerry Robinson claims credit for creating the Joker, saying the idea came from a playing card. Kane agrees that Robinson suggested using the pasteboard prop, but insists that he and writer Bill Finger had

A villain with a flair for comedy, the Penguin answered to the name Oswald Chesterfield Cobblepot, which may be what drove him to deeds like turning umbrellas into flamethrowers. From the cover of *Batman #38* (December 1946–January 1947) by Dick Sprang.

The cover for *Batman #44* (December 1947–January 1948) shows omnipresent Jokers, a recurrent image that emphasized the character's chaotic spirit. Cover by Jim Mooney and Charles Paris.

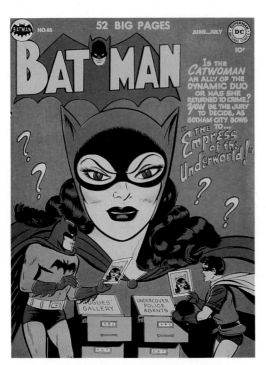

Today's Catwoman stories suggest that male chauvinism drove her to crime, but in the early days everybody understood that she was in business for fun and profit, just like one of the boys. The composite cover for *Batman #65* (June–July 1951) is by Win Mortimer, Lew Sayre Schwartz and Charles Paris.

Almost inevitably, the schizophrenic Two-Face had two names. He was called Harvey Kent when he first appeared, but with *Batman #50* (December 1948–January 1949) his name was changed to Dent to avoid any similarity to Clark Kent. Pencils by Lew Sayre Schwartz and Bob Kane, and inks by Charles Paris.

already come up with the character, deriving his appearance from the silent film *The Man Who Laughs* (1928). After more than fifty years someone's memory has dimmed, but it's a mixup the Joker would enjoy, and perhaps he should take the blame for it.

The Catwoman, who began as the Cat, took a while to develop into the most important woman in the Batman saga. Originally a jewel thief who employed disguises but no costume, Selina Kyle was wearing a furry cat mask by *Batman* #2, and spent years developing a dark, form-fitting outfit that included a cowl with ears. Her resemblance to a female Batman was probably no accident, since she seemed to be a bit in love with him. Judging by Batman's remarks at the end of their initial encounter, the feeling was mutual: "Lovely girl! What eyes! Maybe I'll bump into her again sometime…." He did.

Perhaps the oddest of Batman's oddball opponents was a tubby little chap known as the Penguin. Dressed in top hat and tails, he was suggested to Bob Kane by the bird used to advertise Kool cigarettes. Bill Finger gave the Penguin an array of prop umbrellas that could shoot anything from bullets to bacteria; the link between birds and bumbershoots was tenuous, but somehow it worked. After a deadly debut in 1941, the character was played for comedy. "The Penguin is cartoony, even the Joker's face is cartoony," says Kane. "I wanted the art stylized."

There was nothing funny about Two-Face, who was doubly disturbing because he was tragic as well as terrifying. A district attorney and a friend to Batman, he became a crazed criminal in 1942 after an embittered felon disfigured him with acid. Kane got the idea from *Dr. Jekyll and Mr. Hyde*, but upped the ante by portraying the good and evil sides as two halves of the same face. Fixated on duality and destiny, Two-Face based his decisions on the flip of a coin, and specialized in crimes like robbing a theater showing a double feature. Apparently killed, apparently cured and then deformed again, Two-Face seemed doomed to turn up repeatedly like a bad penny.

These are only the cream of the criminals who arrived in turn to dance a ritualized, costumed duet with Batman. They deliberately left clues to taunt him, and showed less interest in cash than in the contest. The elite of Gotham City provided the setting for the dance by displaying their wealth at balls and shows, inviting badman and Batman to serve as guests of honor. The stories were becoming as formal as a minuet, and they offered much of the same elegance.

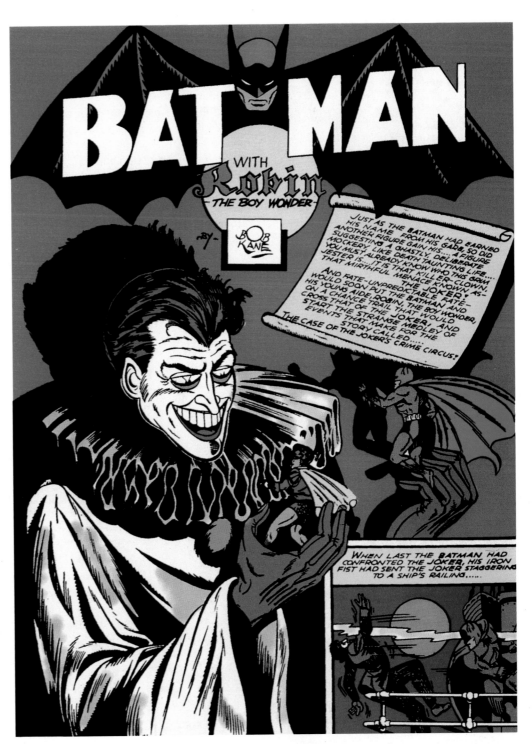

The Joker, perhaps the most notorious of all comic book villains, had achieved such stature by *Batman* #4 (Winter 1940) that Kane and Robinson could depict Batman and Robin as pawns in his hand. No explanation for the cruel clown's appearance was offered (or apparently needed) until a 1951 story revealed that corrosive chemicals accounted for his colorful look. Less convincingly, they also made him a maniacal genius.

THE BATMAN STYLE
Creating a Classic

Dick Sprang

Dick Sprang was noted for his wild splash pages, spectacular story openings that served in effect as second covers. These big, posterlike images rarely depicted a specific scene from the script; more often, they were symbolic summations of the plot. This example from *Batman* #74 (December 1952–January 1953) shows the Joker enjoying a second childhood, whereas in the actual story he merely feigns insanity in order to outwit the law. Inks by Charles Paris.

Although Bob Kane's stylized signature was the only one to appear on Batman stories, keeping the Caped Crusader popular involved the work of many hands. Artists, writers and editors collaborated to create a distinctive house style that sustained itself for decades and is remembered even today, despite years of more individualistic interpretations of the character. "There's quite a body of appreciation for that period," says artist Dick Sprang, whose twenty years of anonymous but impeccable work helped define the look of Batman throughout the '40s and the '50s.

As Bob Kane became less involved in day-to-day production, the artists he called "ghosts" became more important, and Dick Sprang remains his favorite among them. Hired by Whitney Ellsworth in 1941, Sprang had previously worked in pulp magazines. "I realized that comics would be the coming thing," says Sprang. "We were working with sort of a new medium with the long story," he says, and credits editors Whitney Ellsworth, Jack Schiff and Mort Weisinger with perfecting the form. "In my opinion," he adds, "Whit was the driving force that really made DC great."

Among Ellsworth's contributions was creating rough sketches for the bold covers that made Batman stand out. Jack Schiff worked closely with writers like Bill Finger. "We'd take some idea and kick it around," says Schiff, who would then ask for a synopsis before commissioning a script. "It was very thoroughly gone into." Finger was especially appreciated by artists because his stories featured big, impressive props and he provided clippings for reference. "I loved his stuff," says Sprang. "We shared a common visual sense."

Of course the original Batman visuals were created by Bob Kane, who took some inspiration from the newspaper strip *Dick Tracy* by Chester Gould. "His stuff was stiff," says Kane, "but really beautifully designed and flat like a Japanese print." Such a style, at once ancient and avant-garde, was honed to perfection by the unassuming Dick Sprang, who worked without credit under the Kane byline that

was maintained for continuity purposes. That was fine with Sprang, who says, "To me it was a darn good way to make a living and have the freedom to choose where I lived." By 1946 Sprang had proved his reliability and moved to Arizona to work via the mails. The best inker of Sprang's pencils was Charles Paris, whose lines were as sharp as a razor's edge, but although both lived in Arizona they never got together until after their retirement.

The Catwoman story from *Detective Comics* #211 (September 1954) contains only tigers of normal size, but Sprang's dramatic image is used to emphasize the feline ferocity of Batman's antagonist. Inks by Charles Paris.

"I was able to conform to Kane's style pretty accurately," says Sprang. "It was an established character, so why not?" Eventually he thickened Batman's torso and shortened his ears, but achieved more "when Whit Ellsworth told me to go ahead on my own more or less on designing pages." Sprang studied kids reading comic books and learned to hold their interest. "To get the kids to turn the page and not be disappointed by the first panel up there, that was a problem." Perhaps helped by his study of mapmaking, Sprang produced beautifully composed layouts that employed multiple angles and varied panel shapes but remained instantly comprehensible. "I think it must be a prime requisite of the graphic artist to always be clear," he says. In all, he drew 238 stories and 60 covers in the classic Batman style; his retirement from full-time comic book work in 1961 marked the end of an era.

BY THE TIME THE DENSE SMOKE CLEARS...

THE RIDDLER WILL GET AWAY— AND I CAN'T FOLLOW HIM, KNOWING EAGLE WILL SUFFOCATE INSIDE THAT PUZZLE!

NOW BATMAN MATCHES HIS WITS AGAINST A HIGHLY COMPLEX PUZZLE, WITH A LIFE AT STAKE IF HE FAILS!

I'LL NEVER FIND THE SECRET OF THIS PUZZLE IN TIME TO SAVE HIM!

WAIT! THE LITTLE NICKS ON SOME OF THESE STEEL RODS WERE OBVIOUSLY MADE WHEN THE RODS SCRAPED AGAINST EACH OTHER!

BY CAREFULLY FOLLOWING THE TINY NICKS SHOWING HOW THE RODS WERE FITTED TOGETHER, BATMAN UNDOES THE PUZZLE!

JUST IN TIME, TOO!

UHHH!

AFTERWARDS... IT IS A GRIM BATMAN WHO REJOINS ROBIN!

THE RIDDLER'S STAGING A CRIME-CHARADE IN THIS TOWN THAT WE'VE GOT TO STOP! THAT MAN'S DANGEROUS!

MEANWHILE...

THAT WILL DO NICELY FOR MY FINAL CHALLENGE TO BATMAN AND ROBIN— A RIDDLE TO RID ME OF THEM— FOR GOOD!

HIGGINS CANNED CORN

This classic Dick Sprang page is part of a story that introduced a major new villain, the Riddler. Typical of Sprang is the dynamic design of the page, with each panel emphasized by a different size and shape. Points of view range from close-up to long shot, from bird's-eye view to worm's-eye view, and Sprang's last panel is a "hook," initiating new action to pull the reader toward the next page. Significant elements include the moon-drenched cityscape, the giant props, the death trap, a costumed villain issuing challenges and a puzzle solved by detective work. "There probably is a native instinct for being able to create dramatic stuff," says Sprang. From *Detective Comics* #140 (October 1948). Pencils by Dick Sprang, inks by Charles Paris and script by Bill Finger.

Some readers might have imagined that the boy on this cover was Robin, but in fact it's a young Bruce Wayne, mourning the murder of his father and envisioning a new life with all its accoutrements: the Batmobile, the Batplane and the Bat-Signal. The cover of *Batman #47* (June–July 1948) looks like it should be celebrating a special issue or perhaps the character's tenth anniversary, but it's a little premature for either one. Regardless, this is a retelling of Batman's origin that includes a few minor changes (somebody decided it was just too awful to have Batman's mom shot, so she conveniently drops dead instead). New elements include Batman's belated discovery that that the killer was a minor thug named Joe Chill. When his fellow criminals realize that Chill's crime virtually created the Caped Crusader, they promptly bump him off. Pencils by Lew Sayre Schwartz and Bob Kane and inks by Charles Paris.

"Where does he get those wonderful toys?" asks the Joker in the 1989 movie *Batman*, and for decades the Crime Clown and his peers seemed to find jealousy a justification for committing crimes. In this typical Bill Finger story, the Joker robs the "Comedians Hall of Fame," and decides he needs a utility belt of his own after Batman's gas pellets spoil his fun. As a result, the "Harlequin of Hate" takes to wearing sneezing powder and exploding cigarettes around his waist, but of course he still can't win. Doomed to frustration despite his ingenuity, the Joker of the 1950s is reminiscent of contemporary cartoon characters like Daffy Duck and Wile E. Coyote, but the cover for *Batman* #73 (October–November 1952) casts him in a far more menacing light. Penciller Dick Sprang, whose covers were often variations on a theme, summons up a dozen gigantic Jokers, mechanical and reptilian, none of which appear in the tale inside. Inks by Charles Paris.

THAT OLD BLACK MAGIC
The Super and the Supernatural

Fred Guardineer's Zatara got the cover only twice before DC realized it was smarter to play up Superman. From *Action Comics #12* (May 1939).

Long before Siegel and Shuster introduced the idea of the super hero to comics, there had been a literary tradition of characters who acquired great powers from supernatural sources. Wizards had always made handy villains, and they soon came to serve as antagonists for the new breed of comic book headliners. But magicians also had the kind of charisma that could turn them into stars in their own right. They were around from the earliest days of comic books, and some of these uncanny characters had such amazing abilities that they made the average super hero look limited by comparison.

In fact, one of Siegel and Shuster's first DC characters was "Dr. Occult, the Ghost Detective," who made his debut in *New Fun Comics* in October 1935, almost three years before Superman saw the light of day. For most of his brief career, Dr. Occult was a mortal battling the uncanny (his first adventure pitted him against a vampire), but in 1936 he developed immense strength and began flying around in a red and blue outfit. He thus served as a prototype for the unpublished Superman, a character being rejected everywhere by editors who apparently found the supernatural more convincing than super heroes.

When Superman finally did appear in the first issue of *Action Comics* (June 1938), one of the characters he shared the space with was

Zatara, Master Magician. Created by artist Fred Guardineer, Zatara dressed like a classic stage conjurer in top hat and black cape, but spent most of his time "wiping out the forces of outlawry." He could make just about anything happen merely by issuing commands in reverse English ("Ouy era won ni ym rewop!"), and for a while he even had the power to bump Superman off the covers of *Action Comics*.

Jerry Siegel acknowledged the appeal of such hoodoo heroes when he followed up Superman with another important character: the Spectre. Working with artist Bernard Baily, Siegel went all out to create a protagonist who was not merely super but absolutely omnipotent. Clad in a cowled cloak that covered only some of his colorless skin, the Spectre looked like the traditional figure of Death, but was actually the earthbound spirit of murdered cop Jim Corrigan. In the afterlife he was granted the power to fight crime on earth, and the Spectre took things very seriously indeed; one of his favorite tricks was scaring his enemies to death. He thought nothing of journeying into the netherworld or tossing stars around, but apparently readers found him a bit too grim, since his initial exploits in *More Fun Comics* lasted only from 1940 to 1945. Like a good ghost, however, he keeps coming back.

Another spooky hero in the incongruously

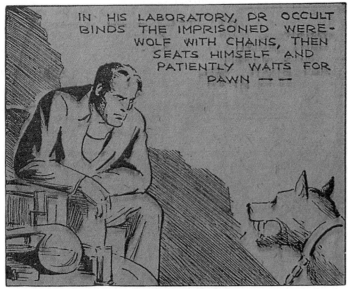

DC's first spooky hero was Siegel and Shuster's Dr. Occult, shown staring down a werewolf in this scene from *More Fun Comics #12* (August 1936). Early on, black-and-white interior pages were a commonplace way of cutting costs.

Bernard Baily drew this cover to introduce Jerry Siegel's menacing hero the Spectre for *More Fun Comics #52* (February 1940). In the next issue, the Spectre's cloak turned green.

Dr. Fate battles ancient sorcery in this page by Howard Sherman, drawn in an old-fashioned but attractive style reminiscent of a woodcut. Sherman designed the entire story for a rigid grid of eight panels per page, and his figures are equally stiff, but the overall effect is one of a strong, integrated design that even extends to the distinctive lettering. The panel at the lower left achieves a magical purity that makes it one of the most memorable images ever generated by such a minor character. The octopoid horror appears to be writer Gardner Fox's tribute to pulp author H. P. Lovecraft. From *All Star Comics* #3 (Winter 1940).

titled *More Fun Comics* was the sorcerer called Doctor Fate. According to one of writer Gardner Fox's captions, "The strange creature known as Doctor Fate keeps watch on the world for the menaces that have to do with the lost wisdom of the ancients." Wearing a golden helmet that kept his features permanently obscured, Fate dwelt in "a tower among the ghostly Salem hills," and ventured forth to defeat foes like the Fish-Men of Nyarl-Amen. As powerful as the Spectre, with whom he traded covers on the comic book they shared, Doctor Fate had an edge thanks to the elegant, Art Deco style of his illustrator, Howard Sherman. Yet despite his appeal to connoisseurs, Doctor Fate retired in 1944 after less than four years of service, suggesting that most fans preferred heroes who fought with fists instead of magic spells.

Comic Book Competitors
DC Inspires a Horde of Heroes

By 1939, the double-barreled triumph of Superman and Batman had knocked the infant comic book industry on its ear. The idea that heroes nobody had heard of a few months before could suddenly sell hundreds of thousands of copies was just too tempting to resist, and promptly sued Fox for plagiarism. "We beat him," says DC's Jack Liebowitz, but Fox didn't even wait for the 1940 judgment and canceled Wonder Man after his first appearance. Fox had some success later in 1939 with the Blue Beetle, who got his strength from vitamins.

In these eye-popping panels from *Plastic Man* #21 (January 1950), Jack Cole's character gets entangled with his evil twin Amorpho.

Plastic Man gets a rise out of a stimulating scene: a blonde reclining on a big pile of money, with a dead guy thrown in for good measure. Jack Cole's satirical take on an American dream appeared in March 1949.

and before long publishers large and small were flooding the newsstands with a cascade of costumed characters. DC had established a new genre with its super heroes, and the competition would be fast and furious.

A rival might come from anywhere, even the same building. Victor Fox, an accountant for DC, saw the sales figures and promptly opened his own office just a few floors away. He hired Will Eisner, later one of the most respected talents in comics, to write and draw a deliberate imitation of Superman called Wonder Man for *Wonder Comics* (May 1939). Eisner never suspected this might be illegal, but DC did

Considerably more creativity was shown in the first issue of *Marvel Comics* (October 1939), which later gave its name to its fledgling publisher. Deriving their powers respectively from fire and water, the Human Torch and the Sub-Mariner were guys with a gimmick. From the same firm in 1941 came the patriotic Captain America, created by Joe Simon and Jack Kirby; after a dispute with the publisher, the innovative team went to work at DC in 1942.

The toughest competitor of all was Captain Marvel, who got his start in *Whiz Comics* (February 1940). The product of a large, established firm called Fawcett Publications, Captain Marvel in his heyday was the biggest seller in the business, but in some ways he seemed suspiciously close to Superman. DC decided to sue. "It took a long time," says Jack Liebowitz. The legal battle dragged on for years as the two corporations duked it out like super heroes, and the dust didn't settle until 1953. DC editor Jack Schiff compiled a scrapbook documenting similarities, but the district court dismissed DC's complaint. DC appealed, and the case was heard by no less a jurist than Judge Learned Hand, who reversed the dismissal and

remanded the case back to the lower court. At this point Fawcett finally decided to settle, and agreed to stop publishing Captain Marvel.

For all of that, Captain Marvel is a great character. Created by artist C. C. Beck and writer Bill Parker, the series developed a humorous slant in scripts provided by Otto Binder. The often obtuse hero was a "Big Red Cheese" to his brilliant enemy Dr. Sivana, and was nearly defeated by an intellectually advanced earthworm called Mr. Mind. Beck's simple artwork had real appeal, and kids loved the idea that young Billy Batson could turn into the "World's Mightiest Mortal" simply by uttering the magic word "Shazam!" In 1973, events came full circle when DC acquired the rights from Fawcett to revive the character with a comic book called *Shazam!*, and a successful TV series followed in 1974.

Captain Marvel wasn't the only hero who eventually became part of the DC family after getting his start elsewhere. When the Quality

Comics Group folded during an industry slump in 1956, DC picked up two major features that had first appeared in August 1941: Plastic Man and Blackhawk. The bizarre brainchild of cartoonist Jack Cole, Plastic Man got some acid in an open wound and ended up "stretchin' like a rubber band." Cole had a surreal imagination, and the convoluted contortions of his character were a joy to behold. Decked out in dark goggles, Plastic Man was perhaps the hippest hero in comics. All his counterparts had jealously guarded secret identities, but "Plas," a reformed criminal, just couldn't be bothered; his sidekick wasn't a kid, but a fat guy in a polka dot shirt. There has never been a funnier crime-fighter.

Blackhawk, by contrast, was born on the bloody battlefields of World War II. A Polish flier shot down by the Nazis, he established a guerrilla unit on an uninhabited island and recruited six aviators from allied nations: Andre, Chuck, Chop Chop, Olaf, Stanislaus and Hendrickson. They had no special powers, but they did have matching uniforms and great planes. One of the first hero teams in comics, the Blackhawks flourished even after the war ended. Created by the prolific Will Eisner, the series would later benefit from the impeccable draftsmanship of Reed Crandall. It began a long run at DC in 1957.

The acquisition over the years of major characters like Captain Marvel, Plastic Man and Blackhawk strengthened DC's stable, and confirmed the company's status as the home of the most famous super heroes in the world. Meanwhile, an entire army of adventurers would enter the ranks beginning in 1939 with the creation of a sister company for DC: All American.

Captain Marvel and his alter ego Billy Batson.

Artist Reed Crandall shows heroes in repose in this unusual character study from *Blackhawk* #18 (Spring 1946). The boys in blue are Olaf, Chuck, Stanislaus, Andre, Blackhawk, Hendrickson and Chop Chop (not in uniform).

Captain Marvel gets a grip on perennial foe Dr. Sivana in this C. C. Beck cover for *Whiz Comics* #57 (August 1944).

ALL AMERICAN COMICS
Making the Business Bigger

By 1939, Jack Liebowitz was convinced that there was a big future in publishing comic books, but Harry Donenfeld, his partner at DC, was inclined to be more cautious. "We had four magazines at the time," recalls Liebowitz, "and Donenfeld thought that was enough. He didn't want to put out any more, so I got together with Charlie Gaines and we started our own company. That was All American."

Maxwell Charles Gaines was already a key figure in the history of comics. As a salesman for Eastern Color Printing in 1933, he had helped develop the first comic books, designed as promotional giveaways, and had then hit upon the idea of selling them at newsstands. Later, he worked for the McClure Syndicate, repackaging newspaper strips into comic books with the help of a young editor named Sheldon Mayer. It was Gaines and Mayer who had recommended that strange strip called *Superman* to DC Comics in 1938, and apparently its success convinced Gaines to try his luck as a publisher.

The relationship between DC and All American was complex. Jack Liebowitz, who was a partner in both, notes that "they were separate companies," and

Hop Harrigan, Jon Blummer's young aviator, drops out of the sky accompanied by a supporting cast that includes redheaded mechanic Tank Tinker. Despite his popularity in other media, Hop rated only occasional covers, like this one for *All-American Comics* #14 (May 1940).

Bud Fisher's famous characters Mutt and Jeff got their start in a newspaper strip back in 1907, and were fixtures on the American scene for decades. The company's only important reprint characters, they appeared regularly in the pages of *All-American Comics* and had their own comic book from 1939 to 1958. This is the November 1946 cover.

the All American office was in downtown Manhattan, at 225 Lafayette Street, while DC was in midtown, at 480 Lexington Avenue. Yet the companies promoted each other's publications, shared DC's distribution system and eventually exchanged copyrighted characters. By 1940 the distinctive DC trademark was appearing on All American's covers. It was perhaps inevitable that the two firms would merge, and it happened in 1944 when Liebowitz bought out Gaines' share. M. C. Gaines went on to found EC Comics, which under the supervision of his son William would produce such innovative offerings as *Tales from the Crypt* and *Mad*.

Sheldon Mayer, who moved over to All American and then stuck with DC, became one of the best editors in the business. He was also a cartoonist, and contributed the most interesting character to the first issue of the new company's first publication: *All-American Comics* (April 1939). The character was Scribbly, a boy cartoonist whose humorous adventures in the new industry were only a slight exaggeration of many a youngster's experience. Joe Kubert, already an experienced artist when he was hired by Mayer at the age of sixteen, read "Scribbly" and says, "I loved it, because it really reflected a lot of my own feelings about trying to get into the business. And I later learned that Shelly felt exactly the same way." Mayer's sympathy for beginners led him to recruit and train some of DC's top talents. "He was always kind and helpful," says Kubert. "The drawing is really the easiest part of what we do, but to put it together in sequential form, and to do it dramatically, that's another whole ball game. And Shelly was really my first teacher as far as that's concerned."

Another boy hero from *All-American Comics* was Hop Harrigan. Created by Jon L. Blummer, this young flier is almost forgotten today, but in his time aviation was considered high adventure, and Hop was one of the few comic book characters to appear in movies and on radio. Still, the big stars of the book were Bud Fisher's Mutt and Jeff, relics of a newspaper strip that had begun in 1907. So publisher M. C. Gaines was proceeding cautiously, but before long All American would produce such important new characters as the Flash, Green Lantern and Wonder Woman.

"Ma Hunkel, the Red Tornado, was the first super heroine." So said her creator, Sheldon Mayer, the cartoonist who became the editor of *All-American Comics*. Mayer may have had his tongue in cheek, but technically he had a point. She was probably the first character to spoof super heroes as well. This page is from her third appearance, in the "Scribbly" story from *All-American Comics #22* (January 1941). Scribbly, the kid cartoonist, unknowingly gave his neighbor Mrs. Hunkel the idea of donning a costume to battle local thugs. Mayer based her on a woman he knew. "She really lived," Mayer recalled. "She never did that kind of thing, but by golly, if she had ever thought of it, she would have."

FLASH COMICS
All American Picks up Speed

Billed as "those three dimwits," and more than a trifle reminiscent of Moe, Larry and Curly, the Flash's comedy sidekicks were (from left to right) Noddy, Blinky and Winky. Cover of *Flash Comics* #72 (June 1946) by Martin Naydell.

The original portrait of the Flash by his original artist Harry Lampert, from *Flash Comics* #1.

By the beginning of 1940 the handwriting was on the wall, and so were the sales figures. Super heroes were hot, and their number was about to be increased by DC's cautious sister company, All American. With the first issue of the new anthology *Flash Comics* (January 1940), editor Sheldon Mayer took a chance and unleashed two super-powered protagonists at once. Each was written by Gardner Fox, and each appeared as the cover boy on alternate issues for close to a decade. Both the Flash and Hawkman became solid hits.

The Flash was a prime example of a super hero with a specialty. While Superman's ever-expanding abilities seemed to include almost every kind of activity, the Flash simply settled for super speed. Moving fast was an appealing idea and eventually inspired a number of imitators, but its early treatment in *Flash Comics* was not utterly inspired. The original artist, Harry Lampert, had a rather crude, almost childish style, and he was replaced after two issues by the more accomplished Everett Hibbard. Such a quick change suggests that editor Mayer really had more control over the feature than its credited creators, and several All American characters would undergo similar sudden switches.

In his introductory caption to the first Flash story, Gardner Fox called his protagonist a "reincarnation of the winged Mercury," but the mythological reference to the ancient Roman god didn't extend much past the winged helmet and boots that set off the hero's red, yellow and blue tights. The power to move at the speed of light came not from the supernatural but from science, of a sort. Accidentally inhaling the fumes from hard water, college student Jay Garrick collapses, then revives while his doctor explains how "science knows that hard water makes a person act much quicker than ordinarily." Armed with this questionable knowledge, the speedy Jay becomes a sports hero to impress his girlfriend, who in contravention of the usual rules is let in on his super secret.

"Boy," he chortles, "this is the stuff!! A football star—and a date with Joan tonight!!" Before the tale is told, Jay has defeated a gang of spies (largely by outrunning their

bullets), adopted his uniform and gone into the super hero business.

Perhaps because the art style tended to be cartoonish from the onset, the adventures of the Flash generally had a strong humorous element, which was further emphasized when he acquired three dimwitted sidekicks named Winky, Blinky and Noddy who seemed to be loosely based on the Three Stooges. They dropped out toward the end of the character's initial run, when new artists like Carmine Infantino and Lee Elias gave things a more serious look. Either way, All American's premier super hero rushed to prominence and even acquired a comic book devoted exclusively to his exploits. To avoid confusion, it had to be called *All-Flash* (Summer 1941).

The Flash's colleague Hawkman didn't get his own comic book, but he was a somewhat more complex and intriguing figure. Billed as a hero "who fights the evils of the present with the weapons of the past," Hawkman was a case of genuine rather than merely metaphorical reincarnation. An Egyptian prince in a previous life, Carter Hall outfitted himself with huge, feathered wings and a menacing, beaked mask before embarking on adventures that often had an eerie, mystical flavor. He was also an equal opportunity employer, and had recruited a female counterpart, Shiera Sanders, to serve as Hawkgirl by issue 24 of *Flash Comics*. An obvious source for Hawkman would seem to be Batman,

but writer Gardner Fox claimed he was inspired by a bird he saw outside his window while he was struggling to come up with a new idea.

The Hawkman mystique was enhanced by unusual artwork. Dennis Neville drew the first three stories, but the feature really took flight when Sheldon Moldoff took over. Frequently signing his work "Shelly," Moldoff was an ambitious artist who wasn't satisfied with the simple line work that was considered good enough for many comic books. Instead he studied the techniques of the most sophisticated newspaper strips, and as a result he came up with a richly detailed style that made Hawkman a standout. Later, beginning in 1945, Hawkman provided an opportunity for the young artist Joe Kubert to win his wings. "I tried to inject myself into the character," he says, "and to do the best job I was capable of doing, but I think the biggest thrill for me was just getting published." He met Fox only briefly, and explains that "the artists were completely separated from the writers then. The editor was the only connection between all the creative ends in putting together a comic book." That influential editor, Sheldon Mayer, would have an even bigger impact on All American's next big star.

The first issue of *Flash Comics* (January 1940) featured a cover by Sheldon Moldoff, who did the covers regularly for years even though he wasn't the artist drawing the title character.

A variant on the inevitable evil twin motif showed up on this May 1946 cover by Joe Kubert for *Flash Comics #71.*

Hawkman was one of the few early super heroes who had a meaningful love life, if that's what you call convincing your sweetheart to dress up like a bird and fight crime. The first time Shiera Sanders tried it, she got shot. Cover for *Flash Comics #37* (January 1943) by Sheldon Moldoff.

Green Lantern
Many Hands Make Light Work

Created by writer Robert Kanigher, the Harlequin was a woman who took up crime to attract Green Lantern's attention and then reformed. Cover by Irwin Hasen for March–April 1948.

Green Lantern, All American's next important hero, was synthesized from as many different elements as there were colors in his gaudy garb. His pants may have been as green as his name, but his shirt and boots were red with yellow details, his mask was black, his hair was blond and his huge, wraparound cloak was deep purple. The outfit looked like it had been thrown together in the dark, and the character was created in much the same fashion, yet somehow everything seemed to work.

Editor Sheldon Mayer actually hadn't wanted to publish Green Lantern at all. When artist Martin Nodell showed up with his initial sketches, Mayer wasn't impressed with the drawings, even though he was looking for more super heroes. So he brought in Bill Finger, the writer responsible for the original Batman scripts, and together they hammered out a storyline that might help support Nodell's shaky style. The artist had to be part of the package, of course, since the original concept was his. It consisted of a costume and a magic lamp.

Green Lantern made his debut in issue 16 of *All-American Comics* (July 1940), thus introducing super heroes into that formerly old-fashioned environment. The origin story, credited to Bill Finger and "Mart Dellon," was a mixture of comic book conventions and the Arabian Nights fantasy of Aladdin. Narrated in part by the lamp itself, it told of a meteor that fell in old China and was fashioned into a magic lamp that possessed strange powers. In fact, the "green lantern" itself was the title character and hero of the tale, instructing young Alan Scott that its verdant light "must be shed over dark, evil things." A ring made of its metal and touched to the lamp daily gave Scott virtual omnipotence (wood somehow resisted his power), and it was his own idea to construct that wild costume, "so bizarre that once I am seen I will never be forgotten."

The character proved his popularity and graduated to his own title, *Green Lantern* (Fall 1941). By that time, most of the art was being contributed by Irwin Hasen, who turned out to be the definitive interpreter. Mayer introduced a slapstick sidekick named Doiby Dickles, a comical cabdriver, to showcase Hasen's cartoonish, deceptively simple approach; the style eventually won Hasen his own newspaper strip, the long-running *Dondi*. New writers for Green Lantern included science fiction specialists Alfred Bester and Henry Kuttner. Bester's scripts were good, but his greatest contribution to All American and DC was recruiting Julius Schwartz to become Sheldon Mayer's story editor.

Julius Schwartz, whose long career would give him a significant influence on DC's output, began as a literary agent for writers like Bester and horror virtuoso H. P. Lovecraft. "I hadn't

read a comic book story in my life," says Schwartz. "I had to learn from a script what a caption was, what a speech balloon was." Schwartz went to work for Mayer in 1944, just months before All American merged with DC, and would stay on the job for more than forty years. "When I was hired, I didn't get involved with the artwork at all," he says. "I didn't have an official title, but I would plot the stories with the writers, edit the scripts, and give them to the artists. Then the artists would bring their pages in and show them to Shelly, and I had nothing to do with that, but I loved to plot." With separate editors for story and art, with scripts created by collaboration between editors and writers, with illustrations divided among pencillers and inkers and colorists, the job of putting together a comic book was becoming a matter of complex teamwork rather than individual inspiration. Producing the regularly scheduled appearances of a successful super hero was more like making a movie than writing a novel, and Green Lantern is a prime example of this process in action.

Sheldon Mayer, Bill Finger and Irwin Hasen were so fond of Green Lantern that they made one of their later characters his fan. Called upon to provide a new hero for the first issue of an All American anthology called *Sensation Comics* (January 1942), they came up with Wildcat. He was Ted Grant, a boxer who wanted to battle corruption and got the idea of dressing up as a black panther when a neighborhood kid described a Green Lantern story to him. "You mean he wears a costume so nobody would recognize him?" asks Ted, so delighted with the plan that he slips his informant a buck. "Gosh," says the kid as Ted runs off to fight crime, "now I can buy *Flash Comics* too!"

Green Lantern's original creator, Martin Nodell, drew the story that introduced the character.

Green Lantern established his importance on his first appearance by taking over the cover of *All-American Comics* #16 (July 1940). Art by Sheldon Moldoff.

Wildcat, drawn by Irwin Hasen, makes his 1942 debut.

The comedy sidekick Doiby Dickles, together with his cab "Goitrude." Cover of issue 49 (April 1943) by Irwin Hasen.

THE JUSTICE SOCIETY OF AMERICA
All American's All Stars Team Up

It was a club every kid in America wanted to join, based on an idea that would ultimately change the face of comic books forever, but nobody seems absolutely sure who thought of it. The credit probably belongs to either editor Sheldon Mayer or writer Gardner Fox, although one story has it that their inspiration came from publisher M.C. Gaines, who wanted a comic book from All American that could rival the sales of Superman or Batman. The result was "The Justice Society of America," a by-invitation-only organization of super heroes that got its start in the third issue of *All Star Comics* (Winter 1940).

All Star Comics began in Summer 1940 as a fairly ordinary anthology, distinguished only because it featured stories about several of All American's already popular characters. Then, with no explanation, it was revealed that eight of them had formed a private club. This was obviously a great notion, since it offered readers a lot of headliners for a dime, and also the fun of watching fan favorites interact. In fact, it was the start of the grandiose concept that all of a company's characters should appear together in one vast and endless narrative. For many readers, keeping track of this intricate history would become a particular pleasure. Yet by acknowledging the presence of the others, every character became a little less special, for each separate super hero had represented a different fantasy about what it might be like to be the one great hope of the world.

The charter members of the Justice Society were the Flash, Green Lantern, Hawkman, the Atom, the Spectre, Dr. Fate, Hourman and Sandman. The selection showed just how closely intertwined All American and DC actually were, since the last four of the eight members were actually DC characters. The Atom, an irritable short guy who had built up his muscles so he could slug crooks, was at least from *All-American*

The boys march on Washington, where the FBI calls on them to seek out spies and saboteurs. Cover by Everett Hibbard for *All Star Comics* #4 (March–April 1941).

Dr. Mid-Nite and Starman join The Justice Society in *All Star Comics* #8 (December–January 1942). Art by Everett Hibbard.

Comics, but Sandman, who wasn't super either once you discounted his sleeping gas, came from DC's *Adventure Comics*. So did Hourman, who in those innocent days got sixty minutes of extra power by taking a pill called Miraclo. Obviously Superman and Batman would have provided more charisma than some of the lesser heroes in the Justice Society, but they didn't need the boost of an additional venue and showed up only twice, as "honorary" members. When the Flash and Green Lantern got their own books, they too became "honorary" and were replaced in the Society by lesser lights. Later, some characters were dropped due to lack of interest, while others came back.

In their first appearance and for years thereafter, the Justice Society heroes weren't quite as chummy as they seemed. They got together at meetings but then went into action separately; they didn't really begin fighting side by side until 1947, and by 1951 the Justice Society of America had run its course. Yet a precedent had been set, and in years to come the idea would be revived, setting in motion the creation of an incredibly complex imaginary universe, one that provided a rich panorama for its fans while sometimes driving its creators to distraction.

The Injustice Society takes on the good guys in a memorable epic written by Gardner Fox for *All Star Comics* #37 (October–November 1947). Cover by Irwin Hasen.

The Justice Society often showed concern for social problems, as demonstrated by the juvenile delinquency story in issue 40 (April–May 1948). Cover by Carmine Infantino.

HEY! EVERYTHING'S GETTIN' GREEN! MAYBE I'M SICK — TOO MUCH EXCITEMENT!

THE GREEN LANTERN! YOU TOUCH YOUR RING TO THE LANTERN AND YOU GET SUPERNATURAL POWERS — RIGHT?

YES — BUT LOOK ABOVE YOU — WHO'S THAT?

THE HAWKMAN! GEE WHIZ, YOU'RE ALL GETTING HERE NOW! I WISH THE REST OF THE CROWD WOULD HURRY...

Johnny Thunder, the character without the costume, is the focus of attention on this page depicting the first meeting of the Justice Society. Johnny, whose magical powers are inadvertent and uncontrollable, has crashed the party and manages to introduce readers to most of the members when he's not accidentally shrinking his own head or dissolving the dinner. Also on view (in order) are the Flash, Green Lantern, Hawkman, Hourman, the Spectre, the Atom and Sandman. Dr. Fate is lurking around somewhere, although as he explains, "The Spectre and I do not touch food." This page from *All Star Comics* #3 (Winter 1940) was drawn by Everett Hibbard, who regularly delineated the exploits of the Flash. Hibbard provided all the introductory material about the club, while the separate adventure narrated by each super hero was illustrated by his usual artist.

AND IN ANSWER TO JOHNNY'S WISH....

HOW DID YOU GET IN HERE? AND WHAT DID YOU DO TO MAKE ME COME HERE SO QUICK?

GEE, SPECTRE I DON'T KNOW! HONEST I DON'T! IT - IT'S A POWER I HAVE — THAT MAKES ME ABLE TO DO ANYTHING I WANT TO!

BRAGGING AGAIN, EH? ONE THING WE JUSTICE MEN DON'T ALLOW IS BOASTING! WE DON'T LIKE SWELL HEADS!

I AIN'T GOT A SWELLED HEAD — IT'S A SMALL HEAD — LOOK!

I GUESS YOU'RE NOT SWELL — HEADED JOHNNY!

WHAT'S HAPPENING TO ME? MY HEAD - IT DOESN'T FEEL RIGHT! C'MON THUNDERBOLT, CUT IT OUT — MAKE MY HEAD NORMAL AGAIN!

AS SOON AS JOHNNY'S HEAD IS ALL RIGHT...

SINCE YOU'RE HERE — YOU MIGHT AS WELL EAT WITH US! IT'S A GOOD DINNER! WE —

AW! — I'LL BET THERE'S NO DINNER AT ALL —

THE FOOD — IT'S · · GONE!

JUST WHEN I WAS ALL SET TO DIG INTO IT!

Gardner Fox's story "Food for Starving Patriots!" looked like another piece of wartime propaganda when it appeared in issue 14 of *All Star Comics* (December 1942–January 1943). Yet there was a humanitarian message here as well as the usual one about beating the bad guys. Concern about hungry people in a world at war was an unusual slant, which was matched by one issue about war orphans, and another on the problems of disabled veterans. Fox was too canny a writer to preach to his audience, and he injected a fair amount of magic and mayhem into a tale that may have helped explain rationing to American kids. Armed with tiny capsules that can be converted into all-American turkey dinners when sprayed with "a secret solution," members of the Justice Society have wild adventures while delivering the goods to eight different nations, vowing "to feed conquered Europe and still keep Nazism undernourished." Cover by J. Gallagher.

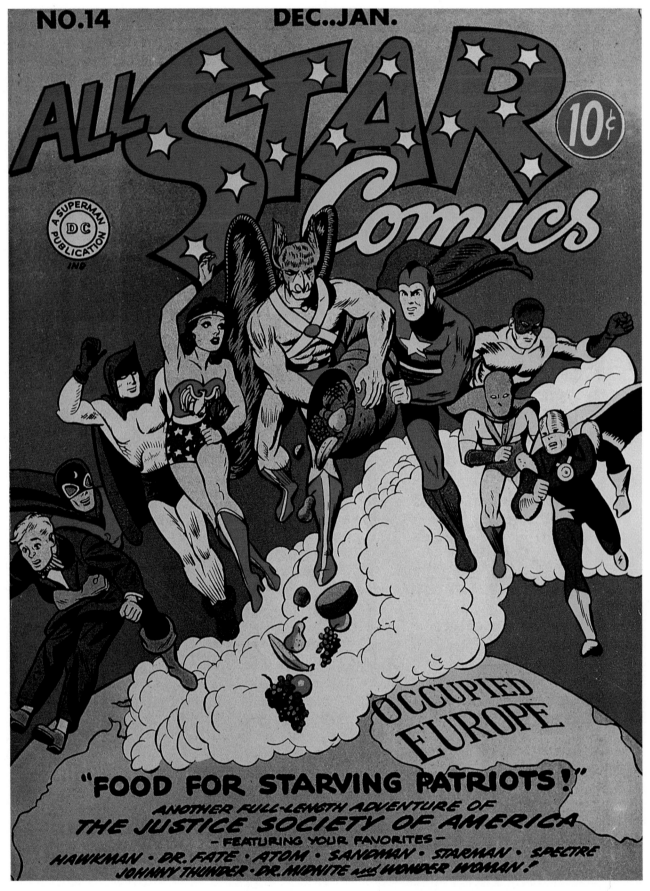

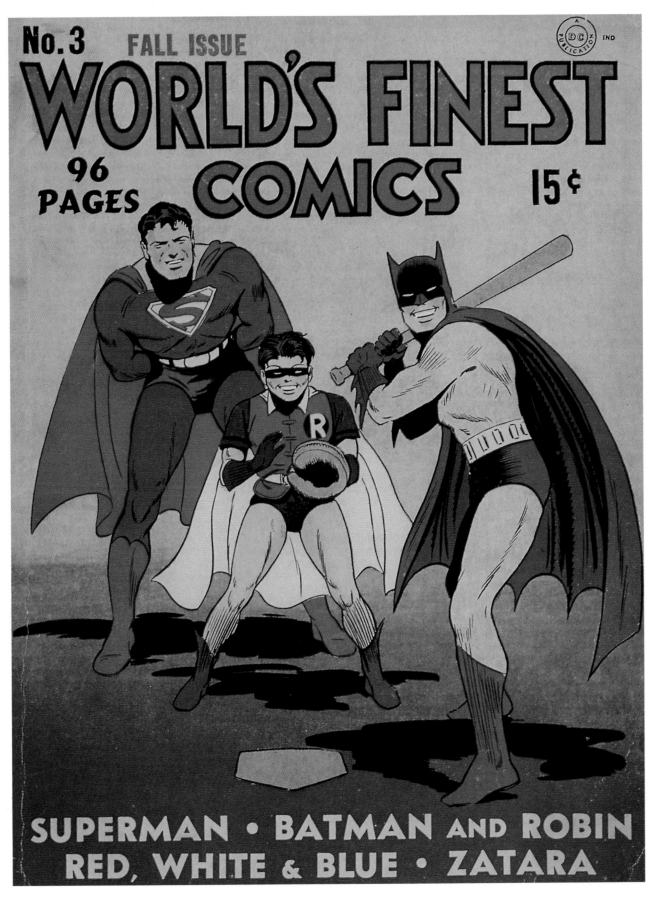

No. 3 FALL ISSUE

WORLD'S FINEST
COMICS

96 PAGES **15¢**

**SUPERMAN • BATMAN AND ROBIN
RED, WHITE & BLUE • ZATARA**

Pairing Superman and Batman made sense financially, since the two were DC's most popular heroes, but their powers were on such different scales that Batman might well seem redundant. DC's short-term solution was to put them both on the covers of *World's Finest Comics*, which offered ninety-six pages for the then hefty price of fifteen cents. Inside, Superman and Batman appeared in separate stories, but covers like this one by Jerry Robinson (Fall 1941) made them pals and helped draw Batman away from his dark domain and into Superman's sunlight. Here the heroes join Robin in a game of baseball, with the Caped Crusader (of course) taking the bat. Superman and Batman shared a brief, one-panel cameo as early as *All Star Comics* #7 (October–November 1941) but didn't really get together until *Superman* #76 (May–June 1952) when they learned each other's identities while on an ocean liner. They began appearing as a regular team in *World's Finest Comics* #71 (July–August 1954), after production economics had shortened the page count and forced them to share the same story.

THE BIRTH OF WONDER WOMAN
A Sister for Super Heroes

Presumably under Marston's direction, artist Harry Peter drew these cartoons that appeared in the *American Scholar* to accompany Marston's article about comic books and Wonder Woman. The one on the right is fairly self-explanatory (although one might question Wonder Woman's effect on prudery), but the one above is fairly strange. Certainly Marston's editor Sheldon Mayer didn't look like that, nor was he hopelessly enthralled by Marston's character. In any case, Marston's characteristic bondage imagery is firmly in place. The little figure in front of the desk, who must have baffled many American scholars, is comedy companion Etta Candy.

One of the most enduring characters in comic books is a woman created by a man who started out as a critic of comic books. She is Wonder Woman, who shares with Superman and Batman the distinction of having been in continuous publication for over fifty years. Her creator was William Moulton Marston, a prominent psychologist best known as the inventor of the lie detector.

Marston, whose background was very different from that of the average comic book creator, had taught at Columbia, Tufts and Radcliffe, and was the author of scientific texts like *Integrative Psychology: A Study of Unit Response* and the definitive *The Lie Detector Test* (1938). Yet he was also a student of popular culture who wrote a book about vaudeville, and an author of historical fiction with a special interest in the cultures of ancient Greece and Rome. He was widely known to the general public as a writer of self-help articles, often reprinted in *Reader's Digest*, with titles like "The Art of Marriage," "Obey That Impulse" and "Take Your Profits from Defeat." To separate these activities from his career in comics, Marston published his Wonder Woman stories under the name Charles Moulton, but once they became successful he was perfectly willing to acknowledge them publicly.

According to editor Sheldon Mayer, Marston had written an article attacking the content of comic books that came to the attention of All American publisher M. C. Gaines. As Mayer described the situation, "Gaines was cynical enough, and wise enough, to suspect that this kind of article would cease if William Moulton Marston was contacted and persuaded to write for comics." In 1941, Mayer met Marston for dinner at the Harvard Club in New York, and an agreement was reached, initially calling for Marston to offer advice on ways to make comic books more psychologically beneficial to young readers.

Marston later explained his involvement in comics, which were not considered a prestigious platform, in the very posh pages of the *American Scholar*, a quarterly published by Phi Beta Kappa. "I was retained as consulting psychologist by comics publishers to analyze the present shortcomings of monthly picture magazines and recommend improvements," he wrote. "It seemed to me, from a psychological angle, that the comics' worst offense was their blood-curdling masculinity. A male hero, at best, lacks the qualities of maternal love and tenderness which are as essential to the child as the breath of life." Marston was so sure of himself that he agreed to write comics about a character who would be "tender, submissive, peaceloving as good women are," one who would possess "all the strength of a Superman plus all the allure of a good and beautiful woman."

"Marston was an early feminist," said Sheldon Mayer, "no question about it. He felt that a woman would and should be president some day." A potential problem was that the readers of comic books, especially the super hero type, were generally boys. "He was writing a feminist book," said Mayer, "but he was dealing with a male audience." Claims have been made that Wonder Woman was published for girls, but All American knew that her audience was predominantly male. Marston wasn't worried about alienating men, however. "Give them an alluring woman stronger than themselves to submit to," he wrote, "and they'll be *proud* to become her willing slaves!" Marston's emphasis on the issue of who should "submit" would eventually provide critics with a field day, but not before Wonder Woman became the huge success that M. C. Gaines wanted. She may even have had more effect on America

Hippolyte, Queen of the Amazons, explains the meaning of life to her daughter with the aid of Athena's Magic Sphere. For Wonder Woman's somewhat incoherent origin story, writer William Moulton Marston narrated part of the comic book in typeset prose. Art by Harry Peter.

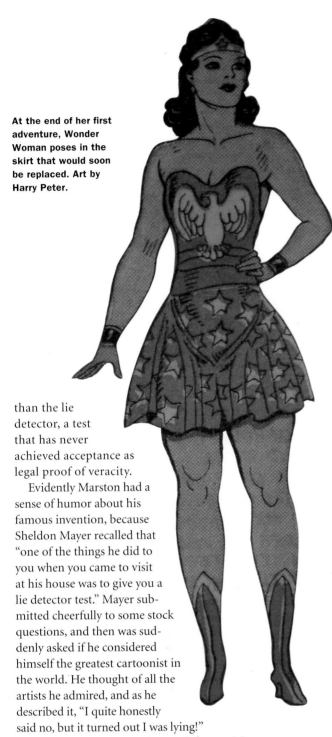

At the end of her first adventure, Wonder Woman poses in the skirt that would soon be replaced. Art by Harry Peter.

than the lie detector, a test that has never achieved acceptance as legal proof of veracity.

Evidently Marston had a sense of humor about his famous invention, because Sheldon Mayer recalled that "one of the things he did to you when you came to visit at his house was to give you a lie detector test." Mayer submitted cheerfully to some stock questions, and then was suddenly asked if he considered himself the greatest cartoonist in the world. He thought of all the artists he admired, and as he described it, "I quite honestly said no, but it turned out I was lying!"

Obviously Marston understood the need for self-confidence in creative types, and he also had a shrewd understanding of comics. "It's too bad for us 'literary' enthusiasts, but it's the truth nevertheless—pictures tell any story more effectively than words," he wrote. And he reassured parents that fantasies about super heroes might even be good for their kids. "Feeling big, smart, important, and winning the admiration of their fellows are realistic rewards all children strive for. It remains for moral educators to decide what type of behavior is to be regarded as heroic." Wonder Woman, the embodiment of Marston's theories, made her debut in a short story added to the usual Justice Society extravaganza in *All Star Comics* #8 (December 1941–January 1942).

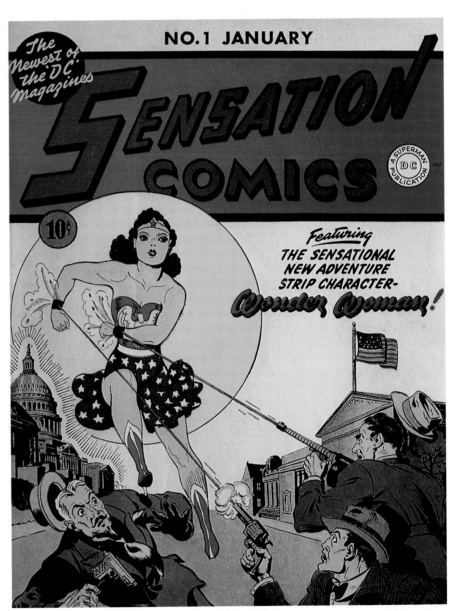

Wonder Woman became the lead character of *Sensation Comics* with its first issue (January 1942), but for some reason the cover was done by Hop Harrigan's artist, Jon Blummer.

WONDER WOMAN'S DEBUT
Amazon Grace

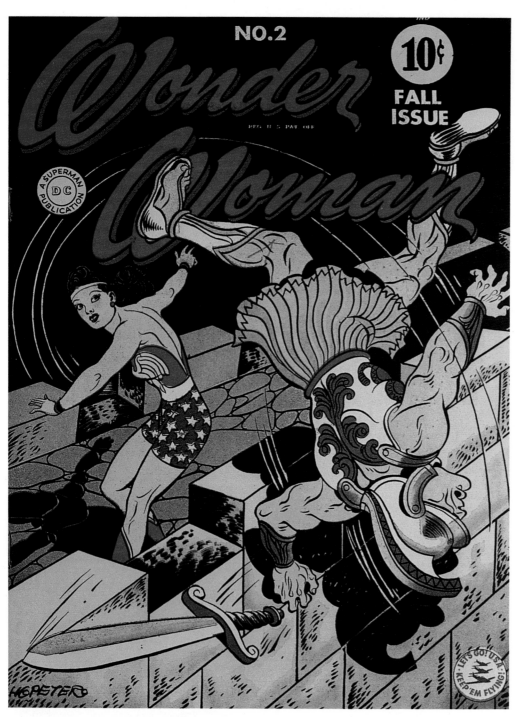

Mars flips for Princess Diana on this Harry Peter cover for *Wonder Woman #2* (Fall 1942). The ancient god of war was selected by William Moulton Marston as his heroine's inevitable enemy.

She is known only as Wonder Woman, but who she is, or whence she came, nobody knows!" So wrote William Moulton Marston in his first comic book story, "Introducing Wonder Woman," but if nobody knew whence she came, it wasn't going to be Marston's fault. In fact, he was beginning one of the most elaborate origin stories in the history of comics, about a princess in an imaginary civilization that he constructed from equal parts of mythology, metaphysics and moonshine.

The story is set on Paradise Island, home to a race of Amazons who live without men and don't worry since they are conveniently immortal and thus have no need to reproduce. They dress like show biz versions of ancient Greeks and worship the goddesses Aphrodite and Athena, but have perfected futuristic devices like invisible airplanes, along with magical ones like ropes that compel obedience.

Hidden from the rest of the world after their legendary battles with men, the women's lives are disrupted when an American pilot named Steve Trevor crashes on their island. Their queen decrees that an Amazon will be required to go abroad with Trevor and fight for "America, the last citadel of democracy, and of equal rights for women." Of course the chosen one turns out to be the queen's daughter Diana, who sets out wearing a costume designed by mom and based on the American flag. "Why mother, it's lovely!" she gushes, but before long she replaces its star-spangled skirt with more practical pants.

This brief story appeared in the back of *All Star Comics* just a few weeks before the United

This unusual photo of the Wonder Woman staff was taken in 1942 by associate editor Alice Marble, apparently the only woman working on the character. From left to right: Writer William Moulton Marston, artist Harry Peter, editor Sheldon Mayer and publisher M.C. Gaines.

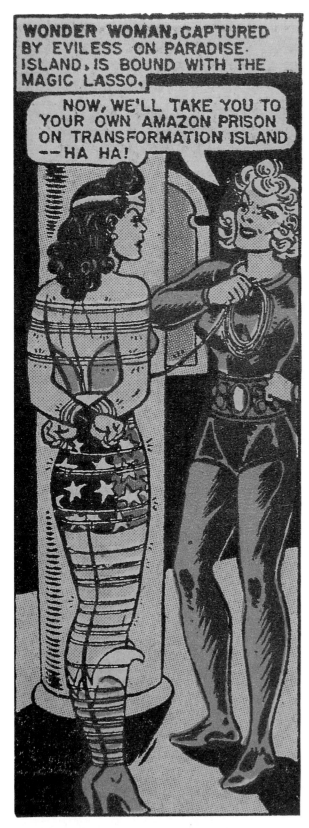

WONDER WOMAN, CAPTURED BY EVILESS ON PARADISE ISLAND, IS BOUND WITH THE MAGIC LASSO.

NOW, WE'LL TAKE YOU TO YOUR OWN AMAZON PRISON ON TRANSFORMATION ISLAND -- HA HA!

Everyone was all tied up in knots during Wonder Woman's early years, and never more than in the book-length story "Villainy, Incorporated" from _Wonder Woman_ #28 (March–April 1948). More art by Harry Peter, who reportedly employed four assistants.

States entered World War II. From the beginning, Marston was muddling his feminism with patriotism, praising the same nation that his tales were intended to reform. Wonder Woman was a hit anyway. Almost immediately she became the leading character in the new anthology _Sensation Comics_ (January 1942), and her own title, _Wonder Woman_, followed in Summer 1942. She also joined the Justice Society of America, where she was rather condescendingly appointed secretary although she was selling more comics than the male members. At least some credit was due the idiosyncratic style of artist Harry Peter, a newspaper veteran selected by Marston on the enigmatic grounds that he knew "what life is all about."

What Marston himself thought life was all about was a source of bewilderment to some readers and to Wonder Woman's editor, Sheldon Mayer. The stories grew progressively more peculiar. "Marston's idea of feminine supremacy was the ability to submit to male domination," at least as Mayer saw it. "That was one of the things that Marston fought to keep in. He also fought to keep in other things that I fought to keep out." Wonder Woman's adventures were increasingly dominated by images of female figures bound by ropes and chains. A short story published in 1942 featured fifteen separate panels depicting someone in bondage; a long story published in 1948, and apparently completed just before Marston's death, contained no fewer than seventy-five bondage panels, many of them including multiple prisoners. Kids were inclined to accept these scenes as games of capture and escape, but adults like Mayer grew a bit suspicious. "There was a certain symbolism that Marston engaged in, which was very simple and very broad," Mayer said after Marston's death. The psychologist was consciously working on his audience's subconscious, using various types of sexual symbolism to create emotional responses, or so Mayer believed. "I suspect it probably sold more comic books than I realized, but every time I came across one of those tricks, I would try to clean it up. I probably made it worse. But the fact is, it was a runaway best-seller."

Marston died in 1947, and Harry Peter left Wonder Woman soon thereafter. Both the writer's intensity and the artist's eccentricity proved harder to replace than might have been expected, and the Amazon's popularity plummeted. She remains a key figure in comic books, but has rarely had so many readers again. "I realized that what Marston contributed to the thing had something to do with its success," Mayer admitted, "and I found myself quite annoyed at the absence of his antagonism."

A lot had changed by then. All American had been absorbed into DC, with Whitney Ellsworth supervising the editorial department. Wonder Woman was turned over to Robert Kanigher, a talented writer and editor whose greatest successes came eventually with stories about soldiers, and not about "a woman to whom the problems and feats of men are mere child's play." As for Sheldon Mayer, he gave up his editorial position to return to his first love, the drawing board. The inspiration came when he heard a young artist refer to him as "the old man." He was only thirty, he recalled, "and that afternoon I resigned to become a cartoonist, which I felt I should have been doing all along."

Wonder Woman had her female foes as well, including the psychotic debutante who adopted the identity of the Cheetah. Cover by Harry Peter for the sixth issue (Fall 1943).

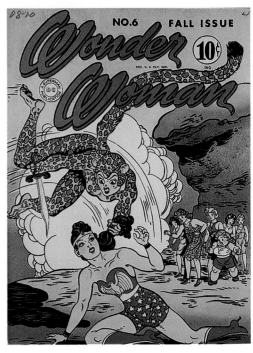

Wonder Woman sits astride a steed called a Kanga on the cover of *Sensation Comics* #6 (June 1942) by Harry Peter. This is a key issue in the development of Wonder Woman, and for once the cover is less lurid than what's inside. The Kangas aren't used for catching crooks, but for a game on Paradise Island in which the Amazons compete in "a girl-roping contest." Entrants yank their sisters to the ground and tie them up; Wonder Woman is the victor. Her reward is a lasso, crafted from tiny links of a magic chain, that gives her complete domination over anyone it encircles. Wonder Woman, who was in fact created by the inventor of the lie detector, is now able to use her lasso to force prisoners to tell the truth. "I can change human character!" exults Princess Diana. "I can make bad men good, and weak women strong!" Evidently bad women and weak men will escape her ire in the world envisioned by William Moulton Marston, but Wonder Woman has acquired one more compelling bit of symbolism.

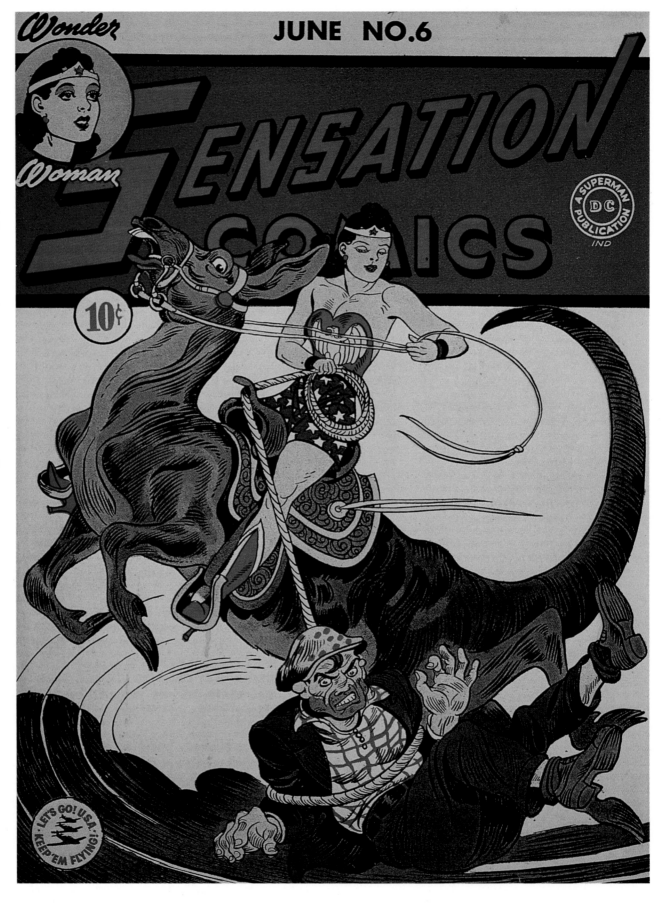

Wonder Woman pulls Captain Steve Trevor out of danger on the cover of her fifth solo comic book (June–July 1943). Although an army officer, Steve was depicted as generally helpless. To reinforce the role reversal, he also wondered why his colleague Diana Prince reminded him of Wonder Woman. Employed in military intelligence, Steve nonetheless bought Wonder Woman's story that they couldn't become involved until after she rid the world of crime. A more interesting male was Dr. Psycho (the strange little figure in the corner), a misogynist whose unhappy wife's ability as a medium gave him strange powers. Charlatan, hypnotist and murderer, Dr. Psycho presumably did not represent Dr. William Moulton Marston's actual view of medical men. Wonder Woman's creator probably just went along with the idea that in comic books, doctors were frequently fiends.

COMIC BOOKS GO TO WAR
Fighting the Good Fight

Super heroes sell war bonds, just the way movie stars did, on this Jack Burnley cover for *World's Finest Comics* #8 (Winter 1942–43).

World War II was a boom time for many industries, including comics. If the 1940s are considered the Golden Age of comic books because it was an era of great creativity, it was also a golden time for business. Overall circulation tripled from 1940 to 1945; virtually every kid in America was a regular reader. Comics also had substantial circulation among servicemen, and civilian adults as well. The idea of the super hero, who gave up his ordinary life and put on a uniform to battle the bad guys, had special resonance during wartime; costumed characters became one of the emblems of the age. In a sense, they were America.

Of course there were problems as well as profits. Comic books were a young business, staffed with young men who were eminently eligible for military duty. The United States did not enter the war until after the attack on Pearl Harbor (December 7, 1941), but some people realized that our eventual involvement was inevitable, and they made plans. When artist Dick Sprang was hired in 1941 to work on Batman, he was told by editorial director Whitney Ellsworth that his work might not be published for some time. "He wanted to stockpile all he could," explains Sprang, "in case he lost the artists." As things turned out, Sprang's poor eyesight kept him out of the service anyway. Editor Mort Weisinger joined up and Jack Schiff took over his duties at DC for the duration, but the business expanded so much that after the war there was plenty of work for both of them. Artist Bert Christman, best known for his work on the early Sandman, joined the famous Flying Tigers and died in action.

On the home front, super heroes served propaganda purposes. "Since I wasn't in the service, the only contribution I made was through some of the publications," says Sprang. "We did

a lot of war bond publicity." The covers of many comics became posters urging the sale of war bonds or war stamps. A new title, *World's Finest Comics*, began in 1941 with additional pages and a price of fifteen cents. Superman and Batman appeared in separate stories, but they shared the covers and used them for messages like "Knock out the Axis with bonds and stamps." *Detective Comics* #78 (August 1943) featured a tale called "The Bond Wagon," in which sales were promoted by actors portraying great moments from American history; with Batman's help, they also defeated Nazi saboteurs. Like most established characters, Batman confined himself to such domestic battles, but there were also new heroes, designed specifically for the new war.

DC's top war-oriented feature was the Boy Commandos, created by Joe Simon and Jack Kirby. Their team of fighting kids showed up in *Detective Comics* #64 (June 1942) and got their own comic book that winter. Simon says *Boy Commandos* soon began selling a million copies per issue. The four young belligerents, each from a different country, were theoretically supervised by an adult, Captain Rip Carter, but their real boss was a boy called Brooklyn. The notion that these lads could travel all over the globe to take on the enemy was certainly far-fetched, but the idea that youngsters could be caught up in combat was unfortunately all too believable. Simon and Kirby were soon in uniform themselves, but they left behind over a year's worth of stories.

Simon and Kirby's Boy Commandos roll through the seventh issue of their comic book (Summer 1944). Jack Kirby grew up in a New York neighborhood full of tough kids, and said of the war that "people like myself were ready for that kind of thing. I was in fights almost every day."

Writer Jerry Siegel, working with artist Hal Sherman, made his contribution to the war effort with the Star-Spangled Kid, one of countless costumed characters who wrapped themselves in the American flag. This one's gimmick was that he was an adolescent hero with an adult sidekick, Stripesy. The pair made their debut in *Star Spangled Comics* #1 (October 1941), but despite a big send-off they never caught on.

Of course the super hero with the most to contribute to defense was undoubtedly Superman himself, and in 1940 a major national magazine, *Look*, had commissioned Jerry Siegel and Joe Shuster to explain "How Superman Would End the War." Their two-page piece showed Superman capturing Hitler and Stalin (not yet an American ally) and dragging them before an international tribunal, but not even comics could continue to countenance this kind of wish fulfillment. It would be ridiculous for DC to show Superman stopping hostilities that were bound to continue; reality stymied the Man of Steel as no other opponent could. Superman might encourage the troops or occasionally lend a hand on the home front, but he couldn't win the war. That responsibility fell to what one of his 1943 adventures called "America's secret weapon—the courage of her common soldier," and Jerry Siegel wrote such stories while serving in the real Army that Superman couldn't join.

Look magazine commissioned Siegel and Shuster to do two pages on "How Superman Would End the War" for their issue of February 7, 1940—exactly twenty-two months before Pearl Harbor. Americans in 1940 were still regarding the war with considerable detachment, and the most interesting thing about the story is Superman's offhand remark that he's "strictly non-Aryan."

The Star-Spangled Kid, intended as the big hero of the comic book that bore his name, was the rare Jerry Siegel creation that didn't really make the grade. Hal Sherman drew the first cover (January 1944).

Joe Simon and Jack Kirby's Newsboy Legion became the top attraction of *Star Spangled Comics* with the seventh issue. The youngsters and their super hero pal the Guardian did their part for the war effort in January 1944.

SUPERMAN ON RADIO
Fast as the Speed of Sound

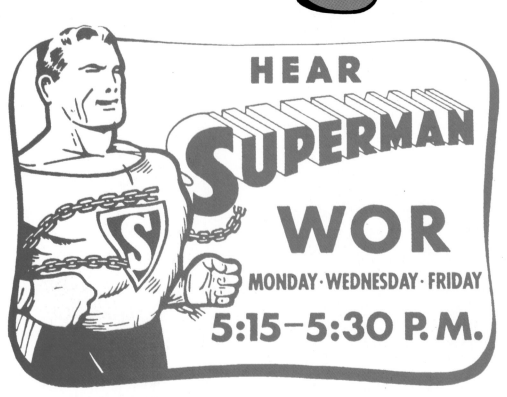

Beginning in 1945, these buttons were given away in boxes of Kellogg's Pep.

Radio made Superman a household word. The character might have sold a million copies of his comic book each month, but that audience could not approach the one enjoyed by the most popular mass medium of its day. For close to thirty years, but especially during the 1930s and 1940s, radio occupied the same place in American life that televison does today, presenting live drama and comedy programs on national networks that reached almost every home in the country. The show called *The Adventures of Superman* was ostensibly intended for young listeners, but it was scheduled in the early evening when parents ended up hearing it too, and its memorably catchy opening became familiar to almost everyone.

"Faster than a speeding bullet! More powerful than a locomotive! Able to leap tall buildings in a single bound! Look! Up in the sky! It's a bird! It's a plane! It's Superman!" That litany, delivered with dramatic urgency by narrator Jackson Beck and a supporting cast, backed up with the sound effects of a gunshot, a steam engine and a whistling wind, is familiar today even though the radio show has not been broadcast since 1951. The mastermind behind it was Robert Maxwell, a DC employee who was given the job of licensing Superman and achieved his finest hour with these dramatizations. Working with writer Jack Johnstone, Maxwell put together a fifteen-minute serial that was rated the most popular of its kind. It was officially launched by the Mutual radio network on February 12, 1940, but in fact the show had already been around for months in an early prototype syndicated through recordings.

Superman was portrayed by Bud Collyer, who shouted "Up, up, and away!" when he took flight and dropped his voice an octave when he changed from Clark Kent to Superman. To maintain a mystique, Collyer played the part anonymously, and didn't reveal his secret identity until publicity was wanted for the show's campaign against racial and religious prejudice in 1946. Joan Alexander was Lois Lane, and Jackie Kelk was Jimmy Olsen. Created for radio to provide the almost obligatory young sidekick, Jimmy Olsen was a cub reporter described on the show as "sixteen, thin, freckle-faced." He proved so successful that DC adopted him permanently, and he even got his own comic book in 1954.

Batman and Robin arrived on the show in 1945 and then began to make frequent guest appearances. Because they showed up intermittently, various actors played these roles. In

This 1941 ad promoted the fifteen-minute serial that ran three times a week. By 1942 it was being broadcast every weekday.

their initial adventure, Robin came to Superman for help in locating a missing Batman, but later Superman would vanish or become preoccupied, so that Batman was virtually the star of the show for weeks at a time. The audio super heroes were quite careless about their secret identities, letting heavy hints slip almost every day so new listeners could get the idea, but fortunately the other characters never noticed.

If Batman and Robin were useful in helping actor Bud Collyer pick up some welcome vacations, nothing was better for arranging time off than a dose of kryptonite. Perhaps the most memorable innovation inaugurated on the radio program, "green, glowing kryptonite, a fragment of the planet on which Superman was born, has the power to rob the Man of Steel of all his strength when he comes within ten feet of it." The concept gave Superman something to worry about, and producer-director Robert Maxwell milked it mercilessly. A female villain named the Scarlet Widow stole the only piece of the rock from the Metropolis Museum, then divided it up and sold the fragments to four other bad guys. Superman was kept busy (and often too feeble to appear) for months, and the story line came to a climax at the end of 1945 in what may have been the show's most sensational sequence, the tale of "The Atom Man."

The Atom Man was the creation of a Nazi scientist, determined to get revenge after Germany's defeat. The mad doctor injects a soldier with kryptonite (described in the wake of the first atomic bomb as "the deadliest, most radioactive element in the world") and creates "an atomic monster" to kill Superman. Atom Man, whose fingers emit cataclysmic blasts of green lightning, announces that he will eradicate Metropolis as a challenge to Superman. The hero prepares for the final conflict near a dam that Atom Man intends to demolish with his bare hands. Clearly on the verge of defeat, Superman grasps his enemy and flies into the air while Atom Man, victory imminent, blasts away mercilessly until Superman is insensible. Only then does the villain realize he is miles in the air with no visible means of support, and only Superman survives their fall. This titanic battle, embellished by the sounds of humming radiation, incessant explosions and threats shouted over howling winds, went on for weeks and remains a highlight in the history of radio. The show continued for six more years, if not in such spectacular fashion, until Maxwell began to prepare a TV version.

Publisher Harry Donenfeld visits with radio performers Clayton "Bud" Collyer (Superman) and Joan Alexander (Lois Lane). Collyer later hosted the TV game show *Beat the Clock*, and made a memorable appearance on Jackie Gleason's *Honeymooners*.

Chester Stratton played Hop Harrigan in a show that ran on different networks from 1942 to 1948, but peaked during the war.

ALSO FEATURING HOP HARRIGAN
AMERICA'S ACE OF THE AIRWAYS

The original audition script for the Superman radio show.

SUPERMAN AUDITION.

LOIS	(CONTEMPT) The boy wonder, eh?
KENT	(STARTLED) Why, Miss Lane, what do you mean?
LOIS	(MOCKING) They tell me you talked yourself into a job....went out west...came back with the biggest story of the month....all in less than a week.
KENT	Well, I guess I was pretty lucky.
LOIS	(CONTEMPT) I'll say you were lucky! And now you're the white-haired boy, eh?
KENT	I'm afraid I don't quite ---
LOIS	Got the old man hypnotized! He thinks you're Horace Greeley.
KENT	(BEWILDERED) I'm afraid I don't ---
LOIS	(ANGRILY) Oh, don't act so dumb! All this nonsense about a time bomb in the cellar! What's the big idea?
KENT	Miss Lane -- I only wish I knew ---
LOIS	Mean to tell me you didn't make it up out of your head?
KENT	I certainly did not!
LOIS	I don't believe it --- now what's the matter?
KENT	Listen --- don't you hear something?

SUPERMAN CARTOONS
The Super Hero on the Big Screen

A Fleischer studio model sheet
shows the many faces of Superman.

Superman stops a scientist's deadly ray and destroys
his island hideaway in *Superman*, the series opener
released in 1941.

This dramatic storyboard drawing shows the throne
room where Superman battles birdmen and their king
in *The Underground World* (1943). One of the anima-
tors, Reuben Grossman, later drew Nutsy Squirrel for
DC Comics.

Most people in 1941 assumed that animated cartoon shorts could contain nothing more than the antics of cute little anthropomorphic animals; they had little reason to imagine that an elaborate science fiction spectacle could unreel before their eyes in a mere seven minutes. A short film called *Superman*, the first in a series of seventeen, changed all that. Nominated for an Academy Award, this Paramount release, along with its sequels, demonstrated how sensationally a super hero could take command of the silver screen, and it took Hollywood decades to duplicate such effects again. Yet these amazing little movies were very nearly never made.

The series got its start when Paramount executives suggested Superman to Max Fleischer, the producer of their other cartoons. The Fleischer studio, in business since 1921, was famous for comedy characters like Popeye and Betty Boop, and foresaw difficulties in creating a new style for Superman. So Dave Fleischer, Max's brother and the organization's leading director, offered to make the films for the then outrageous sum of $100,000 apiece. Probably nobody was more surprised than he when Paramount accepted. Rising to the challenge, the Fleischer staff gave the Superman series

elaborate production values, using a variety of sophisticated camera movements and camera angles seldom seen in a mere cartoon. Special attention was paid to lighting, with scenes planned to reflect a single source of illumination, and careful use of shadows for dramatic effect. This kind of detailed work, hardly ever employed except in the lauded productions of Walt Disney, was possible because labor costs were low during the period, and it would rarely be seen again before the introduction of computer enhancement.

To enhance realism, animators employed the technique of rotoscoping, in which movies of actual human beings in action were traced. For the most part, however, drawing talent did the trick. The figures, especially Superman and Lois Lane, were broken down into groups of boxes and wedges that the artists could move through their imaginary space. Sammy Timberg supplied stirring theme music built around fanfares for brass, and Bud Collyer was recruited from the radio show to provide the most authentic possible voice.

Dave Fleischer directed the most widely admired Superman cartoons, which include *The Mechanical Monsters* (November 1941), *The Arctic Giant* (February 1942) and *The Bulleteers* (March 1942). Each is distinguished by spectacular action epitomizing the exhilaration that the early days of the super hero engendered. In *The Mechanical Monsters*, an inventor has filled a hidden fortress with gigantic robots that he sends out to commit robberies. His creations have the ability to change from humanoid form into airplanes, thus anticipating the immensely popular Transformer toys of more recent days, and audiences might be justified in wondering why theft was necessary when the villain had obviously spent milllions setting himself up in business. *The Arctic Giant* featured a dinosaur discovered frozen near the North Pole. Shipped to Metropolis, the thing thawed out after Lois Lane distracted a technician, and a rampage ensued that may well have influenced the giant lizard movies of the 1950s.

Perhaps the wildest entry in the series was *The Bulleteers*, about a gang that emerges from

Even this simple office scene from the first Superman cartoon benefits from the careful use of lighting, while a subtly askew point of view adds to the impact of the shot.

In scenes from *The Mechanical Monsters* (1941), a criminal mastermind operates his robber robots by remote control. A robot breaks through police lines around a jewelry store and carries off Lois with the gems. Changing in a handy phone booth, Superman takes off in hot pursuit. In the villain's mountaintop retreat, Superman must defeat an army of ambulatory flamethrowers. A typical finish recounts the cartoon's plot in banner headlines.

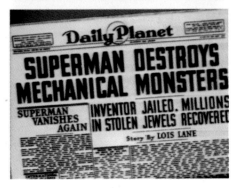

a mountaintop hideout in a hard-nosed rocket ship to blast its way through buildings and rob Metropolis of all its treasures. The images were virtually overwhelming as bad guys blasted across the sky leaving crumbling skyscrapers in their wake, their scarlet exhaust streaking through yellow searchlights while the blue-clad Superman soared aloft to take them down.

In their concentrated doses of extravagant action, Dave Fleischer's films have no peer; however the studio was doomed by its attempt to move into feature production with other projects. Hopelessly in debt, the business was taken over by Paramount, which kept it afloat as Famous Studios. The new Superman directors, like Isidore Sparber and Seymour Kneitel, were men who had previously received story credit. Working on a story meant not writing text, but rather producing a series of pictorial storyboards like comic book continuities, so the promotions were hardly out of line. The proof can be seen in Sparber's stately but scary *The Mummy Strikes* (February 1943) and Kneitel's eerie *The Underground World* (June 1943), which pits Superman against a tribe of winged menaces who could have been based on Hawkman. Ultimately Paramount, which had insisted on the series in the first place, ended up cutting budgets, inserting wartime propaganda and then canceling the cartoons. Nevertheless, the Fleischer films are regarded to this day as milestones in the art of animation.

As the **Joker** pushes **Batman** out of the clock-room into empty space, the **Batman** manages to grasp a jutting number on the building's giant clock-face outside...

I HAVEN'T A REVOLVER, SO I CAN'T PICK YOU OFF FROM HERE, BUT I STILL HAVE MY GAS GUN!

It was tough squeezing comic book action into newspaper strips, as Bob Kane demonstrated with this strip for April 17, 1944. To make his classic clock tower sequence fit, Kane had to turn an image on its side. Inks by Charles Paris.

Pencilled and lettered, a Jack Burnley panel for a 1946 Sunday page before and after inking and coloring.

NEWSPAPER STRIPS
Super Heroes as Everyday Events

Super heroes took another step toward public acceptance when they became daily features in the nation's newspapers. There might have been millions of people buying comic books every month, but there were tens of millions buying newspapers every day, and whole families read the comic strips, which surveys said were the most popular part of the paper. Comic books had their origin in newspaper strips, and feedback into the original medium was a noteworthy accomplishment. "I thought I finally hit the big league with the newspapers," says Batman's Bob Kane.

The first super hero to punch his way into the papers, and one of the few comic book characters to make the transition successfully, was Superman. He did the deed with remarkable rapidity: his daily strip made its debut on January 16, 1939, not long after his appearance in *Action Comics* (June 1938) and well before the first issue of *Superman* (Summer 1939). Some of this speediness was doubtless due to the relationship already established between DC Comics and the McClure Syndicate, whose executive M. C. Gaines had sent Superman to DC. This wasn't a sweetheart deal, however; Superman was a big hit for McClure, the oldest but not the biggest syndicator in the field. By 1941, Superman was on view in three hundred daily and ninety Sunday newspapers in the U.S. and abroad; he had a total circulation of twenty million.

Superman appeared regularly until 1966, with many artists and writers contributing to a long run that outlasted the era of the great adventure strips. Creators Siegel and Shuster started the strip, but perhaps the most memorable newspaper appearances showcased the sturdy Superman of artist Wayne Boring. His contributions, including some spectacular Sunday pages, lasted from the '40s to the '60s, while Win Mortimer did some notable work on the black-and-white dailies from 1949 to 1955.

An unusual arrangement with the syndicate left DC in charge of the Superman strip, and of the newspaper version of Batman that followed it. The editor at DC was Jack Schiff. In fact, Schiff was the one who convinced McClure to syndicate Batman, beginning in 1943. Already editor of the Batman comic book, Schiff found the strip, called *Batman and Robin*, to be "a little different. It had to be done so there was continuity, so the readership would want to see it the next day." Schiff wrote some of the strips himself, partly to get the feel of what McClure wanted, but says "for the most part they left me alone."

Bob Kane, who drew most of the daily strips during Batman's initial newspaper run from 1943 to 1946, found that it wasn't as much fun as comic book work. "What made Batman powerful were the big splash pages I'd create at the beginning of the stories, and then you could break up each page." The narrow row of panels was frustrating by comparison, he says, "because I didn't have enough room to expand on the action." The larger Sunday pages were generally drawn by Jack Burnley, with scripts by Bill Finger, Don Cameron and Alvin Schwartz. The strip's duration, which may have been curtailed by competition with Superman, nonetheless surpassed very brief runs by Wonder Woman and Hop Harrigan. Batman would be revived as a newspaper strip several times in years to come; along with Superman, he brought the idea of the super hero into countless American homes.

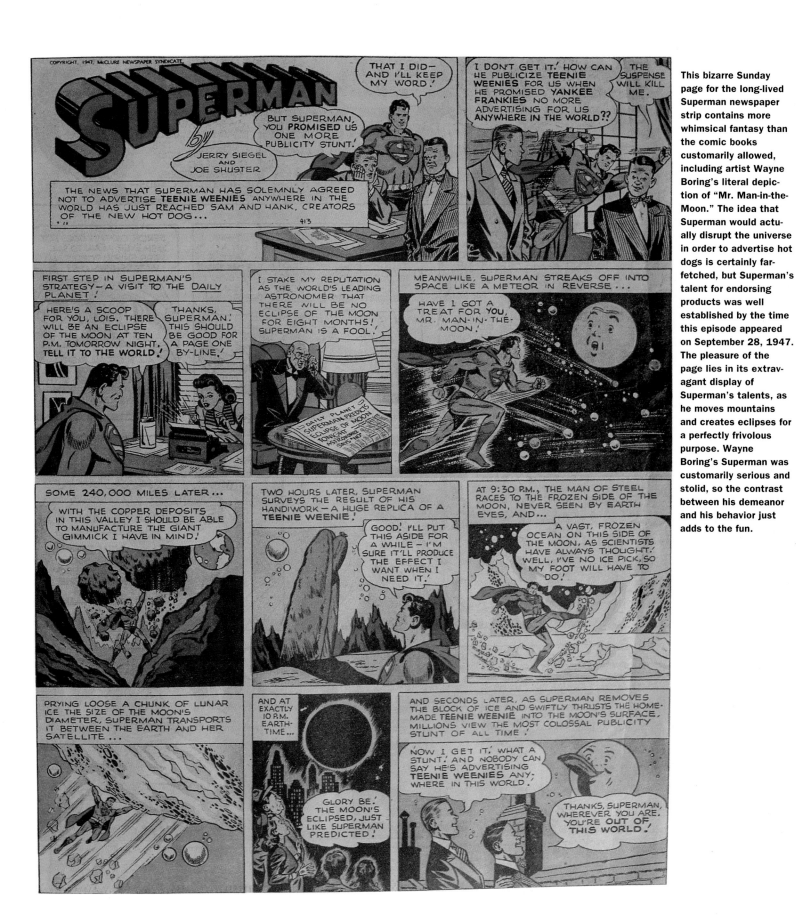

This bizarre Sunday page for the long-lived Superman newspaper strip contains more whimsical fantasy than the comic books customarily allowed, including artist Wayne Boring's literal depiction of "Mr. Man-in-the-Moon." The idea that Superman would actually disrupt the universe in order to advertise hot dogs is certainly far-fetched, but Superman's talent for endorsing products was well established by the time this episode appeared on September 28, 1947. The pleasure of the page lies in its extravagant display of Superman's talents, as he moves mountains and creates eclipses for a perfectly frivolous purpose. Wayne Boring's Superman was customarily serious and stolid, so the contrast between his demeanor and his behavior just adds to the fun.

SUPERMAN TOYS
Transformed into the Man of Tin

As early as 1936, years before any publisher was willing to take a flier on Superman, artist Joe Shuster was daydreaming on paper about the character's future success. On a big sheet of drawings he penciled in slogans like "The strip destined to sweep the nation," and "Too big to be judged by ordinary standards." The predictions were accurate, and so were the sketches Shuster made concerning Superman's merchandising potential. By 1940, with the character appearing in comic books, newspaper strips, animated cartoons and a radio show, a company called Superman, Inc. was created by DC to license the hero's image to manufacturers eager to jump on the bandwagon. Superman was becoming an industry, and playthings bearing his likeness became big business.

The Man of Steel became the Man of Tin, the Man of Wood, the Man of Celluloid and many more as toymakers of the 1940s transformed his image into three dimensions and played their part in turning Superman into one of the most renowned figures in the world.

Made of pressed wood, this rugged 1942 Superman stood less than six inches tall.

This wooden doll from 1940—measuring just over a foot and costing just under a buck—was the first Superman figure to be marketed.

The latex Super-Babe was born in 1947.

The tin Rollover Plane bent over backwards for Superman. It was produced by Louis Marx in 1940.

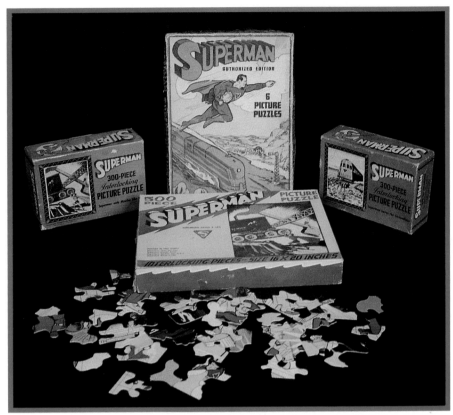

In 1940, Saalfield Publishing Company produced more than a dozen Superman puzzles.

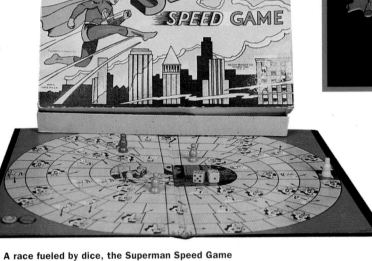

A race fueled by dice, the Superman Speed Game came from Milton Bradley in the 1940s.

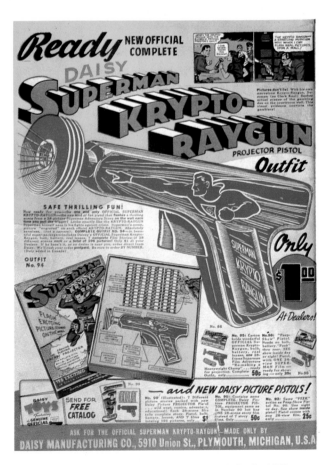

The battery-powered Krypto-Raygun, made by Daisy in 1940, projected Superman film strips.

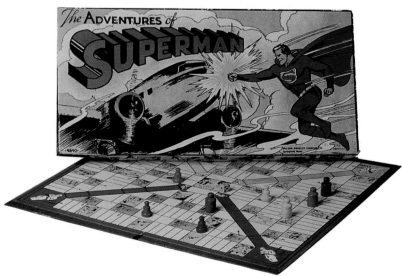

The first Superman game was manufactured by Milton Bradley in 1940.

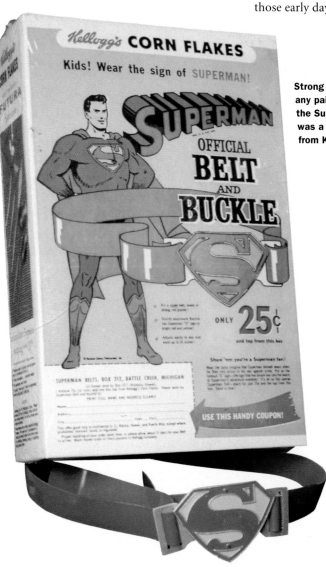

FEATURE FOR

march · 1946

The product most closely associated with Superman was a breakfast cereal, Kellogg's Pep.

SUPERMAN MERCHANDISE
Selling the Salesman of Steel

Superman is ready to work for *you* in 1941," promised the promotional brochure produced by Superman, Inc. "Let Superman be your Super-salesman. Superman has a tremendous, loyal fan following, a ready-made juvenile market that will respond by boosting your sales volume." The company's licensing department was run by Jay Emmett and Robert Maxwell, but much of the inspiration for their work can be credited to Siegel and Shuster, who began to push for merchandising almost as soon as their character was launched.

Superman's fifth adventure, published in *Action Comics* #5 (October 1938) was totally devoted to the idea that there was a lucrative market for products endorsed by Superman. In the story, a con man showed up at the *Daily Star* (where Clark Kent was still employed in those early days) claiming to be Superman's

personal manager. He demonstrated his client's commercial potential with a radio program sponsored by "Crackles, the energy-building breakfast food," and pointed out a blimp promoting sales of a gasoline endorsed by "the strongest man on earth." Both ideas later came to pass in the real world, and Superman also lent his name to everything from shoes to bread. His longest-lasting relationship was with Kellogg's, which sponsored his radio show (and later the television version), strongly reinforcing the relationship in publicity and packaging. In short, Superman turned out to be everything Siegel and Shuster had imagined.

Strong enough for any pair of pants, the Superman belt was a box-top offer from Kellogg's.

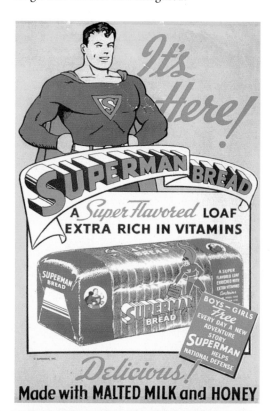

Superman became the staff of life when his likeness was licensed to a number of bakeries in 1942.

Clark Kent is startled by an ad for Superman Gasoline in this 1938 panel....Eight years later, the idea seemed less fantastic.

Siegel and Shuster also came up with this 1938 comic book billboard for an imaginary Superman automobile.

Employing a similar pose, this Superman hood ornament for real cars was a popular item a decade later.

Even footwear got the Superman endorsement; this ad appeared in 1941.

THE BATMAN SERIALS
The Dark Knight in Black and White

Big, busy posters like this were often more spectacular than the low budget, black-and-white movies they advertised.

"I loved the chapter, 'to be continued next week,'" says Batman's creator, Bob Kane, recalling the motion picture serials from his childhood that helped to inspire Batman. So it was appropriate that the first live action film based on a DC character should be *Batman* (1943), a fifteen-part serial from Columbia Pictures. Unreeling one chapter per week at Saturday matinees for kids, *Batman* was part of a tradition stretching back to the early days of silent films. Serials were generally weak on logic and production values, but they offered plenty of action. A fistfight every episode was almost obligatory, and so was a cliff-hanger ending. *Batman* and its 1949 sequel *Batman and Robin* were typical. "They were kinda fun," says Kane, "but they were cheapies, you know?"

"Deep in the cavernous basement of this house, in a chamber hewn from the living rock of the mountains, is the strange, dimly lighted, mysteriously secret Batman's Cave." So intoned the narrator at the start of *Batman*, following credits under-scored by the swirling strings

and ominous brass of Lee Zahler's theme music. Thus, in its first minute, the serial got as good as it ever would, and added its bit to Batman lore. The subterranean hideout, also called "The Bat's Cave," became famous later as the Batcave. Although the comic books had already mentioned secret passages beneath Bruce Wayne's mansion, the movie gets credit for really invading the space and making it memo-rable. The screenplay (by Victor McLeod, Leslie Swabacker and Harry Fraser) has also been credited with introducing Wayne's helpful butler Alfred, who works here as chauffeur when he's not reading mystery pulps. Apparently the result of cooperation between the comics and Columbia, Alfred showed up in DC pub-lications simultaneously.

These two ideas evidently exhausted the ingenuity of the writers, whose wartime tale about Japanese spies stealing radium to con-struct a death ray was nothing new. They were also pretty cavalier about rescuing Batman from his predicaments at the end of each chapter. On one occasion, his plane crashes in flames, but he just gets up and walks away. "Boy, are you lucky!" exclaims Robin after another of these unlikely escapes, which occur so often that the villain suspects he's up against an army of Batmen. The frustrated fiend is played by J. Carrol Naish, Oscar-nominated for other work but strictly slumming here as Dr. Daka. Sometimes known as Prince Daka, the character is a stereotype, but Naish brings him to life for a moment when he runs out of food for his pet alligators and begins to look specu-latively at one of his hypnotized henchmen.

A dramatic shot of Robert Lowery, suited up for *Batman and Robin* (1949).

There are no such special moments for Batman (Lewis Wilson) or Robin (Douglas Croft). The Boy Wonder comes off as an uppity kid with a smirk, and the Caped Crusader distinctly lacks an edge. Lewis Wilson was evidently cast to play Bruce Wayne, so his languid air and upper-crust accent constitute a valid approach, but he can't shake them when he plays Batman, or even when he is disguised as a gangster. Perhaps none of this mattered much to the audience, especially since stuntman Eddie Parker filled in during the best scenes. One wonderful black-and-white shot of Batman silhouetted against the sky, cape unfurled as he leaps down on his opponents, must stand in for over four hours of inadequate attention to atmosphere, but in all fairness, director Lambert Hillyer's budget was less than Max Fleischer got for one seven-minute Superman cartoon.

By the time the sequel was released in 1949, serials were on their way out, and director Spencer Bennet's budget was even smaller. His producer was Sam Katzman, famous for making movies on a shoestring. Bob Kane noticed how things were going when he visited the set. "I was standing in front of a gray convertible," Kane recalls. "The assistant director was there and I said, 'I don't see any car that looks like the Batmobile,' and he said, 'You're standing in front of it.'" Neither serial attempted to duplicate the Batman's hot wheels, but at least the 1943 film had given the hero an impressive black Cadillac instead of a modest Mercury.

The one advantage of *Batman and Robin* is the casting of the title characters. Robert Lowery is a distinct improvement as Batman, a sturdy, tough, no-nonsense hero. Described by Kane as "a good-looking guy and not a bad actor," Lowery had played leading men in movies like *The Mummy's Ghost* and *Charlie Chan's Murder Cruise*. As Robin, John Duncan is clearly too old and doesn't say much, but at least he isn't annoying. The plot is stock stuff about weird inventions and a masked villain called the Wizard, and it's pretty pathetic to see Batman and Robin take their costumes out of a drawer in a file cabinet, but the serial was serviceable in its time, and like its predecessor is good for a few laughs today. In time, these films would help inspire a spoof that became one of the biggest hits in television history.

Dr. Daka (J. Carrol Naish) orders his stooges, hypnotized via their tin hats, to take Batman prisoner. Director Lambert Hillyer had shown a gift for sinister atmosphere in features like *The Invisible Ray* and *Dracula's Daughter* (both 1936), but he had less time and money for the serial *Batman* (1943).

Lewis Wilson as Batman and Douglas Croft as Robin pose for a studio shot that endeavors to make their costumes look as good as possible. Regardless, Batman's ears resemble a devil's horns.

The Wizard, a typical serial villain, wore a disguise the way a typical super hero did. The writers of *Batman and Robin* kept this crook's identity a secret by concealing the information that the most obvious suspect had an evil twin brother.

BATMAN'S EQUIPMENT
What a Millionaire's Money Can Buy

Batman may not have had super powers, but he had something else that was equally appealing to comic book fans: an endless array of artifacts custom-designed to combat crime. These Bat-gadgets, introduced one by one and updated as the years went by, gradually gave Batman a mystique that no other comic book character could match. By 1957, a story could

The Batgyro and the Batarang ("modeled after the Australian Bushman's boomerang") were introduced simultaneously in *Detective Comics* #31 (September 1939). Art by Bob Kane.

One of Batman's most valuable assets was his butler Alfred, shown here with a miniature version of the Bat-Signal. The manservant was stout when he arrived, but he quickly slimmed down. Pencils by Bob Kane and inks by George Roussos.

reasonably be entitled "The 1,000 Inventions of Batman," and if the number was an exaggeration, it didn't seem like much of one.

In 1939, on his very first appearance, Batman sported a broad yellow belt studded with several cylinders of indeterminate purpose. Subsequent stories revealed that this was his utility belt, a veritable cornucopia of labor-saving devices. The first thing he pulled out of it was a glass pellet filled with a knockout gas, one of at least half a dozen varieties he carried

from time to time. The belt appeared to have only twelve compartments, but in fact it was a magical article of apparel from which its owner could extract whatever he needed. It could produce anything from a flashlight to a geiger counter, from a crayon to a complete Batman costume made of some improbably lightweight material. Also concealed in the utility belt was the Batrope, a silken cord that originally hung by the hero's side. Most often used for swinging from one building to the next, it was the simplest piece of equipment Batman possessed.

The most complex item in the early arsenal was the Batgyro. Created by writer Gardner Fox for the fifth Batman story, and apparently inspired by Igor Sikorsky's first successful helicopter flight in 1939, the Batgyro was capable of hovering so precisely that Batman could park it in midair and climb down a rope ladder to the ground, confident that everything would remain in place till his return. Shaped like a bat with a big rotor on top, this device was the forerunner of the Batplane, which made its first appearance in 1940. Originally equipped with a realistic bat's head placed just behind its propellor, the Batplane was later depicted with a more stylized design, and in fact seemed to undergo almost constant modification. By 1946, it could retract its wings and travel on land, on sea or underwater. Despite this convenience, however, Batman also tooled around in a Batboat (first seen in 1946), and in various Bat-subs. His most famous vehicle, however, remains the Batmobile.

For the first few years of his career, Batman was forced to undergo the ignominy of driving a car that looked pretty much like everybody else's. It was sometimes red and sometimes blue, but only when Bob Kane drew a symbolic hood ornament for it did Bill Finger begin writing captions that called it "The Batmobile" (February 1941). From that point on, the auto evolved into a sleek, streamlined custom job of midnight blue, with a scalloped fin protruding from its back and a bat-faced front that functioned as a battering ram. New features were added as time passed, until the crucial year of 1950 when both it and the Batplane were replaced with newer models.

In "The Batmobile of 1950," from *Detective Comics* #156 (February 1950), a crook named Smiley Dix sets off an explosion that totals the Batmobile and leaves Batman in traction. Undaunted, the Caped Crusader creates designs for "the new Batmobile, the one I've

been planning for a long time!" He sits with his leg in a cast while poor Robin is left to build the car, apparently single-handedly. The result, depicted by Dick Sprang, is a bubble-topped American dream, equipped with a bigger fin than ever, not to mention such handy features as radar and rocket power.

Almost simultaneous was a story in *Batman* #61 (October–November 1950) called "The Birth of Batplane II." With the original plane stolen and reproduced in triplicate by a gang of smugglers, Batman and Robin are obliged to build an improved model in their spare time, one powerful enough to defeat its prototypes. This modern version, a jet, incorporated a retractable autogyro among improvements ranging from television to "human ejector tubes." The idea of new models proved popular upon its introduction in consumer-conscious 1950, and there have been updates ever since.

The Batmobile, the Batplane and numerous other goodies were housed in the Batcave, an ever-expanding subterranean lair that was every kid's dream of a perfect hideout. At first little more than a tunnel between Bruce Wayne's mansion and a deserted barn, the underground area was gradually revealed as a bottomless pit with room for a garage, a hangar, a laboratory, a trophy room and even a gymnasium. The Batcave's name and its status as a natural cavern with attendant atmosphere seem to have been inspired by its appearance in the cinema serials, and subsequent versions of Batman have continued to promulgate the lore of this hideout and of the hero who has everything.

The "Bat-Plane" falls into criminal hands in *Batman* #91 (October 1955). Pencils by Dick Sprang and inks by Charles Paris.

When the Batmobile was wrecked in 1950, one surprise was the revelation that the new one would be built by hand in the Batcave. Pencils by Dick Sprang and inks by Charles Paris.

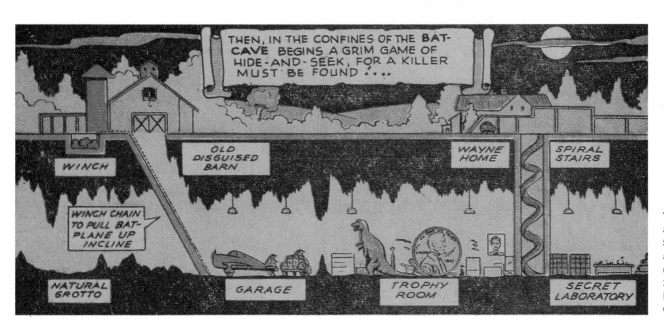

This cutaway diagram appeared in "The 1,000 Secrets of the Batcave," a story in *Batman* #48 (August–September 1948). Pencils by Jim Mooney and inks by Charles Paris.

SUPERMAN'S POWERS
The Evolution of a Super Hero

In his first appearances, Superman was capable of tremendous leaps, but he couldn't fly. Hence his decision to run all the way to Oklahoma in *Superman* #4 (Spring 1940).

As Luthor knew, Superman's X-ray vision could be stopped cold by a lining of lead. Al Plastino's cover for issue 177 ran in February 1953.

By the time this Al Plastino cover appeared in August 1953, Superman's invulnerability was so well established that it could be treated as something of a joke.

The Superman who kicked off the comic book business in 1938 was only a rough sketch of the hero who seems so familiar today. The powers he initially displayed were extraordinary enough to make him unique, but only until imitators began to arrive. Then competition and the challenge of creating something new propelled him forward. "We felt that this would become one of the greatest comics heroes of all time," said artist Joe Shuster.

To survive in the comic book jungle, Superman evolved. "We kept developing new powers for the character," writer Jerry Siegel said. The most dramatic improvement was the idea of flight. In his first appearance, it was stated that Superman could leap an eighth of a mile, but jumping was the only way he could get off the ground. He gave the visual impression of defying gravity, however, and the animated cartoons that began in 1941 seemed to encourage this notion. At about the same time, a few comic book stories began to suggest that the hero could soar like a bird, but there was no consistency until 1943, by which time it had also been established that he could move faster than the speed of light. The

This spectacular stunt from *Action Comics* #77 (October 1944) demonstrated that there was essentially no limit to Superman's strength.

essentially magical ability to fly was inconsistent with explanations that Superman's powers derived from the differences between Earth and his home planet, but it was a talent too tempting to pass up. Besides, lots of the other guys were doing it.

"Nothing less than a bursting shell could penetrate his skin," annnounced the first story about Superman, and in 1939 he still had to be careful of bombs, which could knock him out and might even kill him. Poisonous gases also posed a bit of a problem, and powerful electrical shocks could stun him. He overcame those weaknesses eventually, however, and in 1946 was shown defying the power of not one but two exploding atom bombs. The invention of the hydrogen bomb didn't faze Superman either, and by the 1950s he was immune to just about anything except science fiction forces concocted by increasingly harried writers. His strength increased along with his invulnerability, until by 1951 he could toss a skyscraper into space, and a few years later he was pushing planets around.

Superman's perceptions were also enhanced, so he naturally possessed supersensitive ears and a nose to match, but nothing quite explained his vaunted X-ray vision, which enabled him to see through anything except lead. This power appeared in 1939, gradually augmented by microscopic and telescopic variations, not to mention radar and infrared. Tricks like this came in handy for saving the world, but at least once they enabled Superman to relax at home while reading the books in a faraway Parisian library.

It goes without saying that he was also super smart; less predictable was the fact that his super lips, which expel his mighty super breath, were also capable of super ventriloquism. Not so frequently displayed, but of interest nonetheless, was a power that Lois Lane has apparently always suspected was in his repertoire: in *Action Comics* #306 (November 1963) he administered a super kiss.

Superman predated the atom bomb by seven years, but almost as soon as nuclear weapons were invented, they became the ultimate test for the Man of Steel. The most powerful enemies he faced in his radio series and his movie serials were both called Atom Man (although they were completely different people), and there is good reason to believe that the menace of kryptonite was symbolic of atomic energy. Scripts compared kryptonite's effect on Superman to radioactivity, and the deadly substance from his home planet was introduced on the radio show just a few weeks after the first atom bomb was dropped (although in fact it had been invented for an unpublished story from 1940). The symbolic radioactivity of kryptonite might have been too much for the original super hero, but he offered reassurance to his readers by repeatedly defying the blast of the actual nuclear bomb itself. This image, from October 1946, was pencilled by Wayne Boring and inked by Stan Kaye.

The Superman Serials
Saving the World Once a Week

This Belgian poster for the 1948 serial *Superman* shows that Superman's fame was spreading around the world, but the artist got the colors of the costume wrong.

Lord knows I'll never make an Academy Award movie," admitted producer Sam Katzman, but he also bragged that none of his films ever lost money. He is credited with coining the term *beatnik*, and his productions included *Spooks Run Wild* (1941), *Don't Knock the Rock* (1956) and *Hot Rods to Hell* (1967). After producing fifteen features in his Jungle Jim series, Katzman acquired the nickname "Jungle Sam," and in 1948 Columbia Pictures assigned him the first live-action Superman movie.

"Mr. Katzman did all the Columbia B-movies and serials. He kept the company afloat," says actress Noel Neill, who received top billing in *Superman* (1948) and *Atom Man vs. Superman* (1950) after Katzman decided to keep his leading actor's identity a secret. That idea had worked for the radio program, and Columbia was intent on plundering other media for any ideas that might make the Superman serials successful. In fact, their credits indicate that the screenplays were merely "based on" the comics but were "adapted from" the

radio version. So like his radio counterpart, Kirk Alyn as Superman not only went unbilled in both serials, but also spent all fifteen chapters of *Superman* shouting "Up, up and away!" every time he leaped into the air, as if there were no other way for the movie audience to know he was flying. Even more bizarre was the decision, apparently motivated by the successful Max Fleischer cartoons of a few years earlier, to use animation for most special effects. As a result, each time Superman took flight he turned into a drawing, and the result was quite disorienting.

Superman's four hours were filmed in four weeks according to Noel Neill, who says she was cast because "I had long black hair like Lois in the comic books." Kirk Alyn, formerly a dancer, was also cast for his appearance, and the breakneck pace of filming gave nobody time to do more than say the lines and press onward. Retakes were too expensive to consider, even when the fast-moving Alyn's cape wrapped itself around his face and had to be irritably yanked off.

Despite its shortcomings, *Superman* became the most successful serial in history, presumably because the character was already so popular. The plot was the usual serial stuff about the struggle over plans for a futuristic weapon called the Reducer Ray, and the villain, a blonde in a black mask and an evening gown, was called the Spider Lady (Carol Forman). She had a big, electrified spider web in her hideout, minions in double-breasted suits scattered all over the country, and even a handy supply of kryptonite to keep Superman at bay, but nobody ever really answered the script's question: "Just what is she after?"

Pierre Watkin as Perry White, Kirk Alyn as Superman, Noel Neill as Lois Lane and Tommy Bond as Jimmy Olsen pose for a publicity still.

The inevitable sequel, *Atom Man vs. Superman* (1950), was also "adapted from" the radio program, but used only the name of the Nazi super villain that the show had made famous. The cinematic "Atom Man" is actually comic book villain Lex Luthor, wearing a big shiny mask to disguise the fact that he is slipping in and out of prison via "a secret ray which breaks down your

atoms and reassembles them wherever I desire." The bad guy's big move is to disassemble Superman and send him into space, where the hero wanders around transparently among the planets, victim of a condition called "The Empty Doom." A ruse convinces Luthor that Superman has escaped, the master crook sends a henchman into the void to investigate, and in the confusion Superman returns. The script by George Plympton, Joseph Poland and David Mathews is full of such ingenious devices; Luthor is also revealed as the inventor of the flying saucer (animated) and the first ship to reach outer space (ditto). Yet with all this expertise at his disposal, and the obvious capacity to earn billions legitimately, Luthor and his men inexplicably spend their time robbing shoe stores and laundries.

Kryptonite casts its eerie glow over Kirk Alyn and Forrest Taylor in the third chapter of *Superman*.

Much more ambitious than its predecessor and most other serials, *Atom Man vs. Superman* is none-theless still mired in the juvenile conventions of the form; it also lacked the budget to realize its more grandiose concepts, which included fire, flood and earth-quake along with the fantasy.

Veteran character actor Lyle Talbot played Luthor with authority, opposite a cast of returning players that included Kirk Alyn, Noel Neill, Pierre Watkin (as cigar-chomping editor Perry White) and Tommy Bond (as ace photographer Jimmy Olsen). With any justice, *Atom Man vs. Superman* should have done better than its predecesor, but by 1950 television was pushing weekly chapter plays toward oblivion. Going to the movies ceased to be a habit, and for a time it was feared that films might become obsolete. Perhaps this is why the despised Luthor is depicted as the owner of a TV station, its trucks used to observe prospective victims. Hollywood's scare tactics didn't work, however. Before long the serial was dead, and by 1951 Superman was on his way to the home screen.

Kirk Alyn strikes a classic pose in *Superman* (1948).

Lyle Talbot played the definitive Superman villain, Lex Luthor, in the 1950 serial *Atom Man vs. Superman*.

MATINEE MADNESS
More Serial Thrillers of the 1940s

If Superman and Batman were the biggest names in comic books, and the only super heroes to receive two serials apiece, they were hardly alone in the realm of Saturday afternoon chapter plays. Comic book characters both

chief rival. Republic was a small studio, but in terms of low-budget action films, it was a class act. DC took its business to Columbia Pictures, a more important outfit that had its share of Academy Award winners and consequently

Artist Mort Meskin explains serial technique for a spread on shooting *The Vigilante* serial in *Real Fact Comics* #10 (September 1947).

The villain was the Scorpion, and the hero was a boy named Billy Batson (Frank Coghlan, Jr.) who became even more of a hero when he said "Shazam!" and turned into Captain Marvel (Tom Tyler).

major and minor had their movie moments, and in fact some of the figures who made it to the silver screen are so obscure that their presence there is a bit baffling. But one of the biggest starred in the serial widely considered to be the best of the bunch.

The Adventures of Captain Marvel, released in 1941 by Republic Pictures, was the first comic book serial, an honor that should and could have been enjoyed by an adaptation of Superman. In fact, both Republic and DC announced in 1941 that they would be making a serial about the Man of Steel, but negotiations fell through and Republic ended up making a deal with Fawcett Publications for Superman's

didn't take its serials too seriously.

Republic's special effects experts, brothers Theodore and Howard Lydecker, solved the problem of a flying man with a lifelike dummy that zoomed across the sky on unseen wires. Intercut with shots of Tom Tyler, the actor who played Captain Marvel, the gimmick was state-of-the-art for its era, and certainly more convincing than the cartoons Columbia used.

The Adventures of Captain Marvel also benefited from the enthusiastic efforts of stuntman Dave Sharpe, whose leaps and flips as he entered a scene helped create the illusion of a super hero. Republic was famous for its stunts, and the film's directors, William Witney and John English, had developed an effective style of staging fights that was adapted from the choreography of Busby Berkeley musicals. Republic's miniature sets, vital for fires, floods and similar low-rent spectacles, looked unusually convincing because they were photographed outdoors, in the same light where the main action occurred. Such techniques, combined with a solid story set atmospherically on an archaeological dig, made this serial seem special.

Meanwhile, back at Columbia, producer Sam Katzman was promoting a much more pedestrian product, making movies about comparatively unimportant DC characters whose significance for him may have been that

they could be shot for a song. *Hop Harrigan* (1946) not only had a radio show to promote it, but its aviation theme had been used in many previous Columbia films that could provide plenty of props and stock footage. William Blakewell played Hop, on the trail of a death ray and bad guys called the Chief Pilot and Dr. Tobor (screenwriters seem to have a thing about spelling words backwards).

Next for Columbia was *The Vigilante* (1947), a western about the struggle for some priceless pearls. Created by Mort Weisinger and drawn with vigor by Mort Meskin, the Vigilante got his start in the back pages of *Action Comics* #42 (November 1941) as a singing cowboy who lived in modern times and rode a motorcycle instead of a horse. No doubt this appealed to the budget-conscious Katzman, who did at least throw in a gorilla for the fans. The title role was played by Ralph Byrd, best known for portraying Dick Tracy in movies and on television.

By 1948, "Jungle Sam" Katzman had his hands on Superman and Batman too, but he still had time to live up to his nickname by producing *Congo Bill*. Like Superman and the Vigilante, Congo Bill was a regular in *Action Comics*, although he had first appeared in *More Fun* #56 (June 1940). The plot of the serial, which featured a witch doctor, a wicked trapper and the inevitable "white goddess," was perfectly suited to the parsimonious Katzman's collection of palm trees and pith helmets. Bill was played by Don McGuire, who later went behind the camera to write or direct such Jerry Lewis films as *Three Ring Circus* and *The Delicate Delinquent*.

A few years later, serials were running out of steam, doomed by the episodic delights of television, which was also showing the old chapter plays. One of the last of the breed, and the last of all to be based on a comic book, was Katzman's version of *Blackhawk* (1952). The Quality Comics hero, who would soon be transferred to DC, led a gang of uniformed aviators, so at least the costume budget had some beef in it, but otherwise Columbia was resolutely avoiding any unnecessary expense. In fact, little seemed to have changed. The story was about a death ray, the hero was Kirk (Superman) Alyn and the villain was Carol (Spider Lady) Forman. The fifteenth chapter was called "The Leader Unmasked," and that was all they wrote.

Congo Bill (1948), based on the DC character created by editor Whitney Ellsworth, contained chapters with titles like "Trail of Treachery" and "Lair of the Beast."

Not all of Blackhawk's six sidekicks made it into Sam Katzman's budget-conscious movie version, but by 1952 serials were on the way out.

Hop Harrigan didn't get many covers after Green Lantern came along, but *All-American Comics* #77 (September 1946) was used to plug Hop's new serial. William Blakewell starred.

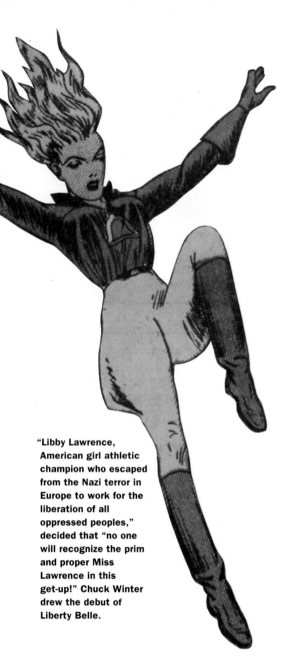

"Libby Lawrence, American girl athletic champion who escaped from the Nazi terror in Europe to work for the liberation of all oppressed peoples," decided that "no one will recognize the prim and proper Miss Lawrence in this get-up!" Chuck Winter drew the debut of Liberty Belle.

THE ALSO-RANS
Trapped in the Back of the Book

Some super heroes were born great, some achieved greatness and some merely filled the back pages of the anthologies that were the most common comic books of the Golden Age. For every Superman or Wonder Woman who attained worldwide fame and apparent immortality, there were dozens of characters who just slogged along for a few years, then hung up their tights and retired. Some were perhaps too dull to make it, some just a little too weird, and some were victims of bad timing, but dozens dropped out along the way. These are some of their stories.

The Crimson Avenger was a pioneer who probably spent his declining years cursing his bad luck. With his red cloak and black mask, he was one of the first costumed characters in comic books when he showed up in *Detective Comics* #20 (October 1938). By December he was on the cover, but a few months later someone named Batman arrived, and suddenly the Crimson Avenger had competition. He took a leave of absence, then came back with a gaudier costume, but he never recovered his momentum and finally gave up in 1945. Created by artist Jim Chambers, he could have been a contender.

Then there was the totally clueless super hero, Johnny Thunder. He wandered into the first issue of *Flash Comics* (January 1940),

barely aware that he could be granted an hour's worth of omnipotence every time he uttered the words "Say, you." That phrase, in common usage half a century ago, sounded exactly like a "Bahdnisian" witch doctor's spell, and it called up a living lightning bolt that would fulfill Johnny's every wish. The brainchild of writer John Wentworth and artist Stan Aschmeier, Johnny was "a dope" even to his magical slave. He couldn't afford a costume, but he did have one big moment when an idle remark of his inspired the first meeting of the Justice Society of America. As a result, he was allowed to become a member, but he was always patronized by the real super heroes in the organization, and he suffered the ultimate indignity in 1947 when a supporting character in one of his stories began to push him out of his spot in *Flash Comics*. Her name was the Black Canary.

If it was risky being a costumed character in comics, being a woman as well made the job even tougher. Few females besides Wonder Woman survived for long, but the Black Canary was someone special. A glamorous blonde whose black costume included high-heeled boots and fishnet stockings, she was lovingly drawn by Carmine Infantino for her debut in *Flash Comics* #86 (August 1947). Infantino and writer Robert Kanigher were evidently tired of Johnny Thunder's comical antics and eager to promote the Black Canary, who in February 1948 bumped Johnny from both *Flash Comics* and the Justice Society stories in *All Star Comics*. With a bit of assistance from her boyfriend, a private eye named Larry Lance, she fought crime in a slightly shady way until 1951. That should have been the end of the line, but somebody liked those stockings, and the Black Canary was revived in 1963. Defying the odds, she's been around ever since.

Liberty Belle, the other female contender from the period, didn't turn out to be so tenacious. She made her debut in *Star Spangled Comics* #20 (May 1943), and like many characters in that comic book she owed her existence to World War II. Another blonde, she donned a blue and yellow costume with a Liberty Bell emblem and took on the Nazis after they killed her father. Dished up by writer Don Cameron and artist Chuck Winter,

The Crimson Avenger, a throwback to pulp heroes like the Shadow, had his moment of glory on this Jim Chambers cover for *Detective Comics* #22 (December 1938).

No. 22 — 64 PAGES OF Thrill-Packed ACTION — DECEMBER, 1938
Detective COMICS
Reg. U.S. Pat. Off.
10¢
FRIEND OF THE NEEDY, FOE OF THE UNDERWORLD, THE CRIMSON AVENGER APPEARS IN THIS AND EVERY ISSUE!

she really had nowhere to go after the war ended, but like the Black Canary, she had replaced someone strange. Preceding her in the first nineteen issues of *Star Spangled Comics* was editor Mort Weisinger's character Tarantula. Suction cups gave him the ability to climb up walls, and his gun shot webbing to ensnare his foes. Such talents make Tarantula an avatar of Spider-Man, who would become a big success for Marvel Comics beginning in 1962, but in 1941 the idea of a hero who acted like an arachnid was apparently just a bit too bizarre.

The weirdest DC hero, however, was another Weisinger creation: Air Wave. His sidekick was a parrot instead of a kid or a comedian, but that was nothing compared to his gimmick. Air Wave wore a big yellow helmet with twin antennae that somehow sucked electricity out of the atmosphere, thus providing power for the roller skates he used to zoom along telephone wires pursuing the bad guys. Exactly how useful this could have been is difficult to say, but Air Wave, introduced in *Detective Comics* #60 (February 1942), stuck it out for more than six years. Lawyer by day and lunatic by night, Air Wave is doubtless rolling through some comic book heaven now, his bird behind him and the plaudits of a grateful nation ringing in his ears. Nobody was ever more of an also-ran.

Johnny Thunder may have his name in big letters and cartoon hearts spinning around his head, but it doesn't take a psychic to predict that the Black Canary's debut will be his downfall. Pencils by Carmine Infantino and inks by Frank Giacoia.

John Law, mystery writer, fights crime as Tarantula, but can only come up with a couple of hooky-players in *Star Spangled Comics* #16 (January 1943). Art by Al Avison.

Even when he's half-unconscious and aloft in a balloon, poor Air Wave can't escape the lectures of Static, the Proverb Parrot. Art by George Roussos from *Detective Comics* #104 (October 1945).

More Fun Comics #104 (July–August 1945) featured Dover and Clover by Henry Boltinoff, whose humorous fillers were a staple in DC comic books of the era.

By depicting an early encounter between Superboy and Lois Lane, this Win Mortimer cover from May 1948 contradicted the first Superman stories in which the meeting took place years later.

Many of the Superboy stories featured Lana Lang, a teenager who shared Lois Lane's initials and also her insatiable curiosity. Eventually, the two women would meet and become rivals. Cover by Win Mortimer, from September 1951.

THE SAGA OF SUPERBOY
Remembrance of Things Past

If super heroes were popular, and their kid sidekicks were popular, then depicting the world's most famous super hero as a kid was bound to meet with widespread approval. That was the idea behind Superboy, who made such a modest debut in the pages of *More Fun Comics* #101 (January-February 1945) that he didn't even make the cover for a few issues. When he did, he shared the space with a couple of comedy characters named Dover and Clover, because *More Fun* was converting to humor. Superboy went to *Adventure Comics*, where he began an extended run as the leading character in 1946. When he finally got his own comic book in March-April 1949, *Superboy* was bucking the tide that was sweeping super heroes out of fashion. In fact, *Superboy* was the last important title of the Golden Age.

The appeal of Superboy was that he provided a chance for a look back at the development of a legend; the problem was that depicting a costumed kid contradicted the original story in which Clark Kent didn't become a champion of justice until he grew up. Nobody gave the problem much thought at the time, but this was the first major contradiction to appear in DC's continuity. As years went by and more stories accumulated, the job of keeping track would become almost overwhelming.

Superboy struck a chord with readers, but few remember that on first appearance he

seemed extremely young, perhaps seven years old. Within a year he looked about twelve, and he finally settled down as a teenager. This spurt of growth was clearly not planned as part of a scheme to bring the character to full maturity; the adolescent Superboy just had more story potential. He acquired a redheaded sweetheart, Lana Lang, and went to high school in his newly named hometown, Smallville. This idyllic community was vital to the expanding Superman myth, and may have had even more resonance for Superboy's adult chroniclers than his young readers. There wasn't much attention to period detail, yet the sense of an innocent, prewar, small-town America, of a dreamworld that was already disappearing, made these tales of Superman's roots feel like more than just a spinoff.

Editor Jack Schiff is credited with the original suggestion for the Superboy series, but says today that "it never really came to fruition" as he had conceived it. The initial scripts were by writer Don Cameron, and Superboy soon fell under the supervision of Mort Weisinger, who became editor of all Superman features when he came back from the war. One reader who didn't care for Superboy was another returning soldier, Jerry Siegel.

Siegel and his partner Joe Shuster had been growing unhappy with DC for a number of reasons, most of them stemming from the original agreement they had made when Superman was first published in 1938. Like virtually all other comic book creators, they had sold all rights to their character when they sold the rights to their first story about him. Although better paid than most of their colleagues, they were essentially employees.

The Superboy stories proved to be a bone of contention because they initially appeared under Siegel's name but without his participation; he was in the army at the time. Dissatisfaction over the situation led to a 1947 lawsuit, in which the court ruled that Siegel and Shuster were entitled to compensation on the Superboy matter, but that DC was the legal owner of Superman. Another result of the suit was almost total estrangement between DC and the team. Siegel would return briefly to write a few stories, but the breach was not really healed until 1975, when a settlement was made in which Siegel and Shuster received pensions and had their credits returned to their creation. When asked about the difficulties, Jerry Siegel said "I really don't believe in looking back." Yet, in a sense, that's what Superboy had been all about.

It's not quite Mom and apple pie, but it is Mom and blueberry pie as artist Al Plastino delineates a domestic scene for the cover of *Superboy* #8 (May–June 1950). Many early Superboy stories seemed devoted to extolling the virtues of life in America's small towns, and covers made Smallville look like a dreamworld where few problems existed and all of them could be solved by Superboy. Other covers show Superboy trimming hedges, painting a picket fence, washing dishes, carving a roast and plowing a field—humble household chores all performed at super speed. Indeed, the early *Superboy* might fairly be called the *Saturday Evening Post* of comic books.

DIEHARDS
A Quartet That Wouldn't Quit

Green Arrow plays William Tell with his sidekick, Speedy, for *More Fun Comics* #80 (June 1942). Cover by the duo's original artist, George Papp.

The decade after World War II was marked by a decline in the popularity of super heroes. Perhaps because these uniformed battlers had been so closely associated with the global conflict, they were temporarily out of style. Yet if the characters that had put comic books on the map were experiencing a slump, the business as a whole was booming. Popular new genres sprang up, ranging from humor to horror, and overall industry sales almost tripled between 1945 and the peak year of 1953. Meanwhile, DC cancelled *More Fun Comics*, *Flash Comics* and *All-Flash Comics*, and dropped costumed characters from *All Star Comics*, *Sensation Comics*, *All-American Comics* and *Star Spangled Comics*. Other publishers followed suit, and it's often assumed that the only super heroes to carry on through these years were Wonder Woman, Batman and Superman (also available in the form of Superboy). The truth isn't quite that simple.

The anthology was still a viable form when a big star headlined, so books like *Action Comics* (with Superman), *Detective Comics* (with Batman) and *Adventure Comics* (with Superboy) continued in defiance of the slump. Backup features ranged from Congo Bill to Roy Raymond, TV Detective, but also included four diehard super heroes whose very longevity made them noteworthy: Johnny Quick, Green Arrow, Aquaman and Robotman. The first three were originated by editor Mort Weisinger; the fourth was an underestimated gem from the author of Superman.

"Mort Weisinger was very, very creative," says his editorial colleague Julius Schwartz. Weisinger was certainly productive, working successfully as a writer of nonfiction and novels in addition to his comic book work. Some people in the business admired him, while others found him overbearing or arbitrary and have questioned his creativity. His characters, while not particularly original, were still well-crafted enough to become minor classics.

Weisinger began to turn out super heroes almost as soon as he showed up at DC, at a time when *More Fun Comics* needed a boost. For issue 71 (September 1941), he delivered Johnny Quick. On the surface, Johnny was not too different from the Flash or other fast-moving characters. He had a red suit, and and he got his power by reciting the secret formula "3X2 (9YZ) 4A." Any kid could try it to see if it worked, but who knew how to pronounce parentheses? Johnny Quick really came alive under the hands of artist Mort Meskin, who conceived an original and effective way to show supersonic speed. Johnny was literally everywhere at once, showing up at several spots in the same panel. The effect was startlingly surreal.

Two issues later, Weisinger gave *More Fun* both Green Arrow and Aquaman, and when that title folded, the pair of them took Johnny Quick with them to *Adventure Comics* #103 (April 1946), where they joined Superboy for an exceptionally solid lineup. "Solid" was the word for Green Arrow, a carefully constructed character whose modus operandi could not disguise the fact that he was based on the blueprint of Batman. An archer in a Robin Hood costume, Oliver Queen never actually punctured anyone with his shafts, relying instead on devices like the "boxing glove arrow," which had a tiny leather fist at its tip and was used for knocking people out. That was novel (if a little nutty), but this hero was also a wealthy playboy with a kid assistant; he drove a car

Mort Meskin's technique for showing Johnny Quick's speed was particularly appropriate, since it suggested the separate images on a strip of movie film, and Johnny in civilian life was newsreel cameraman Johnny Chambers. From *More Fun Comics* #96 (March-April 1944).

called the Arrowmobile, and was summoned to crime scenes by police with the signal of a flaming arrow projected into the night sky. It was all very familiar, but still fun. Aquaman was more like Johnny Quick, in that the gimmick wasn't new but the treatment was. The original underwater character was the Sub-Mariner, from DC's rival Timely Comics, and he was the misanthropic leader of an inhuman race. Aquaman, the human son of a scientist, was trained to live underwater, and seemed to be just a nice fellow whose friends were fish. The denizens of the deep gave him the power to protect his domain (electric eels and octopi were especially handy), and he was promoting ecology years before the term came into common use.

Perhaps the best of the diehards was Jerry Siegel's Robotman, a character who is especially impressive in his anticipation of modern fiction's fascination with cyborgs. The original machine-man of comic books, he was a scientist whose brain ended up inside his own invention after he was mortally injured by criminals. He created a human disguise for himself, and a super intelligent mechanical dog to keep him company. Robotman began in *Star Spangled Comics* #7 (June 1942) and jumped to *Detective Comics* in 1948. Along the way he fell into the hands of artist Jimmy Thompson, whose handsome design and humorous dialogue made this super hero a treasure prized by connoisseurs. Undaunted by his bizarre existence, Robotman exhibited a light touch that seems unrealistic by today's standards, but may explain how he survived when many bigger names were forced into retirement.

For a guy who was basically just a brain in a tin can, Robotman had an awfully good time. This wonderful splash page illustrated by Jimmy Thompson shows his whimsical touch, and showcases Robbie the Robotdog on clarinet. From *Star Spangled Comics* #58 (July 1946).

Aquaman, a hero with a sense of porpoise, makes his first appearance, drawn by Paul Norris. From *More Fun Comics* #73 (November 1941).

DOING THE RIGHT THING
Education and Public Service

The first issue of *Real Fact Comics* (March–April 1946) emphasized the variety of true stories available on the inside. Cover by Dick Sprang.

By its eighteenth issue (January–February 1949), *Real Fact Comics* had begun to rely on action more typical of ordinary comic books. Pencils by Dick Sprang and inks by George Roussos.

Tommy Tomorrow began in *Real Fact Comics* #6 (January–February 1947) as part of an attempt to present scientific predictions, but he later became an adventure hero in *Action Comics*. Virgil Finlay's drawing here only hints at the intricate detail of his more celebrated illustrations for science fiction pulps.

Comic books have always been known for fantasy, but at least one DC editor was happiest when he could remind readers about the real world, and even offer them some advice on how to deal with it. Jack Schiff's most crucial job may have been guiding the career of Batman, but he got his greatest personal satisfaction from less conspicuous credits like *Real Fact Comics*, which first appeared in March–April 1946.

The impulse to educate through the comic book medium owed at least some of its momentum to the experience of World War II, when super heroes were constantly encouraging their fans to buy bonds and conserve rationed items. After victory in 1945, the opportunity to do more good was hard to resist. *Real Fact Comics* argued that truth could be as entertaining as fiction, and attempted to prove it with the work of top artists like Joe Simon and Jack Kirby. The busy covers used spot illustrations

and a lot of text to highlight the stories inside, and a typical issue promised "14 Star Features," all of them "True Stories from the Drama of Life." Biographical items highlighted "The Perilous Story of Clyde Beatty, Daredevil Wild Animal Trainer," and pointed out that "The World's Most Famous War Photographer Was a Girl—Margaret Bourke-White." *Real Fact Comics* explained "What Happens to Men Who Come Back from Battle?" and showed "How G-Men Are Trained."

Although it tried valiantly to become the comic book equivalent of a general-interest magazine for adults, *Real Fact* didn't enjoy real success. Schiff says DC was selling eighty percent of the roughly 250,000 copies printed, which would have been fine at a later time but wasn't much during the postwar boom in comic book sales. Behind-the-scenes stories on DC characters like Batman and Vigilante were introduced; gradually more and more covers featured guys with guns. A noble experiment, *Real Fact Comics* folded in 1949 after twenty-one bimonthly issues.

Jack Schiff enjoyed more success, however, with an even more idealistic experiment. This was a series of single-page public service announcements that he created and wrote for publication in all DC titles. "That was my pet baby," says Schiff, who kept the feature going long enough to influence more than one generation. "I worked with the National Social Welfare Assembly. They came from different organizations, and we used to meet regularly to discuss ideas for what would be a good page that kids would be interested in. How to study, how to do chores around the house, things like that. And we had that page every month in thirty magazines." Schiff worked with a distinguished group headed by Nobel Prize winner Pearl Buck, then used DC's characters to get the message across. Green Arrow encouraged contributions to the Community Chest, Superman offered tips on traffic safety, and western hero Tomahawk recommended classic novels by James Fenimore Cooper.

"I must give our publisher Jack Liebowitz credit," Schiff says. "These pages were requested by schools, and we printed them by the thousands and sent them out. It cost him a fortune." These reprints were part of the policy that caused DC to hire psychologists and educators as consultants, and to employ guidelines concerning violence. It was a conscious attempt to present DC as a good citizen at a time when, as Liebowitz says, "a lot of people came into the field who didn't have any standards at all."

Superboy teaches a lesson in tolerance to the kids of Smallville on this page, which appeared in every DC comic book published in January 1955. The sentiment is certainly worthwhile, but writer Jack Schiff was determined to avoid giving offense, and he evidently didn't choose to mention those groups likely to be the real targets of bigotry. Are pretty blondes from Scandinavian nations commonly crushed by prejudice? The artist for this idealistic offering was Win Mortimer, a native of Canada who became one of DC's most prolific cover artists. While working on the daily Superman newspaper strips between 1949 and 1956, Mortimer delivered his drawings directly to editor Jack Schiff. In the office, he often received an assignment for a single page of work like a cover or one of these public service strips.

ANIMAL ANTICS
All Creatures Take a Fall

If the decline of super heroes in the decade after World War II would ultimately turn out to be temporary, it nevertheless led to a period of rich variety. Comic books covered as many subjects as any other art form, and overall industry sales were at a peak, but it was an odd era for the company that introduced the super hero. "We put out what I now consider strange products," says editor Julius Schwartz. "We put out animation comics. The Three Mouseketeers. The Fox and the Crow."

The parade of funny animals at DC began as early as the summer of 1944, with the first issue of *Funny Stuff*. The Three Mouseketeers were featured, but this was a fairly narrow concept and before long the covers were ceded to The Dodo and the Frog. This pair, a supremely silly pink bird and his irritable friend Fenimore, proved so popular that they eventually took over the book entirely; it became *The Dodo and the Frog* in September 1954. A similar success was achieved simultaneously by the aptly named character who turned the anthology *Funny Folks* into *Nutsy Squirrel*. And in the same month, *Animal Antics* became *The Raccoon Kids*. The mischievous Kids, however, did not wear the gigantic neckties that Nutsy Squirrel and the Dodo invariably sported. DC's critters covered virtually every species, from Rube the Rodent to the pig who was callously called Peter Porkchops.

The most brilliant beasts in DC's menagerie, the pair who eventually achieved a status halfway betweeen cult and classic, were The Fox and the Crow. They were also among the few actually based on animated cartoons. By the time DC became interested in animal antics, many of the best characters, including the products of Walt Disney, Walter Lantz and Warner Bros., had been snapped up by Dell Publishing. When DC's executive editor Whitney Ellsworth turned to Hollywood for ideas, he naturally consulted Columbia Pictures, which was adapting DC's heroes for big-screen serials; however, Columbia's animation department was in disarray, with management being replaced almost every year. In 1941, the production supervisor was Frank Tashlin, a talented veteran of Disney and Warner Bros. who wrote and directed a Columbia cartoon called *The Fox and the Grapes*. A succession of sight gags that helped inspire the later Road Runner films, it inaugurated a Fox and the Crow series in which a fast-talking, cigar-chomping Crow tried to swindle a naive, good-natured Fox. These cartoons became the basis for DC's stories, which began in *Real Screen Comics* in 1945 and continued in *The Fox and the Crow* from 1951 to 1968.

The driving force behind Crawford Crow and Fauntleroy Fox was James F. Davis, a West Coast animator who managed the comic book studio producing the feature and assumed the artwork chores in 1948. His drawings had vigor and personality, and they were matched by ingenious and unpredictable scripts from Hubert Karp or Cecil Beard. There was real if ridiculous suspense in these stories, in which the apparently outwitted Fox would occasionally triumph—sometimes through his innocence, sometimes in a burst of indignation. The variations on a simple theme seemed all but infinite as the series racked up a run of twenty-three hilarious years.

"Some of Superman's best friends are squirrels," reads the text for this 1950 company ad, as the Man of Steel meets Rube Grossman's character Nutsy Squirrel.

DC's first animal title (Summer 1944) pioneered the "Mouseketeer" concept; the characters were revived by Sheldon Mayer in 1956, but without costumes.

DC's top animal stars, including The Fox and the Crow, The Dodo and the Frog, Nutsy Squirrel and the Raccoon Kids, appear together on Otto Feuer's cover for *Comic Cavalcade* #34 (August–September 1949). DC's fifteen-cent big book of beasts began in 1942 as an anthology of super heroes.

The popular spaceship motif sparks Otto Feuer's cover for *Peter Porkchops* #6 (September–October 1950).

IF YOU'RE PLANNING TO GO HOME AND DON ONE OF YOUR MANY *DISGUISES,* YOU'LL BE WASTING YOUR TIME, BECAUSE I HAVE EVERY ISSUE OF "REAL SCREEN COMICS" AND I CAN CHECK ON *ANY* COSTUME YOU EVER OWNED OR USED ON ME.' *HA.'*

WHAT A REVOLTIN' DEVELOPMENT *DIS* IS.' WHAT STARTED OUT TO BE A SIMPLE LITTLE CHISELIN' SORTIE HAS ENDED UP IN *CALAMITY.'* ME VERY EXISTENCE AS A *CHISELER* IS TREATENED.' DAT FOX HAS A *COMPLETE HISTORY* OF EVERY CHISELIN' METHOD I EVER INVENTED.'

I'LL NEVER GIVE UP.' NEVER.' HE CAN'T STOP *ME.'* EVEN THOUGH HE HAS DA SACRED SECRETS OF ME TRADE, I'LL CREATE *NEW ONES.'* AND I'LL DO IT *NOW* TOO.'

RAP RAP

SO...

HEH.' HEH.' DIS I'VE *NEVER* TRIED.' *STILTS.'* NOW ON WIT' DA LONG COAT AN' I'M ALL SET.'

YIII.' A GIANT.' A 15-FOOT GIANT.'

Comics meet metaphysics in this classic tale of The Fox and the Crow. In a desperate attempt to defend himself from Crawford Crow's schemes, Fauntleroy Fox has become a student of his own comic book past. As Crow realizes, his very existence is threatened by Fox's knowledge that their lives are only lines on paper. Ultimately, Crow sucks his adversary back into the compulsory cycle of conflict by pointing out that canceling the game would leave Fox the loser forever. This flight of fancy was written by Hubert Karp for *Real Screen Comics #42* (September 1951). James F. Davis, who drew the characters for twenty years, embellishes this page with a nice little layout gag. The absurd, irregularly shaped panel at the lower right is his vivid way of emphasizing Crow's stilts, and also of sparing the character the indignity of walking through the story doubled over.

52 BIG PAGES

THE ADVENTURES of

BOB HOPE

AUG. SEPT.
NO.10
10c

DOING ANYTHING TONIGHT, HONEY?

JOIN THE LAUGH LEGION WITH HOPE AS HE FLIRTS WITH DANGER AND DAMSELS IN THE ZANIEST STORY THIS SIDE OF THE SAHARA!

Spoofing a movie genre that Hope had touched upon in his 1942 film *The Road to Morocco*, this Owen Fitzgerald cover for August 1951 captures the comedian in a typical situation, distracted from duty by a pretty face.

The visual impact of film on comics has long been recognized, but at DC the content of movies had an effect as well. This influence emerged as early as April 1939 with the first issue of *Movie Comics*. Edited by Sheldon Mayer, this publication attempted to create comics out of the available still photographs from such important features of the time as *Stagecoach* and *Gunga Din*, but the results were awkward and *Movie Comics* folded after six issues. *Feature Films*, a 1950 variation using art instead of photos, lasted only four issues.

What worked better was the idea of turning show biz stars into comic book heroes, using a composite of roles an actor had played to create a viable character. The process had already been employed by other publishers, using the names and likenesses of popular western stars, but DC was a little late getting started and, for example, had to settle for Dale Evans instead of her infinitely more marketable husband, Roy Rogers.

Editor Julius Schwartz still recalls the dismay he felt in 1949 when editorial director Whitney Ellsworth came back from Hollywood with a contract to publish the exploits of Jimmy Wakely. "Who the hell is Jimmy Wakely?" was Schwartz's immediate response, but nonetheless DC published tales of the singing cowboy for three years. DC also signed up the well-known actor Alan Ladd in 1949, but since he appeared in so many kinds of movies he was portrayed simply as an actor, and coming up with believable adventures was a major strain. He came and went in nine issues.

DC finally put show business to work by creating something new: comics about comics. Comedians, that is. Movies, radio and television provided a stream of well-known and well-liked personalities whose exaggerated exploits returned comics to their roots as a source of humor. DC's comic book *The Adventures of Ozzie and Harriet* flopped on its debut in 1949, ahead of its time in being based on the radio show and not on its more successful television incarnation, which ran from 1952 to 1966. Still,

the title provided the format for some of the genre's biggest successes, notably *The Adventures of Bob Hope*.

"We put out some good stuff there," says Jack Schiff, who edited the Bob Hope comic and others of its ilk. "We had a lot of leeway. I mean, we submitted the stuff to them for an okay, but for the most part we were free." Actually, the "Bob Hope" persona, established for years, was perfectly suited for comic book work. A typical Hope film tossed its vaguely lecherous, cowardly and greedy hero into an established Hollywood formula and allowed him to deconstruct it through his failure to live up to the expected heroic standards. His career as an entertainer has lasted so long that it's possible to forget what a brash, anti-establishment presence he originally projected, or that in the years before television he was the most popular comedian in radio and films.

Hope appeared in horror movies (*The Ghost Breakers*, 1940), swashbucklers (*The Princess and the Pirate*, 1944) and westerns (*The Paleface*, 1948); his comic book incarnation followed a similar pattern, giving him improbable jobs ranging from explorer to bullfighter and using an entire issue to tell one story, which was unusual at the time but helped create the effect of a feature film. The comic book was a solid seller from its first appearance (February–March 1950) to its last exactly eighteen years later.

DC's work with Hope aided access to the next comedy sensation from Paramount Pictures, leading in July-August 1952 to *The Adventures of Dean Martin and Jerry Lewis*. A sudden and spectacular success, especially with kids, the team consisted of a suave straight man and a frantic comedian. DC had the formula down pat by now, and was able to drop the pair into wild stories where they might be shown, for instance, as two explorers or two bullfighters. The duo eventually dissolved, but *The Adventures of Jerry Lewis* soldiered on from 1957 to 1971.

If Bob Hope and Jerry Lewis were the champions in this field, DC produced many other comedian comics with shorter life spans, often the same length as the first run of the entertainer's television show. Examples include *Jackie Gleason* (1956–58), *Sgt. Bilko* (1957–60), and *The Many Loves of Dobie Gillis* (1960–64). In fact, the approach was still valid for the 1976 *Welcome Back, Kotter* comic book, but in recent years has been most successful when applied to less humorous TV fare like *Star Trek*, which first became a DC comic in 1984.

The debut of a classic sitcom family that didn't quite come across in comic book form (October–November 1949).

Al with gal and gun in a photo cover from the second issue of his short run (December 1949–January 1950).

Human sacrifice looms for the comedy team of Martin and Lewis on Bob Oksner's cover for January 1954. When the duo divorced, Lewis got the comic book.

The sixth and last issue of *Movie Comics* (September 1939) had the best cover, with an image from a serial starring Bela Lugosi and a very strange-looking robot.

Go West
Cowboys Conquer Comic Books

Nighthawk drawn by Gil Kane.

If DC didn't quite catch the brass ring when it came to signing up movie stars for its western comics, the company did create enough of its own characters to make a substantial showing during the cowboy craze of the late 1940s and early 1950s. In fact, sagebrush and six-guns had been part of DC history ever since 1935, when the first story in *New Fun Comics* #1 concerned the exploits of westerner Jack Woods. The big stampede began when DC inaugurated a specialty anthology, *Western Comics*, in January 1948. The designated star and perennial cover boy was the red-shirted Wyoming Kid; he got some competition from his more glamorous colleague the Nighthawk, whose mask and color-coordinated costume, complete with a bird emblazoned on the chest, made him look something like a super hero.

As cowboys caught on, DC developed what Irwin Donenfeld calls "a whole slew of them." The son of publisher Harry Donenfeld, he came into the company in 1948 and took charge of determining what would sell when the super heroes experienced a slump. "I worked with the distributing company. We had road men all around the country, and local men who spent their time in one town. And they would report to me what other, competitive magazines were doing." DC, once the prime mover in the business, would be obliged to keep an eye on other publishers until the pendulum swung back and super heroes returned to favor.

"We were looking for magazines that would sell in the three, four, or five hundred thousand range," says Donenfeld. The company's top sellers were *Superman* and *Batman*, still hovering at under a million copies per issue. Yet most other super heroes lacked staying power, so cowboys turned the faltering *All-American Comics* into *All-American Western* in November 1948. In April 1951, *All Star Comics* became *All Star Western*; the invulnerable Justice Society of America unceremoniously vanished and was replaced by a bunch of unfamiliar gunslingers.

All-American Western continued the adventures of a cowpoke called Johnny Thunder, who had made his debut just before the title went western. Oddly enough, the character took the name of the spoof super hero who had inspired the Justice Society. The new Johnny Thunder was a "fighting plainsman" who moonlighted as a gunfighter but earned his living as a schoolteacher. He was one of the few comic book heroes who disguised himself with hair dye, switching from light to dark when he went into action. Written by Robert Kanigher and drawn by Alex Toth, Johnny Thunder later moved into *All Star Western*, where the cover characters were a pair of identical mavericks known as the Trigger Twins.

The most original of DC's frontiersmen was Tomahawk. The character made his debut in 1947 in *Star Spangled Comics*; his own comic book, *Tomahawk*, got its start in September-October 1950 and lasted for an impressive twenty-two years. Jack Schiff, who edited the feature, credits its success to artist Fred Ray. "He was just magnificent," Schiff says. *Tomahawk* was set a century earlier than most westerns, during the colonial days around the time of the American Revolution. Hero Tom Hawk and his teenage companion Dan Hunter wore coonskin caps, and an ad described them as "Batman and Robin in buckskin." Their adventures anticipated the success that Walt Disney achieved with his 1955 televison shows about coonskin character Davy Crockett, and demonstrated that DC's best work inevitably came from functioning not as a follower, but as a pioneer.

This comic book with its unusual historical setting succeeded on the strength of sheer craftsmanship. Much of the credit goes to artist Fred Ray, whose cover adorned this first issue.

An odd but interesting pair, the Trigger Twins were the stars of *All Star Western*, and of this bold cover for issue #73 (August-September 1953) by Carmine Infantino.

Ordinarily set in the modern west, Pow-Wow Smith's adventures could encompass this fish-out-of-water story about a city subway, drawn by Bruno Premiani for *Detective Comics* #169 (March 1951).

CARELESS OF HIS OWN SAFETY, THE BATTLING OLD SHERIFF ACTS...

YOU'RE NOT GOIN' TO USE ME TO AMBUSH JOHNNY!

YUH'LL HAVE NOTHIN' TO SAY ABOUT IT, SHERIFF! HA HA HA!

THE FOLLOWING DAWN, A LONE RIDER PAUSES IN FRONT OF THE MESA CITY JAIL BULLETIN BOARD... THEN GALLOPS AWAY...

AS THE SUN RISES, A SHOCKED CITIZENRY STARES AT AN UNMISTAKABLE MESSAGE...

SHERIFF TANE'S BADGE!

ARROYO MUST'VE KILLED 'IM!

HE COULDN'T HAVE GOTTEN THE BADGE OTHERWISE!

WANTED DEAD OR ALIVE

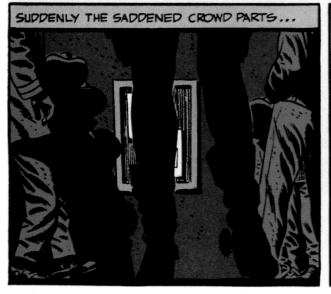

SUDDENLY THE SADDENED CROWD PARTS...

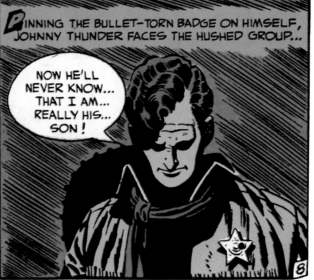

PINNING THE BULLET-TORN BADGE ON HIMSELF, JOHNNY THUNDER FACES THE HUSHED GROUP...

NOW HE'LL NEVER KNOW... THAT I AM... REALLY HIS... SON!

When editor Julius Schwartz was assigned to work on westerns, he gave the character Johnny Thunder to Alex Toth, whom he considered "my best artist at the time." Toth's work did not have the flashy surface that might have made him a big favorite with the fans, but his sense of layout and design have earned him much admiration within the industry. Robert Kanigher's script tells the archetypal tale of a hero who must avenge his father's murder, but Toth's interpretation makes it fresh. He uses a stock grid of six panels, but chooses unusual angles and selects subjects that are far from the norm. The use of hooves and feet to herald the hero's arrival is a remarkable touch, building suspense until the final panel when his face is finally seen. Toth creates mood and structure through his placement of black areas, known in the trade as "spotting." From *All-American Western* #121 (August–September 1951).

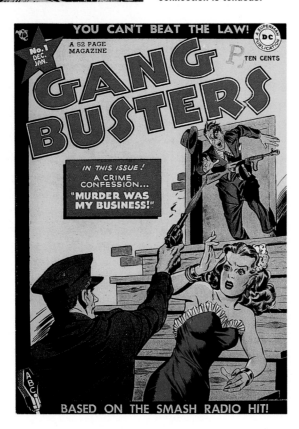

SWEET MYSTERY OF LIFE
Keeping Crime and Horror Quiet

In the nineteenth century, writers like Edgar Allan Poe used the term *mystery* to describe both detective stories and tales of terror; a hundred years later, DC treated both its crime and horror comics as mysteries, emphasizing puzzles and intellectual enigmas while understating the lurid aspects that seemed to fascinate some other publishers.

Curt Swan, an artist who would later become one of the finest interpreters of Superman, enjoyed his early work on the DC crime comics because the subject matter was close to the realistic illustration he originally intended to pursue. He was careful not to become too realistic, however. "If the writer went off the edge a little bit, I wouldn't illustrate it," says Swan. "I wouldn't show any physical damage to a person. Maybe I would show a silhouette or something like that." Such discretion was typical at DC, perhaps because the editor of mystery titles was the least likely suspect: Jack Schiff. Proud of DC's public service strips, Schiff wasn't the type to indulge in exploitation, but he was experienced enough to handle mystery professionally. "We had some of that in the pulps," he says. Schiff worked mostly with the writers (George Kashdan was copy editor), while art director Murray Boltinoff supervised the drawing, but Schiff says "we worked closely together. We had a very tight little group there."

Wanda wasn't really a werewolf, but she got the cover of *House of Mystery* #1 (December 1951), DC's tentative stab at horror. A radio show of the same name had run from 1945 to 1949, but the connection is tenuous.

A little old-fashioned sex and violence kicked off the first issue of *Gang Busters* (December 1948). Cover by Howard Sherman.

The best *Mr. District Attorney* covers, like this one by Win Mortimer for the third issue (May–June 1948), relied more on symbolism than illustration.

Frank Frazetta, whose later paintings made him one of America's most successful illustrators, drew this equine splash panel for *Gangbusters* #14 (February–March 1950).

The craze for crime comics got its start with the first issue of *Crime Does Not Pay*, published by DC's competitor Lev Gleason in June 1942. Based on true or purportedly true stories and featuring lots of blood and bullets, this book really took off in the postwar era and acquired numerous imitators, not to mention critics who felt such material was corrupting the nation's youth.

DC took a different tack; its three crime comic books were based on popular radio programs. On the air from 1936 to 1957, the *Gang Busters* show was the brain child of powerhouse producer Phillips H. Lord, who served as host until he was replaced by Colonel H. Norman Schwarzkopf (years later, Schwarzkopf's son would lead American troops in Operation Desert Storm). The FBI lent its official support, and descriptions of wanted criminals were broadcast. DC's version (December 1947) was more modest but still outlasted the radio show by a year. DC's other adaptations were *Mr. District Attorney* (January 1948) and *Big Town* (January 1950). The latter show had featured actor Edward G. Robinson as a crusading

newsman, but he left before the DC version, which didn't use his likeness.

The most notorious horror comic book of the era was *Tales from the Crypt*, published by EC Comics. The head of this firm was William Gaines, son of the M. C. Gaines who had founded All American Comics with Jack Liebowitz. Widely imitated, in its day the savage and sardonic *Tales from the Crypt* was extremely controversial, and along with *Crime Does Not Pay* clones inspired an outcry against comics that nearly crippled the industry. DC had only one horror comic during the height of the craze, and it was extremely restrained. In fact, *House of Mystery* looked a little bland when it appeared in December 1951, but as a result it outlasted attacks on the genre and during its amazing thirty-two year run would become a showcase for artists with atmospheric tales to tell. DC horror was so far above criticism that a second title, *House of Secrets*, was launched in 1956 after such material had been virtually banned from newsstands. By handling horror with care, DC would help keep the genre alive.

Half host and half hero, the Phantom Stranger oozed in and out of six issues starting with August–September 1952. He returned from beyond seventeen years later. Cover by Carmine Infantino.

The first issue of *Mystery in Space* (April–May 1951) featured a cover with ingredients that wouldn't have been out of place on an old pulp magazine: rockets, rays and a beautiful woman who apparently could hold her breath for a long, long time. Pencils by Carmine Infantino and inks by Frank Giacoia.

Science fiction, as a gimmick permitting many super heroes to perform their mighty deeds, was one of the cornerstones of comic books, but it had also existed as a separate genre since the medium's inception. DC's earliest anthology titles had included such short-lived science fiction series as "Don Drake on the Planet Saro" and "Astra, Girl of the Future," but the first futuristic hero to enjoy

something approaching solid success was Tommy Tomorrow. His adventures ran alongside Superman's in *Action Comics* from 1948 to 1959, but oddly enough he originally appeared in *Real Fact Comics* in 1947. Tommy turned up in that improbable venue because he was originally designed by creators Jack Schiff and Mort Weisinger to provide sober predictions about scientific advancements, but he was soon transformed into a member of that elite twenty-first-century corps, the Planeteers.

The heyday of science fiction in comic books was the 1950s, after the discovery of atomic energy had made anything seem possible, and before the reality of space exploration had lowered expectations about amusing aliens lurking behind every asteroid. During this peak period and beyond, the future at DC was in the capable hands of editor Julius Schwartz, whose professional activity in the genre dated back to his days as a literary agent. "I love science fiction," says Schwartz. "And I had a number of science fiction people writing for me, including Manly Wade Wellman, Otto Binder and Edmond Hamilton." Always actively involved in plotting, Schwartz specialized in coming up with little-known scientific facts that characters could use to extricate themselves from exotic dilemmas. "I always had happy endings," he says.

Schwartz' first title in the genre, *Strange Adventures*, began with the August-September 1950 issue, a show-biz tie-in promoting the movie *Destination Moon*. The eighth issue of *Strange Adventures* achieved some sort of classic status. The cover showed a gorilla in a zoo holding up a slate that read, "Please believe me! I am the victim of a terrible scientific experiment!" This "Incredible Story of an Ape with a Human Brain" had strong sales, and Schwartz recalls that "Irwin Donenfeld called me in and said we should try it again. Finally all the editors wanted to use gorilla covers, and he said no more than one a month."

By this time, Irwin Donenfeld had become a major force in the business. "I didn't have a title," he says. "It was family. I worked part time as editor in chief, head of the entire comic book division, and I also worked with the distribution. We used to have editorial meetings every month or so. We'd kick ideas around. Somebody would say something, somebody would embellish it, and I'm the guy who said 'Let's go!'" Donenfeld's growing role might have brought him into conflict with longtime executive editor Whitney Ellsworth, but

Adam Strange became DC's biggest space star.

alien transported to Earth by an aged scientist who inconveniently died and left him stuck, he took the secret identity of John Jones and became a police detective who used his Martian powers to fight crime. In short, he was suspiciously similar to a certain visitor from Krypton, and he was a hit. "We used to get a lot of mail on that," says Martian Manhunter's editor Jack Schiff, and the character helped pave the way for a new generation of super heroes that was waiting in the wings.

Ellsworth was on his way to Hollywood to supervise an important new TV project. Still, he had time to propose a new title to Julius Schwartz. "I said you'll be hard pressed to come up with one," Schwartz recalls, "because in those days there were thirty or forty science fiction pulps and there were no titles left." Ellsworth's suggestion was the wonderfully evocative *Mystery in Space*, which on its debut in 1951 became DC's major genre offering, a showcase for imaginative short stories and eventually, perhaps inevitably, a springboard for several memorable characters. It was in DC's nature to look for a hero who could become a franchise.

The recurring features in *Mystery in Space* ranged from the workaday world of "Space Cabby," written by Otto Binder and illustrated by Gil Kane, to the epic adventures of "Adam Strange," written by Gardner Fox and drawn during its most impressive incarnation by Carmine Infantino, with elegant inking by Murphy Anderson. The series depicted an ordinary Earth man caught in an interstellar ray that regularly transported him to a planet called Rann in the system of Alpha Centauri; there he found love and a series of outrageous menaces to overcome. Although he appeared late in the science fiction cycle, not making his first appearance until 1958, Adam Strange became DC's most memorable spaceman.

Still, perhaps the most significant science fiction hero of the era didn't appear in the sf comic books at all. He was J'onn J'onzz, Manhunter from Mars, and he arrived in *Detective Comics* #225 (November 1955). An

Win Mortimer's famous cover for May 1951 started an onslaught of similar simians who acted like human beings.

John Broome wrote the Captain Comet stories, which became the lead feature of *Strange Adventures* starting with this June 1951 issue. Cover by Carmine Infantino and Frank Giacoia.

Stranded on earth by "The Strange Experiment of Dr. Erdel," the Martian Manhunter became DC's first new super hero in years. Script by Mort Weisinger and art by Joe Certa.

BACK TO THE BATTLEFIELD
Comics Tell More Soldiers' Stories

Star Spangled Comics turned to war in August 1952. Pencils by Curt Swan and inks by Stan Kaye.

Sgt. Rock, America's most famous comic book soldier, first appeared in a story written by Bob Haney, but really took off when writer-editor Robert Kanigher took charge of the character. Art by Joe Kubert.

I would like to say that I was the innovator of war comics, but I wasn't," admits Irwin Donenfeld, DC's editor in chief in 1952. "Somebody put out a war magazine and it sold fairly well. And I'm looking for stuff to put out, so I said let's try a war book, and we did." In fact, DC jumped into the genre feet first, creating three titles simultaneously (August 1952) to capitalize on a growing market that owed its existence to the ongoing Korean War. *Our Army at War* was brand new, while *Star Spangled War Stories* was a revamp of the moribund super hero anthology *Star Spangled Comics*. *All-American Men of War* had recently been *All-American Western*, itself an adaptation of the old *All-American Comics*. These sudden changes might suggest unseemly haste, but in fact DC's war comics proved to be the most solid ever seen, and additional offerings were soon added, like *Our Fighting Forces* and *G.I. Combat*. Competitors treated the genre as a fad and dropped it in a few years, but DC was still publishing its war stories decades after their debut.

The man chosen to marshal DC's forces for its assault on the comic book battlefield was Robert Kanigher. A controversial character whose confrontational style disturbed some of his colleagues, Kanigher seemed perfectly suited to his subject, and in addition to editing he was also his own chief writer. For the first few years he concentrated on stories without recurring heroes, but inevitably things changed, and Kanigher began turning soldiers into stars just about the time that an artist arrived who was ideally suited for drawing them. Joe Kubert, who had worked for DC as a teenager, served in the army during the early 1950s, then returned to the industry with a scheme to produce comics

in 3-D. Together with colleagues Norman and Lenny Maurer, Kubert briefly turned comics inside out with this approach (Superman and Batman both appeared in 3-D), but it proved to be simply a spasm. Then Kubert entered into his important collaboration with Kanigher. "He has been a terrific pro all the time that I've known him," Kubert says. "He was able to evoke images in my mind through his writing that were so graphic to me that I couldn't help but draw the stuff better."

The most famous Kanigher-Kubert collaboration involved Sgt. Rock, who has gone on to become a part of our collective mythology as the archetype of the gruff, cynical, good-hearted noncommissioned officer that we like to believe represents the best in America. Writer Bob Haney originally created Rock for a story in *Our Army At War* #81 (April 1959). "It was certainly the prototype," says Haney. "And then Kanigher began doing longer stories, running with the ball, so to speak."

Kubert's bold, gritty, angular style helped define Sgt. Rock, and the same thing happened with a less likely hero that Kanigher called Enemy Ace. A German fighter pilot from World War I, Hans von Hammer first appeared in *Our Army at War* #151 and took discerning readers by storm. "The character was so provocative that it pushed me into doing a hell of a lot of research," says Kubert. "Here was a guy that was not all good or not all bad, but a mix of these things who lived by some sort of code." The Enemy Ace stories, with their anguish and irony, were only one example of the varied series on display in the war books; their sophistication anticipated the time when DC's combat comics would carry the slogan "Make War No More."

Russ Heath, an outstanding war artist, drew this detailed panel for a *G.I. Combat* series about "The Haunted Tank," whose crew was aided by the ghost of a Civil War general.

AS I WATCHED THE SMOKING TRAIL OF THE ENEMY SHIP SCREAMING TOWARD THE NO-MAN'S LAND OF CERISY 1000 METERS BELOW... LIKE THE BONY FINGER OF DEATH SCRATCHING MY 50th VICTORY IN THE SKY...

ONCE THE FRENCH-MAN ALLOWED ME TO GET INTO POSITION ABOVE AND BEYOND HIM--HE WAS KAPUT! JUST AS CERTAINLY AS IF HE HAD PUT HIS NECK UNDER THE EXECUTIONER'S AXE! FOR I HAVE BEEN TRAINED TO KILL!

Joe Kubert's spectacular, full-page shot of a World War I dogfight was a highlight of writer Robert Kanigher's first story about Enemy Ace. Given to observations like "The sky is a friend to no one," the German fighter pilot was an unusual hero whose philosophy occupied a territory halfway between existentialism and nihilism. His only friends seemed to be a wolf from the Black Forest and his red Fokker triplane. Kubert's careful attention to the details of military hardware impressed many readers, but ultimately it was the portrayal of Rittmeister von Hammer that won them over. "I think the character had a lot more depth and a lot more breadth than many others," Kubert says, "and that was interesting and stimulating to me." From *Our Army at War #151* (February 1965).

WHAT'S LOVE GOT TO DO WITH IT?
Romance Comics on a Roll

The first love comic book ever published was Joe Simon and Jack Kirby's *Young Romance* for Prize Comics (September–October 1947).

The first romance comic book from DC, like so many others, featured a photo cover. After all, this was not supposed to be fantasy.

The first issue of *A Date with Judy* (October–November 1947), which used love for laughs. Cover by George Storm.

The romance comics craze caught on rather slowly at DC, but the company characteristically stayed in the game years longer than its competitors. In truth, however, it was those competitors who got DC started. The first entry in the field, *Young Romance*, was created for Prize Comics in 1947 by DC alumni Joe Simon and Jack Kirby. It proved to be a big success with female readers, sold close to a million copies a month and inspired a rash of imitators. Before *Young Romance*, love stories had ordinarily appeared only in humorous comic books like DC's *A Date with Judy*. A radio show since 1941, *A Date with Judy* was a minor phenomenon that became a comic book in 1947, a movie in 1948 and a TV program in 1951. "That was a very big title," says Irwin Donenfeld, and it led to a line of DC "teenage" comic books including *Leave It to Binky* and *Here's Howie*.

Next DC tested the waters with a western-romance hybrid called *Romance Trail* (July 1949). Julius Schwartz was assigned to edit the book, although he wasn't very interested in either of the genres. Like similar two-headed monsters inexplicably released by several publishers, *Romance Trail* rapidly headed for the last roundup.

When DC finally attempted a full-fledged love title, editor in chief Irwin Donenfeld made the unprecedented decision to hire a woman as editor. "The romance magazines really appealed to young girls," he says, "so I felt a woman would have a better handle on what a young girl would like, better than a guy like Bob Kanigher, who was doing the war books." Actually, Kanigher would eventually become editor of the love line for a while, but that event was many years after Donenfeld appointed Zena Brody as editor and launched *Girls' Love Stories* (August-September 1949). Other women who would rule the romance roost included Ruth Brandt, Phyllis Reed and Dorothy Woolfolk (who had worked at All American Comics as Dorothy Roubicheck before marrying prolific comics writer William Woolfolk). They helped open doors for the

This definitive 1950s romance page appeared in a story called "No Happy Returns" from *Girls' Love Stories* (July–August 1953). Pencilled by Arthur Peddy and inked by Bernard Sachs, the page is a catalog of the hand-to-face gestures with which a heroine like Susan demonstrates degrees of despair. Meanwhile, the dark-haired seductress Carla makes all the right moves, clinging to Phillip's arm when she isn't striking a hot hussy pose in the background. At first Phillip is shown finding Susan's annoying, goofball antics to be "crazy—and adorable!" She finally drives him away, however, and in the real world the last panel shown here would be the finish. Of course in the comic book there's a happy ending for her: Phil just can't stay away. "It's you I'll always love, Susan, in spite of your funny little ways—or maybe because of them!"

many women who occupy important positions in the business today, long after love comics have become only a memory.

Following *Girls' Love Stories*, DC unleashed *Secret Hearts*, *Girls' Romances* and *Falling in Love*. In 1955 it picked up *Heart Throbs* from a collapsing Quality Comics, and in 1963 DC acquired the original title in the field, *Young Romance*. As if that wasn't enough, its creator Joe Simon ended up as its editor when he returned to DC in the 1970s. In fact, DC was still publishing romance comics thirty years after their inception, but the genre was on its way out.

If love didn't last quite forever, it may have been because comic books, still thinking of themselves as essentially juvenile fare, couldn't compete with the increasingly racy TV soap operas. "They certainly weren't sexy in any sense of the word," says Irwin Donenfeld. The sexual revolution, joining hands with women's liberation, drove a stake into the broken heart of the empty-headed girl who cried into her pillow because Mr. Right had done her wrong. Now everyone laughs at love comics, but for some strange reason everyone remembers them as well.

"I Found My Love at the Woodstock Festival" was actually the title of this story, created during the era that made nostalgia out of romance comics. From *Falling in Love* #118 (October 1970). Pencils by Werner Roth and inks by Murphy Anderson.

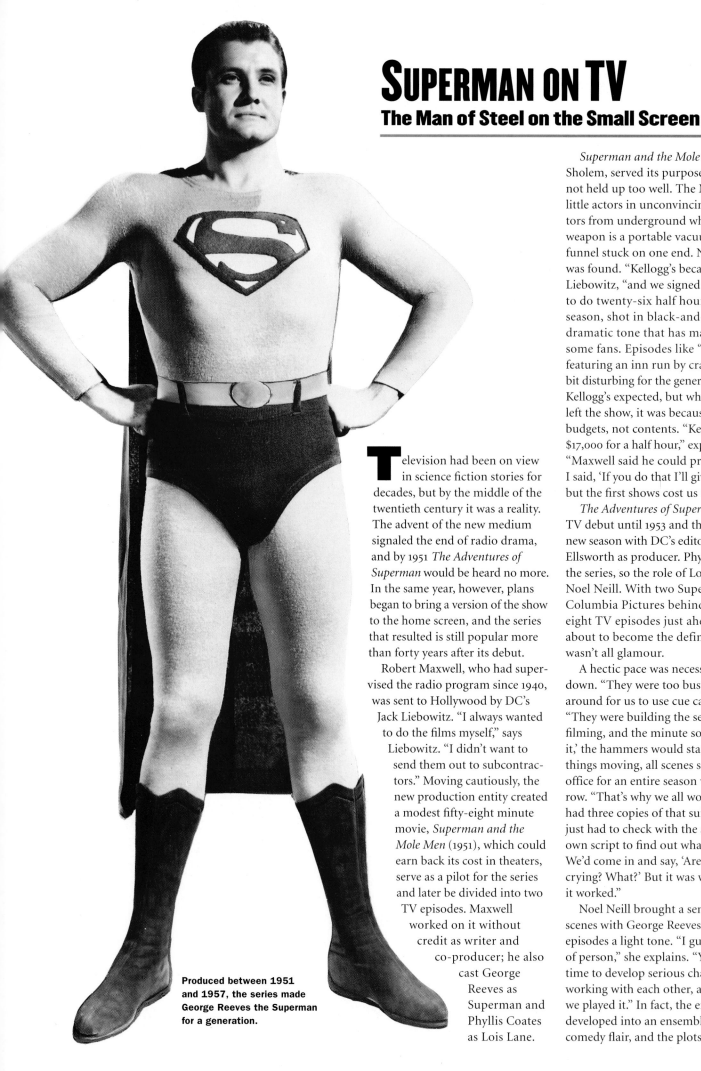

SUPERMAN ON TV
The Man of Steel on the Small Screen

Television had been on view in science fiction stories for decades, but by the middle of the twentieth century it was a reality. The advent of the new medium signaled the end of radio drama, and by 1951 *The Adventures of Superman* would be heard no more. In the same year, however, plans began to bring a version of the show to the home screen, and the series that resulted is still popular more than forty years after its debut.

Robert Maxwell, who had supervised the radio program since 1940, was sent to Hollywood by DC's Jack Liebowitz. "I always wanted to do the films myself," says Liebowitz. "I didn't want to send them out to subcontractors." Moving cautiously, the new production entity created a modest fifty-eight minute movie, *Superman and the Mole Men* (1951), which could earn back its cost in theaters, serve as a pilot for the series and later be divided into two TV episodes. Maxwell worked on it without credit as writer and co-producer; he also cast George Reeves as Superman and Phyllis Coates as Lois Lane.

Produced between 1951 and 1957, the series made George Reeves the Superman for a generation.

Superman and the Mole Men, directed by Lee Sholem, served its purpose at the time but has not held up too well. The Mole Men, played by little actors in unconvincing bald caps, are visitors from underground whose mysterious weapon is a portable vacuum cleaner with a funnel stuck on one end. Nonetheless a sponsor was found. "Kellogg's became interested," says Liebowitz, "and we signed a contract with them to do twenty-six half hour shows." This first season, shot in black-and-white, had a dark, dramatic tone that has made it a favorite of some fans. Episodes like "The Evil Three," featuring an inn run by crazed killers, were a bit disturbing for the generally juvenile audience Kellogg's expected, but when producer Maxwell left the show, it was because of problems with budgets, not contents. "Kellogg's was paying us $17,000 for a half hour," explains Jack Liebowitz. "Maxwell said he could produce it for $13,000. I said, 'If you do that I'll give you the difference,' but the first shows cost us $28,000 each."

The Adventures of Superman did not make its TV debut until 1953 and then began filming a new season with DC's editorial director Whitney Ellsworth as producer. Phyllis Coates had left the series, so the role of Lois Lane was taken by Noel Neill. With two Superman serials from Columbia Pictures behind her, and seventy-eight TV episodes just ahead, Noel Neill was about to become the definitive Lois Lane. It wasn't all glamour.

A hectic pace was necessary to keep costs down. "They were too busy moving things around for us to use cue cards," says Neill. "They were building the sets while we were filming, and the minute somebody said 'Print it,' the hammers would start up again." To keep things moving, all scenes set in the newspaper office for an entire season would be filmed in a row. "That's why we all wore the same outfit. I had three copies of that suit," says Neill. "You just had to check with the script girl or your own script to find out what had just happened. We'd come in and say, 'Are we happy? Are we crying? What?' But it was well thought out and it worked."

Noel Neill brought a sense of mischief to scenes with George Reeves that gave her episodes a light tone. "I guess I'm just that kind of person," she explains. "You really didn't have time to develop serious characters. We enjoyed working with each other, and that was the way we played it." In fact, the entire cast of regulars developed into an ensemble with a distinct comedy flair, and the plots were perhaps less

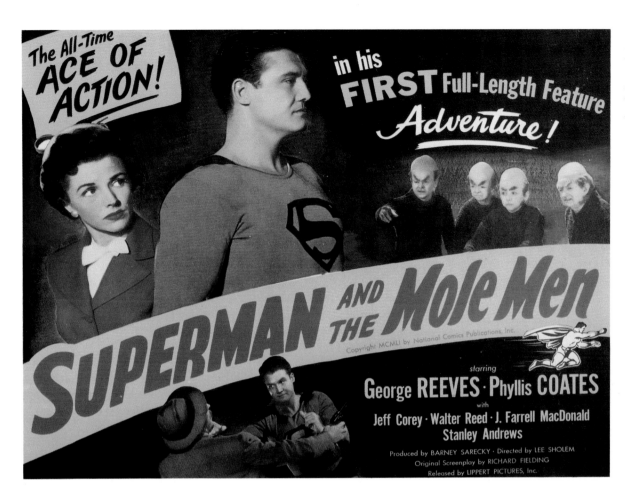

The All-Time **ACE OF ACTION!**

in his **FIRST** Full-Length Feature *Adventure!*

SUPERMAN AND THE **Mole Men**

Copyright MCMLI by National Comics Publications, Inc.

starring
George REEVES · Phyllis COATES
with
Jeff Corey · Walter Reed · J. Farrell MacDonald
Stanley Andrews

Produced by BARNEY SARECKY · Directed by LEE SHOLEM
Original Screenplay by RICHARD FIELDING
Released by LIPPERT PICTURES, Inc.

Copr. 1952, Nat'l Comics Pub., Inc.

SUPERMAN

NOW ON TV!

THRILLING-
ACTION-PACKED
ADVENTURES

important than the interaction of personalities: Jack Larson as the eager young reporter Jimmy Olsen, John Hamilton as the gruff but lovable editor Perry White, and Robert Shayne as the dignified if baffled Inspector Henderson.

Perhaps the most common story line in the show concerned eccentric scientists whose strange inventions fell into criminal hands. In "The Machine That Could Plot Crimes," written by Jackson Gillis, the device was an oversize prototype of the modern computer. Gillis also showed prescience with "Superman in Exile," in which the hero prevented a nuclear meltdown and became temporarily radioactive. Ingenuity superseded special effects in Peter Dixon's script for "Jungle Devil," when Superman replaced a missing jewel by compressing a piece of coal until it became a diamond; this mixture of science and instant gratification riveted many a kid. The director of all these episodes, the most prolific on the series, was Thomas Carr.

Jack Liebowitz and Whitney Ellsworth had the foresight to film the last fifty-two episodes in color, which may partly account for the show's enduring popularity, but clever scripts, a personable cast and an unforgettable hero help too. Along with *I Love Lucy* and *The Honeymooners* (the only shows of comparable vintage still regularly shown), *The Adventures of Superman* is a television classic.

S-39

THE MAN WHO WAS SUPERMAN
The Legend of George Reeves

Hollywood actors are frequently identified with their roles and are commonly villified by unfounded rumors. George Reeves was a case in point. He played Superman in 104 half-hour television episodes that have been constantly on display for more than four decades, thus imposing his image on the role almost indelibly. He also played it very well, exhibiting a casual charm and mature self-assuredness that leave many other portrayers of super heroes looking like Superboy. Embodying the mild-mannered Clark Kent is the easy part of the job, but some actors are apologetic about portraying his better half. It's no small trick to make Superman's invulnerable decency seem convincing without turning him into either a block of wood or an arrogant bore. It's also tough to wear tights and not look self-conscious, but George Reeves pulled it off.

He was born George Brewer and like many actors has several reported birthdates; the earliest (and perhaps most probable) is 1914. Once an aspiring boxer, he studied acting while holding a day job, and gradually worked his way into the movies. He played small roles in Hollywood classics like *Gone With the Wind* (1939) and *From Here to Eternity* (1953), and had substantial screen time in lesser attractions like the Charlie Chan mystery *Dead Men Tell* (1941). His most impressive appearance came in *So Proudly We Hail* (1943), in which he played a wounded soldier opposite Claudette Colbert, shortly before he joined the army himself. He felt that his career never recovered from that interruption, and was doing minor movies when he took the role of Superman. Television was not considered especially prestigious in 1951, and Reeves was discouraged because he believed that his work would only be seen by children. He certainly never envisioned becoming virtually immortal.

His colleagues remember Reeves as an affable actor who breezed through his role with the help of a photographic memory, and made work a pleasant experience. "He had a good sense of humor, but he was a serious actor and a good actor, otherwise it would have been a total farce," says the perennial Lois Lane, Noel Neill. "He helped me through the first rough days" (when Neill replaced Phyllis Coates after the first season). "The director was tough on me and George finally took him aside. I appreciated that very much." Reeves also came to the defense of Robert Shayne, who played the recurring role of Inspector Henderson. An active union man, Shayne was accused of being some sort of radical during the Hollywood witch hunt of the 1950s, and might have lost his job if George Reeves and producer Whitney Ellsworth had not stood up for him. During a difficult time, this made TV's Superman a real-life hero.

By all accounts, however, Reeves was not as saintly as Superman in other respects. He enjoyed a drink and the company of women, and it was widely known in the business that one of his lady friends was the wife of a prominent studio executive. He occasionally lost his temper on the set, notably when an attempt to "fly" him with wires ended in a potentially dangerous fall. Still, everyone who knew him was shocked when he was found dead of a gunshot wound on June 16, 1959.

Ridiculous rumors began to circulate immediately after the actor's death. One of the most common stated that Reeves had lost his mind and jumped from a skyscraper wearing his costume, suffering from the delusion that he could fly. Even those who rejected such melodrama were inclined to believe that Reeves had shot himself because he could not find work after the end of the Superman

Reeves, George LExington 2-1100
S. S. No. 545-24-8600 TELEPHONE EXCHANGE

Leads, Character, Straight, Comedy, Heavy, Announcer, Commentator, Director, Narrator.

DIALECTS: Brooklyn, Midwestern, Western, Southern, Rural, Mexican, Hillbilly, Tough, English, Cockney, Irish, Scotch, Continental, French, German, Hungarian, Italian, Spanish, Russian, Japanese.

RADIO: Lux Radio (Coast), Stars Of Tomorrow (Coast). Helped run KWKW (Coast). On Broadway: The Clock.

STAGE: Broadway: Dr. Carrol in Yellow Jack; Lt. Thompson in Winged Victory. Ran Newport Playhouse (Coast). Stock.

SCREEN: Lead Opposite Claudette Colbert in "So Proudly We Hail"; Lead opposite Merle Oberon in "Lydia." (Leads in some 30 others).

Height	6'1"
Weight	190
Hair	Brown
Eyes	Hazel
Voice Range	25-45

9/49

Seen here with Vivien Leigh as Scarlett O'Hara, Fred Crane and George Reeves played the Tarleton twins in the Hollywood classic *Gone With the Wind* (1939).

series. In truth, however, he had recently become engaged and was about to begin a new season of Superman shows. "He had directed three episodes and was going to do more" says Noel Neill. "We were going to start in September. I saw him two or three days before. He seemed fine. He was playing gin rummy. Who knows? Nobody knows."

The official coroner's report listed the death as a suicide, but this verdict was controversial. Whitney Ellsworth accepted it, but Robert Shayne never did. Jack Larson, who played Jimmy Olsen in the series, reports visiting the scene and seeing several bullet holes in the wall. This would seem to be an argument against suicide, yet in at least one interview Larson seemed tempted to accept the verdict. "Jack and I have avoided comment because it's just specu-

Launched by a springboard concealed below camera range, George Reeves leaped through many a window. What audiences didn't see was the mattress lying on the other side of the set to break the actor's fall.

George Reeves and Noel Neill as Clark and Lois on the set of the television episode "Panic in the Sky," a popular favorite because of its extensive special effects.

lation," says Noel Neill. "We really don't know. It doesn't seem right that he would do it." The actor's mother, convinced there was foul play afoot, hired a private detective and a lawyer but was unable to find a killer. Nonetheless, some of Reeves' friends believe that his philandering may have caught up with him on the eve of his impending wedding. The one sure thing is that he had not been driven to despair by the end of his work as Superman, a role he seemed born to play. "He would lift his glasses a little bit and look into the camera and wink," recalls Noel Neill. "He was our hero."

George Reeves poses with a pair of fans; the one who's not with the program is dressed as Davy Crockett. Actually, it was awkward for Reeves to mingle with kids, since they often tried to test his invulnerability by assaulting him.

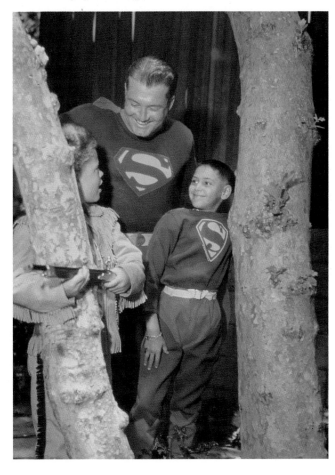

TOYS OF THE 1950s
TV Creates a Super Salesman

This pocket watch was produced in 1959.

The popularity of the syndicated *Adventures of Superman* created a market of millions of kids who were eager to get more Superman in their lives. Of course the television show didn't hurt comic book sales, but it also inspired countless new items that bore the image of the Man of Steel. Just his likeness on its side was enough to make an item like a lunch box seem suddenly desirable.

Some manufacturers appeared to be putting old wine in new bottles, so to speak, when they repackaged products like horseshoe sets with Superman's picture on the box to encourage sales. Yet unlike many other children's programs of the time, *The Adventures of Superman* never wrote items into the story lines (a secret decoder, for instance) to be made available to the viewers for a price. The show's sponsor, Kellogg's, did however arrange to associate Superman with its cereals through a number of special offers and giveaways. Some of them, like 1955's free miniature comic books, had real appeal and have since become valuable collector's items. Like the best of the toys, they captured some of the spirit of Superman rather than merely trading on his name.

The trick camera came with three "exposed" Superman action pictures.

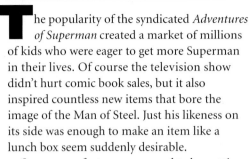

The Superman wrist watch, our hero's version of a classic concept in character merchandising.

Another merchandising perennial—the lunch box based on a character—was only as good as its design, which made the 1956 Superman model a robot-fighting winner.

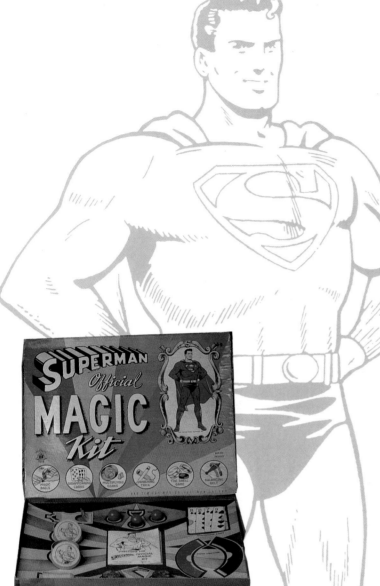

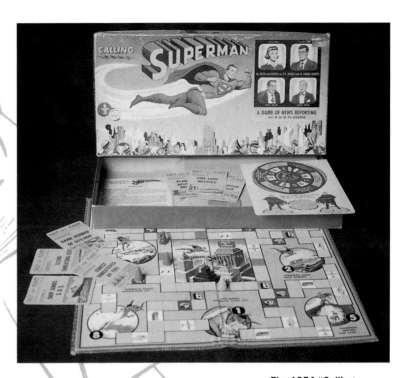

The 1954 "Calling Superman" game from Transogram concerned itself with chasing news instead of criminals, but its dramatic design created an impression.

Tricks in this 1950s Magic Kit from Bar-Zin included the old shell game.

By using a small pump to create water pressure, a kid could actually launch a Krypton Rocket to an amazing height. This was a wet, spectacular, satisfying toy.

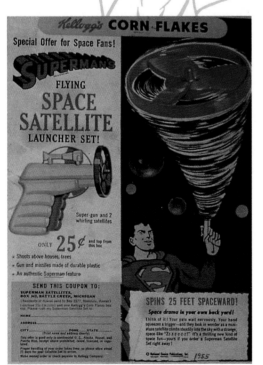

Kellogg's offered this Superman Space Satellite in 1955, two years before the Russians launched Sputnik. The whirling disk might have been more accurately described as a flying saucer, but it put on a good show anyway.

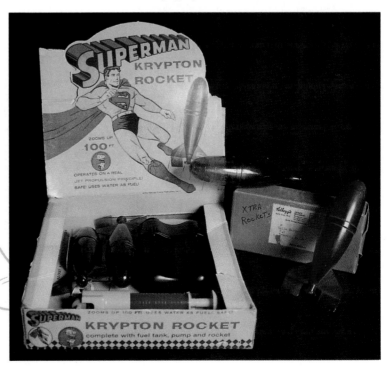

THE COMICS CODE CRUNCH
What Makes a Doctor Mad?

The ax fell on comic books in 1954. Business was at its all-time high, with industry-wide sales estimated at from 70 million to 150 million copies per month. Evidently nobody knows just how many were being sold, but every kid in America, and quite a few adults as well, seemed to be reading them.

Some of the kids reading comics were under the care of Dr. Fredric Wertham, a psychiatrist who had worked at Bellevue Hospital in New York and organized a clinic in what his official biography called "a slum area in Harlem." Working exclusively with children who were in trouble, Wertham concluded that his patients were being corrupted by comics. "In the lives of some of these children who are overwhelmed by temptations the pattern is one of stealing, gangs, addiction, comic books and violence." The fact that a phrase like "Coca-Cola" could be substituted for "comic books" in that sentence is indicative of the nature of Wertham's attack, which was largely based on guilt by association. There was also the veiled implication that certain people, already judged inferior in some ill-defined way, were especially susceptible to "chronic stimulation, temptation and seduction by comic books." Certainly Wertham never imagined that he himself, obsessively consuming comics, might also be a victim of excessive stimulation.

Seduction of the Innocent (1954) was the title of Wertham's assault on comics, which panicked a lot of parents in 1954. What frightened them was the spectre of juvenile delinquency, and Wertham blamed this growing problem on the crime comic book. Born in nineteenth-century Europe, Wertham apparently couldn't comprehend a crazy American culture, and lapsed into hysteria with his accusation that publishers would deliberately push a kid into delinquency so he would have more money to buy comics. "They tempt him, they lure him, they show him how to steal," Wertham wrote. His principal targets were the crime comic books, with their lurid depiction of violence, but he lumped all comics together, and argued that "this Superman-Batman-Wonder Woman group is a special form of crime comics."

Since it was DC's policy to avoid the gory details that Wertham waved like a red flag, he responded with a cockeyed kind of character assassination. One of his most famous charges, still recalled with amusement forty years later, is that Batman and Robin were gay. "We have inquired about Batman from overt homosexuals treated at the Readjustment Center," wrote Wertham gravely. Today's readers may be less concerned about Batman and Robin than about the ominously titled "Readjustment Center," but even in 1954 people should have realized that heroes who exist only on paper have no lives off the printed page. Wertham also insisted that "the Lesbian counterpart of Batman may be found in the stories of Wonder Woman," but couldn't come up with anything quite so titillating for Superman, merely concluding that "psychologically Superman undermines the authority and dignity of the ordinary man and woman in the minds of children."

Most of Wertham's accusations seem transparent today, but in his day the repercussions rolled straight into the halls of the U.S. Senate. The principal target of the Senate's hearings was William Gaines, whose EC Comics published the gleefully gruesome *Tales from the Crypt* and the savagely satirical *Mad*. Tennessee's Estes Kefauver, an aspiring presidential candidate, got his name in the papers by grilling Gaines about a cover featuring a severed head.

There was a public outcry, and the industry responded by creating a self-censoring body called the Comics Code Authority. At the time, such "voluntary" action seemed the only way to avoid government intervention, but the damage was already done. Jobs were lost, reputations were ruined, the majority of publishers went

The zeal of Code censors resulted in absurdities like the rewriting of this story from *Plastic Man* #63 (July 1956). Having created Mr. Aqua, a villain made of water, Jack Cole disposed of him with a gag. Obviously Woozy has just swallowed Mr. Aqua, but the Code demanded new lettering to assure everyone that the bad guy had merely been spilled instead. As a result, no kid who read this comic book ever became a cannibal.

One of the few survivors of the purge inspired by Dr. Wertham, DC demonstrated its confidence in its own good intentions by launching a horror-type title, *House of Secrets*, just a few months after the Code was instituted. The cover of the first issue (November 1956) is by Ruben Moreira.

This Johnny Craig cover for May 1954 was typical of the wild EC line published by William Gaines, son of comic book pioneer M. C. Gaines. The cover got the younger Gaines into the Congressional Record, and also into a lot of trouble.

out of business, and within a year or so, comic books sales had dropped by seventy-five percent. An art form had been branded a force of evil, and comic books seemed near destruction. Juvenile delinquency, of course, did not decline. Today the idea that comics could corrupt the country seems silly, yet self-appointed experts still promote the notion that attacking the arts is a practical way to combat crime.

William Gaines stopped printing EC comics, including *Tales from the Crypt*, which is regarded today as classic Americana. He converted *Mad* into a black-and-white magazine that has flourished as a voice of healthy skepticism for generations of American kids, and which eventually became part of the DC family.

DC was one of the few comic book publishers to survive. "We didn't have titles that were really attackable," says Irwin Donenfeld. "And I went all around the country. I spoke before PTA groups. I was on TV discussing the problem of comics and how helpful they are in teaching kids to read." Such action was useful, but longtime editor Julius Schwartz says, "Things were going downhill." Something was needed that would be as effective as the horde of heroes DC had unleashed a generation earlier, and Schwartz was about to provide it.

Mad, the one EC publication to survive the Comics Code, began as a color comic book that spoofed other comics. In the fourth issue (April–May 1953), writer Harvey Kurtzman and artist Wallace Wood make light of the lawsuit between Superman and Captain Marvel.

FLASHBACK
The Return of the Super Hero

Nobody remembers who came up with the idea that turned American comic books around, but it happened in the DC offices sometime in 1956. "We were a very close-knit group," says editorial director Irwin Donenfeld. "Everybody was rooting for everybody else." Donenfeld can't recall whose bright idea it was to resurrect the Flash, but the revival led to a renewed interest in super heroes that may have saved the moribund comic book industry.

Julius Schwartz can't remember either, but he hasn't forgotten the moment when "Irwin asked who would be the editor, and they all looked at me." After all, Schwartz had been editing the Flash when the character's original launching pad, *Flash Comics*, had been cancelled in 1949. Schwartz, however, wasn't interested in looking backward. "I said I didn't want to do the Flash," he recalls. "Everything was wrong about it. I didn't even

The cover for *Showcase* #4 featured motion picture film imagery. Pencils by Carmine Infantino and inks by Joe Kubert.

The Elongated Man, one in a long line of stretchable super heroes, made his debut in *The Flash* #112 (May 1960). Drawing rubbery Ralph Dibny were Carmine Infantino and Joe Giella.

like his uniform." Eventually, Schwartz agreed to the plan only if he could have a free hand to introduce radical changes. In fact, he reasoned that few kids reading comics in 1956 would even remember the old Flash.

In those troubled times, launching a new character was a risky proposition. "In the fifties," says Schwartz, "we were really suffering." So DC had inaugurated *Showcase*, which presented an entirely new feature in each issue, thus minimizing the risk of publishing something unpopular. When Schwartz's Flash showed up in *Showcase* #4 (September 1956), sales zoomed. The character got further tryouts in the eighth, thirteenth and fourteenth issues, and was finally rewarded with his own title, *The Flash*, in February–March 1959. The new issue was designated as number 105, continuing the numbering from the long-defunct *Flash Comics* in the hope that readers would be impressed with the hero's longevity. In this cautious manner, a new era began.

Julius Schwartz had assembled a topflight team to mold the new Flash. For the script, he turned to the next desk in his two-man office and called on writer-editor Robert Kanigher. As was his custom, Schwartz conducted a story conference before turning the assignment over to Kanigher. "So," says Schwartz, "Kanigher did create the Flash, no question, but we plotted to a certain extent." After one origin story, however, Kanigher's busy schedule forced him to drop the character, and he was replaced by John Broome. Schwartz, who had recruited Broome from pulp magazines years earlier, calls him "my best writer," and adds that "he became my best friend." A polished professional, Broome wasn't known for startling innovations, but his scripts were carefully constructed and full of interesting details. It was Schwartz, however, who inaugurated the practice of using footnotes to explain the scientific principles behind the Flash's fast-moving feats.

The artist who got the Flash going was Carmine Infantino. His pencils were inked at first by Joe Kubert, but most often by his boyhood pal Joe

Giella. Infantino's virtues lay in his clarity of line and design; in tandem with Broome's writing, Infantino's art resulted in impeccably crafted comics. His most notable innovation lay in the consistent use of elongated panels that stretched across the entire width of a page, reminiscent of the wide-screen movies that had recently come into vogue.

Infantino's costume for the new Flash was a sleek one-piece model, basically a burst of red with yellow highlights. It also included a cowl to answer Schwartz's complaint that the old Flash "had a secret identity but never wore a mask." The new Flash even had a new name, Barry Allen, and a handy new job, as a police scientist. He acquired his powers when a bolt of lightning struck his lab, bathing him in spilled chemicals and high voltage. Allen also had a love interest, reporter Iris West, and

A memorable villain faced by the Flash was Grodd, renegade from a race of intellectual gorillas. Here Grodd encounters an under-cover agent in *The Flash* #106 (April–May 1959). Pencils by Carmine Infantino and inks by Joe Giella.

One way Carmine Infantino dramatized Barry Allen's speed was to depict the rest of the world as almost motion-less. The lunch that may never land is from *Showcase* #4 (October 1956), inked by Joe Kubert.

gradually acquired a roster of regular villains, including Captain Cold, the Mirror Master and the Weather Wizard. In January 1960, he even got a kid assistant when the long arm of coin-cidence transformed his sweetheart's nephew, Wally West, into Kid Flash.

In short, *The Flash* was a streamlined, modernized version of much that had gone before, but done with such care and flair that the character seemed new to a new generation of fans. The Flash's return pioneered the idea that super heroes were due for a comeback, inspired a host of followers and helped shake up the few remaining super heroes who had never really retired but sometimes seemed to be in danger of just fading away.

Carmine Infantino gives the fans an art lesson in the pages of *The Flash* #169 (April–May 1967).

THE SUPERMAN FAMILY
Strength in Numbers

While editor Julius Schwartz was reviving super heroes for a new generation, his colleague and boyhood friend Mort Weisinger devoted his considerable energy to keeping the original super hero alive. Weisinger managed the Man of Steel's career not only in DC's flagships *Action Comics* and *Superman*, and in their junior versions *Adventure Comics* and *Superboy*, but even in that improbable publication *Superman's Pal Jimmy Olsen*. The rare comic book starring a sidekick who wasn't even a costumed hero, *Jimmy Olsen* got its start in September–October 1954 at the height of Superman's television run, and the art job was assigned to Curt Swan.

For Swan, his ten-year stint on *Jimmy Olsen* was "like being introduced to the Superman Family—the Super Family, I should probably put it. It was a stepping stone." Swan insists, despite fan speculation, that "in no way did I try to do a George Reeves Superman," but acknowledges that he did alter the image of the prototypical comic book hero, and with Weisinger's approval. "Mort liked the direction I was going in, so he said perhaps I should even go a little farther with that and make the character of Superman more clean-cut, youthful and heroic." By 1961, Swan's new look would replace Wayne Boring's patriarchal version. Swan's Superman became definitive, and ultimately he would draw, as he says, "more Superman stories than anybody else."

While Julius Schwartz was using the experimental *Showcase* comic book to cautiously reintroduce the Flash, Weisinger edited a Lois Lane issue of *Showcase* in August 1957 and a mere seven months later inaugurated *Superman's Girl*

Bizarro, a grotesque artificial duplicate of Superboy, was destroyed during his first appearance, in *Superboy* #68 (October–November 1958). However he was such a hit that a whole tribe of Bizarros was introduced. Script by Otto Binder and art by George Papp.

Friend Lois Lane. Kurt Schaffenberger was the principal artist on this series, which was notable for introducing the "imaginary story." These "hypothetical" tales explored the manner in which the Superman saga might be affected by events (like birth, death and marriage) that otherwise had to be avoided in order to maintain a reassuring continuity.

The idea of stunts like the imaginary stories became increasingly important to Weisinger, who felt that they kept the fans coming back at a time when audience turnover was assumed to occur every few years. When the *Superman* TV series stopped in 1957, putting an end to Weisinger's stint as its story editor and also cutting back on valuable publicity for the comics, he threw caution to the winds in his efforts to amaze his readers.

Many of Weisinger's new gimmicks were invented in collaboration with writer Otto Binder, who had previously created many of the best adventures of Superman's rival Captain

Curt Swan's model sheet illustrates the many moods of Superman.

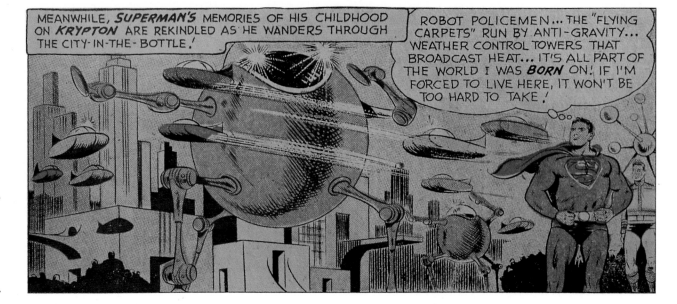

Superman shrinks down to enjoy Kandor, that little slice of Krypton preserved under glass. Pencils by Wayne Boring and inks by Stan Kaye from *Action Comics* #245 (October 1958).

Marvel. One of the team's principal techniques was to take Superman's formerly unique abilities and spread them around to an ever-increasing cast of characters. In *Action Comics* #242 (July 1958), they introduced a powerful interplanetary villain named Brainiac, whose habits included collecting cities from around the universe by shrinking them and putting them in bottles. Among these treasures Superman discovered Kandor, the capital of his home planet Krypton. Superman whisked Kandor away to his Arctic Fortress of Solitude (introduced in the previous issue). There he discovered that he could reduce his own dimensions and visit the civilization of which he had presumably been the sole survivor. Operating without his powers in his native environment, Superman recruited Jimmy Olsen as a teenage sidekick, and as Nightwing and Flamebird they became Kandor's equivalent of Batman and Robin. Later, a number of Kryptonian villains were revealed to be alive outside Kandor, banished to the other-dimensional Phantom Zone from which they would occasionally escape to wreak havoc as super criminals.

Superman was hardly lonely, then, when Weisinger and Binder unleashed their biggest surprise of all: Supergirl. Actually, DC had trademarked the name "Supergirl" as early as 1944, but it wasn't until *Superman* #123 (August 1958) that a prototype "Girl of Steel" was tried out; she was created by a magic spell and didn't outlive the issue, but her popularity led to the debut of the real Supergirl in *Action Comics* #252 (May 1959). She was Superman's cousin, Kara, and like him she had been sent to Earth in a rocket—arriving years later, since she was part of a colony of Kryptonians who had miraculously survived the destruction of their home planet. The premise was farfetched, but readers were intrigued by the blonde teenager with super powers. "I'll take care of you like a big brother," announced Superman, assuring everyone that this potential mate would not supplant Lois Lane in his affections. He sent Kara to an orphanage under the cover name Linda Lee; only in 1962 did he tell the world of her existence. Along the way she acquired such companions as Streaky, the Super-Cat and Comet, the Super-Horse; this wasn't just female frivolity, since Superman already owned Krypto, the Super-Dog. With cousins and criminals, pets and whole populations, Superman certainly had an extended family. It might even have been overextended, but such stunts kept sales booming during tough times.

Pets come complete with capes as Supergirl and Superman fail to notice how weird their world is getting. Art by Curt Swan and Stan Kaye from *Action Comics* #277 (June 1961).

The kid sidekick triumphs and gets his own title in 1954, complete with a cover by Curt Swan.

Supergirl arrives with a bang on the cover of *Action Comics* #252 (May 1959). Pencils by Curt Swan and inks by Al Plastino.

KRYPTONITE
The Achilles' Heel for the Man of Steel

Scholarly fans know that kryptonite, the radioactive substance so menacing to Superman, was introduced on the *Superman* radio show in 1945. Kryptonite was also a key element in the 1948 movie serial *Superman*, but oddly enough did not show up in DC's comic books until 1949. This strange state of affairs suggests that DC resisted the kryptonite concept, only giving in when the idea had achieved public acceptance on a wide scale. In fact, little-known evidence exists to prove that DC could have introduced this menace to Superman much earlier, but instead decided to turn it down.

Around 1939 or 1940, Superman's creator Jerry Siegel wrote a story that has never been published. Siegel's typed script still exists, as do pages of inked and lettered artwork from his partner, Joe Shuster. Siegel's first caption announced that the tale was "guaranteed to leave you gasping." In fact, it appears to have caused a few gasps among DC editors, who evidently decided that they shouldn't or couldn't publish it.

Siegel radically altered his approach to Superman, and kryptonite was the least of it. Siegel called it "the K-Metal," a glowing green element from the planet Krypton, and it caused Clark Kent to collapse in pain. Discovered by Professor Barnett Winton in Mongolia, the fragment in a lead box wasn't the big problem, however; a huge kryptonite meteor hurtling past Earth had completely robbed Superman of his powers. "I know the meaning of pain," groans Superman, "I must be dreaming!" He concludes that his crime-fighting career is finished, and expects to die as Clark when he and Lois Lane are left to suffocate in an abandoned mine along with a gang of crooks. The meteor moves beyond Earth just in time, and a momentous decision is made. To save Lois, Clark reveals his secret identity and batters his way out of the mine. The bad guys helpfully kill each other, but the cat is out of the bag:

> **Lois** (*as they streak down out of sky*): How foolish you were not to let me in on the secret! You should have known you could trust me! Why—don't you realize—I might even be of great help to you?
>
> **Superman**: You're right! There were many times when I could have used the assistance of a confederate. Why didn't I think of it before?
>
> **Lois** (*arms around Superman's neck*): Then it's settled! We're to be—partners!

Siegel planned this tale to run twenty-six pages, twice as long as most 1940 stories, and that may have been a problem. His portrayal of Superman experiencing agony and despair for the first time is so dramatic that it may have caused his editors concern. However, it's most likely that the idea of letting Lois in on Clark's secret is what kept this story unpublished. The

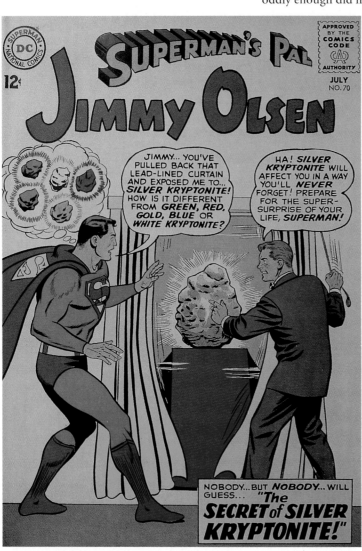

The horror, the horror. Superman contemplates the many varieties of kryptonite when confronted with the new challenge of silver kryptonite; it turns out to be a joke in honor of his silver anniversary. Cover for *Jimmy Olsen* #70 (July 1963) by Curt Swan and George Klein.

Clark Kent comes to grips with the concept of kryptonite in an early, unpublished story by Siegel and Shuster.

PRESENTLY... MELTED AWAY ONLY ONE-THIRD OF THE METEOR-- NOW MY X-RAY VISION IS TOO WEAK TO MELT THE REST-- ALL MY POWERS FADING--

Trapped next to a chunk of green kryptonite that fell from the sky, Superman seems doomed in this panel from *Superman* #130 (July 1959).

duel of wits between the pair would be a key component of Superman's saga for decades to come.

Kryptonite finally got into the comic books in *Superman* #61 (November–December 1949), but it was inexplicably colored red. It got green and stayed that way, however, in dozens of appearances over the next decade; editor Mort Weisinger was entering the era of gimmicks, and kryptonite was too good to ignore any longer. It could cause weakness, paralysis, unconsciousness and eventual death; one side effect caused Superman to build robot duplicates of himself, to have on hand "when I suspect that criminals are waiting to use kryptonite against me." Before long, evil mastermind Lex Luthor was synthesizing the stuff.

In *Adventure Comics* #252 (September 1958), Superboy found a new type, red kryptonite. His computer told him it was ten times stronger than the green kind, but in later stories this red version, altered by passing through a "cosmic cloud," became utterly unpredictable. Never acting the same way twice, it might turn Superman into a monster, a baby, a giant or even two separate people. It usually wore off in a couple of days, but it provided writers with an endless supply of zany plots.

Then there was blue kryptonite, which showed up in *Superman* #140 (October 1960). Invented by Superman himself, using Luthor's imperfect duplicator ray on green kryptonite, the blue kind worked exclusively against the strong but stupid Bizarros who had been created by training the same ray on Superman. Next came gold kryptonite, which could rob Superman of his powers forever. White kryptonite, a real nonstarter, destroyed all vegetation and once saved Supergirl from evil plants from space. The catalog grew to include such variations as jewel kryptonite and X-kryptonite. Things were spinning out of control, and in 1971, when Julius Schwartz became Superman's editor, all kryptonite was banished. Curt Swan, who had drawn—and objected to—some of the more outrageous kryptonite tales, says, "I extended my plaudits to Julie, who came along to change some of this stuff." But kryptonite's half-life is long, and time would prove that its pure form was vital to Superman's legend.

"BUT THE MARTIAN HAD BROUGHT ALONG A GLOWING RED MINERAL, AND..." BAH! I'LL USE THIS *RED KRYPTONITE* I FOUND IN SPACE! IT'S DIFFERENT FROM THE *GREEN KRYPTONITE* YOU KNOW! MY CONTROL DEVICE WILL MAKE ITS RED RAYS TRANSFORM YOU INTO YOUR *TWO* SPLIT PERSONALITIES! HOLY COW! CLARK AND I ARE NOW BOTH ALIVE AT THE SAME TIME!

Red kryptonite gives Superboy and his alter ego two separate identities in this flashback from *Superman* #139 (August 1960).

AND THIS *BLUE* FORM IS *BIZARRO KRYPTONITE!* IT'S HARMFUL TO *YOU*, BUT NOT *ME!* GO BACK... OR ELSE! S-SUPERMAN THROWING *BLUE KRYPTONITE* AT US, ME FEEL PAIN! ME START R-RETREAT BACK TO OUR OWN WORLD AND MAKE NEW WAR PLAN!

Blue kryptonite defeats an army of Bizarros in *Superman* #140 (October 1960).

A major anniversary in June 1983 inspired this group shot by a variety of DC artists, which shows how the Legion had grown from its original three members.

The *Legion of Super-Heroes* began as a gimmick and took years to acquire momentum, but it gradually developed into an innovative series that would help to shape the direction of comic books for years to come. Rarely a top seller but always a favorite of the most committed fans, the series became an experimental laboratory where a generation of comic book personnel got their training while they tried to stretch the boundaries of the form.

It all began innocently enough with a little story by Otto Binder in *Adventure Comics* #247

(April 1958). Three kids called Cosmic Boy, Saturn Girl and Lightning Boy (their names are printed on their shirts) come from the future and invite Superboy to try out for membership in their club. They arrange a series of contests that he invariably loses, and he is reduced to tears ("How will I ever tell them back in Smallville?") before he realizes he's been tricked and has qualified for the Legion after all. This was a cute, formulaic, juvenile story of the type editor Mort Weisinger often favored, complete with a little lesson on the virtues of sportsmanship, and probably all but forgotten when the first follow-up appeared twenty issues later.

Over the next few years, a trickle of Legion stories slowly became a flood. "Tales of the Legion of Super-Heroes" became a regular series with *Adventure Comics* #300 (September 1962), and before long Superboy was appearing (in the book where he'd once been a headliner) only because he belonged to the Legion. The roster increased with new characters like Chameleon Boy, Invisible Kid and Triplicate Girl; like most members, they came from distant planets and had given names like Reep Daggle, Lyle Norg and Luornu Durgo. The kids had an oath, a constitution and a clubhouse that looked like a rocket that had half buried itself in the ground. This gang felt like something youngsters might start themselves: these were heroes with small powers that seemed a little silly, and striving to belong was a recurring theme. Readers responded with an unusually strong sense of identification, and their letters were full of suggestions for new members and new plots.

The artist during the Legion's formative years was John Forte, whose work, though often described as stiff, created a strong impression with its simplicity. The writers were old pros Jerry Siegel and Edmond Hamilton, but in 1966 a thirteen-year-old boy named Jim Shooter thought he could do better. He sent an illustrated script in from Pittsburgh, and Mort Weisinger accepted it. Shooter achieved national recognition as a comic book prodigy and became the regular writer on the series until the workload overwhelmed him. He returned to the business as an adult and eventually served for a decade as editor in chief of Marvel Comics.

Shooter was the first of many young fans who would learn their trade or refine their skills working on scripts for the Legion. Among his successors were such important writers and editors as Cary Bates, Gerry Conway, Len Wein, Jim Starlin and Roy Thomas. Yet few contrib-

utors to the adventures of the Legion were more important to DC than Paul Levitz, who originally wangled his way into the office as the teenage editor of a fan magazine and would gradually work his way up to become DC's executive vice president and publisher. In 1973 he was working as an assistant editor while studying business at NYU, and he gradually began to get scripts published.

"*Legion* was probably the first title I seriously collected," Levitz says, "and when I got a chance to write it, I was very excited." When Levitz took on the title in 1976, it was, in his words, "a book you needed a scorecard to read, much less to write." While the comics of an earlier era had been created with the casual reader in mind, *The Legion of Super-Heroes* was designed by and for fans who relished its intricacies. In addition to its vision of an interplanetary future, Levitz cites "the diversity of the characters and the sense of limitless background" as keys to its appeal.

There were so many super heroes in the Legion that they were, as Levitz puts it, "disposable." The characters could die, as Jerry Siegel demonstrated as early as 1963, or they could marry, as Levitz showed with the wedding of Lightning Lad and Saturn Girl in 1977. Levitz wasn't satisfied with his work and left in less than two years, convinced that "I had my shot." Yet in 1980 he returned and embarked on "an unbroken eight-year run, probably some of the

best writing of my career." Working with artist Keith Giffen, Levitz completed the transformation of *Legion* into a science fiction saga of considerable scope and depth. Its sophistication set this version far apart from its charmingly childish beginnings in a spaceship full of kids with goofy names like Bouncing Boy or Matter-Eater Lad. Much of the future of comics would lie in this new kind of intricately evolved universe that only the initiated could truly understand.

Even Superboy wants to belong, just like any other kid, which may explain some of the appeal of the first Legion story. Pencils by Curt Swan and inks by Stan Kaye for *Adventure Comics* #247 (April 1958).

The treacherous Time-Trapper turns teens into toddlers in a very bizarre scene from *Adventure Comics* #338 (November 1965). Script by Jerry Siegel and art by John Forte.

The wedding of Lightning Lad and Saturn Girl, during a transition period for the Legion, featured a bride in bell-bottoms. Script by Paul Levitz, art by Mike Grell and Vince Colletta, from *All-New Collectors' Edition* (1977).

A hideous villain traps Chameleon Boy, and the series becomes a powerful interstellar adventure in the hands of writer Paul Levitz, penciller James Sherman and inker Bob McLeod. From *Superboy and the Legion of Super-Heroes* #241 (July 1978).

It is this impurity in the **battery** which will make you powerless over anything **yellow**!

I understand!

An alien explains our hero's powers in the origin story, retold by writer John Broome for *Green Lantern #1*. Pencils by Gil Kane and inks by Murphy Anderson.

Gil Kane's treatment of flying scenes, like this one from *Green Lantern #58 (January 1968)*, gave his work unusual flair. Inks by Sid Greene.

GREEN LANTERN LIT AGAIN
Comics Get Cosmic Consciousness

In 1959, editor Julius Schwartz made the second move in his campaign to revive classic super heroes. "I said, now that the Flash is a success—well, I always liked Green Lantern," he recalls. Nonetheless, he felt the character needed an update. "I decided to use more of a science fiction angle," he says, and in fact he dropped the vaguely magical premise of the old Green Lantern for a concept that sent its protagonist careening through space and time, through new dimensions to other worlds.

To write adventures on a cosmic scale that had never really been attempted in a super hero series before, Schwartz called on his friend John Broome. Collaborating on the plotting, they conjured up the tale of Hal Jordan, a test pilot who is drawn by an eerie force to the wreck of an alien spaceship. Within lies Abin Sur, a bald, scarlet-skinned, moribund visitor from beyond. He identifies himself as one of the "selected space-patrolmen in the super-galactic system," passes on his mission to Jordan, and promptly expires. Armed only with a ring powered by a battery of overwhelming energy, Jordan dons his benefactor's costume and becomes Green Lantern.

"Julie and John Broome figured out the essential qualities for the character, and I figured out a costume for him and so on," says Gil Kane. An artist who started in comics as a teenager, Kane had aspired to work at DC but found it at first "very hard to get into." After a false start he became a DC regular in 1949 "and then I stayed there forever." A thoughtful artist who was critical of his own work and always striving to improve, Kane began to forge a new approach to super heroes when he got his chance with Green Lantern. "I started to use the lines of the body as a basis for the costume,

not just putting on a pair of tights and an initial on the chest," he says. The design was part of an approach that emphasized grace as well as strength, an approach especially notable in Kane's flying scenes. Most heroes seemed to struggle to stay aloft (perhaps because Superman began as a jumper, not a flyer), but Green Lantern appeared to soar effortlessly across the cosmos. "That lyrical look sort of caught on," says Kane, "before super heroes started bristling with weaponry and all sorts of mechanization."

The new Green Lantern made his debut in issue 22 of the tryout comic book *Showcase* (October–November 1959), but Schwartz was confident enough to bring him back for the next two issues, and *Green Lantern #1* (July–August 1960) was apparently a foregone conclusion. John Broome stayed on for fifty-nine issues, and Gil Kane for sixty; there was ample time for the team to envision a saga of unusual scope and power. Their grand vision was evident as early as the first issue, when Green Lantern was introduced to his supervisors, the blue-hued Guardians who police the universe. In the ninth issue, readers encountered the entire Green Lantern Corps, a group of similarly empowered beings drawn from the farthest reaches of outer space. For all his amazing abilities, this super hero was just a cog in a vast machine.

His power, however, was virtually infinite. Fueled every day by the battery that resembled an old-fashioned lamp, Green Lantern's ring cast forth verdant rays that he could transform through pure will into any shape, force or energy. Even by Superman's standards he seemed casually omnipotent, but there was a fly in the ointment: due to an "impurity in the battery," Hal Jordan was helpless against anything colored yellow. This was a somewhat strained solution to the necessity of giving the protagonist problems to solve, but in the days of multicolored kryptonite, perhaps it was inevitable.

"Julie ran a very tight ship," says Kane. "John Broome was a sweet, lovely man," he adds, but writers and artists had limited contact in this era. "Everything came through Julie, and Julie would plot every single story." No one can recall who was responsible for specific details, but Green Lantern got a typical supporting cast with a few interesting twists. His young sidekick, a Jimmy Olsen type with no

powers, was an Eskimo mechanic named Thomas Kalmaku. Hal Jordan's romantic interest, Carol Ferris, ran the company whose planes he tested. There was the usual stuff about her loving Green Lantern and ignoring Hal, but the fact that she was his boss added some spice, especially since she was occasionally transformed into "that mistress of mighty powers and eerie energies" called Star Sapphire. Clad in a clinging crimson costume, she was one more reason for him to recall his oath:

> In brightest day . . .
> In blackest night,
> No evil shall escape my sight!
> Let those who worship evil's might
> Beware my power—
> Green Lantern's Light!

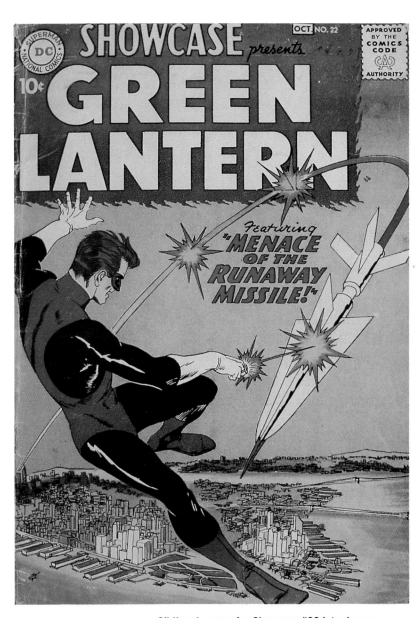

Gil Kane's cover for *Showcase* #22 introduces a new costume concept and overtones of Cold War politics. The artist says he based his version of Green Lantern on actor Paul Newman.

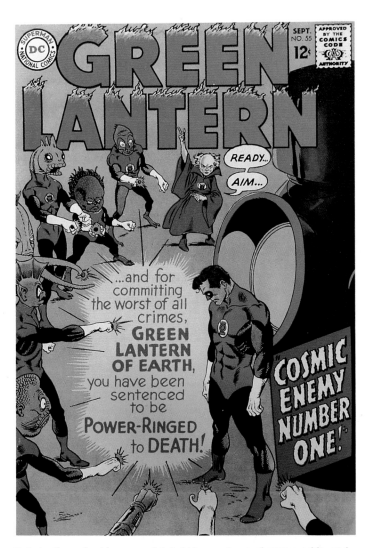

Being a Green Lantern was a job held by creatures of many worlds, and Hal Jordan is having trouble with all of them on this cover for *Green Lantern* #55 (September 1967).

Anything yellow, including a pterodactyl, is immune to Green Lantern's powers. Art by Gil Kane and Joe Giella for *Showcase* #23 (November–December 1959).

THE JUSTICE LEAGUE OF AMERICA
A Team of Good Sports

After his great success introducing revamped versions of the Flash and Green Lantern in *Showcase*, editor Julius Schwartz determined to bring back another feature from All American, DC's sister company of the 1940s. "In addition to *Showcase* we had a magazine called *The Brave and the Bold*," he says, "on which we decided to use the same procedure." So this minor comic book became a tryout title, and in its twenty-eighth issue (March 1960), it introduced a powerhouse team called the Justice League of America. The earlier group had been the Justice Society of America, which Schwartz thought sounded somehow uppity; the new name suggested sports, with all the notions of democracy and fair play that this implied. It caught on, and *Justice League of America* was launched in October–November 1960.

The members of the Justice League were good sports without a doubt, cheerfully cooperative and often so crowded together in their adventures that they had little room for temperament or even personalities. They also showed their egalitarian tendencies by giving the backseat to big boys Batman and Superman; the most active members were newcomers Flash, Green Lantern and Martian Manhunter J'onn J'onzz, together with diehards Wonder Woman and Aquaman. The last three weren't characters Schwartz normally edited, but playing in the Justice League boosted their careers, while Batman and Superman were still top attractions under the firm control of their respective editors Jack Schiff and Mort Weisinger.

To illustrate the crowded cast, Schwartz called on penciller Mike Sekowsky. A veteran noted for his speed at the drawing board, Sekowsky had a talent for composing panels crowded with characters, even if his figures were sometimes a trifle stiff. To write the stories, Schwartz selected "of course, Gardner Fox." A veteran of the old Justice Society days, Fox was a past master at the task of juggling an expansive cast. But he put an extra strain on the pages by introducing Snapper Carr, a teenage sidekick with an annoying line of ostensibly hip chatter. The first story was just one of many in which Snapper saved the day when the group was threatened by an overwhelming menace. He was clearly intended to provide audience identification, but more than a few readers were grateful when, in *Justice League* #77, he misguidedly betrayed the team and was thrown out of the game.

Gardner Fox stuck with *Justice League* for sixty-five issues. Mike Sekowsky lasted for sixty-three, and his replacement, Dick Dillin, stayed on the job until he died in 1980, having achieved the impressive total of 120 consecutive issues. Along the way the roster of heroes changed; eventually so many were added that there wasn't room for all of them in most issues. Superman and Batman began to assert their authority and some of the original mem-

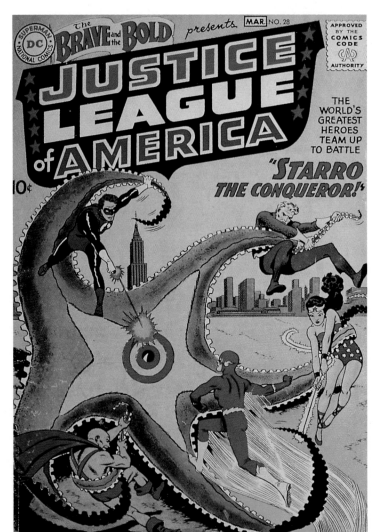

The initial Justice League adventure featured an interstellar starfish invading Aquaman's undersea domain. Cover by Mike Sekowsky and Bernard Sachs for *The Brave and the Bold* #28 (March 1960).

Not until the ninth issue (February 1962) was it revealed that the Justice League began when the various super heroes were drawn to the same alien menace. For the record, Batman was the one who suggested they form a club. Cover by Mike Sekowsky and Murphy Anderson.

Bickering breaks out among the members in this story from *Justice League of America* #66 (November 1968). Eight years had passed, and super heroes with prickly personalities had come into vogue, due in part to the efforts of young writers like Denny O'Neil. "Some of that was to keep the job interesting for myself," he says. In this story, called "Divided They Fall," the characters with less impressive super powers (Batman, Green Arrow, the Atom and Snapper Carr) begin to feel patronized by their mightier colleagues. A walkout results, forcing Superman, Wonder Woman and Green Lantern to rethink their roles. Everything is settled amicably, but clearly the times were changing. This dramatic board meeting features pencils by Dick Dillin and inks by Sid Greene.

Perhaps the most annoying teenage sidekick in comics, Snapper Carr accidentally helped the Justice League and became an honorary member during their first appearance.

bers were unceremoniously pushed aside, but no matter who was in the lineup, *Justice League* was a hit. It solidified once and for all the importance of super hero groups, and in the process provided a playground where DC's characters could attract new fans while entertaining established admirers. And by integrating so many separate superstars into a single package, it introduced the idea of brand loyalty to comic book readers.

If Superman had problems with Lois Lane, they were nothing compared to what Green Lantern went through with Carol Ferris. Not only was she Hal Jordan's employer, but she periodically turned into "the crimson changeling" called Star Sapphire. In her third appearance, from *Green Lantern* #41 (December 1965), "the wily woman in red" is joined by a double, and each is bent on forcing the hero to marry her by any means, including violence. Carol seemingly bests him in a duel of power beams, but she turns out to be the alien from planet Zamaron, operating under false pretenses, so Green Lantern gets to stay single.

Stories like this, based on impersonation or possession, enabled characters like Carol to behave in ordinarily unacceptable ways, and the Star Sapphire series made for an interesting study in sexual politics. Eventually, Green Lantern's apparent love interest divided into male and female halves and then merged again to become a dyed-in-the-wool villain. Pencils by Gil Kane and inks by Sid Greene.

On this striking cover by Murphy Anderson, Green Arrow joins the Justice League, thus becoming the first super hero added to the group since its inception. And although they are discreetly absent on the cover, not wishing to steal the thunder from their less popular colleagues, both Superman and Batman appear in this adventure as well. Striving mightily to overcome the obvious imbalance among the characters, writer Gardner Fox and editor Julius Schwartz arranged a situation in which Green Arrow's adroitness with nonlethal projectiles could save colleagues with more impressive powers. Thus he won "membership for life—with all privileges and gratuities including the wearing of the signal device and possession of the golden key which permits entry into the secret sanctuary, its library and souvenir rooms." Encased in the jewel within the pages of *Justice League of America* #4 (May 1961) are Wonder Woman, the Flash, Aquaman, Green Lantern and the Martian Manhunter.

THE SILVER AGE
Applying a Fine Shine

Comic book fans from the baby boomer generation believe that the late 1950s and early 1960s constituted a Silver Age, an outpouring of talent comparable to the Golden Age that had begun the business a generation earlier. The Silver Age was largely an era of super heroes, and its success defined American comic books in terms of such characters. Genres such as comedy and romance would gradually be phased out once television became the principal purveyor of general popular entertainment; comics by contrast became highly specialized.

The primary architect of the Silver Age, editor Julius Schwartz, followed up the Flash, Green Lantern and the Justice League of America with new takes on two more heroes in hibernation: Hawkman and the Atom. The earlier Atom was just a short tough guy, but his Silver Age counterpart had the power to shrink himself down to any size, even microscopic, by employing the beam of a white dwarf star. It didn't seem the most useful ability around, but writer Gardner Fox and artist Gil Kane managed to make it interesting and exciting. Schwartz named the character for his friend Ray Palmer, a diminutive science fiction editor. The Atom first appeared in *Showcase* #34 (October 1961) and got the first issue of his own comic book in June–July 1962.

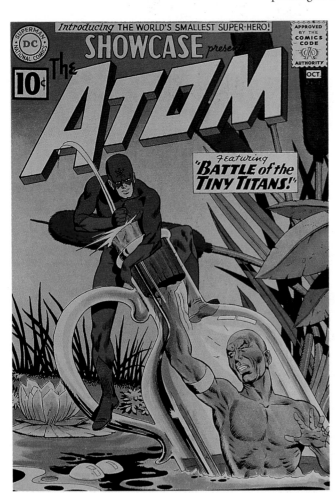

The debut of the Atom demonstrated that interesting artwork could overcome an apparently unpromising premise. Cover for *Showcase* #34 (October 1961) by Gil Kane and Murphy Anderson.

Julius Schwartz, whose vision of what super heroes could become gave birth to the Silver Age.

Hawkman took a little longer to get off the ground. He showed up initially in *The Brave and the Bold* #34 (March 1961), but had to wait three years for *Hawkman* #1 (April–May 1964). Gardner Fox wrote the series, as he had decades earlier, and the first stories in the revival were drawn by Joe Kubert. His style, though widely acclaimed, may have been a bit too gritty for the adventures of a flying man. Eventually, Hawkman really took off when artist Murphy Anderson took over. Most frequently employed at DC inking other artists' pencils, Anderson came into his own with his elegantly ornamental version of the Winged Wonder.

Murphy Anderson's inks were frequently used on Gil Kane's pencils for the Atom or Green Lantern. "He drew really well," says Kane, and "he had such a strong style that I always felt I inherited some of that quality." Kane was dissatisfied with some other inkers, but using two artists on one story gave DC considerable control over the final result. "They used a standard of meticulous lines," says Kane, and this helped define a company style. As heroes rubbed shoulders in books like *The Justice League of America*, a DC look was a commercial advantage.

"During that period the editorial people created all the comics," says Kane. "They created the new titles, they created the new characters," and the writers and artists were on assignment. Kane reported to Julius Schwartz and rarely consulted with writers like Gardner Fox or John Broome. "Julie was so precise, he wanted things to satisfy a very specific need in his own nature, in terms of what he thought the material should be like." A strong single vision emerged, although talented artists like Kane sometimes felt constrained by scripts that indicated the number, placement and contents of the panels on the page.

DC's new super heroes became so popular that they began to influence other publishers. Chief among these was an outfit formerly known as Atlas, which had fallen into such decline after the Comics Code controversy that by 1960 it wasn't putting any identifying company logo on its comic book covers. The sole editor, Stan Lee, also wrote most of the scripts, and publisher Martin Goodman stayed in comics largely because DC's Jack Liebowitz agreed to distribute his small line. Industry legend maintains that during a 1961 golf game Liebowitz mentioned *The Justice League's* big sales to Goodman, who promptly ordered Lee to create a super hero group for Atlas. Liebowitz,

however, does not confirm the tale: "I'm sure I didn't discuss anything with him about that, but everybody knew what the sales were." In any case, the result of Goodman's order was *The Fantastic Four* (November 1961), a collaboration between Stan Lee and artist Jack Kirby.

Kirby had been at DC not long before, working with writer Dave Wood on a quartet of characters who had no special powers but did possess plenty of nerve. On view as early as *Showcase* #6 (February 1957), the foursome had earned *The Challengers of the Unknown* #1 by April–May 1958. This title lasted over a dozen years, but the peripatetic Kirby left after eight issues. "I'd get into fights with editors and I'd get into arguments with publishers," Kirby said decades later. "Whoever gave me work, that's the guy I went to. And I was like a yo-yo." The collaboration between Kirby and Lee unleashed a torrent of distinctive new characters, including the Incredible Hulk, the Mighty Thor, the Silver Surfer and the X-Men. Goodman's reinvigorated company took the name Marvel Comics and emerged as another house of super heroes, becoming DC's greatest rival and a major force in defining modern comics. The future of comic books was assured and its contents were defined in the Silver Age, and Julius Schwartz was its prophet.

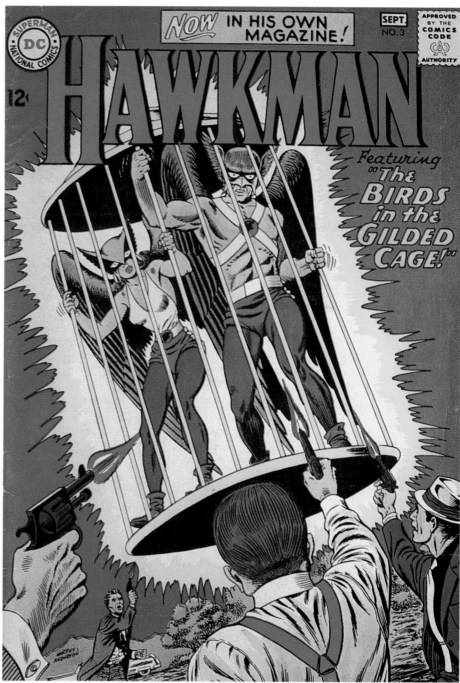

Everybody else's inker at DC, Murphy Anderson got his own shot at pencilling with the new Hawkman, a visitor to earth who teamed with his wife to fight crime. This cover is from the third issue (August–September 1964).

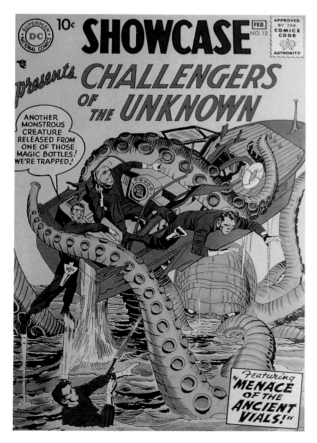

Jack Kirby's cover for *Showcase* #12 (February 1958) features four tough guys who made a habit of meeting monsters.

EARTH-TWO
The Old Heroes' Home

When Julius Schwartz was reinventing the Flash in 1956, he was to some extent reinventing the super hero as well, and an iconoclastic idea suddenly occurred to him. "There's no reason why if a fellow gains super powers he has to become a good guy—he could become a bad guy." So to explain his protagonist Barry Allen's axiomatic career choice, Schwartz showed the character reading a copy of the Golden Age *Flash Comics* and thus being influenced to use his speed in a good cause. "It was sheer inspiration," says Schwartz, pleased by this logical explanation even though he knew that most of his young readers wouldn't remember the old Flash. However, he eventually came to feel that "by doing that I created, really, another Earth," one where the old heroes lived. There was "no preconceived notion" that the comics would ever show this world, but when readers opened the pages of *The Flash* #123 (September 1961), there it was.

The story, which ran an unusually expansive twenty-five pages, was called "Flash of Two Worlds," and it introduced DC fans to the concept of Earth-Two. Schwartz gave the script assignment to Gardner Fox, who was not usually the writer of the Silver Age Flash but had originated his Golden Age namesake. The story features both versions of the hero. While

Acknowledging that the Golden Age Flash was the inspiration for the Silver Age version, editor Julius Schwartz decided that the two should meet in *The Flash* #123. Pencils by Carmine Infantino and inks by Joe Giella.

The idea of the crossover story, in which one character appears in another's comic book, got a real workout when Justice League encountered Justice Society on this cover by Mike Sekowsky and Murphy Anderson.

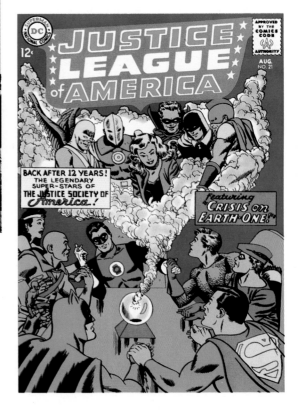

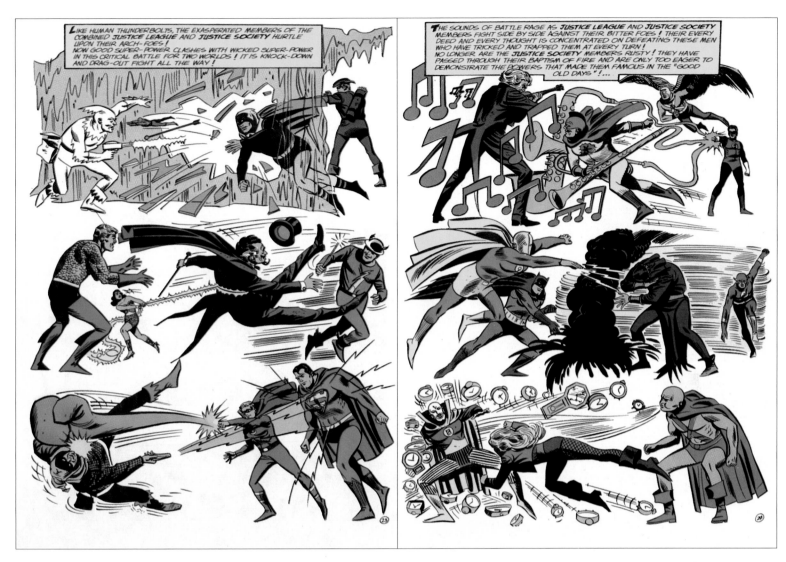

performing the Indian Rope Trick at a charity show, Barry Allen sets up vibrations that transport him to another dimension. Various clues enable him to realize he's in the home of Jay Garrick, the Flash he'd read about in the comics, so Barry looks up Jay in the phone book. Barry expounds about vibrating parallel universes to his Earth-Two counterpart, explaining that Gardner Fox had been inspired to write about Jay by dreams that spanned dimensions.

"I thought I had a cute thing," says Schwartz, and readers agreed. Barry Allen visited Earth-Two again, and on his third trip encountered not only Jay Garrick but the cast of the Golden Age super group, the Justice Society of America. "The best thing, of course," says Schwartz, "was that it led to a team-up with the Justice League of America." So Society met League, in *Justice League of America* #21 (August 1963), and the pages were so packed with super heroes that the story was continued in the next issue. Penciller Mike Sekowsky and inker Bernard Sachs had to draw sixteen super heroes and six villains in various battles, culminating in a two-page spread of mass mayhem when the good guys of one

world defeated the baffled bad guys of the other. As Dr. Fate said, "We saved not only Earth-One and Earth-Two—but for all we know, Earth-Three as well!"

In fact, Earth-Three was just around the corner. The crossover between Justice League and Justice Society became so popular, says Schwartz, that "I did it every summer." Writer Gardner Fox was already juggling more heroes than anyone had before when Schwartz indulged himself with a different answer to the question that had started this whole brouhaha. He posited a dimension where the super heroes had not followed the path of virtue, and this became Earth-Three, introduced in 1964.

The ranks of both League and Society swelled; characters like Batman who'd never been retired and then revived still had to face their former selves; the DC universe became a multiverse, and chaos loomed. Decades would be spent straightening out the details, but along the way were nice moments, such as when Black Canary decided to leave Earth-Two and keep company with Green Arrow on Earth-One. It was probably a matter of vibrations.

Everybody and his brother gets into the act in *Justice League of America* #22 (September 1963). The bad guys, who seem unfairly outnumbered, are the Icicle, the Wizard, Dr. Alchemy, the Fiddler, Felix Faust and Chronos. The big battle was the climax of "Crisis on Earth-Two" in this issue. Pencils by Mike Sekowsky and inks by Bernard Sachs.

FELLOWS, THAT NOTE'S A *PHONY!* NO TEEN-AGER WOULD USE THE WORD "MUSIC" IN A HIP LANGUAGE MESSAGE... THEY'D USE "JIVE!" AND THAT BARN WAS WRECKED BY SOME TERRIFIC WIND!

Teen Titans
Assistants Earn a Promotion

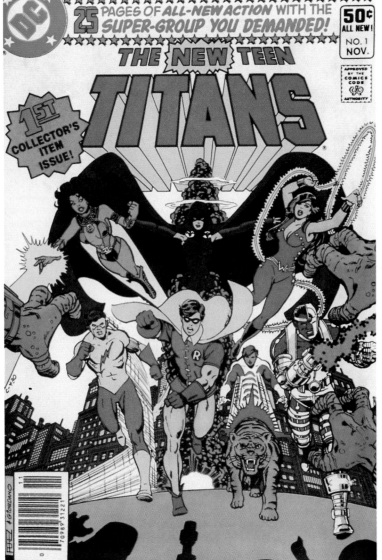

"They just couldn't wait," says the cover blurb, but actually it was a year and a half after their debut that the kids got *Teen Titans* #1 (January–February 1966). Art by Nick Cardy.

Teenagers and teenagers-in-training have always provided an avid audience for comic books. That's why kid sidekicks were so common at DC, but it wasn't until 1964 that the company decided to let its young heroes loose without adult supervision. Writer Bob Haney and editor George Kashdan started a boys' club after a hint from management. "They wanted a team book," says Haney, "and this was pretty much my idea although George came up with some suggestions. I said let's do the junior members and let's put them all together." The feature was known as "Kid Flash, Aqualad and Robin" when it got started in *The Brave and the Bold* #54 (July 1964), but Wonder Girl was recruited by the time of *Teen Titans* #1 (January–February 1966).

"My audience was still the twelve-year-old kid in Ohio," says Haney, who took some ribbing for the writing style that described the

Robin discusses the nuances of hip language with Aqualad and Kid Flash in Bob Haney's story for *The Brave and the Bold* #54 (July 1964).

Teen Titans as "the Cool Quartet" or "the Fab Foursome." The attempt to reach the youth culture then embracing performers like the Beatles and Bob Dylan impressed some observers as strained, but Haney went about as far as he could go. "I knew better," says Haney, who lived in Woodstock and "went on protest marches, got hit by the cops and all that," but it would take another generation before super hero comics would deal with youth more realistically.

The Titans were retired in 1973, revived in 1975, and then revived again in 1980 by writer-editor Marv Wolfman. "Marv did a wonderful job," says Haney. "He opened it up." In fact, within a few months of its November 1980 debut, *The New Teen Titans* became DC's most popular comic book, a position it retained for most of the decade. "I do not believe in using current slang," says Wolfman. "It looks condescending, and readers sense sincerity above anything else." His goal was to show respect for the characters. "I tried to treat them as I would have treated Superman or any other character. The fact that they were teenagers did not mean that everything they did had to reflect teenage problems." To Wolfman, the youth of his heroes meant not kid stuff, but strength, passion and ferocious independence.

Wolfman was one of the new comics creators who entered the business as part of the youth boom that had helped inspire the old Titans (he'd even worked briefly on their original run). By 1980 he had been editor in chief of Marvel Comics, and on returning to DC he was eventually able to serve as his own editor. "Writer-editors are willing to try things that somebody working purely as an editor may never give them the freedom to do," he says. Wolfman created new heroes to supplement the old group, and chose George Pérez as the artist to work with him. "George was in every possible way the co-creator of the series, and that's why eventually we went to co-editing," Wolfman says. "He may not have come up with the characters originally, but certainly his visuals made them work."

Considerably more formidable in their comeback, the New Teen Titans included Starfire, Raven, Wonder Girl, Kid Flash, Robin, Changeling and Cyborg. Pencils by George Pérez and inks by Dick Giordano.

"I knew that I had this incredible artist who could draw almost anything that I wanted," recalls writer-editor Marv Wolfman. "So I decided to make the story just the biggest spectacle I could come up with, because I knew I only had him for five issues." José Luis García-López was briefly available after co-creator George Pérez left the Teen Titans behind, and the García-López pencilling style was the raison d'être for Wolfman's epic exploration of Wonder Girl's background in the world of ancient myth. The cosmic scale of the imagery and the sophistication of the page design are a far cry from the old tales about teenagers trying to find out who wrecked the barn. Inks by Romeo Tanghal, for *The New Teen Titans* #8 (May 1985).

The new Titans included Cyborg and two fascinating females named Raven and Starfire. Yet Wolfman admits he most enjoyed writing about Dick Grayson, who was the prototype kid sidekick as Robin, but eventually went on to independence as Titans leader Nightwing.

That sort of empowerment epitomized the series for readers and creators. "George and I had the freedom to do things that interested us," Wolfman says. "It could be a big, cosmic story line or something small and personal. It really was whatever we felt like."

The Metal Men are not only the stars, they're the setting as well (Iron and Lead are serving as crossbeams). *Showcase* #39 (August 1962) has Ross Andru pencils and Mike Esposito inks.

ODDBALLS
Super Heroes with a Difference

With the Silver Age solidly established, DC began to look for new ideas, and the results were sometimes strange. Something was in the air in the early 1960s that inspired a new breed of super heroes, a series of eccentrics who anticipated the spirit of nonconformism that would flower later in the decade. The writer most responsible for these oddball characters was Bob Haney, but the one who got the ball rolling, almost by accident, was Robert Kanigher.

A comic book emergency gave birth to the Metal Men. Due to a slipup, nothing had been scheduled to fill issue 37 of *Showcase* (April 1962), and the fast-working Kanigher was recruited to create a new feature virtually overnight. The result, drawn by Ross Andru with inks by Mike Esposito, was a colorful, comical tale about Dr. Will Magnus and his team of robots. Each built from a different element and endowed with various qualities from strength to flexibility, the mechanical marvels included aristocratic Gold, steady Lead, intellectual Mercury, reliable Iron, ineffectual Tin and high-strung Platinum. These unusual heroes proved popular enough to earn themselves *Metal Men* #1 (April–May 1963) and Kanigher's off-the-cuff flight of fancy proved to be the start of a trend.

"Sometimes the only way you could get work," says Bob Haney, "was to start a whole new book with an editor." With that idea in mind, Haney and writing partner Arnold Drake submitted the Doom Patrol to editor Murray Boltinoff. The concept involved three people turned into embittered freaks by grotesque accidents, then transformed into super heroes by a mysterious, wheelchair-bound scientist known as the Chief. The first misfit was Robotman, who, like his Golden Age namesake, was a brain in a metal body, but unlike him was dismayed at the drastic change in his life. Next was Elasti-Girl, who developed the ability to expand or shrink after breathing mysterious tropical vapors. The strangest of these "World's Strangest Heroes" was Negative Man, who was wrapped in bandages to contain radioactivity that had contaminated him during a space flight. His alter ego, a being of pure energy, could perform amazing feats but could only be set free from its host body for a minute at a time.

"I thought we had something pretty decent," says Haney. "We did the second issue, and I dropped out." He went on to other projects, while Drake continued the series with artist Bruno Premiani. It began in *My Greatest*

Negative Man is coming apart, Robotman hasn't been changed from Automaton and Elasti-Girl is so small you can hardly see her. Maybe that's why they were called the Doom Patrol. Cover by Bruno Premiani for *My Greatest Adventure* #80 (June 1963).

Adventure #80 (June 1963) and that anthology became *The Doom Patrol* with issue 86. The stories were as dark as the Metal Men's were light, and when the series was killed in 1968, Drake broke precedent by actually killing off the heroes. Time would prove, however, that comic book characters have as many lives as a cat.

For editor Boltinoff's *House of Secrets* #61 (August 1963), Haney and veteran artist Lee Elias introduced another oddball hero, Eclipso. Billed as "The Genius Who Fought Himself," the character was a scientist under a curse that brought his dark side to the surface during each eclipse. "I didn't do my best work on it," admits Haney, and the series never quite caught on, perhaps because the bad guy had all the good moves. Years later, however, Eclipso returned as one of DC's most powerful villains.

"The most creative single thing I ever did was Metamorpho," Haney says. "I worked with George Kashdan, who was also a friend of mine and a good editor, underrated." Kashdan gave him "a little stimulus" by suggesting "a guy who changes chemically." Haney turned the hint into a series that got its start in *The Brave and the Bold* #57 (January 1965) and was soon rewarded with *Metamorpho the Element Man* #1 (July–August 1965).

Tough adventurer Rex Mason was transformed into the grotesque Metamorpho after exposure to a meteorite hidden in an ancient pyramid. Sections of his body had changed into cobalt, copper and other brightly colored elements, but he could also transform its shape and composition at will. Haney called him a "wounded, partly destroyed character who gets whammied and his whole life is changed." A monstrous figure redeemed by a saving touch of humor, Metamorpho found an ideal interpreter in artist Ramona Fradon, described by Haney as "one of the most talented artists in the business." She was also one of the very few women working in comic books at the time, and her bold, funny drawings made Metamorpho memorable. Unfortunately her stint on the series was short (she eventually worked on the newspaper strip *Brenda Starr*), and after her departure the Element Man began to slip. Metamorpho was so popular and so unusual (he even spurned membership in the exalted Justice League) that DC executives ordered big print runs. Sales were good, according to Haney, but looked bad because of overprinting, and soon Metamorpho was history. In fact most of the oddballs didn't last long, but their eccentricities enlivened the industry.

A smash hit with a short half-life, Metamorpho the Element Man showcased the best comic book work of writer Bob Haney and artist Ramona Fradon. This initial issue is dated July–August 1965.

Beyond the odd and into the silly, the Inferior Five were created by alumni from *Mad*: writer E. Nelson Bridwell and artist Joe Orlando. *Showcase #62* (May–June 1966).

Hero and villain in one body, Eclipso makes things hard on himself in *House of Secrets #61* (August 1963). Art by Lee Elias.

Batman Comes to TV
Broadcasting the Bat-Signal

The Riddler pretends to go straight in this 1965 Gardner Fox story, which became the basis of the first television episode.

Abetted by Frank Gorshin's manic performance, television boosted the Riddler into the ranks of the big-time bad guys.

In 1966, Batman took America by storm, but not much more than a year before, he'd been a hero in need of rescue. The character's comic books had been in a long decline, and attempts to borrow innovative ideas from other DC features hadn't helped. Following the success of the "Superman Family" concept, Batman was saddled with a supporting cast, including Batwoman (1956), Batgirl (1961), the masked dog Ace the Bat-Hound (1955) and even a miniature pixie called Bat-Mite (1958). "We wanted to have characters the kids could talk about," says Jack Schiff, who was still editing Batman after more than twenty years. Surrounding the Caped Crusader with so many cheerful companions, however, diminished his appeal as a nocturnal avenger, and even Schiff admits it was "a little far out" when science fiction elements were added to the mix.

After his successful revivals of so many dormant super heroes, editor Julius Schwartz seemed like the natural choice to get Batman back on track. Taking over in 1964, Schwartz made cosmetic changes (such as putting a yellow oval behind the black bat on Batman's chest), and drastic changes (such as killing off the butler Alfred), but his main emphasis lay in bringing back a sense of mystery. "Since Batman is sometimes called the world's greatest detective," Schwartz told his staff, "let him act as a detective." He also brought back the classic bad guys "who had been sadly missing from the magazine. It's so great to do a story when you have a strong villain operating." The Schwartz Batman, featuring scripts by John Broome and art by Carmine Infantino, was firmly established by the time Hollywood came calling.

There are many stories, some of them obviously apocryphal, about how Batman got on network television. Schwartz likes to tell one in which producer

William Dozier was inspired by a comic book he found on a plane; Dozier always maintained he was reading *Batman* while flying across the country because the ABC television network had already acquired rights to the character. ABC wanted the show produced at 20th Century-Fox, and Dozier's independent production company Greenway was on the Fox lot. Why ABC was interested is another matter of conjecture. An executive named Yale Udoff has claimed credit for the idea, but Bob Kane believes the show was inspired by *Playboy* editor Hugh Hefner's interest in the old Batman serials from the 1940s. "One of the ABC executives was at the Playboy mansion in Chicago when they were running fifteen chapters together," Kane

Traps like this one for barbequed Batman and Boy Wonder left viewers twisting slowly between Wednesday and Thursday. The villain to blame this time was the Minstrel, played by Van Johnson.

says. "The bunnies and Hugh and his friends were laughing and screaming and hissing the villains. It was very campy."

The influence of the serials is most obvious in the unprecedented decision to run the half-hour show on two consecutive nights, allowing for a cliff-hanger on Wednesday that would be resolved on Thursday. Bob Kane recalls that he suggested that idea to Dozier, saying, "I think that'll really grab the audience." Also reminiscent of the serials is the pompous narration, which began in the first show with the phrase "Meanwhile, in an abandoned subway toolroom under Gotham City…." After auditioning several actors, Dozier decided to deliver these

lines himself, and cast members noted wryly that when *Batman* became a huge hit for ABC, the narrator was the first performer to get a raise.

To write the original script (and eventually to win the title of executive script consultant), Dozier called on Lorenzo Semple, Jr. Each of them would claim he came up with the idea of treating the TV *Batman* as a spoof, but Semple's comedy credits seem to give his argument the edge. Dozier had previously been associated with high-minded fare like the drama series *Playhouse 90*. Dozier also claimed in an interview that he and Semple had concocted the plot of the first episode, when in fact it was based on Gardner Fox's script for "The Remarkable Ruse of the Riddler," which appeared in *Batman* #171 (May 1965). The broadcast of this story turned the Riddler (until then a minor character) into one of Batman's most famous foes, while simultaneously providing a memorable role for actor-impressionist Frank Gorshin. He would not be the last performer to find that his appearance on *Batman* had marked him for life.

Of course nobody was more identified with the show than the actors chosen to play Batman and Robin. Adam West, who won the role of Batman over competitors like Ty Hardin and Lyle Waggoner, had been around long enough to realize that such a role might hurt his chances for more serious work, but also recognized that he was being offered the unique opportunity to embody an icon. Burt Ward, an untried newcomer who showed up at the studio gates hoping for a shot at Robin, impressed director Bob Butler with his appearance and a certain ingenuous quality, and he was promptly hired. After consultation with Semple, Butler filmed the show using the twisted camera angles (known in the trade as "Dutch tilts") that helped define *Batman*.

The show made its debut on January 12, 1966, and became one of the most spectacular successes in television history.

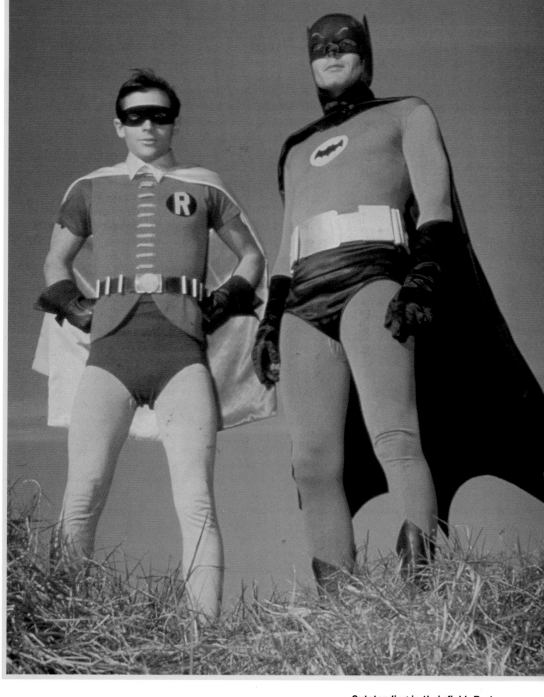

Outstanding in their field: Burt Ward as Robin and Adam West as Batman.

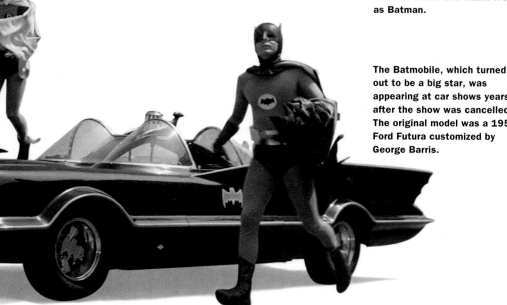

The Batmobile, which turned out to be a big star, was appearing at car shows years after the show was cancelled. The original model was a 1957 Ford Futura customized by George Barris.

BATMAN CONQUERS TV
Batman and Robin Go to Camp

Batman on television created the kind of sensation that sends pundits scurrying to the thesaurus in search of adjectives. Obviously the show was entertaining, but that hardly seemed explanation enough for such a phenomenal fad. Critics seized on the word *camp*, previously used to describe entertainments so inept that they became inadvertently humorous. The *Batman* show, however, was spoofing itself, and may have pulled crowds because kids could view it as high adventure while adults took it as a joke. To succeed in both areas meant walking a razor's edge, and many participants feel that the show only maintained the proper balance in its first, short season.

Timing was certainly significant. With *Batman*, a struggling ABC inaugurated the idea of a "second season," premiering the program in midwinter during an era when most of the new fall shows had started to lose some luster. *Batman* was also designed to capitalize on the growing acceptance of color television; art director Serge Krizman utilized the blazing hues of the comic book page to create vibrant visuals that put mere realism to shame. And at the time of a rock 'n' roll renaissance, the show had a great theme song by Neal Hefti: a simple, striding, rhythmic riff with a one-word lyric that incessantly called out the hero's name.

It was also the era of Pop Art, a period when artists and intellectuals began to look back with affectionate disdain on aspects of America's throwaway culture. For some this was an effort to view their lost innocence from an aesthetic distance, while others eschewed such self-consciousness and began carefully collecting the few remaining comic books of the bygone Golden Age. The TV show acknowledged Pop Art with a second season show called "Pop Goes the Joker," in which the Clown Prince of Crime passes off meaningless scrawls as priceless paintings.

The Joker was the second villain on the show, followed immediately by the Penguin. "I thought Burgess Meredith was great as the Penguin," says Bob Kane, "and Cesar Romero was great as the Joker." The show attracted top character actors even before it aired, and once it became a hit, successful performers actually clamored for roles. The bad guys included Academy Award winners Anne Baxter, George Sanders, Shelley Winters and Cliff Robertson, but as Kane says, "the original crew of villains" was the most effective. Notable among them was Julie Newmar, whom Kane calls "terrific" as the Catwoman. Adam West considered her "the sexiest woman on television" and she worked at it, using her dancer's training to strike provocative poses and altering her costume to emphasize her voluptuous figure. *Batman* provided her most famous role, and it did the same for Burgess Meredith, who, after decades of distinguished work on stage and screen, seems a bit bewildered that he is best known today as the squawking, waddling Penguin.

As Egghead, perhaps the most amusing menace concocted for the show without a comic book precedent, veteran villain Vincent Price was called upon to heave an egg at Robin. He ended up throwing dozens, egged on by a film crew who believed that actor Burt Ward's ego required some deflating.

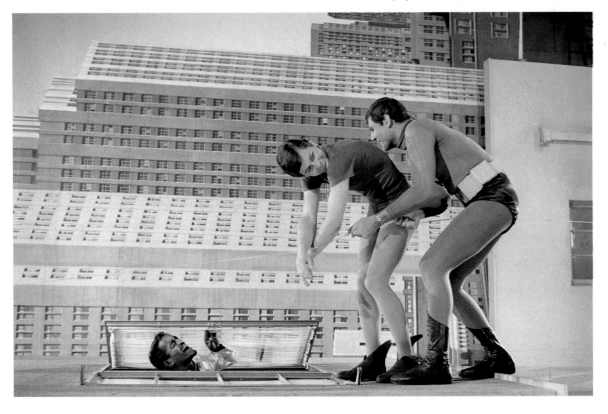

Stars like Sammy Davis, Jr., were so eager to be on the show that they agreed to the quick cameos that took place during the deliberately unconvincing "Batclimbs." This rehearsal shot shows how the climbs were accomplished, with the camera tilted at a ninety-degree angle.

If the villains were the spice of the show, the meat and potatoes were provided by a solid supporting cast. Alan Napier played a suave Alfred the butler (who was resurrected in the comics because the TV show was using him), Neil Hamilton portrayed a dignified Commissioner Gordon and Stafford Repp was a baffled Chief O'Hara. Aunt Harriet, introduced in the comics to allay suspicions about an all-male household, was played by Madge Blake. When Yvonne Craig was brought in as Batgirl in the third season, it was a sign of desperation. Ratings were down, and there was hope that a new character might give the show a shot in the arm. She couldn't have come at a worse time, however, since *Batman* had been cut back to one segment of thirty minutes each week and there was hardly room for her. And anyway, she couldn't help looking like a less challenging version of Catwoman.

The show was on its way out, falling as fast as it had risen. Bob Kane thinks it would have lasted longer if not for the saturation of two shows a week, but that programming policy guaranteed that even with a short run there were 120 episodes, enough to guarantee a solid syndication schedule. Cancelled in 1968, *Batman* has been running somewhere ever since.

Some serious fans deplored the program's patronizing air, but it created a new interest in comics and catapulted the Batman books to the top of the sales charts. "When the television show was a success, I was asked to be campy," says editor Julius Schwartz, "and of course when the show faded, so did the comic book." TV postponed the slump that followed the Silver Age, then left comics in worse shape than before. The idea of super heroes as camp relics of an outmoded sensibility was all but institutionalized, and journalists fighting deadlines are still starting their stories about comics with strings of the words superimposed over the show's fight scenes, from AIEEE! to ZAP! Post-Pop, comics would have to prove anew that they had something to offer. Fortunately, they had hidden allies in the millions of kids glued to their TV sets, who never knew that their colorful heroes were supposed to be only a joke.

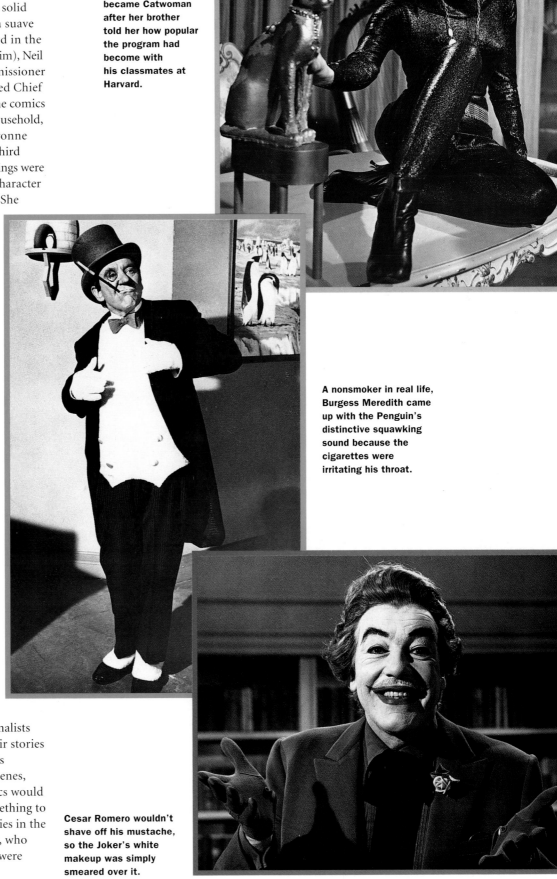

Julie Newmar became Catwoman after her brother told her how popular the program had become with his classmates at Harvard.

A nonsmoker in real life, Burgess Meredith came up with the Penguin's distinctive squawking sound because the cigarettes were irritating his throat.

Cesar Romero wouldn't shave off his mustache, so the Joker's white makeup was simply smeared over it.

The Batcave, a hero's hidden lair, became a suitcase full of fun with this eighteen- by eleven-inch vinyl version made by Ideal in 1966. It opened up to provide a playroom for plastic figures of Batman, Robin and the Joker, not to mention the Batmobile and Batplane.

BATMANIA
Caped Crusader Collectibles

Television executives theorized that the initial popularity of *Batman* resulted from its simultaneous appeal to adults and children. As the show's audience began to erode, it was the kids who remained loyal, and one reason for cancelling the show in 1968 was that prime-time advertisers weren't very interested in buying the attention of the very young. Yet viewed from another angle, the millions of kids represented a potential bonanza: their intense identification with Batman and Robin made them eager to own something more closely related to their heroes than just a sponsor's product. They wanted Batman merchandise, and manufacturers were quick to respond.

Relatively inactive for his first quarter century, Batman suddenly leapt out from Superman's shadow to become a licensing success story of unprecedented magnitude. Hundreds of different items were produced in quantities that totaled millions, and even after the show's brief run Batman merchandise continued to be a sturdy seller. There were Batman hats and Batman shoes, Batman puzzles and Batman games, Batman mugs and Batman glasses, Batman banks and Batman jewelry, Batman bubble gum and Batman toothbrushes to counteract the gum's more insidious effects. There was even a Batman wastebasket, and a lot of these items must have ended up in it, because mint condition artifacts from the heyday of Batmania (1966–68) are now collector's items worth many times their original price.

At the height of Batmania, these buttons were sold in vending machines. With variations in coloring and lettering, the fourteen designs actually became fifty-six.

The Batmobile became a steady best-seller for Corgi, which produced metal die-cast versions for more than a decade after the boom in 1966. This five-inch model is from the 1970s.

Aurora, a company that specialized in plastic model kits of pop culture figures, had the Caped Crusader in stock when Batmania struck in 1966; more models were added as the TV show took off.

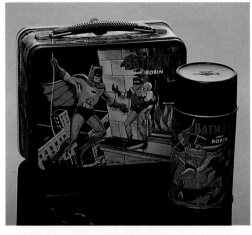

A perennial favorite, the Batman lunch box got its start with this model from Aladdin in 1966. Made of metal, many of the early lunch boxes have survived.

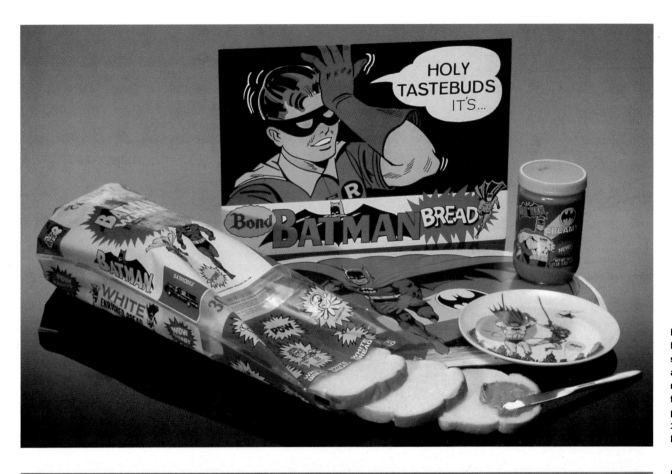

Batman bread was baked in 1966, the same year the plate and the sign were made. The placemat is from the 1970s, but the peanut butter is circa 1988, so watch that Batman sandwich!

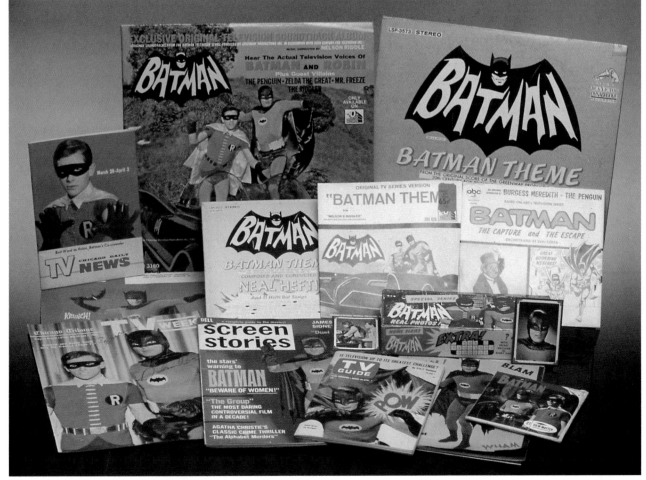

Most Batmania items featured generic images of the characters; pictures of the actors appeared on only a few items, including records, magazines, gum packages and a Viewmaster reel.

Saturday Morning Cartoons
Television Makes New Friends

When Superman returned to animated cartoons after an absence of almost a quarter of a century, it was television that brought him back. A lot had changed since the days of the lavish Max Fleischer version of Superman; by 1966 the production of animated shorts for theatrical release was rapidly becoming a thing

In various incarnations, this Hanna-Barbera program ran on ABC for years and years.

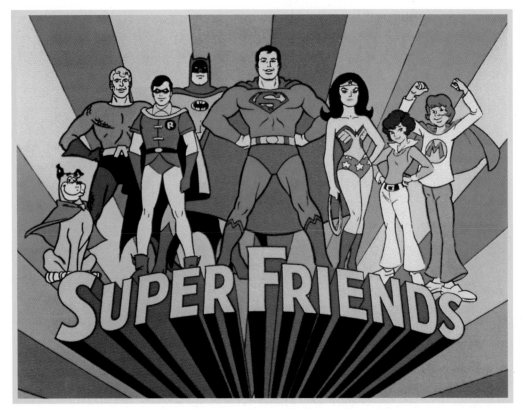

of the past, and cartoons could survive only by lowering their standards. Small budgets and mass production became necessities, and if cartoons lost some of their artistry, they were suddenly available in staggering quantities.

The first cartoon produced especially for television was 1949's *Crusader Rabbit*, a forerunner of producer Jay Ward's *Rocky and His Friends*, but the real turning point was achieved by Bill Hanna and Joe Barbera, whose breakthrough program was *Huckleberry Hound* (1958). The trick lay in making animated characters less animated, minimizing movement by such techniques as pulling a motionless character across the screen, or

drawing people with only their mouths in action. Critics decried this technique of "limited animation," which did look pretty pathetic compared to the old theatrical cartoons also available on TV, but young audiences didn't seem to notice the difference, especially when the new cartoons featured popular characters. As a result, DC's super heroes were much in demand to fill time slots in the Saturday morning lineups of all the major networks.

The New Adventures of Superman, "A Filmation Production," made its debut on CBS in September 1966, with DC's Mort Weisinger serving as story consultant. Soundtracks were especially important when motion was curtailed, so executive producer Allen Ducovny employed the old radio voices of Bud Collyer (Superman), Joan Alexander (Lois Lane) and Jackson Beck (narrator). The program was composed of short seven-minute adventures, some of them featuring Superboy (Bob Hastings) and his dog Krypto.

In 1967, CBS offered *The Superman-Aquaman Hour*, which repeated some material from the previous show along with segments featuring DC's super hero of the sea. He wasn't the best known character available, but his friendship with animals (even if they were oysters and octopi) seemed to make him ideal for kidvid. In any case, the show hedged its bets by presenting an entire army of unbilled DC heroes, including the Atom, the Flash, Green Lantern and Hawkman. The voice of Aquaman was provided by Ted Knight, and his segments were recycled for an *Aquaman* program in 1968. In the same year CBS presented *The Batman-Superman Hour*, using old Superman stories with new Batbits featuring Olan Soulé and radio personality Casey Kasem doing the voices of Batman and Robin. In 1969, the Dynamic Duo returned in *The Adventures of Batman*.

Model sheet drawings of Wonder Dog and Wonder Woman used by TV animators.

The idea of recycling cartoons for an ever-changing audience of young viewers reached its apogee when Hanna-Barbera introduced the *Super Friends* show on ABC in 1973. Loosely based on the Justice League, the show featured Superman (Danny Dark), Batman (Olan Soulé), Robin (Casey Kasem), Aquaman (Norman Alden) and Wonder Woman (Shannon Farnon), along with Wonder Dog and a couple of kids named Marvin and Wendy. After running for years, *Super Friends* was followed on ABC by *The All-New Super Friends Hour* (1977), *Challenge of the Super Friends* (1978), *The World's Greatest Super Friends* (1979) and *Super Friends: The Legendary Super Powers Show* (1984). Actors came and went, but Casey Kasem stayed on forever. Meanwhile, CBS kept going with

Aquaman on the job with an assist from the Blackhawks in a completed scene from a cartoon adventure.

An animation cel of Aquaman's Aquaflier, ready to be superimposed over an undersea background.

The Batman-Tarzan Hour and *The New Adventures of Batman* (both in 1977). Then NBC got into the act with *Batman and the Super 7* (1980) and *The Kid Power Hour with Shazam* (1981), the latter featuring the original Captain Marvel.

Probably nobody could have gotten his mind around all this except for Plastic Man, who had his own show on ABC in 1979, then came back the next year to join forces with his bouncing boy "Baby Plas." These shows came from Ruby-Spears Enterprises, which brought things full circle when it put its Superman program on CBS in 1988.

Such shows have not always been great, but they provided work for DC writers like Bob Haney and George Kashdan, and they helped support DC with licensing fees. They also created new generations of fans for the company's gang of super friends.

Alex Toth's bold storyboard for a *Super Friends* sequence shows the relationship between comics and cartoons, but the finished TV images rarely had this kind of impact.

SUPERMAN ON BROADWAY
It's Curtains for Clark Kent

Superman flew on stage, if only for a few seconds, in *It's a Bird, It's a Plane, It's Superman*.

Superman (Bob Holiday) performs a feat of strength with some help from a backstage forklift.

On March 29, 1966, while the *Batman* television show was taking America by storm, Superman arrived in New York in the first musical ever based on a comic book character. Newspaper strips had inspired a few Broadway shows previously, but *It's a Bird, It's a Plane, It's Superman* was something new.

The concept came from two *Esquire* magazine writers, Robert Benton and David Newman, whose humorous articles had encouraged songwriters Charles Strouse and Lee Adams to ask them for ideas. Benton and Newman were newcomers to the stage, but Strouse and Adams had recently enjoyed a big success with *Bye Bye Birdie*. The producer-director was Hal Prince, who would go on to such gigantic hits as *Cabaret*, *Evita* and *Sweeney Todd*. With all this talent behind it, *Superman* opened on Broadway to excellent reviews; in fact the *New York Times* called it "easily the best musical so far this season." Yet ultimately the show failed, closing on July 17 after 128 performances, and its creators are still wondering why.

David Newman blamed it on "capelash." In his 1974 autobiography, *Contradictions*, Hal Prince agreed that the show was a victim of bad timing, unable to compete with Batman on television even though the play was written a year earlier and was not an imitation. He also felt he hadn't hit his stride, that he could have done a better job directing after a little more experience. Although the Superman musical has its defenders, recordings and descriptions of the original production suggest weaknesses that may have taken their toll.

Top billing went to actor Jack Cassidy, a recognized star who performed enthusiastically but was essentially playing a supporting role. As egotistical newspaper columnist Max Mencken, he lusted after Lois Lane and vaguely encouraged the machinations of the villainous Dr. Sedgwick (Michael O'Sullivan), but in fact Cassidy's character was peripheral to the main action of the story. Sensing this, Cassidy disrupted rehearsals in his attempts to expand his role, thus throwing the play further off balance. An even less significant character, Mencken's secretary, got the best song in the show when she appraised Clark Kent in the rhythmic "You've Got Possibilities," belted out by future star Linda Lavin.

Most of the musical's songs lacked drive. Strouse and Adams appeared to be experimenting with attenuated lines, with additional phrases tacked on to the end; the results were

Photo: Van Williams

Photo: Van Williams

clever songs without memorable melodies or real momentum. The tricky orchestrations by Eddie Sauter emphasized the problems with arrangements that relied on counterpoint and tended to neglect the beat.

The script by Benton and Newman seemed similarly unfocused. Everyone's idea was to have fun with Superman without making fun of him, but the attempt to achieve balance between seriousness and spoof resulted in a story not entirely successful on either level. The show was too light to have the dramatic pull of many modern musicals, but it wasn't sufficiently hilarious to work as pure parody. The most ingenious touch was to have the villain work on the invulnerable hero's mind, using psychological methods to instill doubt and confusion. Yet Superman (Bob Holiday) recovered merely by reprising his musical declaration that "every man has a job to do, and my job is doing good," while his relationship with Lois Lane (Patricia Marand) went unresolved. Keeping Lois in the dark was of course true to the comic book tradition, but it negated the romantic resolution expected in a Broadway show.

It's a Bird, It's a Plane, It's Superman was perhaps most impressive as a spectacle. In one scene, the stage was filled with boxes through which the characters moved as if they were occupying panels on a comic book page. Superman flew through the air like Peter Pan, and in one stunt, he supported an entire platform full of people to prevent a deadly accident. In the finale, he fought off a gang of thugs played by back-flipping acrobats. Reasoning that such imagery might appeal to kids, Prince scheduled extra matinee performances, but they weren't enough to save the show.

In 1975, *It's a Bird, It's a Plane, It's Superman* appeared on ABC television in a version so universally deplored that it seemed likely to bury the play permanently. In 1989, however, Superman's fiftieth anniversary inspired more than twenty revivals around the country, and in 1992 a production at Connecticut's prestigious Goodspeed Opera House included new songs written by Strouse and Adams. Meanwhile, Strouse had demonstrated his facility at adapting comics with the mega-musical *Annie*, while Benton and Newman had become successful screenwriters whose hits included the 1978 movie *Superman*. Such ironies suggest that the first Broadway appearance of the first super hero may indeed have been the victim of bad timing.

The stage becomes a comic book page in a scene from *It's a Bird, It's a Plane, It's Superman.*

David Wilson played Superman when the musical show was presented on TV, almost a decade after its Broadway premiere.

POP ART
Comics Hang on a Wall

Like the *Batman* TV show, Pop Art carried the imagery of the comic book to a new audience. And like the oversimplified television foray, the introduction of comics into the world of fine art brought recognition to the comics while simultaneously threatening to embalm them.

For decades, artists striving to reach a museum rather than a mass medium had been tentatively exploring the impact of popular culture on the mental landscape of the twentieth century; in the 1960s, two American painters made a career of it. Andy Warhol and Roy Lichtenstein were in the vanguard of the Pop Art movement, and DC comics provided a main source of inspiration.

Warhol, whose sense of showmanship prompted him to dabble in almost every art form, first achieved notoriety by commandeering images from raffish venues like advertising and comics and transferring them to the traditional respectability of the framed canvas. Perhaps best known for immortalizing Campbell's soup cans and Brillo boxes, Warhol began painting characters from the comics in 1961. Choosing these figures for their familiarity—which he apparently perceived as banality—Warhol concentrated on newspaper comics, but he also produced a number of Superman paintings. Implicitly acknowledging the Man of Steel as an American icon, Warhol's work also seemed to suggest that Superman was passé, that he had become as familiar and yet as devoid of real meaning as a label in a supermarket.

While Warhol concentrated on content, Roy Lichtenstein concerned himself with form. In the stylization of comic book panels, Lichtenstein saw an abstract quality of design that matched the archetypal simplicity of certain ritualistic story elements. Ignoring the spectacle provided by the super heroes, he chose to concentrate on the elemental passions on view in the less popular genres of love and war. Pulling single panels out of their comic book context, Lichtenstein found pure pictures of a civilization's stereotypes in garish graphics depicting weeping women and murderous men.

Assiduously collecting and dissecting DC comic books like *Girls' Romances* and *G.I. Combat*, Lichtenstein drew his inspiration from the work of artists like Tony Abruzzo,

This Andy Warhol version of Superman hangs today in the office of DC's president, Jenette Kahn.

Roy Lichtenstein's 1963 painting *Drowning Girl* (right) is based on a splash panel (above) by Tony Abruzzo for *Secret Hearts* #83 (November 1962).

whose heartbroken girls defined the romance genre, and Russ Heath, whose sweating men and shining machines epitomized comic book combat. Of particular interest to Lichtenstein was artist Irv Novick, who had been Lichtenstein's superior officer in an army unit assigned in 1947 to create posters, signs and other artistic ephemera of military life. Fifteen years later, Novick was a journeyman comic book artist on DC titles like *All-American Men of War*, and the panels he drew were providing fodder for Lichtenstein paintings that would eventually sell for millions of dollars apiece.

Of course, Lichtenstein's paintings were more than simple copies, even if he has referred to his material as "swiped." He refined and re-designed his found images, altering details of color and composition and sometimes combining elements from several different panels. He also emphasized the mechanical aspects of comic book reproduction by applying color in dots that parodied the printing process. His technique was to draw a small version of his picture, then project it onto a canvas for painting, enlarged so "we can see how abstract and unreal it really is."

By putting a frame around comic book images, Pop Art simultaneously exalted and debased the medium. It was a way of looking at the work as an artifact of an obsolete culture, as a museum piece. The challenge for DC would be to rise above this left-handed compliment and produce work that readers could continue to recognize as relevant.

Part of this panel by Russ Heath, from *G.I. Combat* #94 (June–July 1962), found a place in Lichtenstein's painting.

This plane, from *All-American Men of War* #89 (January–February 1962), also showed up in "Okay, Hot-Shot." Art by Irv Novick.

"Okay, Hot-Shot," a major piece of Pop Art by Roy Lichtenstein, employs elements derived from several of DC's war comic books.

This 1975 self-portrait of DC publisher Carmine Infantino shows him at a board meeting with some of the characters he drew, including Adam Strange, Batman, two Flashes and the troublesome Gorilla Grodd.

ROOM AT THE TOP
New Owners and New Editors

By 1966, the year when Batman took television by storm, DC was undergoing radical structural changes. From a business point of view, the company had remained relatively stable for almost thirty years, although there were public stock offerings for the first time around 1961. That was the year when publisher Harry Donenfeld died, although his son Irwin and his partner Jack Liebowitz provided continuity through 1967, when DC was acquired by Kinney National Services. Originally centered on funeral parlors and parking lots, Kinney was expanding under the leadership of entrepreneur Steve Ross, and DC was one of its first entertainment acquisitions. In 1968, Kinney bought the Warner Bros. motion picture company; DC was a cornerstone of what would eventually become the Time Warner media empire.

Meanwhile, Carmine Infantino was rapidly rising through the ranks to a position of power unprecedented for an artist. Infantino's strong and innovative cover designs had brought him a job offer from Stan Lee at Marvel Comics in 1966, and in response Irwin Donenfeld promoted Infantino to DC art director. Infantino began to attend editorial meetings and present his sketches of cover concepts. "He passed them around to the various editors," says Julius Schwartz, "and we all agreed Carmine's covers were better." Covers are considered the key to sales, and some of Infantino's ideas—like the image of an empty costume, or the face-off between two squads of super heroes—have become industry standards.

After Irwin Donenfeld's retirement, Jack Liebowitz appointed Infantino editorial director. Putting an artist in such a position was something new at DC, where editors were traditionally most involved with stories and scripts, and Infantino emphasized the change by naming three other artists as new editors. They included Joe Kubert (who took charge of the war books he was already illustrating), Mike Sekowsky (best known for drawing the adventures of the Justice League) and Joe Orlando (long associated with EC titles like *Tales from the Crypt* and *Mad*). Additionally, Donenfeld hired Dick Giordano, an artist-editor who brought along some of his staff from the struggling Charlton Comics. Among them were artist Steve Ditko and writer Dennis O'Neil, nicknamed Denny by Stan Lee.

"Bringing in artists as editors was a very good idea," says Joe Orlando. "We shook up a lot of people, like the production department. If they thought a line would print well then that artist was hired, and a lot of artists had not been hired because they weren't working in the DC house style."

Orlando felt that an important quality he brought to his new job was empathy for the artists, but like Infantino he became involved in editing and gradually cut back on his own drawing. "It's physically tough," says Orlando.

One of the last new characters drawn by Infantino, Deadman helped inaugurate a trend toward dark heroes. The cover of *Strange Adventures* #205 (October 1967) was inked by George Roussos; the script was by Arnold Drake.

"It's a grind." On the other hand, Dick Giordano and Joe Kubert couldn't keep away from the drawing board. "I said unless I could continue drawing I wasn't interested in the job at all," Kubert recalls. His transition was comparatively easy, since he continued to work on the same characters, but for his colleagues things would be more challenging.

Infantino's administration proved to be a transition period of sorts. Flagship characters like Superman and Wonder Woman endured alterations, and countless new characters were introduced (most of them without much success). After years of stasis, the staff was augmented by young talent, while pillars like editor Mort Weisinger retired. There was a struggle for direction as the industry sank into a slump after the Pop Art boom, while cover prices crept inexorably upward and the small retail outlets that had supported comics became obsolete. For some professionals, it looked like the lettering was on the wall. A group of veteran writers, including Bill Finger, Gardner Fox and Otto Binder, pressured DC to provide pensions and insurance; they ended up losing their jobs.

"Comics were really a dying business at that time," says Paul Levitz, who attended college while working as Joe Orlando's assistant. Levitz found it a great time to learn from the old pros "who didn't have a lot of pressure in their lives at that stage because the business wasn't growing." In turn, youngsters like Levitz would grow into the business and gradually help turn it around.

Carmine Infantino was promoted to publisher in 1972, but his era was over a few years later. He had been determined to maintain DC's presence on the newsstands by publishing a large number of titles, but the downward spiral of comic book sales often meant that only the income from licensed merchandise kept the company profitable. By 1975, the red ink wasn't only on DC's covers, and management decided it was time for a change. "We agreed to disagree," says Infantino.

Infantino remains controversial among his colleagues. "I might have been tough," he says, "but I always respected creative people. And I was never tougher on anybody else than I was on myself." By making changes and opening the company to innovation, Infantino helped comics struggle toward the future. As Joe Kubert says, "Carmine was a guy who really devoted his life to the job, to what it was he wanted to do—because he loved it, and he was so deeply involved."

New editor Dick Giordano brought artist Steve Ditko and writer Denny O'Neil to DC, where their first creation had a sinister appearance and some self-deprecating humor. The initial issue is dated May–June 1968.

This team of spies got started in May 1968 but folded after seven issues without ever identifying their mysterious leader. Cover by Frank Springer and script by E. Nelson Bridwell.

SQUARE PEGS
Experiments with Weird Heroes

Even stuffed and mounted, the grotesque gunfighter will prove to have an itchy trigger finger in the *Jonah Hex Spectacular* (Fall 1978). Script by Michael Fleisher and art by Russ Heath.

Some strange characters emerged during the Infantino era at DC, when new editors, writers and artists decided to take their chances with unconventional ideas. The editor most associated with such experiments was Joe Orlando, who got his training on the wild and woolly EC Comics of the 1950s. In fact, one of Orlando's first moves was to revive a DC character from the 1950s, the Phantom Stranger. "Now there I really developed the book," Orlando says. After a tryout in *Showcase*, the first new issue of *The Phantom Stranger* appeared in May–June 1969, but it was composed almost entirely of reprints because editorial director Infantino wasn't convinced it would be a winner. When sales turned out to be solid, Orlando was able to commission a new script by Robert Kanigher and have it illustrated by rising star Neal Adams. The series ran for a solid seven years, and along the way included some adventures of a mysterious woman known as Black Orchid. Golden Age editor Sheldon Mayer wrote most of the series for Orlando, who was trying to prop up a flagging *Adventure Comics;* one gimmick involved keeping Black Orchid's secret identity a secret even from the readers.

Adventure Comics also became home for the Spectre, the sinister Golden Age character who got a new lease on life after Orlando was mugged and decided the world needed a really relentless super hero. The character came back with a vengeance in *Adventure* #431 (January 1974) and quickly became a cause of controversy. Orlando plotted the stories with writer Michael Fleisher, and they emphasized the gruesome fates of

The elusive Black Orchid takes a bow in *Adventure Comics* #428 (July–August 1973). Pencils by Bob Oksner and inks by Dick Giordano.

criminals who ran afoul of the Spectre. The Comics Code had recently been liberalized, but this series pushed its restrictions to the limit, often by turning evildoers into inanimate objects and then thoroughly demolishing them. Jim Aparo's art showed criminals being transformed into everything from broken glass to melting candles, but Fleisher was quick to

One more crook bites the dust at the hands of the Spectre in *Adventure Comics* #432 (March–April 1974). Script by Michael Fleisher and art by Jim Aparo.

point out that many of his most bizarre plot devices were lifted from stories published decades earlier.

"Carmine Infantino and I found out that the word *weird* sold well," Orlando recalls. "So DC created *Weird War* and *Weird Western*." Jonah Hex was the star of *Weird Western Tales*, the new name for *All Star Western* as of June–July 1972. Hex, a disfigured bounty hunter with a soft streak, was originally created by writer John Albano. "You can look back and see that he's a western Two-Face," says Orlando. "He's the Phantom of the Opera, too." The character was popular enough to get his own comic

book, *Jonah Hex*, which began in March–April 1977 and continued for eight years. Many of the best Hex stories were the work of Michael Fleisher. In his most notorious tale, Fleisher envisioned the gunfighter growing old, getting shot and ultimately being stuffed to serve as an exhibit in a wild west show.

The weird heroes of this era were not always successful, but they represented attempts to expand the borders of DC's comics, often by introducing a dark streak into the company's predominantly sunny personality. "That was the fun of being an editor," Orlando says. "Taking a risk."

A bizarre series planned for only seven episodes, *Manhunter* featured a dazzling script by Archie Goodwin and a new take on action sequences by rising artist Walter Simonson. The hero, revived from suspended animation, must do battle with countless clones of himself. From *Detective Comics* #442 (August–September 1974).

A Time to Be Topical
Comics Strive for Relevance

I was a little late to be a real hippie, born a little too early, but we were in a rebellious generation and there was real political concern." That's how writer Denny O'Neil describes the conditions that produced one of the most widely publicized comic books in history. When *Green Lantern/Green Arrow* #76 was published in May 1970, it took the country by surprise and was recognized as an important innovation by publications like the *New York Times*. This single issue was perhaps the definitive demonstration that a new type of talent was taking center stage at DC.

Editor Julius Schwartz assigned *Green Lantern* to O'Neil and artist Neal Adams because sales were slumping and some sort of new approach was required. O'Neil decided to go for some "experimental stuff," and one of the changes was to throw Green Arrow into the mix. Originally a hero with lots of gimmicks but no personality, the Emerald Archer had already undergone some transformation when Neal Adams changed his appearance, but O'Neil took the new look of a bearded Robin Hood and embellished it with a touch of bohemian rebelliousness. "If you established Green Lantern as sort of like the world's best cop, a good guy, but very much an establishment guy, you needed somebody to play off that. So it was almost the plot as much as anything else that dictated Green Arrow's altered personality," explains O'Neil.

In the opening of the new series, Green Lantern rescued a businessman being attacked by a young thug, only to learn that the victim was actually a slumlord bent on throwing his elderly tenants out into the street. In a celebrated sequence, an old man berated the interplanetary hero for devoting his efforts to helping races with blue skins, orange skins and purple skins, but never having enough time for the black skins on his own world. Meanwhile, the hipper Green Arrow sneered at his colleague's insensitivity to social problems, urging him to "Go chase a mad scientist or something!"

"It was super heroes questioning themselves in fictional stories for the first time," says O'Neil. "It wasn't a bad thing to do." Of course there was a difficulty inherent in the approach,

A pile of old clothes spontaneously comes to life and adopts an alternative lifestyle in Joe Simon's *Brother Power, the Geek* #1 (September–October 1968).

A teenager is lured into politics by the corrupt "Boss Smiley" in the first issue of Joe Simon's satirical *Prez* (August–September 1973).

Green Arrow's sidekick, ironically named Speedy, was revealed to be a drug addict in *Green Lantern/Green Arrow* #86 (November 1971). Script by Denny O'Neil, pencils by Neal Adams and inks by Dick Giordano.

because confronting a super hero with racism meant that he would be obliged to admit defeat. He could hardly announce that he had solved the problem, as Jerry Siegel realized in comparable circumstances when Superman took on World War II. So Green Lantern was exposed in his essential helplessness, and while that might be seen as a salutary lesson for a single story, it made for a self-destructing series.

"Even if these characters existed," O'Neil observes, "the fact that they have preternatural powers would not solve the world's real problems." However, the people who bought super hero comics may not have wanted to be reminded of this fact on a monthly basis: this series of stories was canceled after thirteen issues. "I don't know why," says O'Neil. "Even editors in those days didn't see sales figures." Still, DC seemed proud of the stories and the publicity they received. In fact, DC made other efforts to produce topical comics, but none of them lasted long, either.

Steve Ditko, the original artist on Marvel Comics' popular Spider-Man, came to DC from Charlton Comics along with writer Steve Skeates, and together they produced an early series that indirectly reflected the division among Americans over policy in Vietnam. After a *Showcase* tryout, *The Hawk and the Dove* #1 took flight in September 1968. Two young brothers are granted wondrous powers to avenge an assault on their father, a judge, and extend their political disagreements into arguments over crime-fighting tactics. Despite skillful execution, *The Hawk and the Dove* lasted only six issues.

Joe Simon, a Golden Age veteran known for his collaboration with Jack Kirby on characters like the Boy Commandos, offered his interpretation of alternative lifestyles with the fanciful *Brother Power, the Geek*, but this 1968 offering lasted only two issues. And Simon rounded off the era of topical comics with the debut of *Prez* (August-September 1973). The adventures of a teenage president of the United States, however, lasted only four issues.

So in longevity as well as impact, *Green Lantern/Green Arrow* was the most significant comic book of its type. It dealt with issues from feminism to pollution, and even took the sometimes sanctimonious Green Arrow down a peg when it was revealed that his young side-kick Speedy had become a drug addict. "I remember talking to a friend at the time and saying we were trying new stuff," says O'Neil. "But I'm very surprised that people remember."

Among the most famous panels in comic book history are these from *Green Lantern/Green Arrow* #76 (May 1970). Script by Denny O'Neil, pencils by Neal Adams and inks by Dick Giordano.

Two brothers, the Hawk and the Dove, symbolizing aggression and pacifism, made their debut in *Showcase* #75 (June 1968). Story by Steve Skeates and art by Steve Ditko.

REVAMPING THE CLASSICS
The Old Guard Gets a New Look

In a time of new owners, new editors and new heroes, it was perhaps inevitable that DC would attempt to update its best-known characters. More than a quarter of a century after their creation, Superman, Batman and Wonder Woman were familiar figures in the public's imagination, yet sales suggested that they could not afford to rest on their laurels. In an era of innovation, the classics ran the risk of being left behind, but modernizing them proved to be quite a challenge. As it turned out, the same writer was selected to rework all three of DC's flagship heroes. "I do seem to have been in on a lot of events," admits Denny O'Neil. "Part of it was just to keep the job interesting for myself."

The character who got the most dramatic overhaul was Wonder Woman. In 1968 she lost her costume (metaphorically) and her powers (literally) and was sent out into the world as a mere mortal. "I'm not ashamed of what we did," says Denny O'Neil today, "but I'm not sure I'd do it again." O'Neil was also editing the book at the time, but the instructions to do something new with the Amazon came from head honcho Carmine Infantino. Despite her fame, her sales were dismal, so in

Wonder Woman #179 (November-December 1968) Princess Diana relinquished her magical abilities rather than leave earth along with the other Amazons of Paradise Island. As if that weren't enough, in the next issue her longtime love interest Steve Trevor was killed. She was given a blind martial arts instructor named I Ching, and before long she was quite capable of defending herself without magic ropes or bracelets.

O'Neil's idea was to turn Diana Prince into a contemporary, independent woman, but *Ms.* magazine editor Gloria Steinem was quick to protest that a feminist icon had been stripped of her strength. Not that *Ms.* readers had been buying *Wonder Woman* in significant numbers, but "The New Wonder Woman" didn't attract a big audience either, and the old version was back in business after twenty-five issues.

The changes in *Batman* were far more successful, perhaps because in large measure they consisted of going back to basics. "The TV show had gone off the air and they didn't know what to do with him," says Denny O'Neil. "I just read a lot of the old *Batman* comics and tried to take him back to before the invention of Robin."

Editor Julius Schwartz, who says he also favored "going back to where Batman was at the very beginning," gave O'Neil the assignment and paired him with artist Neal Adams. The two became the hot team in comics, although O'Neil notes that "in those days you didn't collaborate." Scripts and drawings were handled through the editor's office, and the writer and artist rarely even met. Still, says O'Neil, "I was always surprised and delighted to see the final result." The influential Adams style moved comics closer to illustration than cartooning,

A mod Amazon temporarily kisses the past goodbye in *Wonder Woman* #178 (September–October 1968). Pencils by Mike Sekowsky and inks by Dick Giordano.

The new Superman snacks on kryptonite and likes it in *Superman* #233 (January 1971). Pencils by Curt Swan, inks by Murphy Anderson and script by Denny O'Neil.

MMMM... NOT BAD! A TRIFLE *STALE*...

...AND IT COULD USE A BIT OF *SALT*...

...BUT ALL IN ALL, A NICE LITTLE SNACK!

CONTINUED ON 2ND PAGE FOLLOWING.

EVEN *CRIMINALS* GET *OLD!* THOSE WHO DON'T, END UP IN PRISON, THE *GUTTER...* OR THE *GRAVE!*

A brooding Batman returns to his role as avenging angel in this panel from *Batman* #251 (September 1973). Script by Denny O'Neil, pencils by Neal Adams and inks by Dick Giordano.

Elegant stylization of the long-eared Batman from *Detective Comics* #475 (February 1978). Pencils by Marshall Rogers, inks by Terry Austin and script by Steve Englehart.

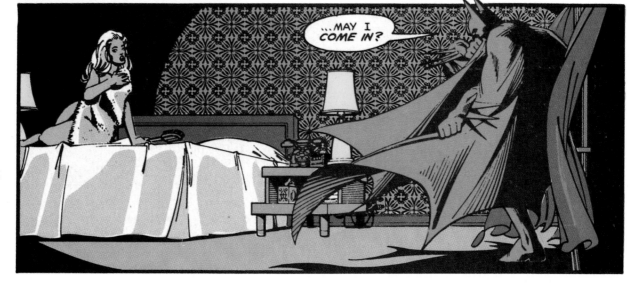

...MAY I COME IN?

and he brought a menacing mood to Batman's adventures that was augmented by Dick Giordano's dark, brooding inks. O'Neil's interpretation of Batman as a vengeful obsessive-compulsive, which he modestly describes as a return to the roots, was actually an act of creative imagination that has influenced every subsequent version of the Dark Knight.

"I didn't want to do Superman," says Julius Schwartz, but when his friend Mort Weisinger retired in 1970, Schwartz was the natural choice to succeed him. "I said I would do it if I could make changes," says Schwartz. "And I said I wanted the best writer at the moment. That was Denny O'Neil, who was very reluctant to do Superman."

"Superman at his extreme was able to blow out suns the way you blow out birthday candles," says O'Neil, whose fantasies were customarily less grandiose. "We decided to scale Superman back because I thought that would make stories possible." So when the revised version appeared in *Superman* #233 (January 1971), the story called "Superman Breaks Loose" included numerous ideas to make him more manageable. A nuclear reaction left Superman much less

super but eliminated all kryptonite and the repetitious plots that went with it. The robot duplicates who got Superman out of many a tight spot were also jettisoned. Schwartz wanted a more modern wardrobe for Clark Kent and got it; he also gave the reporter a new job. "I wanted to take him out of the *Daily Planet* and put him on television."

Artist Curt Swan liked the changes. "Go with the times, absolutely," he says. Working with inker Murphy Anderson, Swan produced some of the best Superman art of his long career during this period, but some of the new ideas didn't last. "After a year or so they decided I was making too many changes," says Schwartz. The reluctant Denny O'Neil soon left the feature, and although there were talented replacements like Cary Bates, they were less inclined to buck tradition. The Superman lore accumulated over decades had taken on a life of its own, and soon Hollywood would be enshrining it anew.

Clark Kent as a stylish TV newsman in the groundbreaking *Superman* #233 (January 1971).

EXACTLY FOUR SECONDS LATER...

CLARK KENT FOR *WGBS-TV* AGAIN! THE MAIL ROCKET IS IN FINAL COUNTDOWN...

HAUNTED HOUSES
Fear as an Art Form

By 1971, the Comics Code had lost some of its teeth, and comic books had won back some of their fangs. Changing times had made many of the Code's more drastic provisions seem obsolete, as was demonstrated when the issues depicting Green Arrow's fight against drug addiction were successfully distributed without the Code's seal of approval. With the liberalization of the Code, rulings against characters like vampires and werewolves were lifted, which was good news for editor Joe Orlando. "Doing horror was my job," he says. "I liked it."

House of Mystery, which had been around since 1951, was one of Orlando's first assignments when he became a DC editor. "It was a reprint book," he says. "For the first few issues they gave me some terrible old science fiction stories, and I was allowed to buy seven or eight new pages, maybe ten at the most. And a cover." Necessity became the mother of invention as Orlando drew on his experience with the old EC horror line in an effort to make the old stories seem more palatable. "That's why I developed my intro character, which was not a new idea, but for me became a useful tool. I had him make fun of the story," Orlando explains. The host for *House of Mystery* was the bewhiskered and bespectacled Cain. His brother Abel, another Orlando creation, soon began introducing tales in *House of Secrets*, then being edited by Dick Giordano. Eventually Orlando took charge of both *House* comic books.

"At the beginning, because I was an outsider, I wasn't getting the best DC artists and DC writers," Orlando says. He bought scripts from *Tales from the Crypt* veteran Jack Oleck, then began working with new talent like Len Wein and Marv Wolfman. "I would come up with a beginning and an end and I would give it to a writer," says Orlando, who also worked to develop new artists like Mike Kaluta and Berni Wrightson. With his shadowy, crepuscular style, Wrightson would become the top new horror artist of the decade. Orlando began to attract the better DC artists, like Neal Adams, as well as colleagues from the EC era like Wally Wood and Al Williamson. With room for several short stories in each issue, the horror comics became a showcase for artists, a gallery for stylists of mood and atmosphere. "You create a good product, something that people want to be in," Orlando explains. "They want to be there because they want to be with their peers."

"It was a very exciting time creatively," says Paul Levitz, who was Joe Orlando's assistant at the time. "Joe is one of the most extraordinarily wide-ranging creative people I've run across. He has a very peculiar, personal kind of intelligence in how he dissects things and finds ways to make them work." In a few short years, Orlando took the formerly despised horror genre and transformed it into an aesthetic success that also outsold most of DC's super heroes. The next step was to introduce a monster who would become one of the few comic book characters since the Golden Age to achieve worldwide fame.

See what reading this stuff can do to you? Cover by Mike Kaluta for *House of Mystery* #201 (April 1972).

It's ice hockey vs. figure skating in this old-fashioned horror cover by Nick Cardy for *House of Secrets* #114 (December 1973).

Horror hosts Abel and his big brother Cain, drawn by Jerry Grandenetti for *House of Secrets* #81 (August–September 1970).

Wally Wood illustrates Jack Oleck's script, playing on a kid's fear of doctors, in *House of Secrets* #96 (February–March 1972).

A dame and a dinosaur prove to be a potent combination in "The Beautiful Beast," from *House of Mystery #185* (March–April 1970). The artist is Al Williamson, who had worked with editor Joe Orlando on EC comics like *Weird Science* and *The Vault of Horror*. Williamson's atmospheric technique, which relied on subtle textures as much as hard lines, was not typical of traditional DC art. "A lot of good artists hadn't been hired because they didn't have the DC house style," Orlando says. "I broke the rules of house art and got complaints from the production department." Horror comics, not previously one of DC's strong suits, proved to be a laboratory that produced not only monsters, but also some interesting drawing styles.

SWAMP THING
Mulch Ado about Bayou

Half-human and half-hummock, the original Swamp Thing makes his first appearance in *House of Secrets* #92 (September 1971). Art by Berni Wrightson and script by Len Wein.

"FOLKS 'ROUND THESE PARTS SAY THAT FELLA NEVER *DIED*--THAT HE *MINGLED* WITH THE SWAMP--BECAME PART OF IT! EVERY TIME SOMEBODY *DISAPPEARS* IN THAT BOG, FOLKS SAY IT'S THE *SWAMPSTER* THAT DID IT--LOOKING FOR COMPANY TO PASS THE LONELY YEARS..."

This prototype for Swamp Thing turned out to be a man in a rubber suit. Script by Len Wein and art by Tony DeZuniga for *The Phantom Stranger* #14 (July–August 1971).

Growing like a fungus in the pages of editor Joe Orlando's horror comics, a gigantic mass of moss unexpectedly emerged as one of DC's most beloved heroes, and one of the few comic book characters recognized by people who don't read comics. "They know the name," says co-creator Len Wein. "It has become a household word." The name "Swamp Thing" first appeared on a little eight-page story in *House of Secrets* #92 (September 1971), written by Wein and drawn by Berni Wrightson. In essence a rather commonplace tale about a murdered man who rises from the grave to punish his killer, it was made memorable by the gradual revelation that the Swamp Thing was more hero than horror, and more to be pitied than feared. Enhanced by Wrightson's gothic grotesquerie, the story was greeted with such enthusiasm that a regular series became all but inevitable.

When *Swamp Thing* #1 emerged in October-November 1972, it was the result of painstaking plot sessions among Orlando, Wein and Wrightson. They all realized that in itself the idea of a muck monster spontaneously generating itself was nothing new; in fact, *Mad* had mocked it as a genre commonplace back in 1953. Orlando added plausibility to *Swamp Thing* by suggesting that the hero, newly christened Alec Holland, be a scientist with a formula to end famine by speeding up plant growth. "I think that formula really made a success of the Swamp Thing," says Orlando. The invention provided a motive for Holland's murder by secret agents, set up a long-running espionage subplot, and helped explain how Holland returned as an overgrown vegetable.

After ten memorable issues, the team broke up when Berni Wrightson dropped out. "He was great," says Joe Orlando, but like many artists of his generation, Wrightson was restless. Wein left a few months later, and no replacements could capture the unique flavor of the series, which folded after twenty-four issues. *Swamp Thing* might have ended there, no more than a bright moment in the medium's long history, but the character had caught Hollywood's eye, and plans for a film revived the comic book as *The Saga of Swamp Thing* in May 1982. The editor was Len Wein.

The new writer was Marty Pasko, and the artists were drawn from the first graduating class of the Joe Kubert School of Cartoon and Graphic Art. Tom Yeates was first, and was succeeded by penciller Steve Bissette and inker John Totleben. These two took Swamp Thing's classification as vegetation very seriously,

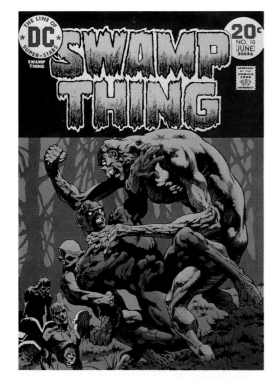

By *Swamp Thing* #10 (May–June 1974), Wrightson's lumpy monster had developed the body of a super hero, perhaps to distinguish him from the misshapen Un-Men unleashed by the villainous Arcane.

humanity and soul." Trouble emerged, however, with "Love and Death," the story in *Swamp Thing* #29 (October 1984). Artist Steve Bissette blames a double-page spread depicting the series heroine surrounded by "zombies with holes in their skulls and flies everywhere." The Comics Code Authority objected to the images, then read the story and realized that the machinations of the villain Arcane had led to a case of possession that could conceivably be interpreted as incest. "Because of that old standby of the comics industry, the deadline, there was not time to have changes done," Bissette says. "Jenette Kahn and Dick Giordano stood by the story and let it run without the Code," says Berger. DC soon decided that the quality of *Swamp Thing* justified its continued publication without interference from the Comics Code. The label "Mature Readers" was eventually affixed, and the way was opened for an entire line of sophisticated comic books.

producing a monster who bristled with roots and leaves and vines; to match their fecundity, Len Wein solicited scripts from Alan Moore. "I think I was just about the first British writer brought into American comics," says Moore. As Wein recalls it, "I saw a brilliant writer, and that's my job as an editor."

The team of Moore, Bissette and Totleben took flight at once. "We found out we all wanted to do the same thing with the character," says Bissette. "Alan immediately kicked it into gear with issue 21, 'The Anatomy Lesson.' I had never read a comic script like that in my life." Moore's inspiration, presented in unusually evocative prose, was that vegetation driven wild by the "bio-restorative formula" could have absorbed Alec Holland's memories but not brought him back to life. Science would prove that Swamp Thing was not a walking corpse, but what Moore calls "a kind of earth elemental." Moore wanted to reinvent "a character that I could believe in more, who made more sense to me and who fitted more with the worldview I had at the time." In short, Moore planned a purposeful plant with strong ecological opinions, not the suffering scientist he describes as "a little bit like Hamlet covered in snot."

Karen Berger, a new editor whose books included *House of Mystery*, came on as Moore's editor after a few issues. "I think Alan was the first writer in mainstream comics who was writing for adults," she says. "He was writing a horror comic, but one with a lot of

"Don't forget to read all your vegetables," says Steve Bissette, who drew this pencil study for the cover of *Swamp Thing* #43 (December 1985).

Swamp Thing enters Hell, with Jack Kirby's Demon as a guide. Alan Moore is that rare comics writer whose characters spout theology in verse. Pencils by Steve Bissette and inks by John Totleben, for *Swamp Thing Annual* #2 (1985).

Berni Wrightson's disturbing cover for *House of Mystery* #195 (October 1971) draws its inspiration from a script written by Jack Oleck and illustrated inside the comic book by Nestor Redondo. The story, with a typical twist ending, depicts a criminal who is convinced that the bat attacking him is an agent of supernatural retribution, when in fact it is only a mother protecting her young. Wrightson's eerie image takes things one step beyond, its tortured figures suggesting that man and beast are about to merge. Wrightson has gradually drifted away from comics, but he remains one of the top horror illustrators of his generation, adding his pictures to the words of such novels as Stephen King's *Cycle of the Werewolf* and Mary Shelley's *Frankenstein*.

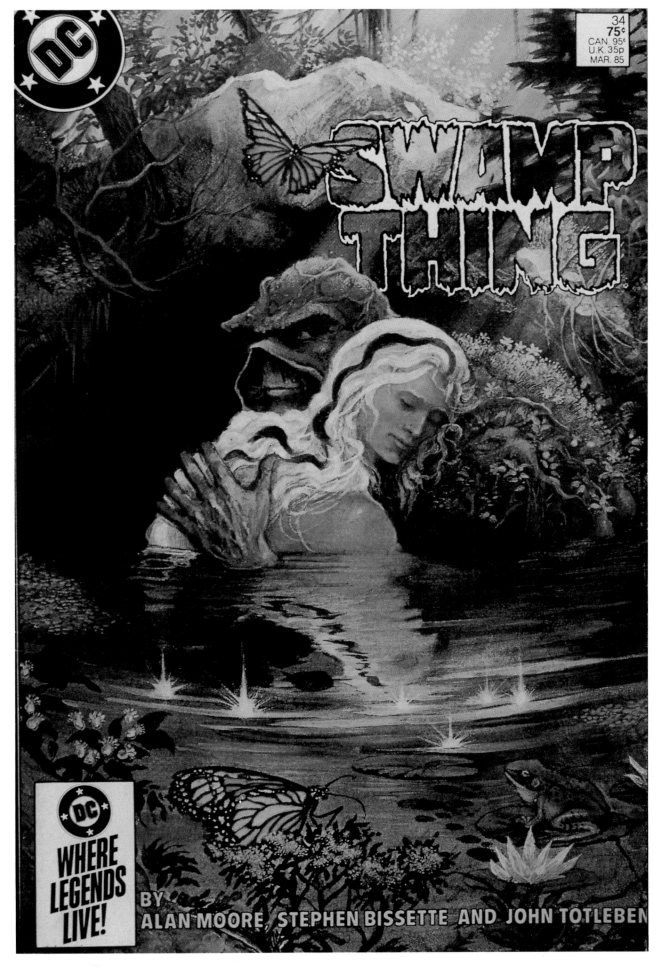

"We had just done a story where Abby dies and is sent to Hell, and Swamp Thing goes down to rescue her," recalls artist Steve Bissette. Out of sympathy for the beleaguered characters, Bissette suggested to writer Alan Moore "a story where Abby and Swamp Thing just get to be in the swamp and enjoy being with each other." The result was a charming tale about love outside the animal kingdom, with transcendental communication achieved after Abby tastes the fruit of her favorite plant. This cover, for *Swamp Thing #34* (March 1985), was drawn in pencil by Bissette and then painted rather than inked by John Totleben. "Steve and John shaped Swamp Thing as much as I did," says Moore, and adds, "There was an incredible rush of energy that circulated amongst us in those days."

THE FOURTH WORLD
New Gods on Newsprint

An escape artist who is more magical than he might appear, Kirby's *Mr. Miracle* took off in March–April 1971. Inks by Vince Colletta.

"**M**y job is to involve the reader," Jack Kirby used to say. He had been doing the job for decades, introducing characters from the Boy Commandos to the X-Men, by the time of his return to DC in 1970 for a major burst of comic book creativity. Kirby was recruited from rival Marvel Comics by editorial director Carmine Infantino; incentives included the chance to write, draw and edit his own stories. After years of successful collaborations with first Joe Simon and then Stan Lee, Kirby was ready to strike out on his own. Best known as an artist, he was also an indefatigable source of plots and characters, and he intended to create his magnum opus.

The result was an epic concept that dictated the storylines of four separate comic book series, integrating them in a way that was unprecedented at the time but has since become commonplace. Equally revolutionary was the idea (never fully accepted by Infantino) that publication would cease after the stories had reached a climax. Now called a limited series, this was another idea that later gained acceptance; Kirby, however, cared less about formats than about his vision of a modern myth.

"Here we were, a society without the kind of gods that used to exist, or the legends that used to travel back and forth with tribes. The tribes had each told the same stories in their own way, and I gave those stories the power of the old concepts with characters from our own day," Kirby said. He wanted to call his new myth "The New Gods," but that became the title of just one of his comic books, and fans who picked up on a cover blurb dubbed his interlocking comics "The Fourth World."

Strangely enough, the Fourth World first appeared in issue 133 of *Superman's Pal Jimmy Olsen* (October 1970), which Kirby agreed to take over in exchange for the chance to launch three new books of his own. *The New Gods* and *The Forever People* made their debut in February-March 1971, and *Mr. Miracle* followed a month later. *The New Gods* was the flagship; there Kirby delineated his dream about a war-torn planet that had been literally blown in half to create the battling worlds of New Genesis and Apokolips. In the seventh issue, which he called his all-time favorite story, Kirby revealed that a truce between New Genesis and its evil enemies had been engineered when the two leaders exchanged their infant sons. Orion, son of the monstrous villain Darkseid, became the hero of the New Gods, while the abandoned scion of the benevolent Highfather became the tormented magician Mr. Miracle.

Kirby gave his characters names ranging in tone from Desaad to Scott Free, and created dialogue veering wildly from hip chatter to bombastic grandiosity. Visually he remained the master of monsters and machines, and his images of massive bodies battering each other set standards for generations of artists. "I think it's a person's background that shapes the kind of stories he tells," said Kirby, who often recalled the violence of the New York neighborhood where he was raised. He called his career in comics "better than fighting on an East Side street corner," but those brawls were never far from his mind.

A combination of discouraging sales and disagreements with Infantino canceled Kirby's epic before it reached its end, but a core of earnest admirers remains, and the unfinished series became one of the medium's most powerful influences. "I love comics," Kirby declared. "It was my way of talking to friends."

The monstrous Darkseid, shown here with his stooge Desaad, outlived the Fourth World to become an enduring DC villain. From *The New Gods* #11 (November 1972). Inks by Mike Royer.

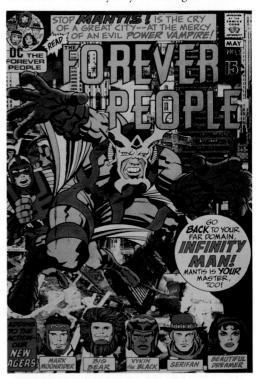

Immigrants from New Genesis to Earth, these heroes were Kirby's version of hippies, from *The Forever People* #2 (April–May 1972). Inks by Vince Colletta.

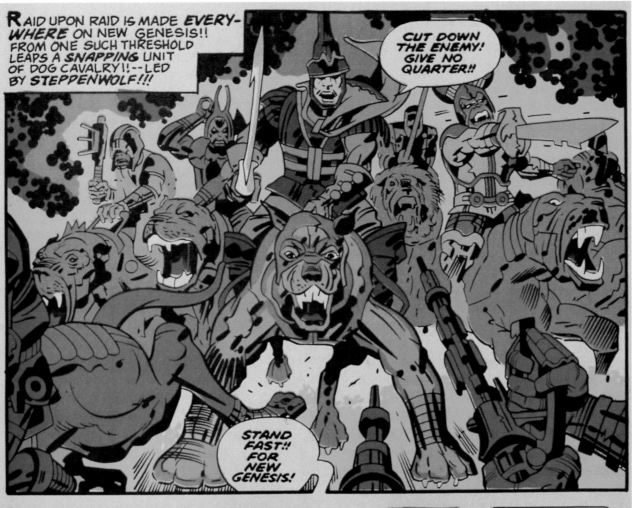

RAID UPON RAID IS MADE *EVERY-WHERE* ON NEW GENESIS!! FROM ONE SUCH THRESHOLD LEAPS A *SNAPPING* UNIT OF DOG CAVALRY!!--LED BY *STEPPENWOLF!!!*

CUT DOWN THE ENEMY! GIVE NO QUARTER!!

STAND FAST!! FOR NEW GENESIS!

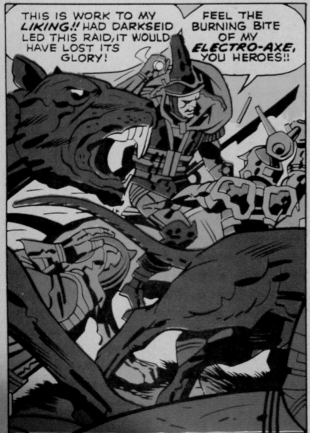

THIS IS WORK TO MY *LIKING!!* HAD DARKSEID LED THIS RAID, IT WOULD HAVE LOST ITS GLORY!

FEEL THE BURNING BITE OF MY *ELECTRO-AXE,* YOU HEROES!!

PRAISE YOUNG DARKSEID FOR *YIELDING* THIS COMMAND TO ME!! THIS IS WHERE A LUSTY WARRIOR SHOULD BE!!

WHAAK!

13

Steppenwolf, uncle of the demonic Darkseid, leads his canine corps into "The Great Clash," the epic battle between good and evil that forms the background for Jack Kirby's Fourth World. Armored brutes, angry beasts and the Electro-Axe are only part of Kirby's vision of Techno-Cosmic War, which also includes such strange devices as Destructi-Poles and Dragon-Tanks. Soon Steppenwolf will fall at the hands of Izaya the Inheritor, who is avenging the death of his wife, Avia. She was the mother of Scott Free, who, as Mr. Miracle, became the hero of another comic book. Kirby's mix of slang and myth, science fiction and the Bible, made for a heady brew, but the scope of his vision has endured. From *The New Gods* #7 (March 1972). Inks by Mike Royer.

Joe Kubert's version of the Lord of the Jungle got its start with *Tarzan* #207 (April 1972), the high issue number indicating that the famous property had been acquired by DC from another publisher.

LOOKING BACKWARD
Nostalgia Comes to Comic Books

As the comic books of the 1970s scrambled for new ideas to prop up a flagging market, they naturally gravitated toward one of the major preoccupations of the decade: nostalgia. For DC, the journey back meant looking beyond the early super heroes to their forebears in the old pulp magazines.

For Joe Kubert, his appointment as an editor meant a chance to work on the type of tale he loved best. Famous for the war stories he created with his colleague Robert Kanigher, Kubert felt most at home with tales of primitive man alone in the wilds. The hero he most wanted to draw was Tarzan, and he viewed his work on the character as a chance "to relive my childhood."

Introduced in 1912 by writer Edgar Rice Burroughs, *Tarzan* became a twentieth-century phenomenon. His first appearance in the pulp *All-Story* led to two dozen novels and even more motion pictures, not to mention a radio series and several television shows featuring live action or cartoons. The English foundling raised by apes to become master of an African jungle was also a major figure in the history of comics. On January 7, 1929, Hal Foster adapted the character for newspaper comic strips, and for the first time the idea of comics without comedy was born. Tarzan later became a comic book standby for several publishers, and when DC got the rights in 1972, Kubert was ready with a lean, rangy, intense version; his scripts and artwork ranked among the most authentic and effective ever seen.

With some early help from Joe Orlando, Kubert became editor not only of Tarzan but of many other Burroughs characters as well. The writer's pioneering space operas about Mars and Venus popped up in comics like *Weird Worlds*, but they never quite caught on, and after little more than two years Kubert had relinquished *Tarzan* to other hands. Burroughs, who had helped shape the American imagination, had apparently gone out of style.

Another pulp hero who got top treatment from DC was the Shadow. Usually attributed to the prolific Walter Gibson, who wrote under the name Maxwell Grant, this character appeared in almost 300 novels between 1931 and 1949 in the magazine called *The Shadow*. Yet he actually began in radio, as the narrator of mystery stories from pulp publishers Street and Smith. The radio version that eventually evolved is the one best remembered today, an invisible crime fighter famous for lines like "Who knows what evil lurks in the hearts of men? The Shadow knows!"

Denny O'Neil, who served as writer-editor on DC's *The Shadow*, relied on Gibson's novels rather than the old broadcasts, which made perfect sense since the pulp Shadow was a black-clad but visible avenger who had helped inspire comics characters like Batman. "We found that it was possible to license it," recalls O'Neil, "but I had a lot of trouble getting it off the ground." Negotiations with several artists ended when Berni Wrightson suggested Michael W. Kaluta, whose moody lighting and oblique angles made him the ideal choice. Yet like many of the young artists of the day, Kaluta was unwilling to be tied down and left after only five issues. An aesthetic success from its debut in October 1973, *The Shadow* lost its momentum after Kaluta's departure and was history again after only a year. During a time when sales were low throughout the industry, reveling in the past was a luxury that comics apparently could not afford.

An alien landscape and flying men set the scene in "Carson of Venus," drawn by Mike Kaluta for *Korak, Son of Tarzan* #50 (January–February 1973).

This version of the Edgar Rice Burroughs series "John Carter of Mars," complete with Tharks, was written by Len Wein and drawn by Murphy Anderson for *Weird Worlds* #2 (November 1972).

This page from *The Shadow* #3 (March 1974) showcases artist Mike Kaluta's pastiche of old pulp illustrations. Effectively inked by Berni Wrightson, Kaluta's style is a homage to Graves Gladney, master of the pulp magazine covers of the 1930s. The story by Denny O'Neil takes place in prison, where a gang leader called the Cobra has taken charge, jailing the warden and turning the place into a hotel for criminals. Dynamite foils the Cobra's scheme, and in this climactic scene he plans to take his nemesis with him; however, it goes without saying that the Shadow knows.

SHAZAM!
Lightning Strikes Twice

Billy Batson and Captain Marvel are two people you should never see in the same place at the same time, but Michael Gray and John Davey don't seem to care.

For nearly the entire decade of the 1960s, a television sitcom character named Gomer Pyle had uttered the expletive "Shazam!" whenever trouble arose. However, the comic book from which he learned the word had been out of business since 1953. Then, after a hiatus of twenty years, DC decided to bring it back. After all, at one point its hero Captain Marvel had been the most popular super hero in the country, and had gone out of business only because of DC's lawsuit contending that he and his publisher Fawcett had infringed on Superman's copyright.

Times had changed since 1953, and there was a chance that the Shazam lightning bolt might not strike with the same effect again. There was even another comic book called *Captain Marvel* already being published by DC's rival Marvel Comics, which had determined that the title was legally available and felt it was a natural for their company even if they did have to invent a new character to carry the name. As a consequence, when DC brought back the original in February 1973, they used the title *Shazam!*

Editor Julius Schwartz, who had succeeded in reviving so many DC characters, was assigned to the project, but now says, "I consider it a failure." Schwartz was accustomed to making alterations in the old heroes he brought back, but says that in this case, "I was told to do it the same way it was done years ago and I just couldn't recapture it." C.C. Beck, the artist most associated with the original Captain Marvel, was hired to work his magic once again, but

TV's first Captain Marvel, Jackson Bostwick, looks happy in his work.

before long he and his editor began to clash. "When I started to make changes," says Schwartz, "C.C. Beck got mad and walked off the job." Kurt Schaffenberger, another *Captain Marvel* artist from the Golden Age, was brought in to supplement the work of younger artists who couldn't quite resurrect the simple cartooning style of a bygone day.

Schwartz's favorite writer, Denny O'Neil, was recruited and gave it his best shot, but felt he couldn't really make *Captain Marvel* fly again. "What we tried to do was what they had done in the '40s: that enormously popular, enormously charming super hero strip that at one point was outselling *Superman*." Yet the story of a kid who could say a magic word that turned him into Captain Marvel seemed to belong to a different era. "It was too sweet-tempered," says O'Neil. "It was too naive. It was very much a fairy tale world, and I still find it charming, but I think the audience had leapfrogged past that in terms of sophistication. Maybe the audience was a little uneasy about liking comic books, so they would reject anything that seemed child-like to them." Actually, the original Captain Marvel stories had possessed an inspired zaniness that was anything but crude, yet the earnestness introduced by writers like O'Neil was certainly more in vogue. The DC version of *Shazam!* struggled on with scripts by E. Nelson Bridwell, but was ultimately saved by television, an invention that was science fiction when Billy Batson uttered his first "Shazam!" in 1940.

A weekly television program called *Shazam!* showed up on CBS on September 1, 1974, and it was this incarnation of the Big Red Cheese that became best known to millions of American kids. The show helped sales of the comic book, especially among younger children, but in fact it contained significant differences. Young Billy Batson (Michael Gray) still said his magic word and summoned the lightning that transformed him into Captain Marvel, but instead of working at a radio station he was now a nomad who wandered across the land, driving a van with a thunderbolt painted on the side. Shazam, the old wizard who had empowered the boy in the comics, was gone and in his place was a character called Mentor (Les Tremayne). The program ran for three years on Saturday mornings, with Jackson Bostwick starting as Captain Marvel and John Davey finishing the run.

While the comics featured goofy bad guys and silly sidekicks, the TV version often showed Billy and Mentor encountering serious social problems; E. Nelson Bridwell compared

it to Denny O'Neil's celebrated series of comic books about Green Lantern and Green Arrow. During three seasons only twenty-eight episodes were produced, and constant repetition of the few stories may have killed the show. It died in 1977 and the comic book folded less than a year later, having already devoted many of its issues to economical Golden Age reprints. Still, broadcast revenues were welcome for as long as they lasted. As DC's publisher Paul Levitz notes, "The logic of the parent company in those days was to make money on licensing."

Shazam! is too good a concept to remain in limbo, however. Writer-artist Jerry Ordway revived the idea again in 1994, in a less whimsical version that seems more in keeping with the temper of today's times. The new monthly series suggests that the hero even lawyers couldn't kill may last forever.

Time heals all wounds, and Superman seems pleased to introduce his old rival Captain Marvel on the cover of *Shazam!* #1 (February 1973). Art by C.C. Beck.

This hardcover graphic novel, written and drawn by Jerry Ordway, reintroduced the classic character in 1994.

Back from the Golden Age, Mary Marvel was kin (Billy Batson's sister), but Captain Marvel Jr. was merely a protégé (newsboy Freddy Freeman). Cover for issue 3 (June 1973) by C.C. Beck.

WONDER WOMAN ON TV
Progressing by Leaps and Bounds

If Batman became an overnight sensation on television, Wonder Woman proceeded one step at a time. More than two years passed between her first appearance and the start of her weekly series, and before the program ran its course there had been changes in the star, the setting and even the network. Along the way a wonderful Wonder Woman was discovered in a self-styled "struggling actress" named Lynda Carter, who says today that "Wonder Woman struck a chord that no one expected."

The first TV Wonder Woman cast was Cathy Lee Crosby, a slim blonde with short hair and rather angular features who looked nothing like her comic book counterpart. She appeared in a 1974 ABC TV movie called *Wonder Woman*, which would hardly have been recognizable without its title. Perhaps basing his scenario on the short-lived attempt to alter the contents of the comic books, screenwriter John Black turned his protagonist into a spy with no super powers and dropped her into a dull plot about stolen code books. This could have scuttled *Wonder Woman* forever, but fortunately Warner Bros. and ABC persevered.

Stanley Ralph Ross, a writer responsible for the Catwoman episodes of *Batman*, came up with a version of Wonder Woman that restored creator William Moulton Marston's concepts, including the World War II setting and the origin story. Ross's screenplay, appropriately entitled *The New, Original Wonder Woman*, became a TV movie in 1975. Executive producer Douglas S. Cramer insisted that Lynda Carter get the title role despite network qualms about her inexperience. Carter herself was hardly concerned about potential problems with typecasting. "To tell you the truth, I couldn't pay my next month's rent when I got the part," she recalls. "I was thrilled to have a pilot of my own."

The pilot was successful enough to spawn two more TV movies, entitled *Fausta the Nazi Wonder Woman* and *Wonder Woman Meets Baroness Von Gunther*. Finally, in December 1976, ABC launched a weekly series of hour-long episodes. True to Marston's themes, the opening episode showed the Amazon princess rehabilitating her enemy, a female Nazi. Comic books were acknowledged by the animated opening credits, and by a scene-setting device in which hand-lettered captions appeared in the corner of the screen. The historical background and the female lead made for an unusual adventure series, but in late 1977 the show was updated to modern times and sold to CBS. "I think they wanted to retool it and modernize it when they bought it, so they weren't just buying the same show," says Lynda Carter.

Lynda Carter strikes a heroic pose in the updated costume designed for a new season on CBS.

Lynda Carter as efficient, myopic Diana Prince. Needless to say, she's beautiful without her glasses.

"I think I was much better in the part when it was modernized," the star says. "The series matured as we went along." She may have grown more comfortable with the role, but something unique was lost when the period setting was dropped. Now called *The New Adventures of Wonder Woman*, the CBS version looked more like a typical action show of the 1970s, with lots of guys in turtlenecks driving around Los Angeles. The only actor to keep Carter company in both versions was Lyle Waggoner. Once considered for Batman, Waggoner played Steve Trevor on ABC, and then Steve's son on CBS.

In any case, the main attraction of the show was Lynda Carter. With her dark beauty and statuesque figure, she made an impression intensified by her apparently commanding height. "I'm 5′9″ but most people think I'm about 6 feet," she says. "It's because I have very long legs." Her appeal was so evident that other qualities she brought to her role have sometimes been overlooked. "I tried to play her like a regular woman who just happened to have superhuman powers," Carter explains. "I figured she'd lived with it every day of her life." As a result, the star seemed poised and natural even while running around in an outlandish outfit. That's not easy, as was demonstrated when future Oscar-nominee Debra Winger appeared on the ABC series as Princess Diana's little sister Drusilla. Despite her talent, she seemed stiff and awkward next to Carter.

Of course Wonder Woman was also a physical role. She was constantly jumping great heights and distances, an effect achieved with spring-boards, reverse photography, and an oversized pendulum called a Russian Swing. "I really loved doing the stunts," says Carter. "I had a lot of stunt women, because they all did something different, but I ended up doing most of the fights myself. The stunt guys taught me how to throw a punch, and eventually I became an honorary member of the Stunt Women's Association." She also "got in trouble" for hanging from a helicopter. "The stunt girl was about to go under it and I said, 'Oh, I can do this!' I ran under and they went up, and when the producers found out about it, they went ballistic."

Lynda Carter's three years of episodes still run regularly today. "I'd like to think I had something to do with it, but it's a phenomenon unto itself," she says. "And it's not too bad to be a sort of pop icon, you know? It's not too tough to handle."

Wonder Woman is all wrapped up in her work in this scene from the first ABC episode, with Linda Day George as a Nazi spy.

Lynda Carter as Wonder Woman and Debra Winger as her kid sister, Wonder Girl.

There's nothing like a guy in a gorilla suit to cheer you up at the end of a long day fighting crime.

MOVING FORWARD
A New Style of Doing Business

In 1976, Jenette Kahn became DC's new publisher. With comics in decline, Warner Publishing chairman William Sarnoff had decided to appoint someone from outside the business, and selected a young woman who had successfully launched three innovative magazines for children: *Kids*, *Dynamite* and *Smash*.

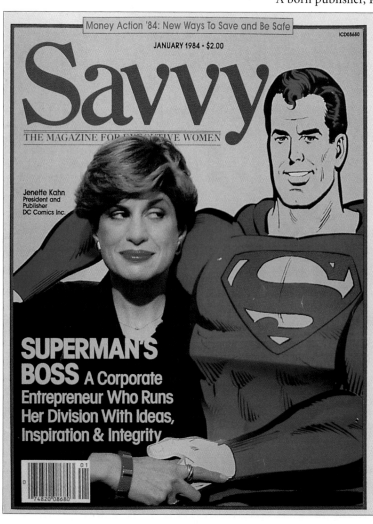

A new logo, known within the company as the DC "bullet," was created by graphic designer Milton Glaser to help give DC Comics a new look.

Ironically, the age of the average comic book reader would rise noticeably during the years that followed. "I think all of us who were at DC then were surprised that it became such a sophisticated medium, not that it didn't always have that potential," says Kahn today. "When we realized what was in the air, we moved very quickly to focus ourselves in that direction." A born publisher, Kahn was determined to concentrate her efforts on the comics themselves, thus flying in the face of conventional wisdom that the characters were most valuable as vehicles for licensed merchandise or media adaptations. "I thought comics were an art form, that we

should be who we are and be very proud of it." One of her first decisions was to drop the euphemistic company name, National Periodical Publications. After all, she reasoned, "readers tended to refer to us as DC Comics." Then she commissioned designer Milton Glaser to create a new DC Comics logo, melding elements from earlier versions into a more modern look.

During Kahn's first years as publisher, Sol Harrison served as DC president and continued to represent the more traditional approach toward running things. "Unfortunately I think the company divided into two camps," says Kahn, who found her most important allies in editor Joe Orlando and his assistant Paul Levitz, still a college student working part time. Before long Orlando became managing editor for the entire line, and Levitz, with his business training, managed the administrative side of things as editorial coordinator. This included keeping the comics on schedule, and trying to provide artists and writers with steady assignments. "Jenette was very focused on ways of making the business better for the talent," Levitz says. "We started a lot of different ways of working with the guys back then, like a medical insurance program for free-lancers, continuity contracts for a year, things like that."

"Paul and Joe and I would talk late at night. We would hang out in my office and say it would be great if we could do this or that," recalls Kahn. "Joe has such a love of creativity and always rises to any challenge. And Paul, who was only nineteen, would say no to me, but with reasons why he was saying no and with solutions, so there was a chance of a real dialogue. The three of us were a little core group, and we still needed some very good editors."

Everyone's first choice was Dick Giordano, who had served in that capacity years earlier but now was a successful free-lance artist, making more from DC with his drawing than he could expect to earn behind an editor's desk. "I said we were going to have to raise the pay scale for everyone because Dick was essential, and that's what happened," recalls Kahn. "Dick had the respect of the free-lancers and was also respected as an editor, as someone who was tolerant and open and supportive, and he contributed tremendously."

Dick Giordano came on board as editor in 1980 and gradually took charge of the comics. In the same year Joe Orlando was named editorial director and became involved with special projects. Paul Levitz became manager of business affairs. Working with this trio, each of

Photo: Joel Meyerowitz

President and publisher Jenette Kahn poses with her most powerful employee on the cover of *Savvy* magazine (January 1984).

THE FIGHT TO SAVE EARTH FROM STAR-WARRIORS

$2.50 C-56 32180

ALL NEW COLLECTORS EDITION

SUPERMAN VS. MUHAMMAD ALI

CAN J SPOT THE CELEBRITIES WATCHING THE GREATEST FIGHT OF ALL TIME-AND-SPACE? (See inside cover!)

Neal Adams created this wraparound cover for a tabloid-sized battle of champions, published in 1978. Audience members range from Jenette Kahn (lower left, near Ali's corner) to President Jimmy Carter (lower right, near Batman).

whom soon earned promotion to vice president, Jenette Kahn was ready in 1981 when Sol Harrison retired and she became DC's president as well as publisher.

"The pledge I made to myself—and Paul was totally supportive of it—was that whenever we were making money we would also give royalties. We were the first major company to do that," Kahn says. DC's royalty plan, inaugurated in 1981, gave percentages to writers and artists on all comics that sold beyond the break-even point of 100,000 copies. There were also additional royalties for the creators of new concepts, even if the creator was not currently working on that character or title. This was a big step in a business where talent had traditionally received no share of the proceeds for their creations. For Kahn, the justification for the move was twofold: "One, on sheer moral principle, and the other was that it just seemed to me good business to want your free-lancers as your allies as much as possible. Without them we wouldn't be here, and therefore the idea of exploitation could only create bad feeling and also perhaps keep some of the best ideas from coming forward."

Within a few years, the progressive approach adopted by the new DC management would result in an outburst of artistic innovation, as well as encouraging Kahn's plans to publish "different lines of comics that appealed to different interests and tastes."

Sword and sorcery enjoyed a flurry of popularity as the new publisher took charge. Cover of *Starfire* #3 (January 1977) by Mike Vosburg and Vince Colletta.

ONLY A YOUNG WOMAN'S SWORD AND HER COURAGE WILL CHALLENGE THE INHUMAN HORDES WHO WOULD ENSLAVE HER PEOPLE!

This plaintive alien by Berni Wrightson graces the cover of *House of Mystery* #255 (December 1977), a book converted to a "Dollar Comic" that gave readers more pages for their money. The idea didn't catch on.

SUPERMAN THE MOVIE
Making a Film Fly

You'll believe a man can fly," promised the posters, and millions flocked to take a look. Yet special effects were only part of the appeal of *Superman the Movie* (1978), the first serious dramatization of a super hero's exploits to draw big crowds of adults as well as children. In fact, upon its release, *Superman* became the top money-maker in Warner Bros. history.

Enacting the title role was a young actor named Christopher Reeve, whose intelligent, engaging portrayal impressed even those critics who were inclined to view comic book characters with disdain. In retrospect, Reeve is modest about his contribution: "This was big-screen entertainment with class A actors, and that was new. And that meant it had to be more daring in terms of the acting. And that's why I took the job. As a regional theater actor with a Juilliard education, I didn't want to throw all that away. I wanted to try to really make him two characters as best as I could. Of course there's a convention at work, and the audience is in on the joke. But I just think I got a better opportunity because of the size and the scope and the style of everything around me, from Marlon Brando and Gene Hackman to the Geoffrey Unsworth photography to music by John Williams. You know, the Fortress of Solitude is a very impressive place. All you have to do is stand in the middle of it and you can look pretty good. I don't think any of the actors before me had the same chance. I had such support from all those things."

The film ignored many of the recent changes in the comic books, but director Richard Donner consulted DC and found inspiration in the comics he perused. Donner was a last-minute replacement after James Bond director Guy Hamilton dropped out, and preparation was hectic. Producers Alexander and Ilya

Salkind, a father-and-son team, had raised an enormous budget, planning to make this movie and its sequel simultaneously. Mario Puzo, author of *The Godfather*, had written a script, which had then been revised by David Newman, Leslie Newman and Robert Benton. But director Donner found the script too campy and hired Tom Mankiewicz, credited as "creative consultant," for a further rewrite. Most roles had been cast, but Donner still needed a Superman, and on a hunch he selected an actor he feared was too young and too thin.

"At first I didn't want to audition for it, to be honest with you, because I thought there wouldn't be a genuine acting opportunity," says Christopher Reeve. "When I read it, and when I met Dick Donner, I saw that there was a chance to combine romantic comedy with heroics, that there would be a sweetness and a playfulness to it." Reeve bulked up for the film and delivered a boyishly charming Superman, along with an endearingly awkward Clark Kent he says was based on "early Cary Grant."

Donner saw *Superman the Movie* as actually three movies. The first was a science fiction epic set on the crystalline planet of Krypton. Top-billed Marlon Brando appeared as Superman's father Jor-El in the film's first few minutes and earned a reported $3,700,000 for his efforts, but Donner said it was Brando's name that enabled the producers to attract investors. The second section was a beautifully photographed, nostalgic pastoral depicting Clark Kent's youth in the American heartland. The third part, Reeve's "romantic comedy," introduced the new star a full 47 minutes into the action, but since the entire movie was 142 minutes long, he had ample time to shine. His romantic banter with Lois Lane (Margot Kidder) contrasted her raspy assertiveness with his almost angelic diffidence,

Superman streaks down the side of a skyscraper to catch a thief whom he has scared a little too much in this scene from *Superman*.

This flight for two made a romantic movie scene, but since she's only being held by one hand, in reality Lois would be dangling down in considerable discomfort.

and audiences found their chemistry volatile. Yet their most famous scene, a midnight flight together, is flawed by Kidder's voice-over recitation of some insipid romantic verse.

There are also problems with a fourth section, never designated by Donner as such, in which Gene Hackman portrays a Lex Luthor bent on flooding California. A superb actor, Hackman unfortunately played Luthor like a villain on the *Batman* TV show, moving the movie from the sublime to the ridiculous. Reeve enjoyed Hackman's ad libs (Superman smashes down the door to the bad guy's hideout, and Luthor quips "It's open, come in"), but they encouraged the descent of the film from the icy intelligence of Krypton into melodrama and burlesque. Somehow this descending structure worked: *Superman* covered all bases. Nitpickers, however, objected to the ending, in which Superman sped around the globe to reverse time and prevent the death of Lois; after all, a hero who can turn back the clock can hardly even be challenged, much less defeated.

Yet *Superman the Movie* succeeded in making comic book material respectable entertainment. "In a way," says Christopher Reeve, "we were the laboratory experiment. Because we succeeded, the others came on, from *Batman* to *Dick Tracy* to even *The Flintstones.*" *Superman* won an Oscar for special effects, but it was a landmark in more ways than one.

Marlon Brando and Susannah York play Superman's Kryptonian parents, Jor-El and Lara, against the imaginative sets designed by John Barry for the brief sequence set on Krypton.

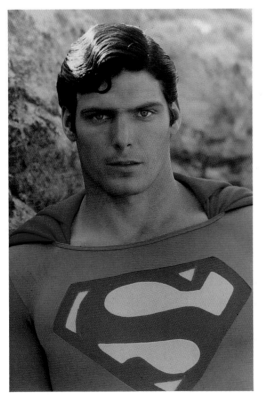

The new Superman for 1978: Christopher Reeve.

A chunk of kryptonite brings joy to Gene Hackman as the villainous Lex Luthor.

SUPERMAN II
Big Fights on Both Sides of the Camera

Man, this is gonna be good," announces a bystander in *Superman II* as the Man of Steel prepared to take on a trio of super villains in the sky over Metropolis. And it is good, but it wasn't easy. The second *Superman* feature had a troubled genesis, but it turned out to be one of the screen's most satisfying depictions of a comic book character.

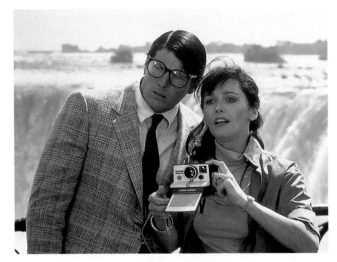

Clark (Christopher Reeve) and Lois (Margot Kidder) investigate fraud at Niagara Falls and end up embarking on a whirlwind affair in *Superman II.*

When director Richard Donner shot *Superman the Movie*, he also shot much of the proposed sequel. Donner fully expected to finish the job, but in the end that did not happen. Guy Hamilton was named as the replacement (he'd also been announced for the first film), but ultimately *Superman II* (1980) was completed by Richard Lester. Best known for the Beatles movies *A Hard Day's Night* and *Help!*, Lester had recently completed a pair of back-to-back films about the Three Musketeers for the Salkinds, which may have given him an inside track but did nothing to placate the indignant Donner.

Christopher Reeve, who was away making the romantic fantasy *Somewhere in Time*, missed most of these machinations regarding the two films. "They're kind of interchangeable in a way," he says. "So much of One and Two were done at the same time. It was really one big script. There was a director change in the middle, but the style of the original had already been set up and needed to be followed—even to the point where Bob Paynter, the director of photography on *Superman II*, had to imitate Geoffrey Unsworth's lighting so that it would cut in with earlier footage. So I see them actually as one big movie."

Richard Donner originally estimated that he had filmed eighty percent of *Superman II*, but detected only fifty percent of his work in the finished product. As Christopher Reeve recalls it, the choice of which footage to save was purely pragmatic. "It was usually done whenever a set doubled or we had a problem with expensive actors being available," he says. "I remember we did many scenes from the *Daily Planet*, if not all of them, while we were doing Part One. So those were pretty much in the bank. Gene Hackman, to the extent he was in Part Two, was also done while he was around for Part One. I don't remember that he came back again."

Richard Lester, however, directed *Superman II*'s most spectacular scene: the wild twelve-minute battle among Superman and the three criminals from Krypton that he inadvertently released from their prison in the Phantom Zone. When General Zod (Terence Stamp), Ursa (Sarah Douglas) and Non (Jack O'Halloran) attacked Metropolis, they arrived on a set based on New York's Times Square but built in England's Pinewood Studios at a cost of millions. "The Salkinds wanted to make a splash," says Reeve. "Their vision was really big." No other scene in any film has come as close as this one to displaying the exuberant mayhem of super hero comics. Fires, explosions, flying buses and broken buildings combine to produce an unprecedented effects extravaganza. Like many expensive movies, *Superman II* contains some overt product placement, but it works to Warholian effect, especially when Superman tosses General Zod hundreds of feet through the air to shatter a gigantic neon Coca-Cola sign. "I remember much of that as being fun," says Christopher Reeve. "The strong wind blowing the cars around, from the three baddies with their super breath, that was all staged by Dick Lester. And it had an element of humor to it, so it was fun for us to think of gags."

The other crowd-pleaser in this superior sequel was the fruition of the romance between

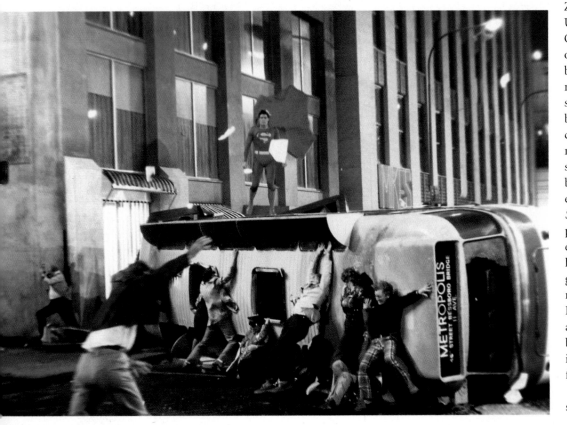

This bus, tossed by super villain Non (Jack O'Halloran), has just landed on Superman, but to the relief of the crowd the Man of Steel emerges unscathed.

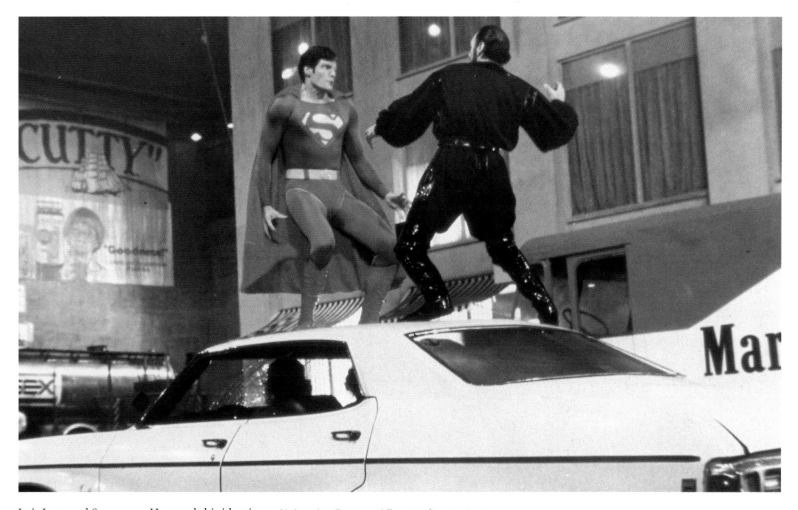

Lois Lane and Superman. He reveals his identity in what seems to be a Freudian slip, and Lois finally gets her man. Yet the image of his mother (Susannah York), somehow surviving in the mysterious crystals at the Fortress of Solitude, says, "If you want to live your life with a mortal, you must live as a mortal." In a grand gesture, Superman renounces his powers, and since the need for the deed goes unexplained, audiences are left with lurid fantasies about the dangers of a Man of Steel's wedding night. Still, Lois and Clark are one, and Clark is the resigned victim of bullies until the emergence of the super villains makes Superman's return mandatory.

Many critics complained about the ease with which Superman regains his powers, officially gone forever, and in fact the finished film never explains this point. According to Richard Donner, the original idea was that Superman would recover his strength by draining those Kryptonian crystals, but in the process he would give up all contact with his parents forever. Thus his sacrifice would parallel that of Lois, who is forced to forget her romantic interlude after Superman administers the super kiss first introduced in the old comics.

Quibbling aside, *Superman II* and its predecessor combine to create an impressive film epic. "For overall, sustained achievement, I think they are a kind of landmark," says Christopher Reeve. "They created a new genre."

Christopher Reeve and Terence Stamp stage a spectacular battle amidst the signs of the times on the streets of Metropolis. This long fight really caught the spirit of super hero comics.

Sarah Douglas as Ursa made an enjoyably mean-spirited super criminal, found guilty of "perversions and unreasoning hatred of all mankind" at her trial on Krypton.

NEW MARKETS, NEW FORMATS
Comics Change with the Times

Frank Miller's art shows a strong Japanese influence, matched by Lynn Varley's subtle colors, in the six-issue series *Ronin*.

A direct sales entry in a quality format, *Sun Devils* #1 (July 1984) features cover art by Dan Jurgens and Rick Magyar.

Despite strenuous efforts throughout the industry, comic book circulation was on the decline during the 1970s. Hoping to get more customers, DC increased the number of pages in each publication (at higher prices) while simultaneously releasing more and more titles; the expansion was optimistically dubbed "The DC Explosion." Nothing seemed to work, however, and cutbacks were initiated that insiders ironically dubbed "The DC Implosion." The competition was in the same boat.

"We were focused very much on the newsstand business," says Paul Levitz, but the old outlets for comics were drying up, and price increases were discouraging to young readers. The only new retail activity came from the handful of small dealers who had sprung up to serve collectors looking for antique comics from the Golden Age. From this unlikely corner of the business came relief. One of the retailers was a New York schoolteacher named Phil Seuling, and Levitz calls him "a pivotal figure in the evolution of comics." Seuling persuaded the major publishers to distribute their comics to the specialty shops, who could purchase them outright because they knew what customers wanted. Regular magazine distributors, by contrast, often returned (or destroyed) thousands of unsold copies. The new system, called direct sales, proved to be the key to the industry's salvation as new comic book stores sprang up all over the country. In 1980, Levitz says, direct sales accounted for less than ten percent of the business, but today it is closer to eighty percent.

The growth of direct sales changed comics in fundamental ways. Retailers who cared about comics made knowledgeable orders and put an end to the days when, as president Jenette Kahn describes it, "we were printing four comics to sell just one." DC established the industry's first marketing department to work with the new system and brought in consultants to establish credit terms. Comics were less likely to be a casual purchase, says Paul Levitz, and "DC acted to make the product more suitable for the intense customer."

"Paul and I shared a dream," says Jenette Kahn. She worked the creative end while Levitz concentrated on business practices, and their goal was to make the comics earn their own keep, rather than being wholly subsidiary to licensing of the top characters. At the same time, however, a licensing department was established to bring organization and quality control to an extremely important source of revenue and publicity. By 1985, largely thanks to the continuing expansion of direct sales, the comics were profitable again, and it became easier to make decisions based primarily on publishing considerations. "And that's why we're here, you know?" says Levitz. "The love comes from that."

In December 1982, DC introduced a twelve-issue series called *Camelot 3000* that was sold exclusively through the comic book shops. This update of Arthurian legends used higher-quality paper, improved offset printing and a new, sophisticated color palette, resulting in an unusually handsome publication. It was followed in July 1983 by *Ronin*, an experimental offering by writer-artist Frank Miller. *Ronin*'s stylized art and subtle coloring resulted from Miller's interest in the Orient, which had developed from his super hero depictions of martial arts techniques. Not an obvious crowd-pleaser, *Ronin* was an early example of the kind of significant work the direct market could support, and would lead directly to one of DC's greatest successes. Comics were turning a corner.

Dart, shown here, was one of the characters created for a comic book version of a video game in *Atari Force* #1 (January 1984). Script by Gerry Conway and art by José-Luis García-López.

The first DC comic book designed expressly for the direct sales market, *Camelot 3000* transposed Arthurian legend into the future. Working with British penciller Brian Bolland and editor Len Wein, writer Mike W. Barr produced a science fiction epic designed with an end in mind, and free of Comics Code restrictions. In a remarkable plot development, Sir Tristan is turned into a woman by a magic spell, and realizing he will never be restored, becomes a lesbian. This page shows evildoers Modred and Morgan Le Fay plotting against Camelot while their prisoner Merlin is entertained by a dancing demon. Pencils by Brian Bolland, inks by Terry Austin and coloring by Tatjana Wood.

SUPER STUFF
Movies Mandate Merchandising Magic

Licensed products featuring the likeness of Superman had never really gone out of vogue since the character was introduced, although Batman had temporarily eclipsed his predecessor in the 1960s. With the sensational success of the new *Superman* movies, however, the original super hero was once again the hottest thing in merchandising. Old favorites like lunch boxes were back again, and there was perhaps less emphasis on toys than on general merchandise. However, one of the most important changes from DC's point of view regarded quality control.

With two *Superman* films released and more in the pipeline, the company began to take an active interest in how the licensed products looked. "We created the first style guides in the industry," explains Paul Levitz, and many of DC's top artists were employed. Joe Orlando took charge of a department that worked with licensees on everything from product development to packaging, and as a result the old days of strange-looking Superman art were left behind.

Aspiring artists quickly got the point with this Superman pencil sharpener (1981, manufacturer unknown).

The classic Superman watch from Fossil (1993) comes in the kind of classic phone booth you can't find anymore.

Superman Vitamins, shaped like the shield on the hero's chest, gave kids the strength to keep on reading comic books.

Superman Peanut Butter, first on the shelves in 1981, went on to capture a twelve percent share of the market in some locations.

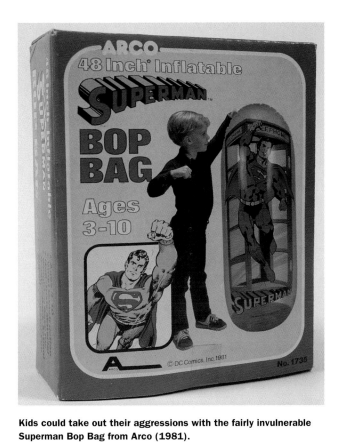

Kids could take out their aggressions with the fairly invulnerable
Superman Bop Bag from Arco (1981).

The Superman
Speeding Figure
(Remco, 1982) has
X-ray eyes that
light up, and kryp-
tonite that glows in
the dark.

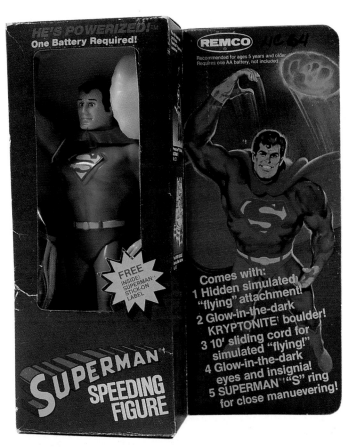

The *Superman III* Card Game from Parker Brothers had players compete for
adventure cards by employing mathematical strategies reminiscent of blackjack.

The Superman lamp, from C. N. Burman Co. (1987),
is easier on the eyes than a Green Lantern.

MORE SUPER MOVIES
Even Kryptonians Get Tired

Corrupted by synthetic kryptonite, Superman begins hanging around in bars in this scene from *Superman III*.

The first two Superman movies were so successful that further followups were almost inevitable, but the law of diminishing returns had begun to set in by the time of *Superman III* (1983). The film was planned to emphasize humor, and writers David and Leslie Newman designed a major part for comedian Richard Pryor. A brilliant standup comic, Pryor had not fared too well in movie roles; the Newmans had expected him to improvise but to their surprise he stuck closely to the script, perhaps because he was a Superman fan. As a result, the film isn't terribly funny, nor can it be taken very seriously.

Disguised as a military man, Gus Gorman (Richard Pryor) slips Superman a handful of synthetic kryptonite in *Superman III*.

Richard Lester, who returned as director, was also best known for comedy, and as Christopher Reeve notes, Lester "was always looking for a gag—sometimes to the point where the gags involving Richard Pryor went over the top. I mean I didn't think that his going off the top of a building, on skis with a pink tablecloth around his shoulders, was particularly funny." That scene, in which Pryor's character lapsed into slapstick while imitating Superman, was balanced by a nice touch when Clark Kent goes home and wears a red Smallville High sweater around his neck, thus unconsciously mocking his other self.

The Smallville scenes also introduce Lana Lang, Clark's schooldays sweetheart. As played by Annette O'Toole, Lana displays an open and affectionate nature, and is fonder of Clark than

of Superman. In fact, the film contains the subversive suggestion that she might make a better mate than the abrasive Lois Lane, who hardly appears in *Superman III*. Still, the main plot thread concerns Pryor's character, Gus Gorman, a computer genius subverted into a life of crime by a corrupt tycoon (Robert Vaughn). By the end of the movie, a huge, sentient computer threatens the world, but Superman handily defeats it and reforms the chastened Gus.

More interesting is the sequence in which Gus attempts to synthesize kryptonite and ends up with something like red kryptonite. It brings out a mean streak in Superman, then splits him in two. "I think the fight in the junkyard between Superman and his evil self is a concept that any comic book lover would support," says Christopher Reeve. "That was David Newman's idea and Richard Lester did a beautiful job staging it. That was a month of shooting." Interestingly, the "good" Superman, ultimately triumphant, was dressed as Clark, thus implying that he is the more valid personality (as well as the one Lana loves). Something might have been made of this, but sadly nothing was.

Instead, producers Alexander and Ilya Salkind went on to *Supergirl* (1984). The proper ingredients appeared to have been assembled, including an attractive newcomer in the title role and several established stars (Faye Dunaway, Peter O'Toole, Mia Farrow) to provide ballast, yet somehow *Supergirl* never came together. Helen Slater displays youthful charm as Supergirl, and there's a wonderful sequence showing her delight when she discovers flight, but most of the movie is a misfire, and director Jeannot Szwarc seems to be to blame. Also disappointing are Faye Dunaway's grotesque performance as a wicked witch, and writer David Odell's idea that Slater and Dunaway should spend most of the movie battling over grazing rights to a muscular gardener.

The end of this round of super movies came a bit later with *Superman IV: The Quest for Peace* in 1987. "You know, when you make sequels, they have to be better each time," says Christopher Reeve. "And the way you make them better, I think, is the creative team has to be good and you have to spend the money. I remember on *Superman II*, we once went down to St. Lucia in the Caribbean from Pinewood—took a whole crew to get a shot of Superman picking a flower by a stream. And we had just been to Norway to get some shots of him in the snow fields. All that was scaled down by the producers on *Superman IV*, and I think the film

looks ersatz as a result."

Directed by Sidney J. Furie, *Superman IV* was produced by Menahem Golan and Yoram Globus. "I was worried when the new producers came on and bought the rights from the Salkinds," says Christopher Reeve. "They didn't have a story that I remember. They just wanted me to play the part again." Reassured when Golan-Globus agreed to back one of his pet projects, a gritty crime drama called *Street Smart* (1987), Reeve brought in some story ideas that were developed by writers Lawrence Konner and Mark Rosenthal. "I may have gotten too worked up about trying to have Superman do something socially relevant, which brought us into the whole question of ridding the world of nuclear weapons," Reeve says in retrospect. "The movie never quite came together." Plot problems were compounded by the fact that Golan-Globus didn't have access to the flexible front projection system developed by Zoran Perisic for the first three movies. So *Superman IV* marked the end of this series, but by then two blockbusters had revolutionized motion pictures. "The part keeps being regenerated," says Reeve. "This is a piece of modern mythology."

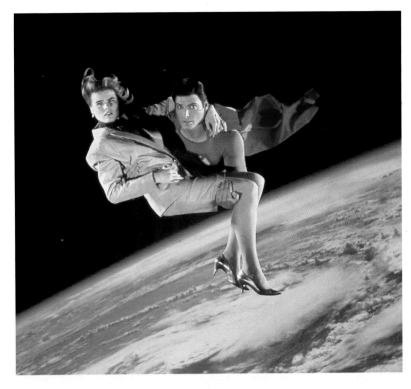

The daughter of the *Daily Planet*'s new publisher gets a free ride in this scene from *Superman IV*, with Christopher Reeve and Mariel Hemingway.

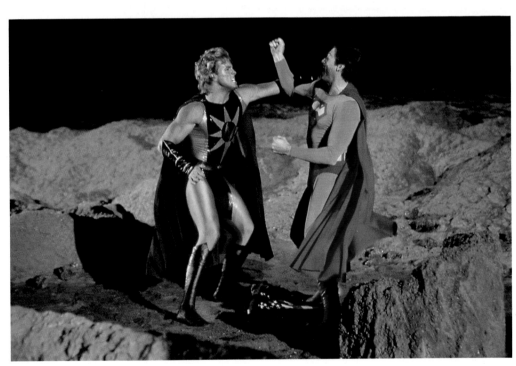

In *Superman IV*, the Man of Steel dukes it out on the moon with Nuclear Man (Mark Pillow), a super being created by Lex Luthor.

Helen Slater made a convincing young Kryptonian in the otherwise awkward *Supergirl* (1984).

Cruising through the clouds, Helen Slater enjoys some of the few good moments in *Supergirl*.

SWAMP THING ON SCREEN
Swamp Thing, I Think I Love You

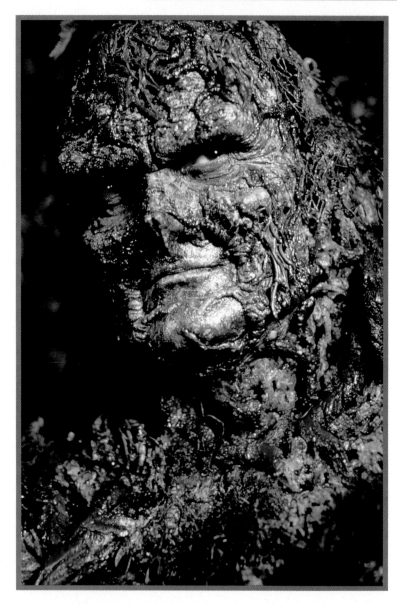

Dick Durock models the elaborate makeup created for the TV show by Carl Fullerton and Neal Martz, based on the comic book drawings by Steve Bissette and John Totleben.

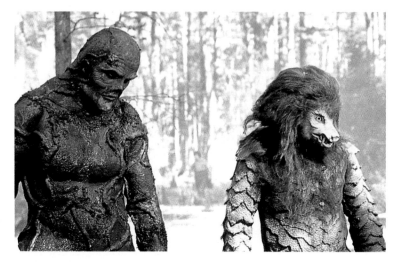

At the climax of *Swamp Thing*, the evil Arcane transforms into another monster to battle the title character, but this shot was apparently taken between rounds.

Part of Swamp Thing's strange plantlike power lies in his influence over Hollywood executives. So great is this control that the feature film *Swamp Thing* (1982) was made years after the original comic book had ceased publication. In fact, it was the small production company Avco-Embassy's decision to make the movie that revived the comic book and led to its long-lasting success.

Much of the media exposure enjoyed by Swamp Thing is due to Michael E. Uslan, a fan who taught the first accredited college course in comics (at Indiana University), wrote scripts for DC, passed the bar and then became a producer. With his partner Benjamin Melniker, Uslan has been involved in two *Swamp Thing* features and a cable television series. Their record of commitment is matched only by stuntman-turned-actor Dick Durock, who endured the discomfort of wearing a foam latex Swamp Thing suit for over a decade.

The most famous name associated with the first *Swamp Thing* feature is writer-director Wes Craven. Already known for two brutally realistic, low-budget horror films, *The Last House on the Left* (1972) and *The Hills Have Eyes* (1977), Craven would later go on to create *A Nightmare on Elm Street* (1984), a movie that led to the biggest horror franchise of the past decade. DC did not retain as much control over Swamp Thing as it had over flagship characters like Superman, and could have ended up with a bloodbath on its hands, but Craven's *Swamp Thing* is one of his kinder, gentler films. Then again, Swamp Thing has always been quite a good guy, as monsters go.

Shot on location in a photogenic swamp in South Carolina, *Swamp Thing* benefits from the presence of the equally photogenic Adrienne Barbeau, who pretty much carries the movie as a character called Cable, who was male in the comics. She's tough and likable and always in the thick of the action, giving such a good account of herself that it's almost annoying when Dick Durock keeps showing up to rescue her. There's also a nice acting job by Reggie Batts as a bespectacled black kid who gets to rescue Barbeau too. He's quite a comedian, and Craven seems to have given him all the best lines, but there's also a lot of bumper-sticker dialogue like "Is the Pope Catholic?" and "You don't have to be crazy to work here, but it helps."

The plot of the film follows the outline of the first Wein and Wrightson comics, with Alec Holland developing a secret formula and a villain named Arcane (Louis Jourdan) attempting to

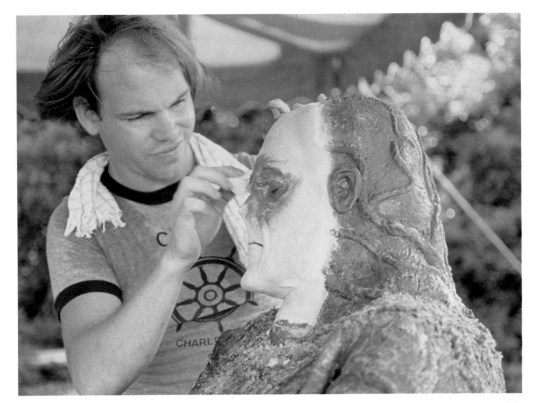

Ken Horn applies the makeup, designed by Bill Munns, to a long-suffering Dick Durock on the set of *Swamp Thing* (1982).

wrest it from him. Up-and-coming makeup artist William Munns and his crew went through hell on the $3 million film, especially in the last scenes when Arcane himself was transformed into a monster and battled the hideous hero. Swamp Thing may have worked as a tragic hero in the early comics, but on film his only tragic flaw was a latex costume that fell apart in the corrosive swamp water.

Still, *Swamp Thing* was fun on its rather juvenile level, whereas the sequel *Return of Swamp Thing* (1989) sank like a boulder bogged down in quicksand. Directed by Jim Wynorski, it brought back Dick Durock and Louis Jourdan; this time they were joined by a perky but otherwise implausible Heather Locklear as Abby Arcane, leading lady of the comics as well as the villain's niece (his stepdaughter in the movie). Influenced by the comic book stories of Alan Moore, *Return* attempted to depict the delicate relationship between gal and greenery, but ended up opting for a lot of dumb jokes instead. The makeup, designed by Carl Fullerton, was better than before, but the character still looked like a man in a rubber suit.

Also inaugurated in 1989, the TV *Swamp Thing* was deadly serious, but sadly the emphasis was on the deadly. The series of thirty-minute dramas ran for years on the USA cable network, but Durock, in a modified version of Fullerton's latex suit, was still lumbering around like a guy who woke up to discover that someone had put too much starch in his shorts. He had also become something of a video therapist, given to utterances like, "Never downplay your own abilities. People feel comfortable when they're with you." Delivered in an electronically altered

basso profundo, such dialogue could stop any show dead in its tracks. Mark Lindsay Chapman played Arcane as a smarmy hipster. No matter how many deaths he caused with his deranged schemes for world conquest, he and Swamp Thing ultimately seemed no more than feuding neighbors, inexplicably obliged to annoy each other on a weekly basis.

The show suggested how difficult dramatizing the best comics might be; Alan Moore, Steve Bissette and John Totleben approached profundity in their printed parables about a philosophical plant; but attempts to adapt them were usually no more than ludicrous. Comics and cinema may be kin, but they are hardly kissing cousins.

Mortally wounded, Adrienne Barbeau will soon be restored to life by the wondrous powers of the big green guy (Dick Durock) in Wes Craven's *Swamp Thing* (1982).

Mark Lindsay Chapman plays the television version of archvillain Arcane, shown here with one of the Un-Men.

ACTION FIGURES
The Joy of Boy Toys

Lex Luthor, Clark Kent, Superman and Brainiac

Action figures are sometimes described as dolls for boys to play with, but it might be more accurate to call them the modern version of the toy soldiers that have been around for centuries. This set of thirty-four characters from Kenner was released in 1985–87 in conjunction with Hanna-Barbera's ABC television show *Super Powers*. The action isn't just in the name, as each figure performs a characteristic movement when squeezed. Darkseid and his criminal cohorts were redesigned by Jack Kirby, and DC was able to offer the protean artist some of the first royalties paid to him for his countless creations.

Penguin, Mr. Freeze, Batman, Robin and Joker

Plastic Man, Dr. Fate, Hawkman, Wonder Woman and Captain Marvel

Cyclotron, Samurai, Golden Pharoah, Tyr and Cyborg

Aquaman, Firestorm, Flash, Green Lantern, Red Tornado, Martian Manhunter and Green Arrow

Steppenwolf, Mantis, Parademon, Mr. Miracle, Desaad, Orion, Kalibak and Darkseid

CRISIS ON INFINITE EARTHS
DC's Cosmic Housecleaning

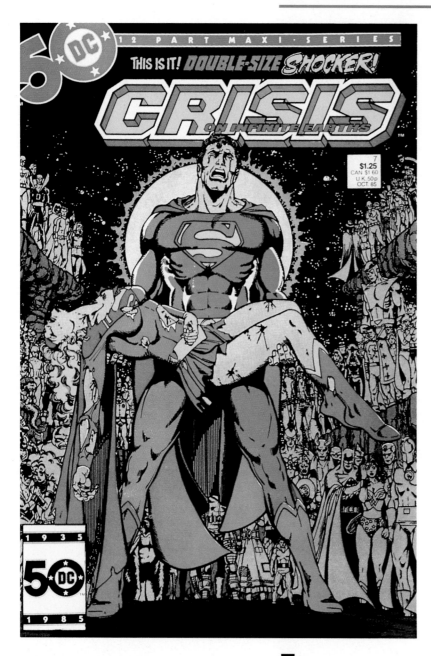

Supergirl really did die in the seventh issue of *Crisis* (October 1985). Three years later, a shape-shifting alien named Matrix adopted her appearance. Cover by George Pérez.

In 1985, DC marked its fiftieth anniversary by attempting to put its house in order. Complications in continuity had existed since the 1940s in the adventures of certain super heroes, but comic books were expected to be as disposable as old newspapers, and most readers stuck around for only a few years. Yet some young fans latched on to the idea that everything published should hang together, and they were the ones who grew up to become comics professionals, like Roy Thomas, Gerry Conway, Len Wein and Marv Wolfman. As characters and narratives proliferated, attempts to interrelate everything became strained, with increasing reliance on the idea that discrepancies could be explained by the concept of parallel universes like Earth-Two. By 1985, the DC Universe included over a dozen different dimensions, and it was just too much.

"Sometimes you have to say this is good for the entire company, and this is bad for the entire company, while also worrying about each book separately," says Marv Wolfman. "It's very, very tricky. Where do you draw the line?" Wolfman found out the hard way when he became the writer and editor of *Crisis on Infinite Earths*, a twelve-issue mini-series that started in April 1985 with the express purpose of clearing up continuity. "Even though I was writer-editor, I couldn't dictate ninety percent of what went in there. I could come up with a lot, but all the individual editors had to tell me what they wanted done with their characters." Editor Roy Thomas was in charge of the Earth-Two characters, those remnants of the Golden Age, and he liked Wolfman's idea of collapsing all the worlds into one. Gerry Conway had once proposed something similar called "the Big Bang," but Wolfman's proposal was far more complicated.

Wolfman's old friend Len Wein served as consulting editor on *Crisis*, while Robert Greenberger was associate editor and co-plotter. George Pérez, already known for his skill in handling large casts, came in as penciller and outdid himself on a series designed to include almost every DC character. When Wolfman requested a cover scene showing three villains, Pérez came up with over sixty. By the eighth issue, the artist was also being listed as yet another co-plotter.

"We were working toward the outcome, obviously," Wolfman admits, "but there is a fairly strong plot actually." The new villain introduced to purge so much of the DC Universe was the Anti-Monitor, a being of incredible negative energy created at the dawn of time and then unleashed to devour dimensions. A new hero was Alexander Luthor, Jr., from Earth-Three, where good guys were bad and vice versa. His realm was destroyed, along with many others, until finally only five were left. These corresponded to DC's Silver Age, DC's Golden Age, and the creations inherited from defunct publishers Charlton, Fawcett and Quality.

The last five dimensions were spared due to the heroic sacrifice of Barry Allen, the Silver Age Flash, who died in the eighth issue to destroy the Anti-Monitor's most powerful weapon. There were hints of his impending doom in early issues as the Flash made erratic appearances at different points in time and space, yet his death was a shocker for readers

No matter what he says, he's really the Anti-Monitor, the villain revealed in *Crisis on Infinite Earths* #5 (August 1985). Pencils by George Pérez, inks by Jerry Ordway and script by Marv Wolfman.

who considered this character to be the one who had revitalized comic books back in 1956. Yet perhaps even more of a sensation was caused by the fate of Supergirl, killed in the seventh issue during a feisty frontal assault on the Anti-Monitor. These cruel fates were not so much dramatic devices as company policy: sales for the Flash had fallen so low that his comic book was due for cancellation anyway, while Supergirl had not only slumped but was felt by DC executives to be damaging a more important character. "They wanted to make Superman special again," says Wolfman, "and they wanted him to be the only Kryptonian." Others died too, including the old cowboy character Nighthawk, rather gratuitously brought back from retirement only to be snuffed out again.

However memorable, the deaths of heroes were less important than the climax of the series in issue 10 (January 1986). The Spectre, the DC character closest to omnipotence, returned through time to the birth of the universe and confronted the Anti-Monitor in a cosmic cataclysm. History was altered as a result, and the characters from all the dimensions that DC chose to save were united on one world. Every surviving character was given a clean slate, with no past except what was introduced again. "The idea of the Crisis was that when issue 12 ended, there would never again be another reference to the Crisis having happened," Wolfman says. Nobody was supposed to remember the past, but almost inevitably there were compromises that rendered the change less effective. Still, this massive crossover series straightened out countless story lines and enabled some key characters to get spectacular jump-starts.

"I enjoy drawing a lot of characters," says George Pérez. "I'm so isolated when I work that it's probably my one bit of socialization." Nobody is lonely on his all-villain cover for *Crisis* #9 (December 1985).

The gruesome death of the Flash in *Crisis* #8 (November 1985). Pencils by George Pérez and inks by Jerry Ordway.

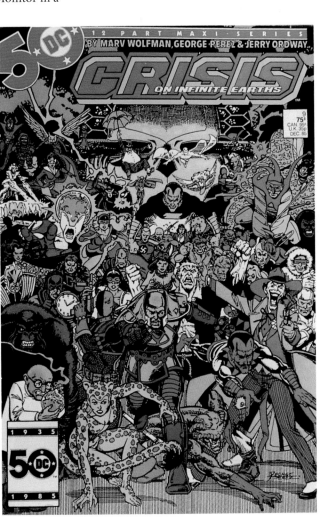

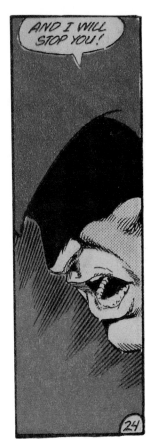

The sinister Spectre was the super hero who was super enough to set things straight in *Crisis* #10 (January 1986). Pencils by George Pérez and inks by Jerry Ordway.

THE DARK KNIGHT RETURNS
Taking Batman to the Edge

In the aftermath of *Crisis on Infinite Earths*, which wiped away the pasts of all DC's characters, the way was wide open for new interpretations of the classic super heroes. Yet strangely enough, the first and in some ways most significant revision was strongly grounded in a hero's history. *The Dark Knight Returns*, a four-issue mini-series created by writer-artist Frank Miller, made its debut in March 1986 and set off shock waves that continue to be felt a decade later.

Miller, who felt that super heroes had become too humanized in recent years, saw Batman as "a god of vengeance," and wanted to restore some of the mythic power he felt had been lost. "Comics had become more and more drained of the content that would give the heroes any reason to exist," he says. "I guess I was looking to bring comics a bit more of an edge."

Miller's story is set in a not-too-distant future when Bruce Wayne, pushing fifty, has hung up the Batman suit and is drifting into alcoholism. Jolted out of inactivity by the urban terrorism of a gang called the Mutants (not to mention the return of his old enemies Two-Face and the Joker), Batman stages a comeback. His ally, Police Commissioner Gordon, is facing retirement, his aged butler Alfred frets and scolds, and an adolescent girl appoints herself the new Robin while Batman embarks on a campaign that stops just short of slaughter. "To my mind it would take a peculiar kind of personality to actually engage in that sort of thing," says Miller, and *The Dark Knight Returns* was partly an examination of Batman's tortured psyche.

What readers and critics latched onto was the vision of a ruthless vigilante, carried to extremes in Miller's image of Batman on horseback, leading an army of skinheads sworn to keep the streets of Gotham safe in the wake of a nuclear winter. This was a disturbing picture, and some observers took it very seriously despite Miller's insistence that he had not written a political tract and would never ask Batman how to vote. The story was simply one individual's extrapolation of certain tendencies apparent in a hero who had been famous for almost half a century, but this Batman was a far cry from the feckless TV hero who still personified the Caped Crusader for so many fans. What humor there was tended to be cruel, as in Two-Face's epithet for Batman's former sidekick: "Robin, the Boy Hostage."

Miller also set himself apart by the bold simplicity of his style. He was a minimalist, at odds with fashionable trends toward embellishments in pictures and prose. "The way I like to work," he says, "is to have the image and the words carry as much impact as possible." Collaborating with inker Klaus Janson and colorist Lynn Varley, Miller gave comics a new look.

In 1986–87 Miller returned to his subject with *Batman: Year One*, which updated the Dark Knight's origin story with emphasis on his symbiotic relationship with Commissioner Gordon. There was also a revamped Catwoman, transformed from a sophisticated jewel thief into an embittered hooker seeking vengeance on an uncaring world. This time David Mazzuchelli did the drawing, but the worldview that so many have described as dark remained. "People use the word *dark*," complains Miller, "to describe anything that isn't so absolutely rosy that it makes me sick."

Frank Miller's weary Batman can also be a frightening figure, as suggested by this grotesque image on the cover of *The Dark Knight Returns* #2.

Frank Miller's narrative is interspersed with small panels shaped like TV screens on which talking heads debate Batman's tactics while civilization crumbles around them.

The cityscape of Frank Miller's Gotham City is dominated by one building; its spiky architecture is a monument to bats even before the hero's signal shines. Inks by Klaus Janson.

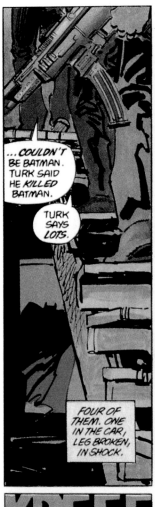

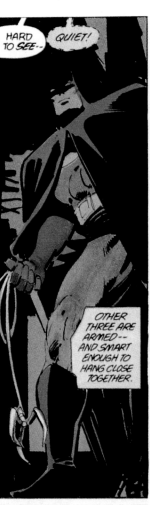

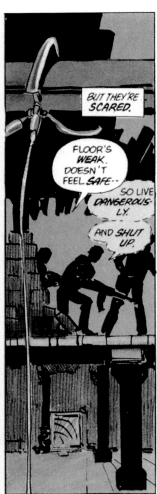

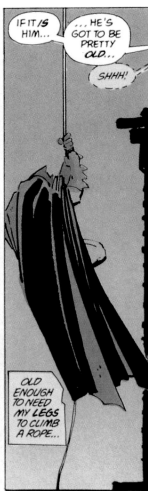

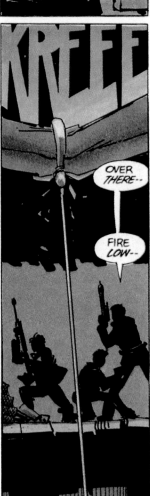

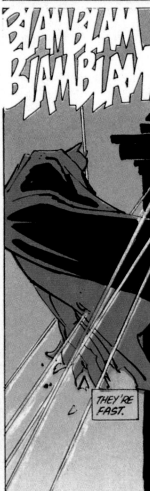

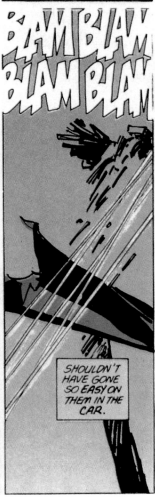

One influential aspect of Frank Miller's work lies in his treatment of fight scenes. Here an aging Batman takes on four young thugs in a nerve-wracking and brutal battle that places the emphasis on strategy. The days of roundhouse punches accompanied by corny quips are long gone. A weary Bruce Wayne struggles to survive and curses himself for being too lenient with his opponents. Miller employs virtually every type of page layout in the course of *The Dark Knight Returns* (1986), including this deceptively simple one which repeats an unusual panel shape eight times. The tall panels enforce the feeling of height during this fight (set in a construction site far above the ground), and the constant repetition of these narrow frames creates a sense of tension that the artist will maintain for twelve more identical panels before the struggle ends. Miller calls Klaus Janson's inks "a good example of how black and white artwork can overcome the limitations of being printed on pulp paper," and cites Lynn Varley's coloring for "transforming the work and giving it tremendous added dimension."

THE MAN OF STEEL REVISED
Starting from Scratch with Superman

John Byrne's cover for the first issue of *The Man of Steel* (June 1986) captured an indelible image and would be widely imitated.

The first issue's new look for Lois would prove influential. Script and pencils are by John Byrne and inks are by Dick Giordano, who stayed at his drawing board even while supervising all DC's comics as the company's executive editor. As Giordano puts it, he could stop drawing only slightly easier than he could stop breathing.

Superman was scheduled for a substantial overhaul in 1986, and the job went to writer-artist John Byrne. Following years of popular work at DC's rival Marvel Comics, Byrne had become, in the words of Superman's editor Andy Helfer, "the strongest card in comics." Byrne's was one of several proposals submitted to a DC team that included president Jenette Kahn and vice presidents Paul Levitz and Dick Giordano. Byrne believes his plan was chosen because it was basically respectful of the character's long history. "I put together what I called a list of unreasonable demands," he says, "and it turned out they weren't all that unreasonable."

Some readers felt that when Byrne returned to the origin of Superman, he really didn't change things all that much, and to some extent Byrne agrees. "If you're starting at zero, you have a whole bunch of bits and pieces to choose from," he explains. His plan was to select the most effective elements from decades of Superman stories. This synthesis was unveiled in a six-issue series called *The Man of Steel*. "Sales were great," says Andy Helfer, who felt that Byrne was on a roll and turned over the editorship to Mike Carlin.

One nice change that Byrne made was leaving Jonathan and Martha Kent alive to enjoy their adopted son's success as a hero, and to help him create the different personalities of Clark and Superman. "As long as he's careful never to let on that he has two separate identities," suggests Pa Kent, "he'll be able to move freely." Thus Byrne was able to eliminate a problem that had bothered him since he was a boy: "When was Superman so stupid that he told people he had a secret identity? Why would he do that?"

Keeping the secret identity a secret also changed the role of Lois Lane, who would no longer spend so much time trying to figure out who Superman really was. "Lois was always such an annoying character," says Byrne. "I wanted to change that." The new Lois was

possibly even more assertive than before, and so skilled at unarmed combat that Superman sometimes seemed redundant, but she wasn't the pest of bygone days, and Clark was more smitten than ever.

Lex Luthor, Superman's archenemy, got a face-lift too. The idea came from Marv Wolfman, who was working on the regularly published Superman comic while Byrne was doing *The Man of Steel* series. Wolfman's thesis was that Luthor would be more convincing and more dangerous as "the richest man on earth," rather than as a brilliant scientist who had to come up with an earth-shaking new invention every few weeks. The new Luthor would just hire somebody to do that for him. As penance, however, he had to undergo the indignity of turning bald all over again.

"I wish I had kept Superboy," Byrne admits in retrospect. Planning to present "a Superman who was only just learning how to be Superman," Byrne returned to Jerry Siegel's original idea that Clark Kent didn't don the red cape until he was grown up. But the idea of an adult Superman "who wasn't very good at it yet" never got off the ground, because DC wanted to get an effective hero back as soon as possible. Superboy stories might have helped Byrne fill in some background, but the charm of his storytelling helped convey his most radical idea of all: this Superman had his deepest roots on Earth and not on Krypton.

Time's cover for March 14, 1988 featured pencils by John Byrne and inks by Jerry Ordway. Byrne didn't like *Time*'s lettering or its description of Superman's powers as "supernatural."

The final page of John Byrne's 1986 mini-series *The Man of Steel* sums up the interpretation that he brought to the character. Like others of his generation, Byrne had grown up with editor Mort Weisinger's evolving conception of Superman, which placed increasing emphasis on the hero's alien origin. Weisinger's version of Superman was primarily a son of Krypton, seeking out other remnants of that lost civilization and feeling most comfortable among them. Byrne decided that the real personality was not Superman but Clark Kent, a kid who grew up in the heartland of America and embraced its ethics. It's all very handy, since the hero is able to stay true to one set of roots while still rebelling against another. A strong sense of Clark's bucolic childhood had been conveyed in the 1978 movie *Superman*, and the film's star also influenced Byrne. "I looked at the face that Curt Swan had been drawing and I realized I couldn't quite capture that," Byrne says, "so I set out to find a face, and certainly I was looking at Chris Reeve a lot." Script and pencils by John Byrne and inks by Dick Giordano.

THE AMAZON REDEEMED
Wonder Woman Returns to Her Roots

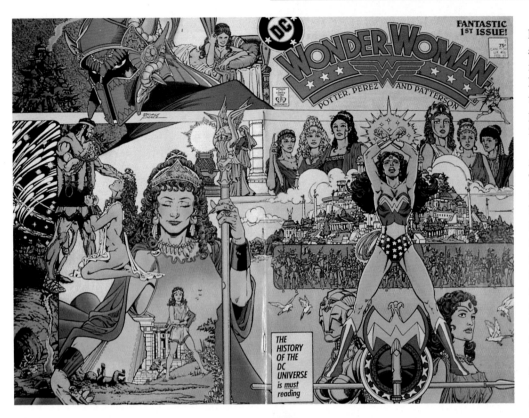

Beneath a pantheon of goddesses, an Amazon springs from a carefully researched background onto the cover of *Wonder Woman* #1 (February 1987).

In *Wonder Woman* #6 (July 1987), the war god Ares is caught in the golden lasso and realizes that a modern conflict might destroy all his worshippers at once. Plot and pencils by George Pérez, script by Len Wein and inks by Bruce Patterson.

Due partly to *Crisis on Infinite Earths*," says George Pérez, "DC was going through an enormous revitalization of their characters." Perhaps Pérez, whose work had been so important to the success of *Crisis*, felt some sense of responsibility for the resultant upheaval, because he found himself almost inadvertently volunteering to revamp one of the most complex characters in the DC pantheon. "After promising myself that I was not going to take on another monthly series," he says, "it just came out of my mouth." At the height of his fame as one of the most popular artists in comic books, Pérez had offered to put his spin on Wonder Woman.

Pérez had come along at an opportune moment for Janice Race, who was supervising the scheduled debut of a new Wonder Woman but "wasn't really happy with the way it seemed to be going," as Pérez recalls. "I asked if she'd be interested if I jump-started the series with my interpretation of the character. And I got kissed by an editor."

Encountering modern civilization, Wonder Woman becomes a celebrity courtesy of publicist Myndi Mayer. Art by George Pérez and Bruce Patterson from *Wonder Woman* #8 (September 1987).

Writer Greg Potter was already on board, but he dropped out due to other commitments shortly after *Wonder Woman* #1 was published in February 1987. By that time, Karen Berger had taken over the editor's post, and by the third issue Pérez was providing plots as well as pencils, with top writer Len Wein providing the finished scripts.

"I wanted to get back to the mythology," says Pérez. "I wanted to purify the concept." This meant remaining as close as possible to the ancient Greek tales that were the springboard of the series. Creator William Moulton Marston had mixed Roman gods in with the Greek, but Pérez kept things straight even when it involved using a less familiar name like "Ares" instead of "Mars." The new version also jettisoned the weird technology anachronistically present on the original Paradise Island; now Wonder Woman could leave her home and enter the modern world with no preconceptions. "I was trying to do a humanist as opposed to a strictly feminist point of view, because I didn't want her to be a confrontational character," explains Pérez. "She had no built-in prejudice."

Pérez also jettisoned the old idea of Wonder Woman's secret identity. Since he wanted a character who was innocent about the ways of the world, "there was no way she could have pulled it off, and she'd have no reason to hide." The decision to do away with the old Diana Prince personality came "with Jenette Kahn's permission." DC's president calls Wonder Woman "one of the three most important DC characters ever created, perhaps the first feminist in pop fiction. I feel that she's a national treasure."

When George Pérez made the unexpected and gallant gesture of offering his services to Wonder Woman, it paid off with a big boost in circulation for the Amazon princess. By the seventeenth issue he was writing the scripts on his own, and eight issues later he turned the artwork over to Chris Marrinan. Pérez finally left to pursue other projects, and in leaving Wonder Woman behind, he showed the Amazons deciding to let men visit their island. "Because what good is preaching brotherhood," Perez asks, "if you're going to be an isolationist?"

The inhabitants of Paradise Island debate the fate of a fallen Steve Trevor in the second issue of the new *Wonder Woman* (March 1987). As it was written in the original version almost fifty years before, Princess Diana must return with Trevor to confront the outer world and the armed might of men, but there are differences. Still segregated by sex, the Amazons are no longer all Caucasians; writer-artist George Pérez, however, was determined to see to it that they were all Greeks. "The Amazons and the Olympians obviously had a well-documented mythology, so that became a nice challenge and allowed me to do something that is seldom done with super heroes: dealing with the question of religion," says Pérez. "My main goal was to purify the concept. If you're going to use Greek mythology, you shouldn't start mixing in Roman mythology and making a hybrid of it." Pencils and plot by George Pérez, script and plot by Greg Potter and inks by Bruce Patterson.

WATCHING THE WATCHMEN
A New Slant on Super Heroes

Who watches the watchmen?" This quotation from the ancient Roman poet Juvenal appears in the book collecting all twelve issues of the limited series *Watchmen*, a comic book that called into question the basic assumptions on which the super hero genre is formulated. And in 1986 everyone was watching

Half ruthless avenger and half pathetic underdog, Rorschach lights up near a kidnapper soaked with kerosene in *Watchmen* #6 (February 1987). Script by Alan Moore and art by Dave Gibbons.

odd-looking fellow with a dirty raincoat and a streak of violence he can't control. Yet even without glamour, he crackles with energy and possesses a twisted sense of honor that makes his saner colleagues seem pale by comparison. "Rorschach's point of view is very difficult to argue with in some cases," Moore admits. "That's his problem. Anybody who's got that much moral integrity is probably going to be a fanatic."

At the opposite end of the spectrum is Ozymandias, a suave super hero turned financial wizard, who has used the fortune derived from marketing his own likeness to become a tycoon of limitless political power. As Adrian Veidt, he has left his crime-fighting days behind, but remains convinced that he has a mis-

Watchmen, which won enthusiastic notices in publications from the *Nation* to *Newsweek*, from *Time* to *Rolling Stone*. A comic book that seemed to transcend the form, *Watchmen* remains a landmark and made celebrities out of writer Alan Moore and artist Dave Gibbons.

"We started out purely wanting to do a strange take on super heroes," Moore recalls. "As the book evolved, it became clear that what I'd really been writing about was something else. I mean, on the very first page there's an atmosphere of apocalypse." Moore envisioned a parallel world similar to ours at the time, with two superpowers poised on the brink of war, then added several super heroes with feet of clay. Most are retired, but one has been murdered, and a grubby little hero called Rorschach suspects that he and his colleagues are in danger: "Somebody's gunning for masks."

Somewhat against Moore's wishes, Rorschach turned out to be perhaps the most memorable character in *Watchmen*. "Rorschach was to a degree intended to be a comment upon the vigilante super hero, because I have problems with that notion. I wanted to try and show readers that the obsessed vigilante would not necessarily be a playboy living in a giant Batcave under a mansion. He'd probably be a very lonely and almost dysfunctional guy in some ways." With his mask removed, Rorschach is just Walter Kovacs, an

sion to save the world. The third key figure among *Watchmen*'s many super heroes is Dr. Manhattan, the only one among them who possesses incredible powers. Exposure to radiation has made him virtually omnipotent, but his transcendent abilities are gradually robbing him of all human qualities. "The initial premise of *Watchmen* was a world in which super heroes had consequences," Moore explains. "Dr. Manhattan turns up and the whole world changes."

Moore has received so much of the credit for *Watchmen* that he is quick to point that "a lot of the ideas were Dave's." Artist Dave Gibbons created the look of the series, of course, but also added innumerable details like "little electric hydrants on the corners" to fuel electric cars. One whimsical thought from Gibbons that proved especially fruitful was the suggestion that since masked heroes weren't special in this world, comic books might feature stories about pirates. This idea was a small tribute to DC editor Joe Orlando, whose early work at EC Comics had included such swashbuckling yarns. "In issue 3 I suddenly saw a way that we could use this very bloody pirate narrative as a counterpoint to the main story," Moore explains. A little kid sitting against a warm electric hydrant and reading comics became a key figure whose fantasy life served as a gloss on the actions of the great and powerful.

A reader comments on an image of doom from a comic book within the comic book *Watchmen* #3 (November 1986).

The unearthly Dr. Manhattan looks at life in *Watchmen* #1 (September 1986). Script by Alan Moore and art by Dave Gibbons.

This is a Watchman watching the world. Amidst his own action figures, Ozymandias, also known as Adrian Veidt, looks outside in *Watchmen* #1. Script by Alan Moore and art by Dave Gibbons.

The kid dies, along with millions of others, in a mysterious cataclysm that decimates New York but so shocks the world that it prevents an imminent nuclear war. The responsibility for the catastrophe lies with one of the story's super heroes, and another is killed so that the strategic sacrifice of so many millions will have its intended effect. This climax is set within the context of the Cold War, a time that Moore characterizes as having an "uncertain, doubtful and anxious energy running through it." He recognizes that recent events may have dated the story, but insists, "I really wouldn't change a word of it."

The ethical dilemmas posed by *Watchmen*'s climax remain intact, as do its questions about the merit of employing might. "*Watchmen* was designed to be read on a number of levels," Moore says. "To a certain degree all interpretations are true. We designed it so it got a kind of crystalline, faceted structure, where you could turn it around in your hands and look at different aspects of it. All of these different little threads of continuity are effectively telling the same story from different angles." In its moral and structural complexity, *Watchmen* is the equivalent of a novel, and it remains a major event in the evolution of comic books.

Armageddon arrives at midnight in *Watchmen* #12 (October 1987). This panel by Dave Gibbons is the first one in the series to use a full page.

Ruth Delfino as Pamela Poodle and Billy Curtis as the title character in the 1958 pilot film *The Adventures of Superpup*.

SUPERBOY ON TV
The Kid from Krypton Grows Up

The first DC television series, starring George Reeves as Superman, was such a solid and long-lasting success that the search for a follow-up began as early as 1958. It would take thirty years for a spin-off to get on the air, but DC executive Whitney Ellsworth certainly can't be blamed for lack of effort.

Ellsworth never returned to New York after his stint producing *The Adventures of Superman*, instead becoming caught up in the Hollywood syndrome of producing television pilot films. His first effort was an astonishing concoction called *The Adventures of Superpup* (1958). Ellsworth's idea was a version of the Superman show designed for young children, with the famous characters played by animals. The animals, however, were portrayed by diminutive actors wearing fiberglass dog masks. Familiar filmland little people like Billy Curtis and Angelo Rossitto portrayed reporter Bark Bent and his irritable boss Terry Bite. A half-hour pilot film for *Superpup* was shot on the same sets used for the *Superman* program; the script by Ellsworth and director Cal Howard showcased the crimes of the wicked Professor Sheepdip. No sponsor bit, and the film has gathered dust for years, but it is at once charming, quaint and completely bonkers.

For his next pilot, *The Adventures of Superboy* (1961), Ellsworth selected "The Rajah's Ransom," a script based on the comic book story "The Saddest Boy in Smallville" from *Superboy* #88 (April 1961). The tale concerns a youth at Smallville High who is ashamed of his father's job as a theater doorman until dear old dad helps Superboy catch some crooks. The plot was a little preachy, filming was rushed, with only three days allowed for everything except special effects, and twenty-three-year-old John Rockwell lacked the reassuring charisma of George Reeves. Ultimately, it was simpler for DC to syndicate the old Superman show rather than pay for a new one, and Superboy went into cold storage.

John Haymes Newton as a pensive Clark Kent in the version of *The Adventures of Superboy* that reached the air in 1988.

A less serious John Haymes Newton stops filming to trim the locks of scriptwriter and DC editor Andy Helfer.

Television's first Superboy, John Rockwell, starred in an unsold 1961 pilot film written by Vernon E. Clark and Whitney Ellsworth.

When Superboy finally made it to television in 1988, it was courtesy of executive producers Ilya and Alexander Salkind, who were seeking to continue the success they had enjoyed with their feature films about Superman. Filmed at both Disney and Universal Studios near Disney World in Orlando, Florida, *The Adventures of Superboy* got its start with John Haymes Newton in the title role, but he lasted for only twenty-six programs. Problems with traffic court had tarnished his image, and salary demands led to his dismissal in 1989. The program underwent a number of other cast changes, and by the time new star Gerard Christopher was firmly established, *The Adventures of Superboy* had been transformed. Originally a rather lackluster offering about youthful antics at Shuster University, the series became one of the most imaginative dramatizations of a super hero ever filmed.

Ambitious scripts were a key factor in the show's success during the latter part of its hundred-episode run, and DC played a part in keeping the ratings high. Superman's editor Mike Carlin and his predecessor Andy Helfer worked as DC's liaisons with the producers. "We did have script approval," says Carlin, "but ultimately we had to deal with the realistic problem of what they had to do on a weekly basis to get something on the air." In fact, DC had declared Superboy nonexistent in 1986, but that didn't stop Carlin and Helfer from contributing scripts for the show. "The way that came about was really weird," Carlin admits. The Writers' Guild was on strike, but not against the Salkinds, who were new to television. So the unions were willing to proceed with the show, provided some new writers were given a chance. Carlin and Helfer were on hand, along with other comics writers such as Cary Bates, Mark Evanier and Denny O'Neil (who brought Mr. Mxyzptlk onto the show). This infusion of talent helped guarantee that stories would not get stuck in typical TV ruts.

"There's much more freedom in comics to do what you want to do," says Carlin, but "it's really a kick to see somebody saying your words, and to see special effects that you wrote about." Carlin and Helfer suggested the idea of continuing one story through two half-hour programs, introduced aliens and kryptonite as plot devices, and included among their fifteen episodes a spoof called "Bride of Bizarro." Like many of the later episodes, this story contained a meaty role for Sherman Howard, the show's second Lex Luthor. Superboy experienced the abused childhood of this archvillain via "psychodisk" in "Know Thine Enemy," a dark story by J. M. DeMatteis that suggested how far the series had progressed from the simplistic early shows. An even meatier examination of role-playing came in "Roads Not Taken" by Stan Berkowitz and John Francis Moore; this two-parter showed Luthor and Superboy journeying to alternate worlds where Superboy had evolved into a despised murderer or a brutal tyrant. Multifaceted portrayals by Sherman Howard and Gerard Christopher added depth to episodes that helped make *The Adventures of Superboy* a standout series, ripe for rediscovery.

Out of the phone booth and into the sky, Gerard Christopher is ready to fly in *The Adventures of Superboy*.

The third and longest-lasting Superboy, Gerard Christopher, picks up another reason for the show's success. Fan favorite Stacy Haiduk plays his high school sweetheart, Lana Lang.

Robin's fate was decided in *Batman* #428 (1988), with a cover by Mike Mignola. There wasn't a happy ending.

WHO KILLED ROBIN?
An Interactive Whodunit

I had a Robin problem," says editor Denny O'Neil. "We could have simply lightened his character, or had some event happen to him that made him change his act. That certainly would have been a way to go." Instead, the decision was reached to let Robin die. An imaginary sidekick's demise captured the nation's imagination and became the most notorious event in comic book history as of 1988. Obscured in the resultant firestorm of public indignation was the question of who should take the final responsibility for his death.

"If I had to do it again, I would certainly have kept my mouth shut," admits O'Neil. Instead, he suggested at one of DC's editorial retreats that the company could do something interesting with the new 900 numbers being offered by telephone companies. It would be a chance to let

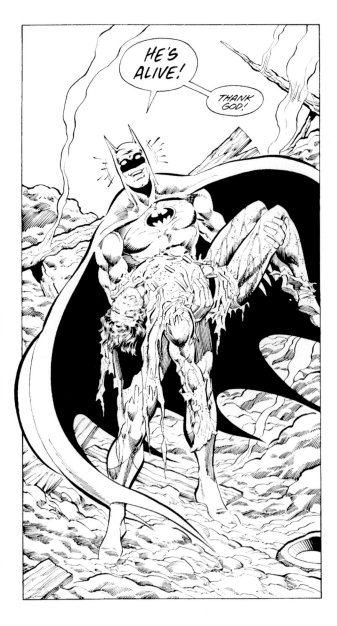

Robin lost by seventy-two votes. This pose, from *Batman* #428, has become all but obligatory for deceased comic book heroes. The black-and-white panel, previously unpublished, is from the alternate version of the same issue—the one with the happy ending. Pencils by Jim Aparo and inks by Mike DeCarlo.

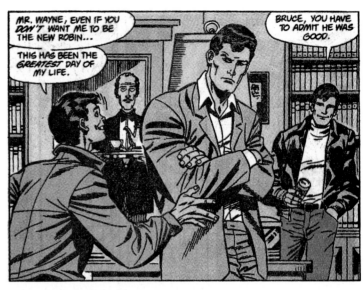

the fans participate in the creation of the comics even more immediately than they could through their letters. Company president Jenette Kahn liked the idea, and subsequent discussions determined that the readers would have to be asked to vote on something significant. So the idea of interactive entertainment came first, and only later did O'Neil realize that he could use it to help solve his "Robin problem."

The Robin in question was not Dick Grayson, who had graduated from his role as adolescent assistant to become Nightwing, leader of the popular group Teen Titans. His replacement was Jason Todd, who might best be referred to as Robin II. Created in 1983 by writer Gerry Conway as a frank imitation of Dick Grayson, the second Robin was rewritten by Max Allan Collins as a tough kid from a bad background. It could have been a good idea, but somehow it didn't work out that way. "Jason had drifted in a direction that is probably my fault as much as anybody's," says O'Neil. "We didn't set out to make him an arrogant little snot, but somehow or other in tiny increments he ended up that way. We reached the point where we were going to have to do a drastic character revision on him or write him out of the series." O'Neil finally decided to let the fans decide.

The four-part story line, written by Jim Starlin with art by Jim Aparo and Mike DeCarlo, appeared in four issues of *Batman* under the title "A Death in the Family" in 1988. The villain was the Joker, tied up in terrorism in the Middle East; at the end of *Batman* #427, Jason Todd was caught in an explosion. On the inside back cover, readers were given two telephone numbers whereby, for two days only, they could vote for life or death. O'Neil had two different versions of issue #428 ready for the printers as he waited for the calls to come in. DC's editorial director Dick Giordano, who had put O'Neil in charge of Batman two years earlier, was convinced that Jason would live, and O'Neil anticipated just the opposite, but both expected a landslide. Instead, they got a cliff-hanger. Finally, by a vote of 5343 to 5271, the public gave Robin thumbs down.

"One respected journalist said it was a setup," reports O'Neil, "but I had no control over it once it started." O'Neil did cast one vote for Jason Todd, "because I suddenly realized that I had set myself up for an enormously difficult editorial task if the kid didn't survive. When we did the deed, we got a blast of hate mail and negative commentary in the press." Publications like *USA Today* and the *Wall Street Journal* carried the story, and inevitably most

people believed that the boy who'd been blown up was Dick Grayson, fondly remembered from old comics or (more likely) the television series. "They reacted as if we had killed a real person," says O'Neil. "There was a lot of talk about Roman circuses out there, and it was really vehement and hateful." The DC publicity department advised him to lay low, but even so he was identified and harangued by several irate strangers before the furor ran its course.

A comparatively small number of readers had voted, but the verdict was thumbs down. Jason Todd was replaced with a third Robin named Tim Drake. Robin I was recruited to ease the way for Robin III, who got a lot of space in the pages of *The New Titans*, courtesy of the writer-artist team of Marv Wolfman and George Pérez. It was a smooth transition, and computer whiz Tim Drake has been accepted as a suitable partner for an American institution. "This time we got it right," says O'Neil.

The whole controversy left its mark, however. "It changed my mind about what I do for a living," admits O'Neil. "Superman and Batman have been in continuous publication for over half a century, and that's never been true of any fictional construct before. These characters have a lot more weight than the hero of a popular sitcom that lasts maybe four years. They have become postindustrial folklore, and part of this job is to be the custodian of folk figures. Everybody on earth knows Batman and Robin."

Tim Drake tries out for the job of Robin III, and Dick Grayson eggs him on in *Batman* #442 (December 1989). Script by Marv Wolfman and George Pérez. Pencils by Jim Aparo and inks by Mike DeCarlo.

The inside back cover of *Batman* #427 offered readers a unique chance to control the destiny of a comic book character.

The small image of Robin in the Joker's hand is a hologram, a cover enhancement that helped boost sales for the October 1991 debut of the mini-series *Robin II*. Pencils by Tom Lyle and inks by Bob Smith.

BATMAN GOES BIG-TIME
A Feature Film Takes the World by Storm

Did you ever dance with the devil in the pale moonlight?" That question, posed by the Joker, runs like a refrain through the 1989 motion picture extravaganza *Batman*. The film is a duet in the dark that turns into a duel between two men who are obsessed, and each one seems disturbingly devilish. "The reason Batman attracted me was because I love extreme characters," says director Tim Burton. "And I love the idea of a man dressed up like a bat versus a man who has literally turned into a clown."

Budgeted at $40 million, *Batman* became one of the biggest hits in Hollywood history, earning back its cost in the first weekend it opened, and going on to gross a reported $405 million around the world. Yet it took ten years to get the movie made. The rights were first acquired by *Swamp Thing* producers Michael Uslan and Benjamin Melniker, who ended up credited as executive producers after powerhouse producers Jon Peters and Peter Guber came on board. "There were many scripts written, many great directors involved with the project," Guber says, "but there was a moment in time when Jon and I saw Tim Burton, saw his creativity, and the whole project began to jell." Burton, who had started his career working on animated cartoons for Disney, made his reputation with the macabre comedy *Beetlejuice* (1988); its success convinced Warner Bros. to green light Burton's *Batman*.

Sam Hamm, who wrote the script with Burton's supervision, credits DC's comic books with inspiring his approach. As a boy he had sought out reprints of the Golden Age Batman, and both he and Burton were impressed with Frank Miller's reinterpretation of the character in *The Dark Knight Returns*. Executives wanted Robin in the script, and a desperate attempt was made to shoehorn him in somehow, even though the plot concerned itself with only the first few weeks of Batman's career. Ultimately, Burton used the precedent of Robin's demise after the recent readers' poll to justify giving the Boy Wonder the boot.

The two key figures in the fabulous success of *Batman* were director Tim Burton and Jack Nicholson, seen here as Jack Napier before his transformation into the Joker.

A brooding Bruce Wayne (Michael Keaton) plots strategy under the watchful eye of his sole confidant, the butler Alfred (Michael Gough).

The fans were not happy, however, about the idea of putting actor Michael Keaton into Batman's costume, casting originally suggested by producer Peters. In fact some enthusiasts were excessively vocal in condemning Keaton, who wasn't the obvious type physically but managed to bring fierce intensity to his role. "Michael Keaton was a less obvious choice," says Tim Burton. "He's not a square-jawed hulk. With Michael, the bottom line is, I could see him putting on a bat suit."

Michael Keaton's portrayal emphasized the pain of being Batman.

If Keaton had to win over the audience, everyone was sold from the first on Jack Nicholson as the Joker. In fact, Batman's creator Bob Kane had been suggesting Nicholson for years. The winner of two Academy Awards, Nicholson is capable of great subtlety, but he can also display a streak of manic malignancy that has helped make him an audience favorite. He had supported some of the screen's greatest villains (Vincent Price, Peter Lorre, Boris Karloff) during his apprentice years, and clearly he had learned his lessons well. "By the time Jack walks onto the set," Tim Burton says, "he feels very clear and strong about the character. So when you're shooting it's great, because that's when you toy around with the levels of how broad to go."

"Jack Nicholson was great as the Joker," says Bob Kane. "He carried the movie." Like many viewers, however, Kane was both impressed and vaguely irritated by Tim Burton's direction. "Tim has a great vision," allows Kane. "Unfor-

tunately he gets so involved with the characterization of the villains, and the scenic backgrounds, that at times he forgets about the story line." Some weak sequences were not entirely Burton's fault, however. Sam Hamm's script, polished by Warren Skaaren, was subject to last minute changes by nervous executives, and the situation was further complicated by a writers' strike. Much to Burton's horror, he and an uncredited Charles McKeown were forced to cobble together some of the scenes just hours before they were shot.

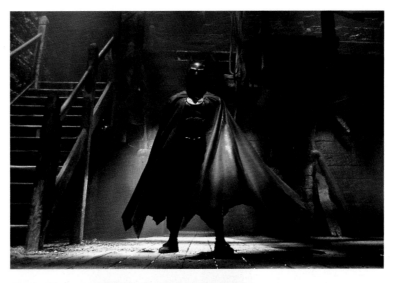

Michael Keaton as Batman, a Dark Knight in rigid body armor. Costume design by Bob Ringwood.

Designed by Anton Furst and built by special effects supervisor John Evans, the seemingly invulnerable Batmobile was made of fiberglass and measured almost twenty feet in length. "We wanted to get brutal violence into it," says Furst.

Aided and abetted by Anton Furst's Oscar-winning production design, Burton gave the film a look that more than made up for various narrative shortcomings. An obligatory love story senselessly forced Bruce Wayne to reveal all his secrets to reporter Vicki Vale (Kim Basinger) when his mysterious alter ego had barely been established, and the movie stopped dead twice to interpolate songs by Prince, but in the long run it didn't matter much. Not even Burton's apparent lack of interest in the fight scenes could derail this spectacular black comedy about two maniacs on a collision course, with its subversive lesson that the one without the sense of humor is bound to win. As Tim Burton says, *Batman* is "a very interesting, surprising action story with a bunch of weird characters running around. What more could you want?"

News photographer Vicki Vale was introduced in the comics in 1948 and later dropped. She was revived for the movie and was portrayed by Kim Basinger.

"Are people going to go nuts hearing that laugh all the time?" That was one of the questions that worried director Tim Burton, but fashion plate Jack Nicholson doesn't look worried at all.

"We tried to imagine what Gotham City was," said production designer Anton Furst of the plans he made with director Tim Burton for the look of *Batman*. "An interesting way of looking at it was to imagine what could have happened to New York if it had all gone wrong, taking the worst aspects of it. For instance, the zoning they did in New York, stepping back the buildings to get light into the streets. We thought we would do the opposite. As you cantilever forward, you get these oppressive canyons. So Tim's description of the city was that Hell had erupted through the pavements and kept on going. And that became Gotham City." Furst's drawings for the film include this ominous long shot of the city under a lowering sky, and a menacing, low angle view of the hemmed-in neighborhood near the Monarch Theater, the area where young Bruce Wayne's parents died.

"I always like to think of the sets as an extension of the characters. There are very few great movie cities and I think both Anton and I wanted to make it a unique place," says director Tim Burton of *Batman*'s Gotham City. The plan was to create something "not too futuristic, not too period, to really jumble it up." The look of the film suggests the styles caricatured in the comic books of 1939, yet it includes such anachronisms as TV sets, computers and jet planes. In defining the characters, Anton Furst reached back into other eras. He created an image of the Industrial Revolution in the huge pipes and the vat where the Joker is born from Jack Napier's fall, and constructed a Gothic cathedral for the final act of the morality play in which good conquers evil. Furst, who won an Academy Award for his work on the movie, died in a fall from a Los Angeles building in 1991 and was declared a suicide. His *Batman* sets at England's Pinewood Studios were built to stand, but were abandoned rather than reused when production on *Batman Returns* was moved to California.

THE SANDMAN'S COMING
A New Approach to Making Myths

He is the Lord of the Dreamworld, one of the Endless, the Prince of Stories, Morpheus. He may appear in the modern world of fast food and serial killers, or in the bygone days of rustic inns and omnipresent plagues. He is sometimes caught in the spotlight, but sometimes seems no more than a shadow cast across a human face. He is the Sandman, half-hero and half-host of a remarkable comic book series created by British writer Neil Gaiman.

DC had long before published two separate heroes called Sandman, but they were virtually forgotten by 1988 when Gaiman created his revised version. His editor was Karen Berger, who, after working with Alan Moore on *Swamp Thing*, had been appointed DC's British liaison by president Jenette Kahn. After collaborating with artist Dave McKean on an effective mini-series about the mysterious Black Orchid, Gaiman suggested that a revival of Sandman might be his next project, but writer Roy Thomas was already working on the old hero. Eventually Kahn told Berger to solicit an entirely new character called Sandman from Gaiman; the result was a mixture of fantasy, horror and ironic humor such as comic books had never seen before.

"I wanted to write a comic for intelligent people," Gaiman says. "I don't understand why people write down. Who are they writing down to?" His intention was to create "a literary comic," and among his influences were talented but apparently outmoded men of letters like G. K. Chesterton, Arthur Machen and James Branch Cabell. "The nice thing about being a writer is you can pick your forebears from any generation you like," says Gaiman, who also had influences closer to home. "What got me into comics was very much Alan Moore. The work he did for DC during the 1980s took comics places they had never gone before."

Working with artists Sam Kieth and Mike Dringenberg, Gaiman envisioned the Sandman as a pale, gaunt, black-clad immortal who reigns over the world of dreams; his siblings include Death, Destiny, Desire, Despair, Destruction and Delirium. Gaiman calls these enti-

ties the Endless, and reports that although he introduced them gradually, "I had pretty much the whole mythology worked out from the beginning." Such planning is unusual in a field where ideas are often developed one issue at a time.

The range of Gaiman's narratives is astonishing. In one story, Dream is handed the key to Hell by a disgruntled Lucifer, and is obliged to arbitrate among the myriad mythical beings who claim this valuable plot of celestial real estate. In another tale, Sandman intervenes to rescue the muse Calliope, imprisoned and abused by an ambitious writer who ends up cursed by an unbearable inundation of ideas. Gaiman even has the Prince of Stories inspire William Shakespeare to pen a play, *A Midsummer Night's Dream*, for an audience of the magical creatures it portrays. This comic book, of which Gaiman admits he is "really proud," received a World Fantasy Award even though that prize had been designed exclusively for works of prose.

In 1941 the Sandman, drawn by Bert Christman, wore a gas mask to protect himself from the weapon he used to subdue criminals. The 1947 version, by Joe Simon and Jack Kirby, looked more like a super hero and often battled supernatural menaces. In his latest and most significant incarnation, drawn here by Sam Kieth and Mike Dringenberg, the Sandman is the deathless ruler of a mystical realm that humanity can ordinarily see only in dreams. Such visions are hardly powerless, however, as writer Neil Gaiman has shown in a series of uniquely imaginative tales.

1941

1947

1989

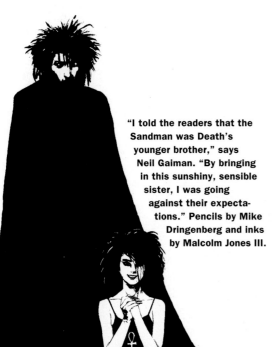

"I told the readers that the Sandman was Death's younger brother," says Neil Gaiman. "By bringing in this sunshiny, sensible sister, I was going against their expectations." Pencils by Mike Dringenberg and inks by Malcolm Jones III.

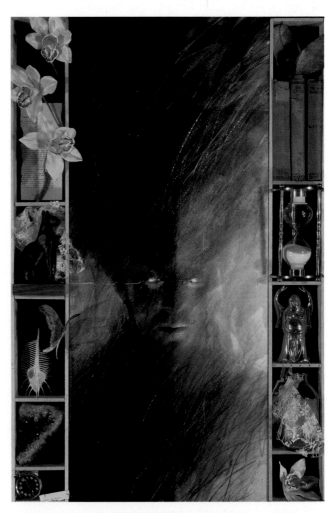

This construction painting for *The Sandman* #1 (January 1989) was the first of cover artist Dave McKean's distinctive contributions to the series.

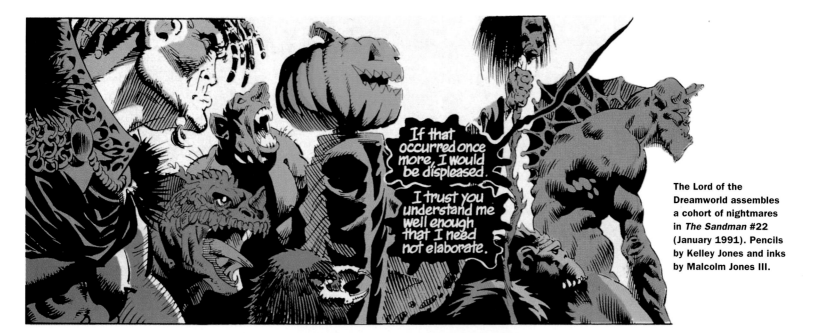

The Lord of the Dreamworld assembles a cohort of nightmares in *The Sandman* #22 (January 1991). Pencils by Kelley Jones and inks by Malcolm Jones III.

Even when he isn't creating a character out of a writer, like Shakespeare or Chesterton, Gaiman uses his forum as a way to assert the primacy of stories and dreams, which far from being mere diversions are presented as the devices by which we comprehend existence itself.

If *The Sandman* seems more writer-driven than any other comic book, it is perhaps because its artists have changed with each new story line. Some tales take one issue and some take several, but with each new narrative a dramatically different drawing style appears. "It started out of necessity," explains Karen Berger, "because the artists we were using couldn't draw a book on a monthly basis. Then we realized that thematically the stories were differing from each other, that it made sense to use a different artist for each one." The various collaborations helped inspire Gaiman, who says "very often the idea of the story was also partly about trying such-and-such an artist, and seeing how he'd work out."

Accustomed to working in limited forms, Gaiman had anticipated from the outset that *The Sandman* would have a beginning and an end. "I was wrong by a factor of about half on how long it would take me to tell the story," he admits. "I figured that by about issue 40 I'd be done." Nonetheless, as the monthly *Sandman* comic book finally concludes in 1995, Gaiman admits, "I'm looking forward to not writing a monthly comic, but I can't imagine leaving comics entirely because I love doing them."

Karen Berger says, "When you have a landmark series like *Sandman* or *Watchmen*, I feel you have to give the creators their due. After all, it's the creators who've lent the series its distinctive vision and voice. We don't want to be like Hollywood. We want writers and artists to feel safe to create."

Sandman defends the essential honesty of fantasy in "A Midsummer Night's Dream" from *The Sandman* #19 (September 1990). Script by Neil Gaiman and art by Charles Vess.

To please its ruler, Dream preserves the wondrous Baghdad of the Arabian Nights within his domain; the devastated city of today is the result. The irony is emphasized by the glamour of P. Craig Russell's art, (left and above), from *The Sandman* #50 (June 1993).

A NOVEL APPROACH
Comics with a Touch of Class

The term *graphic novel*, much in vogue lately, is sometimes used so loosely that it seems to be no more than a euphemism employed to make comics seem upscale. Properly speaking, however, a graphic novel is a specific item: a self-contained story in comics created to appear in the form of a book, either hardcover or softcover. Its format distinguishes it from a comic book, and its contents distinguish it from a trade paperback book, which in this medium constitutes a reprint collection of previously published comics.

At DC, the first graphic novel appeared almost by accident. It was *Star Raiders* (1983), originally intended to run as a four-part mini-series. As editor Andy Helfer explains, the project was planned to run in conjunction with an Atari video game, but "sales fell through the floor on Atari. We were halfway into the second part when they canned the project. We had forty-five pages of beautiful artwork, and Paul Levitz said, 'Can you turn it into a sixty-four page graphic novel?' Well, when you had intended to have seventy-five more pages of story and you get nineteen instead, you compress. We pulled scenes out of the beginning and made them part of the climactic battle, and it was all designed to showcase the wonderful artwork that José García-López had labored on for so long."

Star Raiders, with a script by Elliot S! Maggin and painted panels by García-López, was printed on oversized slick paper and designated on the cover as "Graphic Novel No. 1." It sold for $5.95. To extend the line and to justify the higher price and classier format, DC turned to science fiction expert Julius Schwartz, who edited a group of graphic novels based on works by top authors in the field. The series included Ray Bradbury's *Frost and Fire*, illustrated by Klaus Janson, and Harlan Ellison's *Demon with a Glass Hand*, illustrated by Marshall Rogers. There were also original offerings by comic book creators like Jack Kirby (*Hunger Dogs*) and Ernie Colón (*Medusa Chain*).

DC's graphic novels really went through the roof in 1989 with the publication of *Arkham Asylum*, a best-seller in hardcover at the substantial price of $24.95. Following in the wake of the successful film *Batman*, and featuring macabre paintings by Dave McKean, writer Grant Morrison trapped Batman in a madhouse with his worst enemies and provided a disturbing experience for the hero's many fans. *The Killing Joke* (1988) by Alan Moore and Brian Bolland had already explored the symbiotic relationship between Batman and the Joker to good effect, and these two books in combination turned graphic novels featuring Batman into a small industry unto itself. An "Elseworlds" series has proven particularly interesting, pulling Batman out of his usual environment to interact with colorful characters like Houdini, Dracula and Jack the Ripper.

Super heroes aside, DC has continued to explore the graphic novel as a forum for difficult, quirky, adult narratives. Writer Grant Morrison and painter Jon J. Muth explored murder and metaphysics in *The Mystery Play* (1994), while designer Dean Motter collaborated with art curator Judith Dupré on the script for *The Heart of the Beast* (1994), with Sean Phillips supplying visuals for a tale of romance and decadence among Manhattan artists. In such challenging works, comics achieve new levels of maturity.

Editorial director Joe Orlando turned control of the regular comic book line over to Dick Giordano and became creative director to supervise projects like this first DC graphic novel (1983). Cover by José Luis García-López.

A world of robot dinosaurs was envisioned by Pat Mills and Kevin O'Neill in *Metalzoic* (1986). The striking cover is by one of the most unusual stylists in comics, Bill Sienkiewicz.

Horror writer Karl Edward Wagner plotted this tale of obsessive love with artist Kent Williams; the script for *Tell Me, Dark* (1992) is by John Ney Rieber.

Published in 1989 during the period of increased interest in Batman caused by Tim Burton's feature film, the graphic novel *Arkham Asylum* was an unprecedented success, selling 182,166 copies in hardcover and another 85,047 in paperback. The project was originally planned for an earlier date, with Batman playing a comparatively minor role in what had been intended as a study of his major foes. Arkham Asylum is where some of Batman's most colorful opponents spend time between crimes, but the idea of setting an extended narrative within its confines was something different. Karen Berger edited, with a script by Grant Morrison of *Animal Man* and *Doom Patrol*, and art by Dave McKean. Best known for his *Sandman* covers, McKean produced 120 pages of paintings for *Arkham Asylum*, offering powerful visual reinterpretations of the classic characters. The Joker, shown here luring Batman into the asylum by threatening to blind a witness, has rarely looked so scary. Since Morrison's story was intended to present the hero as a symbolic construct, Batman is a shadowy figure, defined only in relationship to the evil he encounters.

Batman's popularity, combined with his role as a detective, has enabled the character to serve as a vehicle for stories far beyond the range of the ordinary super hero. In *Night Cries* (1992), he investigates the case of a serial killer but eventually realizes that all the victims were guilty of child abuse. The murderer turns out to be a respectable member of society who commits suicide rather than face up to his crimes. Batman is left with the knowledge that thousands of children are suffering, and the fear that he will never be able to save them all. Published in hardcover and paperback, *Night Cries* was written by Archie Goodwin, who is widely regarded as one of the best writers in comic books. His career has included a period as editor in chief of Marvel Comics; Goodwin is now a group editor at DC, contributing to the key decisions affecting the destinies of DC's best-known characters. Cover by Scott Hampton, who also painted the interior pages of the book.

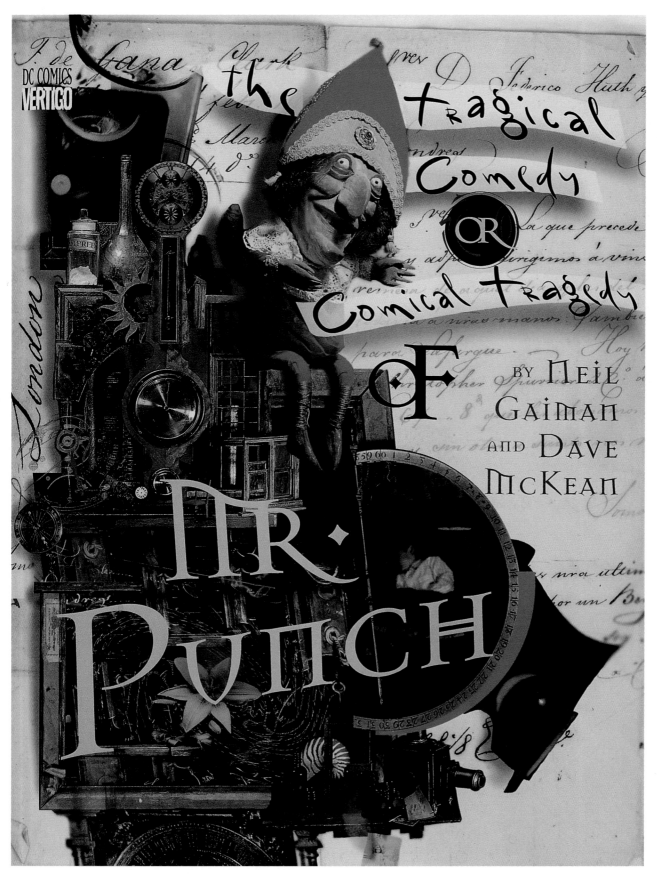

Mr. Punch (1994) is a graphic novel from Vertigo, a new division of DC supervised by executive editor Karen Berger. "Karen has made such a significant contribution to DC," says company president Jenette Kahn. "She's been completely self-motivated, and she defined her own job." Part of that job has involved recruiting talent from abroad—the so-called "British invasion" of American comics. The distinctive quality of that British talent is undeniable, but its roots remain elusive. "It's the rain," jokes Berger, and Neil Gaiman, writer of *Mr. Punch*, suggests "it could be something in the water." In this graphic novel, Gaiman uses the British tradition of the Punch and Judy puppet show as a metaphor for the senseless cruelty of life, seen through the eyes of a small boy for whom Punch is both hero and horror. Dave McKean, who does the covers for Gaiman's *The Sandman*, has often incorporated found objects into those paintings; his cover for *Mr. Punch* is a photographed still life. McKean's work on the interior pages, a combination of painting and photography, constitutes a unique experiment in the history of comics.

GONE IN A FLASH
The Scarlet Speedster on TV

These days, not even super heroes are invulnerable. Take Barry Allen, the version of the Flash created in 1956 and killed off by DC in 1986. In 1990 he showed up on television, alive and kicking, only to be wiped out again in the twinkling of an eye. He went down fighting, however, and in the process introduced some new elements of sophistication to the treatment of comic books on the small screen.

Developed and produced at Warner Bros. by the team of Danny Bilson and Paul De Meo, *The Flash* made its debut on the CBS network in 1990, receiving an obvious boost at the network from the tremendous revenues generated by the 1989 film *Batman*. Bilson and De Meo, longtime comics fans, had first proposed a super group based on various DC characters, but CBS executive Jeff Sagansky preferred the solo speedster. Once the series was approved, it was prepared with immense enthusiasm and considerable expertise by a knowledgeable production team, and each hour-long episode was budgeted at over a million dollars.

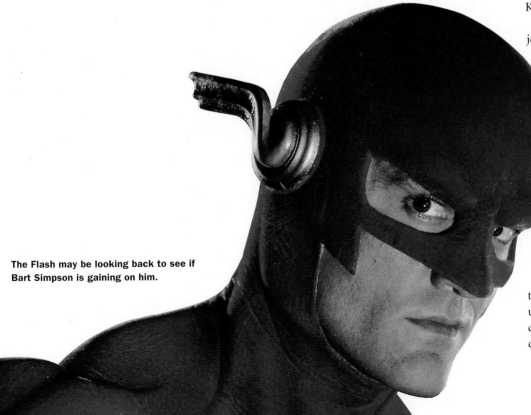

This photograph at least suggests the special effects techniques used to make *The Flash* perhaps the flashiest treatment of a super hero ever to appear on television.

The Flash may be looking back to see if Bart Simpson is gaining on him.

The show's story editors were comic book professionals Howard Chaykin and John Francis Moore; Chaykin's work at DC includes revivals of *The Shadow* and *Blackhawk*. Together with the producers, these story editors guaranteed an awareness of comics nuances. Danny Elfman, who scored *Batman*, composed theme music for *The Flash*; the title character's costume was designed by comics artist Dave Stevens, whose hero the Rocketeer was currently being adapted for the movies from a script by Bilson and De Meo.

The Flash costume was actually an elaborate special effect on which hundreds of thousands of dollars were spent. Working from the Stevens designs, Robert Short constructed a sculpted suit in the *Batman* mode, with foam rubber muscles added under the surface and over the already solid physique of actor John Wesley Shipp. The result was almost too impressive for a character whose talent is speed rather than strength, and it proved to be so uncomfortable that arteries of cooling water had to be built into its bulk. Still, it seemed to fit the current super hero mold. And Shipp, a graduate from the soap opera *As The World Turns*, had a tough, granite-jawed demeanor that made him look more a super hero than any of his predecessors. Yet Shipp, a capable actor, didn't quite come across. The fault might have been with the scripts as much as his performance, yet Shipp's Flash seemed like a generic man in a costume, lacking a distinguishing characteristic like the affable confidence of George Reeves as Superman or the repressed rage of Michael Keaton as Batman.

Special effects expert David Stipes had the job of moving the Flash along, and chose methods that would reproduce the stylized "speed" visuals created years before by artist Carmine Infantino. Red streaks and after-images appear behind the hero courtesy of camera composites, undercranking and retouching via video. The speeding scarlet suit created quite an impression, and added to the powerful look of the two-hour story that introduced the Flash to his Thursday-night audience. Yet it seems in retrospect that the Flash never really had a chance, even if it did take a menace as powerful as Bart Simpson to do him in.

CBS had deliberately put *The Flash* into a time slot opposite NBC's Bill Cosby, whose situation comedy had been the top show in the country for so long that it looked ripe for a challenge. What nobody expected was that the

fledgling Fox network would throw down its own gauntlet with *The Simpsons*, an animated cartoon parodying family life in a disillusioned America. CBS hoped that the Flash would be 1990's poster boy, but that rotten kid Bart Simpson ended up on everybody's T-shirt instead, even appearing in the mysterious guise of Bartman.

Meanwhile, the impeccably produced *Flash* program began to look a little precious. Too many of the scripts seemed tied in to comic book history and to the concerns of specialists. The symptoms appeared in the first story, written by Bilson and De Meo, which made a murdered family member the motive for the hero to don his dazzling duds (just like Batman). The bad guys were organized gang members threatening to take over a city, a situation suggesting Frank Miller's *The Dark Knight Returns*, but not so well handled. Subsequent episodes featured ideas like a super hero from the 1950s who comes out of retirement, and a super villain from the 1950s who does the same. Particularly troublesome was a show about the Trickster, played by *Star Wars* star Mark Hamill. Full of gags and in-jokes, it presented the Flash as a philandering fool and a failure, and if fans loved its audacity, it must have baffled the general public. Too many episodes like this one might have sunk the show eventually, but the competition killed it in one season.

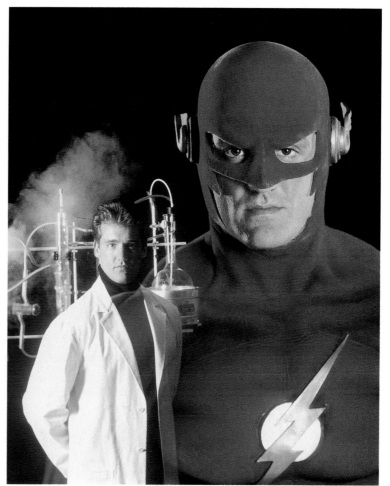

John Wesley Shipp as police scientist Barry Allen, at home in his lab but destined to be overshadowed by his fast-moving alter ego.

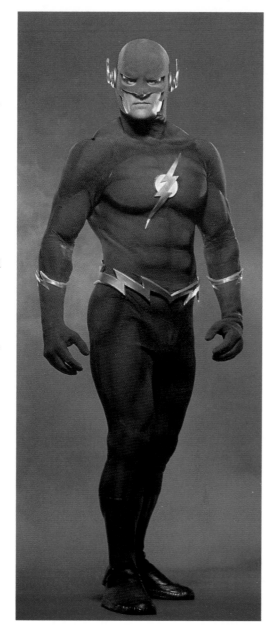

In costume, John Wesley Shipp made a formidable Flash.

With Shipp is Amanda Pays, who portrays Dr. Christina McGee. She knows about the Flash's talent and even designs the scarlet suit that won't disintegrate when he accelerates.

BATMAN RETURNS
Warner Bros. Goes Back to the Batcave

This cartoon of the Bat, the Bird and the Cat was drawn by director Tim Burton.

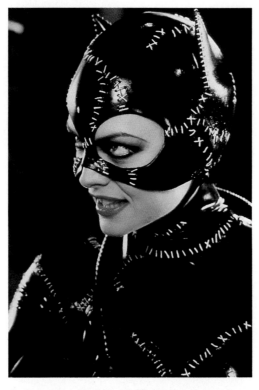

As Catwoman, Michelle Pfeiffer has a gleam in her eye that may be inspiration or just insanity. "She's really a strong counterpart to Batman," says director Tim Burton.

Why a duck? Because Danny DeVito as the Penguin has birds on the brain. "In the comics," says director Tim Burton, "he was just a funny-looking man. We've given him something." "He is without a doubt one of the most evil characters that I've encountered," says Danny DeVito of the Penguin.

When *Batman* became such a box-office success in 1989, a sequel was almost a foregone conclusion, and *Batman Returns* duly appeared in 1992. The new film took in another, if slightly smaller fortune (it became the biggest money-maker of the year), but oddly enough director Tim Burton insisted that it was not really a sequel. "I think it was a sequel," says cartoonist Bob Kane. "I thought both movies were very similar. They both had villains who wanted to take over Gotham City and become mayor. Why follow the same story line?" Burton is on record expressing his disappointment with *Batman*, and may have felt he was not so much continuing the story as virtually remaking it with the follow-up. A more grotesque, more challenging film, *Batman Returns* was also a more personal work. "The point," says Burton, "is to make it fresh and exciting and new but still Batman."

As for Batman himself, his embodiment Michael Keaton reports that "in a lot of ways this was harder, because I found myself doing an impersonation of myself, which was first of all impossible, and second of all really strange." Keaton eventually relaxed into his role as straight man for the forces of evil, which this time were embodied in three separate villains. The least bizarre but most central to the plot is Max Shreck (Christopher Walken), an entrepreneur who seeks ultimate power in Gotham and uses the Penguin (Danny DeVito) as a pawn. The film's Penguin is not the jolly rogue of yore, but a horribly deformed lunatic who has grown up in the sewers and now seeks to achieve public acceptance through fraudulent displays of benevolence, much as the Joker did in the previous movie.

An unexpected ringer appears in the form of Shreck's secretary, Selina Kyle (Michelle Pfeiffer). He tries to kill her after she learns of his nefarious plans, and the shock inspires her transformation into Catwoman. Known for sexiness on screen, Pfeiffer is a revelation as the downtrodden, frumpish office worker, then sensational as the lasciviously loopy Catwoman. Allying herself alternately with the Penguin and Batman, whip-wielding and deliriously perverse in her homemade black rubber costume, she left audiences baffled about whether she should be considered "good" or "bad." "She was always good at

heart but she was always running astray," Pfeiffer replies.

Interpreting this revisionist Catwoman is something of a problem, since she is obviously intended to be a feminist figure, yet all her motivation comes from victimization. The original version, from presumably less liberated days, is nobody's patsy and goes into crime strictly for fun and profit. "I thought it would be a couple of scenes and probably not a fully developed character, but I didn't care," admits

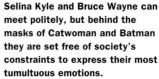
Selina Kyle and Bruce Wayne can meet politely, but behind the masks of Catwoman and Batman they are set free of society's constraints to express their most tumultuous emotions.

Pfeiffer. "I would have done it anyway, because it's a kind of idol from my childhood. Then, to my surprise, I read the script and I found her to be very interesting and very complicated and actually quite a challenge." Pfeiffer and Keaton meet in their suspiciously similar costumes and engage in some suggestive struggles, but they also have scenes as Bruce Wayne and Selina Kyle where they seem to be developing a less stressful relationship. Says Michael Keaton, "There are points where, if you really want to examine it, they almost lose themselves in each other." The immediate impression is that they were made for each other, but the lure of their darker sides proves too great for them. "She's a great match with Michael Keaton," notes Tim Burton of Pfeiffer. "There's four great eyes there between the two of them." Still, Bob Kane's blunt assessment may be closest to the mark: "I think Catwoman stole the show."

The script for *Batman Returns* is credited to Daniel Waters, from a story by Waters and Sam Hamm. Wesley Strick did uncredited revisions too, yet this still seems very much Tim Burton's

film, and apparently his final statement on the subject. Burton produced the film with Denise Di Novi, and they used a team assembled for their previous feature *Edward Scissorhands*, including production designer Bo Welch and cinematographer Stefan Czapsky. *Batman Returns* is as dark as its predecessor and even colder, since snow is always present and even obscures the bat logo in the credits. The film's theme seems to be the disguises with which thwarted humans hide their pain, and the story ends badly for everyone. Max Shreck and the Penguin die, and Catwoman's body is riddled with enough of Shreck's bullets to use up most of her nine lives. She disappears, and Bruce Wayne drives through snowy streets, scanning rooftops for a sign of her. In what looks like a studio compromise to prepare for a Catwoman movie, she appears in the last frame, but remains aloof from Bruce. Apparently she feels their combination is just too combustible. "These are some of the wildest characters in comics," Burton says, "yet for some reason they seem the most real to me."

Michael Keaton returns as *Batman Returns* in 1992.

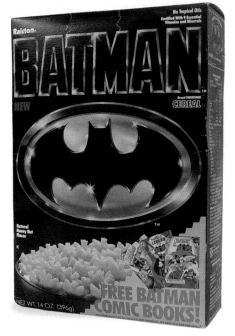

Batman movie tie-ins from Ralston.

BATMANIA II
What's So Bat About Feeling Good?

The Batman movies, with their spectacular success, turned out to be a merchandising bonanza. In fact, interest in obtaining memorabilia from the films was so high that in many cities posters were being stolen as fast as they could be displayed. The fans snapped up simple items like caps and T-shirts by the millions, and the first film's distinctive emblem, a bat within a golden oval, seemed to be emblazoned on every surface the planet could provide.

Many manufacturers jumped at the unusual opportunity to work with the remarkably handsome design concepts provided for the films by artists like Anton Furst and John Evans, who was responsible for much of Batman's paraphernalia. Products ranged from meticulously reproduced models to underwear for the Batman who has everything.

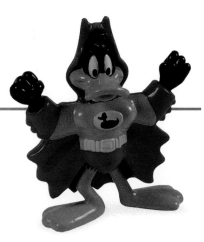

Daffy Duck as Bat-Duck, a 1991 McDonald's promotional toy, came with the assurance that "Bat-Duck is an authorized parody."

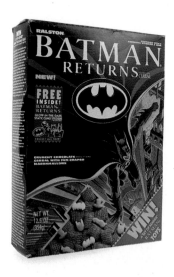

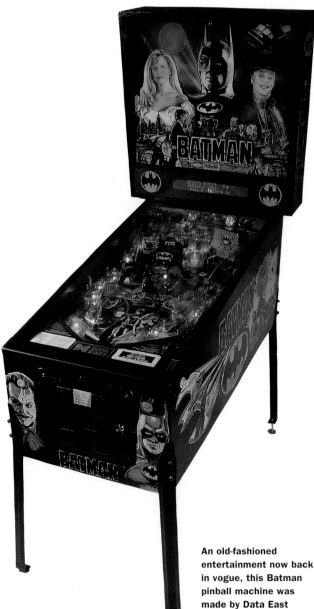

A Batman "Big Impressions" backpack from Ero Industries (1992).

An old-fashioned entertainment now back in vogue, this Batman pinball machine was made by Data East (1992).

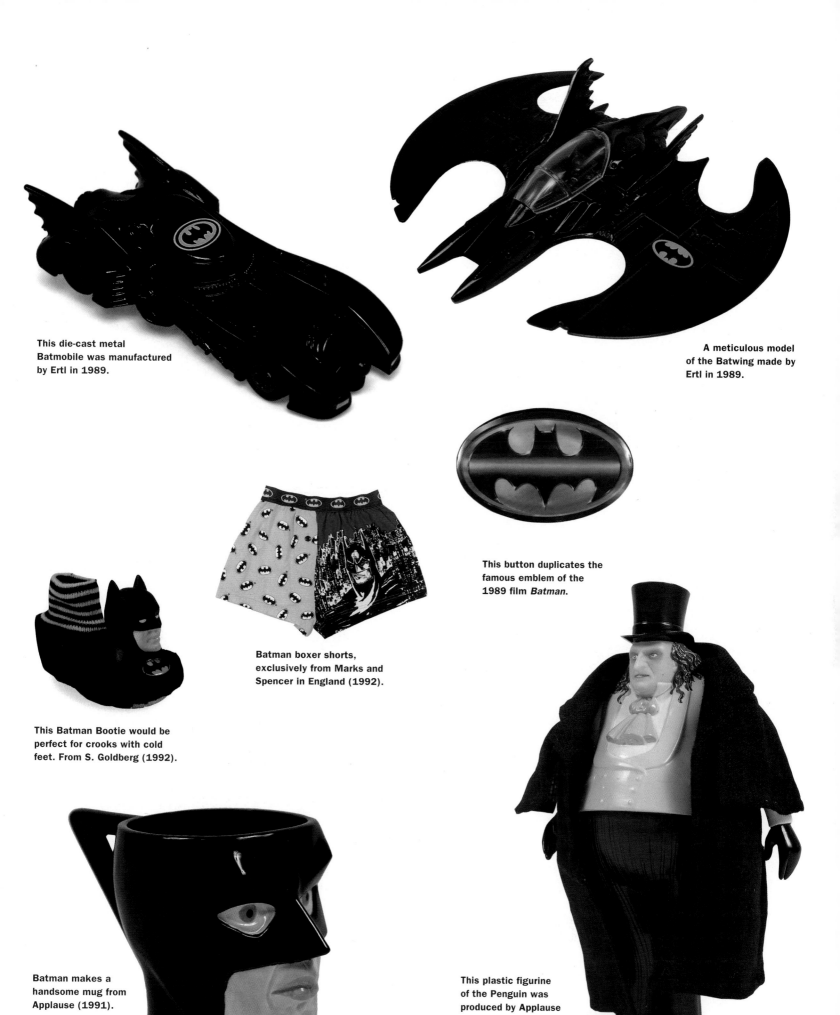

This die-cast metal Batmobile was manufactured by Ertl in 1989.

A meticulous model of the Batwing made by Ertl in 1989.

This button duplicates the famous emblem of the 1989 film *Batman*.

Batman boxer shorts, exclusively from Marks and Spencer in England (1992).

This Batman Bootie would be perfect for crooks with cold feet. From S. Goldberg (1992).

Batman makes a handsome mug from Applause (1991).

This plastic figurine of the Penguin was produced by Applause in 1992.

THE DEATH OF SUPERMAN
A Hero Is Put Out of Action

Superman's famous cape became a flag flying at half-mast on the cover of *Superman* #75 (January 1993). No American comic book that wasn't a first issue has ever sold so well. Pencils by Dan Jurgens and inks by Brett Breeding.

A trade paperback book collected all the issues in the story cycle; the cover featured this art by Jon Bogdanove, Dennis Janke and Reuben Rude.

It became the most famous story in the history of comic books, and the biggest seller DC has ever had, but it started out as a joke. It was the death of Superman, and it never would have happened to him if only he'd been married.

"We have these big Superman meetings," explains Superman's editor Mike Carlin, "with every writer and artist, even the colorists. We all go into a room and just throw out ideas. And at every single meeting, as a joke, somebody has

DC's surviving heroes pay tribute to a fallen friend from atop the Daily Planet building in *Superman* #76. Cover by Dan Jurgens and Brett Breeding.

said 'Let's kill him!' It never failed—then we actually did it." The meetings are vital because Superman appears in four different comic books: *Superman, The Adventures of Superman, Action Comics* and *Superman: The Man of Steel.* They are all interconnected, and what happens in one affects events in the others. "The creators are very important to the mix. It's not like the old days when the editor basically ran the show," Carlin says. "I have fifteen or sixteen people simultaneously working on Superman, and I want a real creative collaboration. I want Superman to be the star of the show."

Carlin and his team had been planning a story line about lowering the barriers between Lois and Clark—the same idea suggested by creator Jerry Siegel half a century earlier. In

fact, Lois and Clark had become engaged in *Superman* #50 (1990), and the wedding of Superman was essentially a foregone conclusion when word was received that a new TV series about the Man of Steel was in the works. "DC's decision was that it would be a good idea to hold off the wedding and do it at the same time as the TV show, if it got that far," Carlin explains. So Carlin and his crew were looking for an interesting idea to fill the time until the TV show's debut in the fall of 1993. That's why Superman was killed in the pages of *Superman* #75 (January 1993).

Since comic books are dated a few months in advance, it was late in 1992 when word of Superman's demise first appeared. Suddenly all hell broke loose. "We were stunned," says Mike Carlin. "I can't believe people went for it as hard as they did. It must have been the way Orson Welles felt when his *War of the Worlds* actually went over." Comic book fans were used to the idea of super heroes dying, and appropriately optimistic about Superman's eventual revival, but people less familiar with the medium were more naive. According to Carlin, the stunt became a sensation only "when the real newspapers started getting hold of the story and actually believing it. If a war had broken out that day, maybe this wouldn't have happened." Publicity snowballed until the news of Superman's death was in every paper and magazine, on every news broadcast, and included as part of every comedian's monologue.

Literally millions of people who didn't usually buy comics wanted a copy of *Superman* #75, which had been shipped to comics shops on November 18, 1992 in a special bagged and sealed edition that also included a promotional poster and a black memorial armband. The regular newsstand edition (without the extra items) was reprinted again and again. The entire saga, including its lead-in stories from the other Superman titles, was collected in a trade paperback book. Eventually, an astonishing six million copies of the tale were sold.

"There's no way we could have bought the attention that we got," Carlin insists. "That's what I keep saying to the cynics of the world who accused us of trying to do it for the money. There is no way anybody could have planned what happened. All we could do was try to keep up with it." Naturally DC did try to take advantage of the situation as it developed. "Our marketing department supported us and made it go ten times as strong. Everybody at DC was working to make something happen

The heavyweight bout that rocked comics began in *Superman* #75 with this splash panel. Script and pencils by Dan Jurgens and inks by Brett Breeding.

An image of a battered and bloody shield became the logo for the story line. The variation shown here served as jacket art for the best-selling Bantam hardcover book, a novelization by DC writer Roger Stern.

Caricature of editor Mike Carlin by Jon Bogdanove.

from the story we had come up with, rather than from a memo that said we needed to boost sales."

The story as it developed over several issues was a simple one, about a berserk monster named Doomsday who escaped from some unspecified captivity and went on a rampage across America that ended in a confrontation with Superman on the streets of Metropolis. Doomsday's origin and motivation were shrouded in mystery, and the final battle that killed both hero and villain took place in an issue, written and pencilled by Dan Jurgens, in which each panel filled an entire page.

"The actual death itself isn't the story," Carlin says. "The fight with Doomsday is just a fistfight in a comic book, but the funeral story after that was where we felt we had the best stuff to contribute. We did eight issues of Superman's funeral where he was literally a dead body, and we thought that was the most daring part of our whole plan. There was a strong analogy for how we felt, which was that Superman was being taken for granted, that Superman was considered corny. We wanted to remind people that some of the values that Superman stands for are still important."

THE ANIMATED BATMAN
Redefining the TV Cartoon

Batman does the traditional rope trick among the stylized buildings of Gotham City in Warner Bros.' *Batman: The Animated Series.*

A Bruce Timm model sheet, entitled "Cape Theories," shows Batman in action.

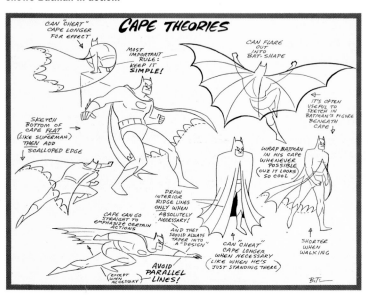

Although animated cartoons made for television have been around for decades, they have not generally displayed high quality. Low budgets account for some of the problem, and so does the perception that audiences composed of children lack critical acumen. In fact, animated super heroes have rarely been well served since the Superman cartoons created by the Fleischer studio half a century ago, which is why Warner Bros. Animation president Jean MacCurdy suggested those Fleischer cartoons as a model for a proposed new Batman series. When she mentioned the idea to staff artists working on other projects, two individuals came up with design ideas so strong that she named them co-producers. Appointed in 1990, the fledgling team of Bruce Timm and Eric Radomski were thrown into deep water with instructions to prepare a series for a September 1992 debut on the Fox television network.

Timm and Radomski complemented each other like foreground and background. Timm, who had planned to work in comic books but ended up in cartoons instead, came up with a simplified, stylized drawing of Batman that would lend itself to animation. He ended up creating the look for many major characters, including Catwoman, Two-Face and Commissioner Gordon. Radomski was interested in settings; he envisioned a bold, impressionistic Gotham City, achieved by the unusual technique of painting on a black background. This created a dark Deco world where a building could be suggested by a shadowy monolith with only one side exposed to light and drawn in any detail. In simplifying the concept for animation, Timm and Radomski ended up reverting to the Golden Age comic book style pioneered by artists like Bob Kane and Dick Sprang. "It's very stylized," says Kane of the cartoon's look, "and almost three-dimensional because the shadows and perspectives are brilliantly drawn, with the bird's eye view and the worm's eye view that I used early on."

Alan Burnett signed onto the team as a third producer, with additional duties as script supervisor. Encouraged by the success of the recent live-action Batman feature films, the network was willing to accept more action than was commonplace on kids' cartoons. The show remained

Batman battles Man-Bat, a villain created via the old switcheroo for a 1970 comic book story by writer-artist Frank Robbins.

less violent than the Batman movies or comics, but at least it was allowed to move, and dialogue was minimized to emphasize the action. Ultimately, Fox took the show seriously enough to show a preview episode in prime time before the series settled into its afternoon time slot in September 1992. Even more remarkably, *Batman: The Animated Series* also ran from December to March on Sunday evenings, so adults could see what the shouting was about.

Batman: The Animated Series opened to critical acclaim and went on to win Emmys for best animated show and best writing on an animated show. It might also have won for best acting in animation if there had been such an award, for like the *Batman* TV series of the 1960s, this

Harley Quinn may drive him crazy, but the animated Joker is good-natured enough to keep her on the payroll anyway.

John Calmette's background "key painting," used as a guide for overseas animators.

more serious show attracted top talent. Voice director Andrea Romano lined up such popular performers as Mark Hamill (the Joker), Paul Williams (the Penguin), Adrienne Barbeau (Catwoman), Ron Perlman (Clayface) and even the 1960s Batman, Adam West (the Gray Ghost). Many episodes were built around classic villains of the past, but new characters appeared as well. By all accounts the most popular has been Harley Quinn (with voice by Arleen Sorkin), a woman in a jester's outfit who serves as the Joker's silly sidekick. Guest stars come and go, but the mainstay of the series is Kevin Conroy, who supplies the voice of Batman.

The new series was so successful that it spawned a theatrical feature for release at the end of 1993. *Batman: Mask of the Phantasm* was designed as a direct-to-video film, but turned out to be impressive enough that additional scenes were shot for the big screen. The $6 million *Mask of the Phantasm* did not draw the anticipated audiences, perhaps because it was booked in many markets for matinees only. The video version, subsequently released, did prove to be a substantial success.

Batman: The Animated Series is as dark and dramatic as any cartoon ever made for television, and really unrivaled as a triumph of technique. It owes some of its mood (and its budget) to the immensely popular Batman films directed by Tim Burton, which provided everything from Danny Elfman's musical theme to the idea of an anachronistic world where everyone has a computer but television is broadcast in black and white. However, the show has its own unique flavor. For two years Batman was shown working alone, but a season of new episodes, all featuring his famous sidekick Robin (with voice by Loren Lester), was produced for the fall of 1994 when Fox renamed the show *The Adventures of Batman & Robin.*

The success of *Batman: The Animated Series* led to the creation of a new monthly comic book series, *The Batman Adventures*. The three men in the car are caricatures of DC group editors Archie Goodwin (rear), Denny O'Neil (front left) and Mike Carlin (front right). Pencils by Mike Parobeck and inks by Rick Burchett for issue 20 (May 1994).

IT'S IN THE CARDS
DC Hits the Deck

Paintings were featured on the first Batman cards, issued by Topps in 1966 to coincide with the successful television series.

Photos from the 1989 *Batman* film were used on the Topps cards that came out at the same time; a complete set recapitulated the movie's plot.

DARKNIGHT DETECTIVE™

Candy cards from 1940 were among the first to feature comic book characters, and Superman was a hot property.

Trading cards, now more than a century old, first appeared in cigarette packages to prevent the contents from getting crushed. Putting images on the cardboard rectangles was an afterthought, but once sets of pictures were printed, collectors were not far behind. Today Americans are more likely to associate the cards with chewing gum, a connection that began in the 1930s with a Philadelphia company called Gum Inc. In 1940, Gum Inc. issued penny packages of Superman Super Bubble Gum, each containing a slab of the sticky stuff and one of seventy-two full-color cards. That same year, the Leader Novelty Candy Company produced Superman Candy, which had perforated cards printed on the back of its cardboard boxes.

Despite the success of the Superman series, gum cards quickly came to be dominated by pictures of athletes, with baseball players the most popular of all. There were still occasional runs of "non-sports cards" (more flatteringly described as "entertainment cards"), usually inspired by the appearance of a successful television show, or a movie like *Superman* (1978) or *Batman* (1989).

The hobby of card collecting has grown dramatically in recent years, spurred by events like a 1991 auction at Sotheby's, where a 1910 Piedmont cigarette baseball card sold for a record $451,000. Entertainment cards have also shown a resurgence, especially where comic book characters are concerned. In fact, most comics cards are no longer premiums attached to some other item, but are packaged and sold on their own.

SkyBox, one of the largest producers of trading cards, released its first DC set in 1992. The *DC Cosmic Cards*, sold in packs of twelve, included 180 regular cards and ten "chase"

cards, so-called because they are rare and must be chased down. They are especially prized because they are printed in smaller quantities and because they contain special enhancements, such as foil embossing, metallic etching or even holograms. As the technology improves, more elaborate cards are produced; the 1994 *Saga of the Dark Knight* series was the first to feature an exclusive new technology called SkyDisk, developed by Polaroid, a hologram that enables an image to turn a full 360 degrees.

Some SkyBox sets like the 1993 *DC Cosmic Teams* run the gamut of the company's characters, while others concentrate on specific characters or situations. Special sets have been released to commemorate *The Death of Superman* (1992) and *The Return of Superman* (1993). Cards in the 1994 *Sandman* set included the first fifty covers in the comic book series, thirty-nine original paintings, and a photo hologram of the title character produced under the supervision of cover artist Dave McKean. The days when cards could be punched out of empty candy boxes are long gone, and so are the anonymous artists who once drew them. Cards are now created by the top talent in the field, and have become the equivalent of miniature, limited edition prints.

The *DC Cosmic Cards*, produced by SkyBox in 1992, traced the history of the company's heroes, and included three different Flashes: Jay Garrick (pencils and inks by Joe Kubert), Barry Allen (pencils by Carmine Infantino and inks by Murphy Anderson) and Wally West (pencils by Greg LaRocque and inks by José Marzan, Jr.).

Placed side by side, three of the *DC Cosmic Teams* cards from SkyBox (1994) form a panorama showing the New Titans: Cyborg, Changeling, Deathstroke, Starfire, Nightwing, Red Star, Phantasm, Wildebeest and Pantha. Pencils by Tom Grummett and inks by Al Vey.

The SkyBox *Master Series* (1994) includes the cornerstone trio of Superman (art by John Estes), Wonder Woman (art by John Bolton) and Batman (foil "chase" card art by Simon Bisley). In this year the art style for cards evolved from line art to fully painted artwork.

These gold-embossed "chase" cards from the *Sandman* set (SkyBox, 1994) include the title character's siblings Desire (art by Jon J. Muth), Delirium (art by Jill Thompson) and Destruction (art by Glenn Fabry).

It's in the Cards 223

ON THE VERGE OF VERTIGO
Comics on the Cutting Edge

The Golden Age vigilante was revived in April 1993 for *Sandman Mystery Theater* by writer Matt Wagner and artist Guy Davis; some confusion with the new Sandman inevitably ensued. Cover by Gavin Wilson.

Inside issue 51 (September 1994), writer Peter Milligan announced that the theme of *Shade, the Changing Man* was "hair." In this series, anything was possible. Cover by Sean Phillips.

Promising "The Shock of the New," DC launched a line of comic books called Vertigo with first issues dated March 1993, but this was the culmination of a process that had been in the works for years. Under the supervision of editor Karen Berger, a new style of storytelling had evolved with new subjects, innovative art and an unprecedented attitude. "The fact that I didn't have a comic book background helped me in being more open-minded to creators who wanted to do something unusual in comics," Berger says, "but ultimately, I just wanted to edit stuff that I would really enjoy reading. That's sort of how Vertigo came about; it coincided with my desire to do material for adults—male or female—who didn't necessarily read comics growing up."

The two most widely known of the comic books that formed the Vertigo line were *Swamp Thing* and *Sandman*. Berger characterizes writer Alan Moore's seminal *Swamp Thing* work as "a horror comic, but a horror comic with a lot of humanity and soul, and realistic, modern characterizations of people." And *Sandman* writer Neil Gaiman says, "I wanted to write a comic that would give other people the kind of buzz that I got as an adult from Alan's *Swamp Thing*." As DC's British liaison, Berger began seeking out

other writers who possessed comparable talents; her success led to what has been called a "British invasion" of American comics.

One title, *Hellblazer*, was a direct result of Moore's work. John Constantine, *Hellblazer*'s hero, had been introduced during Moore's run on *Swamp Thing*, but Moore disclaims full responsibility. Constantine, a seedy blond occultist with a chip on his shoulder and a core of unshakable integrity, was all but forced on Moore by artists Steve Bissette and John Totleben, who drew him into backgrounds as a private joke. "I could only give in gracefully and make him a regular character," says Moore. The first issue of *Hellblazer* appeared in January 1988, written and illustrated by the British team of Jamie Delano and John Ridgway.

"That was right about the time I became British liaison," Berger explains. "Then I started meeting people like Grant Morrison and Neil Gaiman and Peter Milligan, and that's how the next wave of titles came about: *Animal Man* and *Sandman* and *Shade, the Changing Man*. And *Doom Patrol* as well, which sort of came in through a side door, through a different editor."

As sardonic Scottish writer Grant Morrison explains, he started work on *Animal Man #1* (September 1988) because DC was looking for "more cranky Brit authors who might be able to work wonders with some of the dusty old characters languishing in DC's back catalog." In fact, the characters that formed the core of the Vertigo group were all revived and revised by a new generation who saw more in the originals than may have actually been intended. Morrison, working with artists Chas Truog and Doug Hazelwood, picked up an unpromising premise about a super hero who absorbs abilities from nearby beasts; he turned the book into an impassioned plea for animal rights. Yet *Animal Man* became more peculiar as it progressed, expressing some of the eccentric vision that Morrison let loose when he and penciller Richard Case took on the new *Doom Patrol* with issue 19 (February 1989). Morrison admits that the original group of odd heroes frightened him when he was a boy; for his new version he added a few twists of his own and then dropped the heroes into a surreal world that reads like a child's nightmare, complete with characters who have clocks for heads, and an army of relentless, gibberish-spouting villains known as the Scissormen. Of the books that became Vertigo, *Doom Patrol* just may have been the weirdest.

This is not to say that *Shade, the Changing Man* was anything less than strange. Based on

an old Steve Ditko hero, the new Shade was an alien who possessed the power to turn thoughts into solid objects, and who inadvertently became trapped in the body of a murderer being executed in the electric chair. Then the origin story, written by Peter Milligan with art by Chris Bachalo and Mark Pennington, began to get bizarre. Making its debut in July 1990, *Shade* was the sixth building block in the line of books that were first labeled with the Vertigo imprint in March 1993.

A meeting with Jenette Kahn, Paul Levitz and Dick Giordano led to the decision that Berger's "mature reader" comics should have a separate imprint. "I wanted a name that sort of connoted a sense of upheaval," Berger says, "and Vertigo did just that." The launch of the line included Neil Gaiman's mini-series *Death: The High Cost of Living*, a tale about Sandman's sister that became Vertigo's biggest seller, and *Enigma*, a groundbreaking limited series by Peter Milligan and Duncan Fegredo. "I've been very pleased with the growth and evolution of the line," Berger says. "People who haven't looked at comics since they were kids can look at them now with an awareness of the fresh, innovative stuff that we're doing."

Sandman's sister Death became a sensation when her mini-series helped kick off the Vertigo line in 1993. Script by Neil Gaiman, pencils by Chris Bachalo and inks by Mark Buckingham.

Comic book metaphysics turn a villain into pencilled art, then into a sketch that vanishes from the page, in *Animal Man* #12 (June 1989). Script by Grant Morrison and art by Chas Truog and Doug Hazelwood.

Haunted by friends who didn't survive their uncanny experiments, John Constantine carries on regardless in *Hellblazer* #1 (January 1988). Script by Jamie Delano and art by John Ridgway.

One of the most popular titles to be incorporated into the Vertigo line, *Hellblazer* features a working-class hero co-created by Alan Moore. "Most of the occultists I know are street-level, so I thought it would be interesting to see that reflected," says Moore. "And I don't expect anyone to believe this, but after I had written John Constantine as a character, I bumped into him in a sandwich bar, which was one of the eeriest experiences of my life." Moore also reports that writer Jamie Delano, who took over Constantine's adventures with the first issue of *Hellblazer*, experienced a similar eerie visitation. In *Hellblazer* #22 (September 1989), with art by Mark Buckingham and Alfredo Alcala, a long story arc by Delano reaches its conclusion as John Constantine and his companions conjure up two serpents to counteract a demon called Jallakuntilliokan. The cover is by Kent Williams, whose impressionistic painting style is an example of the new look that DC's Vertigo line brought to comics.

This grotesque painting, simultaneously funny and frightening, was created by Simon Bisley for the cover of *Doom Patrol* #33 (June 1990). Bisley's paintings appeared on most of the issues written by Grant Morrison, whose sense of the absurd they deftly matched. Morrison deepened the angst of "man-in-a-can" Cliff Steele and turned Negative Man into a being of mixed race and sex called Rebis. Then the Patrol gained a new partner called Crazy Jane, whose multiple personalities sometimes took physical form. Morrison and his regular penciller Richard Case set these characters loose in issues like this one, where the Doom Patrol encounters a cult of nihilistic puppets who worship "the Decreator" and hope to achieve "nothing. Literally nothing." The hapless heroes battle thugs like the Hoodmen and the Starving Skins, while struggling toward the puppet theater through a city whose landmarks include the Spider Bridge, the Sobbing Stone and the Meat Museum. In short, *Doom Patrol* mined the occasional surrealism of the super hero story and polished it to an iridescent sheen.

SUPERMAN RESURRECTED
A Quartet and a Question Mark

The death of Superman late in 1992 proved to be such a success that it changed DC's plans for a revival. "We had a way to bring Superman back," says editor Mike Carlin, "it was just a question of upping the stakes. We had a bunch of stories we planned to do after he came back that we never did. We just came up with better stuff at the next meeting."

Nobody had ever intended to bring Superman back immediately. "We felt the best stuff we had to contribute was the funeral stuff, which hadn't been done in any other story about the death of a super hero," Carlin explains. "We just thought that we had to make the story even bigger. Now that the world was watching, if he just sat up in his coffin and said, 'Hi, I'm back,' it would have been a bad payoff to a very big story."

As a consequence the Superman staff came up with an elaborate charade designed to keep their hero's ultimate fate in doubt. At the end of *The Adventures of Superman* #500, the hero's coffin was found to be empty, and in the following issues of Superman's four comic books, four separate claimants to his title were introduced. "After we saw how big it was getting," Carlin says, "we called a quick meeting and got all the writers and artists in. Every writer had an idea about how to bring him back, and at the meeting somebody suggested we do all of them. That's when it became the story of the four Superman impostors."

Under the overall title of "Reign of the Supermen," the creative teams associated with each Superman book created their own characters to be introduced in June 1993. In *The Adventures of Superman* #501, writer Karl Kesel and artists Tom Grummett and Doug Hazelwood unleashed a kid with sunglasses and a nervy attitude who claimed to be cloned from

Superman and answered reluctantly to the name Superboy. In *Action Comics* #687, writer Roger Stern and artists Jackson Guice and Denis Rodier gave birth to the Last Son of Krypton, a cold and vengeful super hero who had taken over Superman's frozen Fortress of Solitude. In *Superman: Man of Steel* #22, writer Louise Simonson and artists Jon Bogdanove and Dennis Janke unearthed an armor-clad, African-American construction worker named John Henry Irons, later known as Steel. And in *Superman* #78, writer-penciller Dan Jurgens and inker Brett Breeding unveiled the Man of Tomorrow, a cyborg whose face looked like a mechanical skull.

Of course the public didn't know which, if any, of the four new characters might be an incarnation of Superman. "I guess some people could say we cheated a little bit by not making it any of those guys, but I think we were always fair and honest about it," says Carlin. "Superboy was clearly the most popular, and nobody knew the cyborg was going to turn out to be a bad guy. That really helped build the fun."

Things were finally straightened out in *Superman* #82 (October 1993). The real Superman returned, revived by the scientific genius of the icy Last Son of Krypton (also known as the Eradicator), who also gave his life to help destroy the evil cyborg. John Henry Irons and Superboy remained as viable new characters, and the world's first super hero was back with boosted sales. "I felt an obligation to put Superman back on top," Mike Carlin says, "and with luck we were able to do it. I do think that once people were looking, we didn't drop the ball."

The one and only original super hero returns from his recuperation, complete with a little more hair and nifty hologram fireworks, in *The Adventures of Superman* #505 (October 1993). Pencils by Tom Grummett and inks by Doug Hazelwood.

After displaying nerves of steel by delaying Superman's return for months, DC threw the fans for a loop by simultaneously bringing back four Supermen instead. The quartet, at least three of them bound to be pseudo-Supermen, were formally introduced in June 1993 with these glossy centerfold posters, each of them twice the size of a comic book page. Superboy (upper left), with pencils by Tom Grummett and inks by Doug Hazelwood, appeared in *The Adventures of Superman* #501. The Last Son of Krypton (upper right), with pencils by Jackson Guice and inks by Denis Rodier, appeared in *Action Comics* #687. Steel (lower left), with pencils by Jon Bogdanove and inks by Dennis Janke, appeared in *Superman: The Man of Steel* #22. The Man of Tomorrow (lower right), with pencils by Dan Jurgens and inks by Brett Breeding, appeared in *Superman* #78. As it turned out, none of them was Superman, but some of them did manage to become continuing characters.

DOING IT BY THE BOOK
Licensed Publications Spread the Word

It didn't take Superman long to make the leap from comic books into another form of print; the Saalfield Publishing Company unleashed his first coloring book in 1940, only two years after he arrived in *Action Comics*.

Other DC heroes had a longer wait; the Man of Steel had the bookstores pretty much to himself until 1966, when Batman's television series inspired a coloring book, several paperback collections of comics and a couple of Signet paperback novels authored by Winston Lyon (comics writer William Woolfolk): *Batman vs. Three Villains of Doom* and *Batman vs. The Fearsome Foursome*. Since then the DC super heroes have appeared in a wide variety of book formats, including pop-up books, hardcover novels, collections of Golden Age covers and children's storybooks.

Superman got his first coloring book in 1940.

This 1942 hardcover book, the first novel about a comic book character, was written by George F. Lowther and illustrated by Joe Shuster. It introduced some key elements of Superman lore, including new names for Superman's Kryptonian parents. A facsimile reproduction was published in 1995.

Best-selling crime novelist Andrew Vachss is also an attorney who represents children exclusively. His *Batman: The Ultimate Evil* (1995) depicts Batman confronting child abuse in Gotham City and southeast Asia. Jacket design by Chip Kidd.

The lavish 1994 *Batman: A Pop-up Playbook* from Little, Brown was inspired by the animated TV series. In addition to a fully equipped Batcave, it includes punch-out figures and lairs for such foes as the Joker, Two-Face and Poison Ivy.

George Elrick's *The Cheetah Caper* (1969), a Big Little Book from Whitman, wasn't about the Cheetah who has been plaguing Wonder Woman for years. This new Cheetah was an evil speedster with an addiction to peanut butter.

Based on an idea by Jenette Kahn and edited by Joe Orlando, the 1981 *DC Super Heroes Super Healthy Cookbook* mixed capering super heroes and nutritious recipes like "Perry White's Great Caesar's Salad." Written by Mark Saltzman, recipes by Michele Grodner, pencils by Ross Andru and inks by Dick Giordano.

A hit TV show made licensing more likely, as the original Captain Marvel found out when his *Shazam!* series inspired this Little Golden Book in 1977. Cover by Kurt Schaffenberger.

The Super Dictionary (1978) was the work of nine authors and editors, including several college professors. Concepts created by the team included a bearded Boy Wonder. Cover by Joe Kubert.

THE LANDMARK OF MILESTONE
Making Comics Multicultural

It's something that's been in the air for as long as I've been in the business," says Milestone Media's editor in chief Dwayne McDuffie. "Anytime you'd have a couple of black guys get together and stand around in the hall, they'd start talking about what they couldn't do that they wanted to do." The problem was trying to express an African-American sensibility in a business run by whites, even well-meaning ones. That was the

Wall Street Journal, and had known Cowan when they were children; Cowan and McDuffie had become friends while working for Marvel Comics in the late 1980s. McDuffie credits Cowan for setting things in motion: "Denys had been saying for years that we just ought to get together and do it. And one day he called me, he called Derek Dingle, he called Michael Davis and he said 'It's time, let's just do this.'"

Eager to overcome the restrictions that they felt working on characters owned by Marvel, Cowan and McDuffie quickly realized that only a substantial number of new heroes could provide them with the freedom they wanted. "If you do a black character or a female character or an Asian character," explains McDuffie, "then they aren't just that character. They represent that race or that sex, and they can't be interesting because everything they do has to represent an entire block of people. You know, Superman isn't all white people and neither is Lex Luthor. We knew we had to present a range of characters within each ethnic group, which means that we couldn't do just one book. We had to do a series of books and we had to present a view of the world that's wider than the world we've seen before."

The team ended up with a 400-page "bible" that described numerous characters inhabiting the "Dakota Universe," centered around a fictional city in the Midwest. "Denys did these incredible character designs for that," McDuffie says, "and then we started thinking how we could get this to the widest possible market, because we didn't want to do great books that nobody ever sees." That brought the Milestone owners to DC. "It just struck me that this was a place where we might be able to try something new, something that hadn't been tried before. DC seemed open to new things, and after a couple of meetings with Jenette Kahn and Paul Levitz, I was completely won over."

Milestone's first comic book was *Hardware* #1 (April 1993). Written by McDuffie with pencils by Cowan and inks by Jimmy Palmiotti, it is the story of a brilliant black scientist named Curtis Metcalf who works for a powerful industrialist but is denied a share of the profits from his

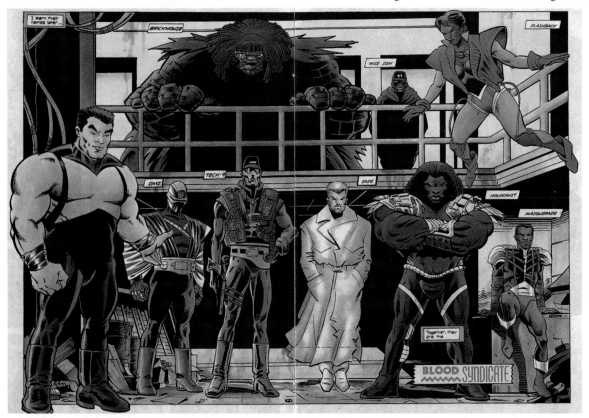

Blood Syndicate #1 (April 1993) displayed a two-page panorama of the gang members who were transformed into super heroes after they were exposed to radioactivity. Interesting characters included Brickhouse, who merged with a wall, and Flashback, who could slip a few seconds into the past. Script by Dwayne McDuffie and Ivan Velez, Jr., pencils by Trevor Von Eeden and inks by Andrew Pepoy.

reason for the 1992 creation of Milestone, a comic book company owned by African-Americans. When Milestone's comics were published the following year, they were printed and distributed through a special arrangement with DC Comics. "I'm passionately dedicated to Milestone," says DC president Jenette Kahn. "The Milestone characters are so genuinely conceived and so well-executed that I really want to see them put on the map in as many ways as possible."

The Milestone super hero characters were created by the company's owners in a series of meetings held before DC was even approached. The Milestone principals include writer-editor Dwayne McDuffie, artist and creative director Denys Cowan and president Derek Dingle; a fourth partner, Michael Davis, quickly dropped out to run Motown Animation. Dingle had worked for business publications, including the

inventions. When he discovers that his boss is also a corporate criminal, Metcalf creates a series of innovative devices that turn him into a high-tech super hero called Hardware. "People always say that the book is about race, but it's not. It's about fathers and sons," McDuffie says. "The one thing that always struck me funny is that no one ever comments on the fact that the first issue of *Hardware* is specifically about us leaving Marvel."

Icon, the third Milestone title, made its debut in May 1993 and is perhaps the most popular, although McDuffie says "all the books are pretty close together. People who like them tend to buy them all." Icon is a black super hero and a political conservative who must be convinced to use his powers to help others. The agent of change is a fifteen-year-old girl who becomes his sidekick, takes the name Rocket and in issue 3 turns out to be pregnant (but not by Icon). Icon has been called "the black Superman" because, McDuffie says, "in the first two pages of the first issue I parodied the Superman origin. Past that there isn't much to it, because *Icon* isn't really about Icon. It's about the girl, Rocket."

McDuffie is one of the best writers in comics, and his scripts are full of ideas in action; he, Cowan and Dingle created the original Milestone characters, but they are not the whole creative staff. Cowan did most of the debut covers, but M. D. Bright did the pencils for *Icon* #1; McDuffie co-wrote *Static* #1-4 before turning it over to his collaborator Robert L. Washington III and penciller John Paul Leon. Subsequent titles, including *Blood Syndicate, Kobalt, Shadow Cabinet, Xombi* and *Deathwish,* have introduced a more racially diverse pool of writers and artists to a mainstream audience. As McDuffie observes, "There were a lot of really good people out there who weren't being heard from."

Icon #1 (May 1993) kicked off a series that editor Dwayne McDuffie characterizes as "more explicitly about race" than other Milestone titles since the hero is forced to serve as a symbol. Pencils by Denys Cowan and inks by Jimmy Palmiotti.

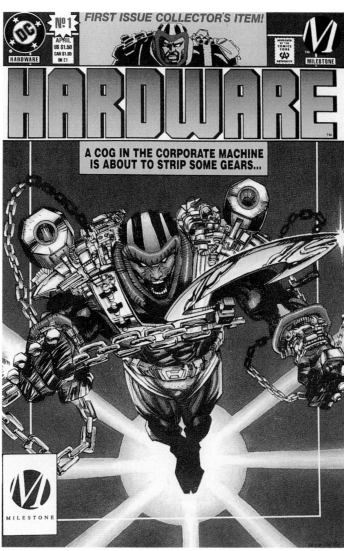

The first story in the first Milestone comic was called "Angry Black Man," and it took the hero several issues to cool down. The cover of *Hardware* #1 (April 1993) has pencils by Denys Cowan and inks by Jimmy Palmiotti.

Static, Milestone's high school hero, showed bright touches of humor during his debut in June 1993. Art by Denys Cowan, Jimmy Palmiotti and Noelle C. Giddings.

KNIGHTFALL
Two Years with Two Batmen

The 'Knightfall' series was an exploration of Batman, an exploration of the idea of a hero, and it was also an exploration of comic book technique," says Batman's boss Denny O'Neil. The DC group editor set himself and his staff a challenging task with this expansive story line, perhaps the longest single narrative in comic book history. "It went on for two years, a total of seventy-one different issues," O'Neil explains, and it ran in ten titles, including *Showcase, Batman, Detective Comics, Batman: Legends of the Dark Knight, Robin* and *Batman: Shadow of the Bat.*

The basic plot of "Knightfall" found an ailing Batman taking on a titanic challenge, suffering an apparently permanent injury, and turning over his famous cowl and cape to an impostor who soon became an interloper. The villain of the piece was Bane, a monstrously brutal bad guy who got things rolling in the spring of 1993 by breaking into Arkham Asylum and unleashing an army of Batman's most dangerous foes. Already weakened, the Dark Knight battled in issue after issue against the likes of the Scarecrow, Killer Croc, Abattoir and the Joker, until he was sufficiently worn down for Bane to take him on in hand-to-hand combat. The battle finally ended when Bane snapped Batman's back.

Bane bashes Batman, then the new Batman bashes Bane, in these covers by Kelley Jones from *Detective Comics* #664 (late July 1993) and *Batman* #500 (October 1993). The melodramatic style employed by Jones made Bane bigger than ever.

Caricature of Denny O'Neil by Jim Aparo.

A new Batman came along in the person of Jean Paul Valley, also known as Azrael, a ferocious fighter trained as a guardian and avenger by the ancient and mysterious sect called the Order of St. Dumas. Introduced in the 1992 mini-series *Sword of Azrael*, the young man with a mysterious past was encouraged by Bruce Wayne and Robin to don the famous cape and cowl that could strike fear into the criminals unleashed by Bane on Gotham City. Soon, however, Valley began to display a disturbing recklessness and violence. Determined to best Bane, whose powers were pumped up by a drug called Venom, Azrael created a new costume bristling with weapons and armor, and as a mechanized Batman he crushed the villain who had crippled Bruce Wayne.

"One of the things I have come to look upon as a storytelling tool is people's expectations of a character," says Denny O'Neil. "This story line was the one thing that the audience knew we would never do to Batman, and therefore we did it. The idea started with my guess that Batman might be running out of steam a year after the second movie, and I had better do something to call attention to the character. Peter Milligan was writing *Detective Comics* at the time, and in a Chinese restaurant in London he mentioned that maybe he'd like to put somebody else in the costume for a couple of issues. Another element was our perception of how the idea of heroes had changed. We wondered if Batman might not be passé, because for all his dark mien he will not inflict more pain than is absolutely necessary, and he will never take a life. We were looking at heroes in other comics, to say nothing of other media, in which wholesale slaughter seemed to be the primary qualification for a hero. So we set out to explore that, to create an anti-Batman, and my greatest fear was that people would love him."

Although "Knightfall" technically ended with the defeat of Bane, it continued seamlessly through issues designated as "Knightquest" and "KnightsEnd." In these, the new Batman became an increasingly frightening figure, given to bouts of paranoia and megalomania. "We let the guy get nuttier and nuttier, month by month. It was classic dramaturgy. And we had the ending in mind from the beginning," explains O'Neil. "I kept thinking, if they love Azrael I don't know what I'm going to do. Fortunately, we began to get a serious amount of hate mail, which warmed my heart. They despised him." The end came with O'Neil's script for *Batman: Legends of the Dark Knight*

#63 (August 1994). A rehabilitated Batman fought his sick successor in the bowels of the Batcave and, through a combination of strength and psychology, finally convinced Azrael to see the light. O'Neil turned the epic into a 342-page hardcover novel, and is now writing a new *Azrael* comic book edited by Archie Goodwin, the DC group editor who made major contributions to "Knightfall."

"As Archie often observes, in the 1980s a lot of us got into sloppy habits where there was no clear notion of what we were attempting to do with the writing," concedes O'Neil. "So try writing against comic book deadlines, coordinating the efforts of at least four primary writers, and spreading it over two years and six different titles. I lived in terror, particularly in the last few months, that my guys and I weren't seeing some big obvious hole in the middle of 'Knightfall.' The story had to be broken down into units that made sense on their own, but when you put it together, you had this two-year production." Acknowledging the contributions of several writers and DC editors, O'Neil says, "We did it and we ended up with an affirmation of our old values. The idea of a moral and compassionate hero is not an outmoded one."

Batman fights the flu while fighting crime in Norm Breyfogle's panel from *Detective Comics* #659 (early May 1993).

Alfred is operating, Bruce Wayne is in traction, Robin is worried, and the new Batman is standing by. Script by Chuck Dixon, pencils by Graham Nolan, inks by Scott Hanna and edited by Scott Peterson. From *Detective Comics* #664 (late July 1993).

Batman and Azrael in their climactic battle for the right to guard Gotham City, from *Batman: Legends of the Dark Knight* #63 (August 1994). Script by Denny O'Neil, pencils by Barry Kitson and inks by Scott Hanna.

LOIS & CLARK
Can There Be Sex for Superman?

Lois and Clark (Teri Hatcher and Dean Cain).

Superman is so well known that his popularity always runs the risk of becoming mere familiarity; the character must be constantly reinvented. That was the thought in Jenette Kahn's mind when she suggested the television series that eventually made its debut in 1993 as *Lois & Clark: The New Adventures of Superman*. However, what Kahn and Superman editor Mike Carlin had originally suggested in 1989 was a program called *Lois Lane's Daily Planet*. "The idea of the show was to focus on their relationship," Kahn explains. "Not that you wouldn't have Superman in it, but you see all these incredible special effects in the movies and there was no budget on television to come close to those. So instead we wanted a sense of urgency, a sense that if not for Superman a problem wouldn't get solved and there'd be terrible consequences. Those are story elements, as opposed to special effects, that could give rise to a wonderful show."

The idea was taken to Lorimar Television, recently acquired by Warner Bros., where creative head Leslie Moonves took an interest in the project. It took a while, but Moonves was ultimately able to work what Kahn calls "Leslie magic" and sell the show to ABC in 1991 without benefit of a pilot or even a script. The key figure in devel-

oping the project was Deborah Joy LeVine, selected as writer-producer because her strengths lay in character development rather than action or science fiction. LeVine came up with the show's cute new title, and visited DC to consult with Kahn and Carlin and to study hundreds of comics with particular emphasis on the new incarnation of Superman introduced in 1986 by writer-artist John Byrne. Elements picked up for the series from the new comics ranged from the survival of Clark Kent's parents to Lois Lane's hairdo.

The show received extensive publicity before its debut as a 105-minute television movie on September 12, 1993. The promotional campaign emphasized the idea of sex: Print ads showed Lois (Teri Hatcher) and Clark (Dean Cain) dressed in underwear and locked in an embrace. TV spots showed Lois lolling on scarlet sheets while purring, "I can't believe it. I just met the perfect man." And in fact she shouldn't have believed it, because the characters have remained resolutely chaste. Yet the tendency toward innuendo was so pronounced that a funny scene in which Clark's mother helped him design his costume took an unexpected turn when she began to make suggestive remarks about his appearance in tights.

The campaign to present Superman as more of a sex object for women than a role model for boys may have drawn some viewers, but was a thing of the past by the time *Lois & Clark* began to find its audience. The debut on ABC found it running third against fierce competition: CBS had the established hit *Murder, She Wrote*, while NBC offered the premiere of *SeaQuest DSV*, a science fiction series from powerhouse producer Steven Spielberg. Eventually, *Lois & Clark* established its style and gained acceptance; it pulled consistently ahead of *SeaQuest* in the ratings and also demonstrated sponsor-pleasing demographics.

The key to the show's success seems to be humor. Initially Lois was somewhat smug and supercilious, but Teri Hatcher's natural inclinations soon took over. "I love comedy so much," she says. "You read so few scripts for women where the character is so broad and full that you can be smart and funny and vulnerable and sexy and, you know, goofy." Dean Cain's version of Clark Kent is unusual but effective. "He's not a nerd," says Cain, who subtly emphasizes Clark's rural upbringing in a way that makes him seem simultaneously naive and sensible. On the first show, Lois called him "farm boy."

Cain's Superman is more problematic. Although he resents critics calling him "Superboy," Cain brings less authority than other actors have to

Lois and Clark get a grip on Lex Luthor (John Shea), the evil industrialist who came within a few seconds of marrying Lois at the end of the first season. During the second season Lex lost his hair.

HAVE YOU BEEN TO METROPOLIS LATELY?

LOIS & CLARK
THE NEW ADVENTURES OF SUPERMAN
SUNDAYS THIS FALL abc

This steamy poster, in which the Superman tattoo looks almost like an afterthought, aroused interest in *Lois & Clark* before the show went on the air in 1993.

Promising "the most human Superman ever," Dean Cain strikes the classic pose in the classic super hero suit.

the role, perhaps in part because he seems young. "The tights and the cape. You know how much grief I get for that?" the actor has lamented, but his apparent discomfort in costume works for the premise of the show, in which Clark wants to be Clark and would probably drop the Superman stuff if it wasn't in such demand.

The special effects, supervised by John Scheele, proved to be better than expected due to advances in the use of computers. The flying sequences, however, still retain their traditional difficulties for Cain, a Princeton athlete who was signed by the Buffalo Bills before a knee injury sent him into show business. "The flying's a very painful thing," he says. "It's really difficult because there are two wires coming out just at my hips. You have to straighten out and your whole body has to be tense. It's physically demanding, but it's getting easier for me." Hatcher found her time in the air with Cain uncomfortable too, but admits that after their first swoop through a window she proclaimed it "the most romantic thing a woman could ever, ever do." That sounds like a case of perfect casting.

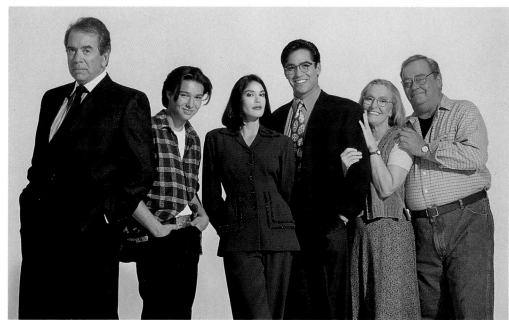

The good guys on *Lois & Clark: The New Adventures of Superman* are Lane Smith (Perry White), Justin Whalin (Jimmy Olsen), Teri Hatcher (Lois Lane), Dean Cain (Clark Kent), K Callan (Martha Kent) and Eddie Jones (Jonathan Kent).

THE PARADOX OF PARADOX
Comics for People Who Don't Read Comics

This is the first of four volumes making up the first work of Paradox fiction: *Brooklyn Dreams*, written by J. M. DeMatteis with art by Glenn Barr.

The cover of the first Paradox mystery: *La Pacifica* (1994). Script by Joel Rose and Amos Poe and art by Tayyar Ozkan.

"Comics can be used to tell a lot of different kinds of stories, but right now in this business we're restricted to telling only one kind," says Andy Helfer, editor of DC's new Paradox Press imprint. "We want comic book readers to read our stuff, because we have really good stories and really good art. But we also want people who don't read comics to read our stuff."

Paradox, introduced in 1994, evolved out of an earlier DC imprint called Piranha Press. "I was offered the opportunity to be experimental projects editor," says Helfer, "and the mandate was to create books to appeal to new markets." When Piranha editor Mark Nevelow resigned, Helfer's first job was to evaluate Piranha's

Piranha's *Beautiful Stories* were not comics but rather prose narratives with illustrations; they had titles like "The Black Balloon" and "Die Rainbow Die," The cover of this first volume (1989) is by Dan Sweetman.

existing projects. "What Piranha was doing appealed to a very narrow subsection of the existing comics audience," Helfer says. "It was for people who dressed in black and had tattoos." The most regularly published Piranha title was *Beautiful Stories for Ugly Children* by Dave Louapre and Dan Sweetman. Most Piranha publications were trade paperbacks,

like Marc Hempel's series of *Gregory* books (1989), about an odd little fellow in a straitjacket whose amusing adventures are confined to a small cell. Piranha was perhaps just too experimental, despite work like Kyle Baker's *Why I Hate Saturn* (1990), an insightful look at alienated young talent in New York.

Paradox kicked off with something far more accessible: *The Big Book of Urban Legends*, an oversize trade paperback containing two hundred one-page accounts of those unstoppable rumors about subjects like alligators in sewers and poodles in microwaves. The artists represented an extraordinary cross section, from old pros like Dick Giordano to underground cartoonists like Justin Green. Available to the general public through bookstore distribution, *Urban Legends* was followed in 1995 by *The Big Book of Weirdos*, writer Carl Posey's bizarre comic book biographies of famous eccentrics from Salvador Dali to Howard Hughes. These "factoid books" were intended to lure readers to the medium with tantalizing tales told in an accessible and funny format.

"The way we tell stories is different from the way regular comics are telling stories today," says Helfer, who believes that experiments in page design begun in the 1970s by artists like Neal Adams have made current comic books fairly unintelligible to the uninitiated. "The last thing people want to feel is that they can't understand comics," argues Helfer, "so we've gone back to the comic strip, with the panel as the integral unit of storytelling. That's why we use the nine-panel grid."

"What we've done with Paradox is break it into two lines," Helfer says. One is the "fun, goofy" Big Book series; the other is a group of paperback novels in comic book form. "Some of the things we are doing, in mysteries and in fiction, are some of the most sophisticated comics that you're likely to find in the market. But they're not impenetrable." The mysteries are "all originals, from novelists, screenwriters, comics writers," including recognized figures like George Chesbro and Max Allan Collins. "The fiction line," says Helfer, "is there to publish great things that come across our desks that DC would otherwise have no place to publish. Stuff like Howard Cruse's *Stuck Rubber Baby* (1995), a fabulous book about a guy growing up during the civil rights movement in the South and coming to terms with his own sexuality. It's something that can give people a chance to reexamine comics and what they are capable of doing."

THIS HERE IS A STORY MY PAL BARNEY TOLD ME. TODAY HE'S A PLUMBER LIKE ME, BUT HE USEDTA READ METERS FOR A LIVIN'.

OLD BARNEY'S GOT A MILLION STORIES, BUT THIS IS MY PERSONAL FAVORITE!

I CALL IT...

THE NUDE HOUSEWIFE

"OKAY, SO THERE'S THIS BROAD DOIN' LAUNDRY IN HER BASEMENT."

"SHE GETS THE MACHINE ALL LOADED WHEN SHE NOTICES HER WHATCHA-MACALLIT--HOUSEDRESS--IS SOILED."

"SO SHE TAKES OFF THE HOUSE-DRESS AN' THROWS IT IN WITH THE REST-A THE WASH."

"AN' SHE'S NOT WEARING A STITCH UNDERNEATH! I'M TALKING BUCK NEKKID!"

"BUT IT GETS BETTER! SHE NOTICES PIPES LEAKING ONTO THESE CAST-IRON CURLERS SHE'S GOT IN HER HAIR..."

"...SO WHAT DOES THIS DAFFY BROAD DO? SHE PUTS HER KID'S FOOTBALL HELMET ON HER HEAD TO PREVENT RUST!"

"WHAT SHE DOESN'T KNOW IS THAT MY MAN BARNEY'S BEEN THERE ALL ALONG READIN' HER METER! HE DOESN'T BAT AN EYE, OLD BARNEY! HE JUST LOOKS THE BROAD UP AND DOWN AND SAYS..."

I HOPE YOUR TEAM WINS, LADY.

"HAW HAW HAW! AN' IF YOU THINK THAT WAS FUNNY, YOU OUGHTA HEAR BARNEY TELL IT!"

"Most urban legends are basically jokes, and the fact that they have been passed on means that they're funny jokes," says Paradox group editor Andy Helfer. The 1994 Paradox project *The Big Book of Urban Legends*, a collection of one-page comic strips, was based on material gathered by University of Utah folklorist Jan Harold Brunvand for books like *The Vanishing Hitchhiker* and *The Choking Doberman*. "We made a deal to use all his books," says Helfer, "and then we got two writers, Robert Fleming and Robert Boyd, to turn them into comics." "The Nude Housewife," complete with punch-line, was drawn by Joe Orlando. One of the mainstays of the early *Mad*, Orlando has had compara-tively little time to draw in recent years; this humorous tale of a peeping plumber is a welcome return for the DC vice president and creative director.

KEEP SMILING
Having a Sense of Humor Helps

The original heyday of DC's humor titles came in the decade after World War II, but that era came to an end with the revival of super heroes and the start of the Silver Age in 1956. Yet the same year saw the emergence of two of DC's longest-lasting comedy characters, a couple of tough customers called Sugar and Spike. The creations of editor and cartoonist Sheldon Mayer, Sugar and Spike were two tiny tots who were old enough to get into trouble but a little too young to talk. As a result, they conversed entirely in baby talk, "the only language that makes any sense." This jumble of syllables was unintelligible to adults, but Mayer helpfully translated it for the readers. In fact, Mayer was pretty much the whole show, writing and illustrating every feature in every issue of *Sugar and Spike* from the first in 1956 until the last in 1971. The whimsical, highly unusual comic book managed to generate an amazing number of variations on what seemed a limited theme, and earned real affection from its audience during the years when super heroes were taking on an ever-increasing burden of angst.

The most famous humor publication associated with DC is undoubtedly *Mad*. It was started as a satirical full color comic book in 1952 by writer-editor Harvey Kurtzman and publisher William M. Gaines, whose father M. C. Gaines had headed DC's sister company All American. Bill Gaines turned *Mad* into a magazine in 1955, thus circumventing the restrictive Comics Code that had recently been introduced. Gaines needed a distributor for the new *Mad* and ended up entering into successful negotiations with Jack Liebowitz, who had been involved in the Independent News Company even before becoming a boss at DC. The deal with Independent News worked out so well that *Mad* magazine was soon selling a million copies an issue.

In 1962, Gaines sold *Mad* to Premier Industries, but with the unique proviso that he would continue to have sole control over the operation of the magazine. It wasn't long before Premier sold *Mad* to DC, but the deal with Gaines remained in force even after DC was acquired by big companies like Kinney and Warner. A series of tough-minded executives evidently recognized the special relationship between the benevolent, eccentric Gaines and his staff, known to readers as "the Usual Gang of Idiots." The biggest idiot of all turned out to be the company mascot, a grinning kid discovered by editor Harvey Kurtzman on an old postcard. Kurtzman's successor Al Feldstein named the jug-eared youth Alfred E. Neuman, and the kid became one of the world's most famous faces.

One veteran of the early *Mad*, Joe Orlando, ended up at DC. In 1973, years before he became a DC vice president, Orlando launched a new DC comic book called *Plop!* Subtitled "The Magazine of Weird Humor," *Plop!* bore some resemblance to the early *Mad*, which had not engaged in parodies of specific subjects. Orlando calls Bill Gaines his "creative father

The weird and wild Basil Wolverton was the cover artist for the first issue of editor Joe Orlando's horribly humorous comic book *Plop!* (September-October 1973)

The kids discover the joy of communication in *Sugar and Spike* #1 (April-May 1956), written and drawn by Sheldon Mayer. Spike's real name, a dark secret, was Cecil.

Daffy Duck and Bugs Bunny try on Halloween costumes in *Looney Tunes* #7 (October 1994). Script by Steve Korté, pencils by Alvaro Flores and Luis Sepulveda and inks by Jessica Russo.

and mentor," and admits that *Plop!* was partially intended "to needle him a bit," but negotiations ensued between DC and *Mad* that were designed to prevent too close a similarity to the more established publication. "I had to agree that I would only satirize genres," says Orlando. "I ended up satirizing horror, doing funny horror stories." The macabre comedy of *Plop!* was a wild mixture, utilizing the darker offerings of established humorists like cartoonist Sergio Aragones, and lighter moments from well-known horror artists like George Evans and Berni Wrightson.

In April 1994, DC began an association with some of the greatest cartoon characters of the twentieth century when it launched *Looney Tunes*. Edited by Katie Main, the new comic book took advantage of DC's long-standing association with Warner Bros. to present the adventures of a stable full of funny animals including Bugs Bunny, Daffy Duck, the Roadrunner, Tweety and Sylvester. The Looney Tunes film series, which got its start in 1930, ran for decades in theaters and has since become a television staple thanks to the talent of directors like Tex Avery, Bob Clampett, Friz Freleng and Chuck Jones; in introducing its version of the cartoon critters, DC continues a long and looney tradition.

In 1992, *Mad* suffered a grievous loss when publisher Bill Gaines died. Throughout his lifetime, DC had honored his iconoclastic independence; after his death, DC selected Joe Orlando to act as its liaison with *Mad*, although Orlando says nobody knew quite what that meant. "What DC wanted me to do was go down there to *Mad* and not shake them up, because they were worried somebody was going to come in and take over. Slowly I gained their trust," says Orlando, who eventually became *Mad*'s associate publisher and is dedicated to continuing whatever it is the magazine stands for. "Right back where I started," says Orlando with a smile.

Wonder Woman can't find a changing room in *Mad* #10 (April 1954). Written by Harvey Kurtzman and drawn by Bill Elder.

Even before Knightfall, *Mad* came up with a new secret identity for Batman…or is it Superman? Cover by Richard Williams for *Mad* #289 (September 1989).

A hero unmasked at last: Alfred E. Neuman stands revealed as "The Sexiest Schmuck Alive" in the 300th issue of *Mad* (January 1991). Cover by Norman Mingo.

"Our comics bring truth, justice and general mayhem to over forty countries in twenty-five languages—from Arabic to Zulu," says Chantal d'Aulnis, DC's vice president of business affairs and international rights. Usually, DC's art is reprinted overseas, with the stories told in translation, but sometimes new images are created for publication abroad. The Superman comic book from Lebanon (upper left) has some interlopers on the cover. The Flash cover from Argentina (upper right) uses American art work by Greg LaRocque and Larry Mahlstedt, but the speedy hero has had his name changed to "Flush Man." The Hong Kong Lobo cover (lower left), with art by Glenn Fabry, provides information in both Chinese and English. In Denmark (lower right), Joe Kubert's cover art appears on the magazine *Yankee*, but the famous character Sgt. Rock has become "Sgt. Flint." Under one name or another, DC heroes appear everywhere from Italy to Indonesia, from Poland to Portugal, from Norway to New Zealand.

The pioneer in DC's overseas distribution was Carroll Rheinstrom, who represented the world's first super heroes all around the world, initially as head of McFadden Publications International, and after 1952 as president of Carroll Rheinstrom International Editions. Circling the globe with his wife, Rheinstrom took DC's characters to countries that hadn't even heard of comic books. International approaches to a classic character can be seen in this quartet of covers featuring Batman. In Japan (upper left), simplicity of design involves the use of the Bat-Signal. In Israel (upper right), the figures are inspired by the look of the Batman animated television show. Thailand (lower left) reprints a romantic scene, stylishly rendered by Todd McFarlane. Germany offers a *Batman* cover with no Batman—just Catwoman, evidently dismayed to discover that somebody got into the bathroom ahead of her.

Michelle Rubin is ready to fight evil on a nifty Batmoto made in Italy by Toys Toys (1992).

TOO COOL FOR KIDS
Upscale Toys for Today's Collector

The comic book audience includes an increasing number of adults who may be motivated by nostalgia, by the collecting bug or by the search for imaginative entertainment. As a result of the phenomenal growth of the collecting hobby in recent years, modern comics-related merchandise includes many items that can't be picked up for just the price of a box top or a handful of pocket change. From limited edition sculptures to the latest in electronic gadgetry, toys based on comics aren't always just for kids anymore. The old days of tin and cardboard and rubber bands are gone for good, but the same spirit lingers on.

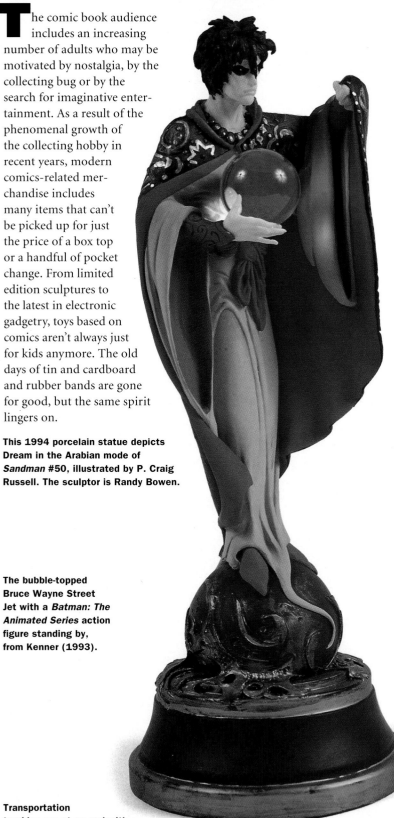

This 1994 porcelain statue depicts Dream in the Arabian mode of *Sandman* #50, illustrated by P. Craig Russell. The sculptor is Randy Bowen.

The bubble-topped Bruce Wayne Street Jet with a *Batman: The Animated Series* action figure standing by, from Kenner (1993).

Transportation troubles are at an end with the Swamp Thing Marsh Buggy from Kenner (1990). It comes complete with "giant grabbing claws and a thrust engine with a spinning blade."

From *Batman: The Animated Series* comes the Ultimate Batman (Kenner, 1994). Eyes and bat emblem aglow, the fifteen-inch figure totes a double-barreled assault weapon.

The Wonder Woman Cookie Bank, guarded by the formidable female herself, will keep those chocolate chip cookies chewy. (Origin unknown, 1978.)

This handsome porcelain statue, designed by *Flash* cover artist Mike Wieringo, was sculpted in 1995 by William Paquet.

Lobo, the uncouth interplanetary bounty hunter, was created by Keith Giffen and Roger Slifer. The porcelain statue was sculpted in 1993 by Randy Bowen, from an illustration by Simon Bisley.

THE END OF TODAY...

ZERO HOUR
CRISIS IN TIME!

DC UNIVERSE

4
SEPT 94
$1.50 US
$2.10 CAN
70p UK

BY DAN JURGENS AND JERRY ORDWAY

DIRECT SALES

The empty cowl of the Flash is a grim reminder of the price paid during the 1986 *Crisis on Infinite Earths*, and a warning of what may be coming in the 1994 *Zero Hour* mini-series. Pencils by Dan Jurgens and inks by Jerry Ordway.

IT'S GONE SO WRONG. ALL THOSE PEOPLE... COAST CITY...

THE UNIVERSE NEEDS A PROTECTOR--A REAL GUARDIAN TO RIGHT THESE WRONGS.

THE UNIVERSE NEEDS ME.

Zero Hour arrives and the universe disappears, leaving the megalomaniacal Hal Jordan unveiled as the instigator. Script and pencils by Dan Jurgens, inks by Jerry Ordway, from *Zero Hour #1* (September 1994).

ZERO HOUR
Countdown to a Crisis

By 1994, the DC Universe was in big trouble. "A rift of draining entropy" was "working its way back through the time stream—simultaneously wiping out time and space!" Back in the offices where the DC Universe was created, some considerably smaller problems had arisen, but they were the reason for the publishing event called *Zero Hour*. A company-wide crossover is common during the summer months, and as DC president Jenette Kahn notes, "Deciding on the big event often solves other problems at the same time." Despite the effort to clean up all of the DC Universe continuity confusion with the 1986 mini-series *Crisis on Infinite Earths*, some loose ends had been left dangling. The solution was *Zero Hour*, another "clean up" mini-series. "*Zero Hour* was certainly necessary," says *Crisis*

writer Marv Wolfman. "Fortunately, I think there are some people at DC like Mike Carlin who will try to make sure that when *Zero Hour* sort of replaces *Crisis*, things don't get screwed up."

Mike Carlin, Denny O'Neil and Archie Goodwin are DC group editors, three seasoned professionals responsible for overseeing any drastic changes in the DC Universe. "We're like a three-headed monster," Carlin says. "We read every proposal and a majority rules on it. If two guys think it's okay, then we go with it. Paul Levitz can tell us we're nuts, but he hardly ever does that. With Jenette and Paul running the show, there's a lot of trust put in an individual editor's gut feeling. They've always encouraged us to fight for what we believe in."

One DC editor with something on his mind was KC Carlson. As Mike Carlin recalls, "What happened with *Zero Hour* was that KC, who was editor of *Legion of Super-Heroes* and dealing with the future, was looking for a way to do a crossover event that would help his books by linking them to the books set in the twentieth century. A week earlier, writer-illustrator Dan Jurgens had sent in a proposal for *A Crisis in Time*, which was his idea for doing a big-time travel event that would shake up the Universe." The two concepts were combined. KC Carlson served as editor for Jurgens, still on a roll after killing off Superman, and the five core issues of the *Zero Hour* mini-series, all dated September 1994, were numbered to count down from #4 to #0. In the same month, most of DC's comic books bore the Zero Hour logo on their covers, and in October they each had a special issue #0, based on Carlson's idea that it would be a good chance to recapitulate the origins and backgrounds of the heroes.

"We were keen to do something of that magnitude," says Mike Carlin. "Crossovers are a pain to pull off, but they really do solidify the Universe, and that's what the readers want to see. It's important for us to have confidence in what we're doing, and I hope that the people who come after us will do the same thing. Otherwise it's stagnation and you might as well put out reprint books. I would be very disappointed if in ten or fifteen years somebody didn't just trash what we've done and say that it was all a dream or whatever."

Making Zero Hour work required the cooperation of dozens of writers, artists and editors. Mark Waid, who writes *Flash*, jokes that he was "terrified" when word of the crossover came down, since *Crisis* in 1985 had resulted in the death of that era's Flash. "After ten years of Barry Allen

being gone, people had finally accepted Wally West as the Flash. They had finally stopped asking us when Barry was coming back. So we thought it would be good to tweak them, now that they like Wally, and make them think we were going to take him away." So the start of *Zero Hour* makes it look like another Flash has bitten the dust, but later issues of *Flash*, edited by Brian Augustyn, show Wally's apparent demise to be a journey beyond the speed of light, from which he returns even faster than before.

Things worked out differently for Hal Jordan, who had been Green Lantern since 1959. The character had undergone some transformations in his own comic book, breaking his vows about exhibiting restraint in the use of his powers. Determined to right wrongs by altering the past, Hal had become a rogue Green Lantern, subduing his colleagues and absorbing their strength. "We were all in this gigantic meeting," says *Green Lantern* editor Kevin Dooley, "and we needed a central villain. Dan Jurgens, who is a good reader of all the DC titles, saw that Hal Jordan's motivation was setting right what's wrong. So basically, *Zero Hour* became Hal Jordan wiping out time." Readers were stunned to see a major hero gradually revealed as a deluded villain, and shocked when he was apparently killed by his old comrade in arms, Green Arrow.

The demise of a hero has frequently been used to shake up the fans, and in fact it has recently been revealed that Hal Jordan is still around, although the role of Green Lantern has been assumed by a new man, Kyle Rayner. Killing a character is now commonplace, Dooley admits, but "replacing the old hero with a new one is something different. We've added to the DC Universe, thus enriching the whole. And we aren't afraid to make a change if it's for a good story."

A hero is hemmed in by lasers as Zero Hour strikes, on the flashy cover for *Flash* #94 (September 1994) by Mike Wieringo and José Marzan, Jr.

October 1994's *Wonder Woman* #0 gave readers a chance to reacquaint themselves with the Amazon Princess. Cover by Brian Bolland.

Penciller Jon Bogdanove and inker Dennis Janke knocked themselves out to duplicate the different looks of Batman over several decades for the time warp cover of *Superman: The Man of Steel* #37 (September 1994).

With the universe out of whack, the new Superboy is confronted with the old one in the Zero Hour cover for *Superboy* #8 (September 1994) by Tom Grummett and Doug Hazelwood.

BATMAN FOREVER
The Dark Knight Lightens Up

The Batmobile spent the weekend in Manhattan, but nobody noticed. That extraordinary event was just one surprise in the production of the 1995 blockbuster *Batman Forever*, a film intended to revise the Batman franchise in the wake of two hit movies and an ongoing animated television show. The mandate was to create a film that could carry on the series while lightening the tone a tad for an anticipated audience of younger viewers. The ingredients included the addition of Robin, a new Batman, a new director, two new villains and a new view of Gotham City. For *Batman* and *Batman Returns*, the hero's hometown had consisted entirely of studio sets, but this time the backgrounds were augmented by location shooting in both New York and Los Angeles. New York production manager Peter Pastorelli scheduled shots of the Batmobile for Sunday night in the financial district's Exchange and Gold streets, and put up small temporary walls to block the view of passersby. "There's nobody there," he says. "You might as well be in the Gobi Desert."

"Jenette Kahn at DC Comics says the world is divided into Batman fans and Superman fans," recalls director Joel Schumacher. "I was always a Batman fan, because I think he's darker and sexier and more fun and more iconoclastic and more rock 'n' roll in a sense than Superman is." When Schumacher was offered the chance to take over from his colleague Tim Burton and become director of the third Batman feature, he hesitated only "because Tim is a friend of mine and I didn't want to do it if he didn't want me to do it."

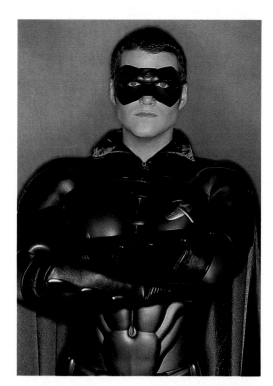

Chris O'Donnell comes on strong as a no-nonsense Robin in *Batman Forever*.

Creator Bob Kane considers actor Val Kilmer to be more appropriately cast as Batman than any other actor to date.

With Burton's blessing, however, Schumacher jumped at the chance. His intention was to let the audience "have fun" by creating "a living comic book for them," by trying to reproduce the look and the color schemes of Batman's adventures on the printed page. "There are so many great artists that have worked on the Batman comics, and I'm trying to do some of those bold moves on the screen." Schumacher's films have been a varied lot, but they include such moody warm-ups for the Dark Knight as the adventures of adolescent vampires in *The Lost Boys* (1987) and the study of supernatural guilt called *Flatliners* (1990). Yet Schumacher wanted to bring more light to the project. "I think the word *comic* is important in this," he says. "We have Jim Carrey and Tommy Lee Jones adding dark comedy. All the characters have their own sense of humor, and I hope that comes across too."

The new Batmobile from *Batman Forever* is even more sleek and futuristic than its predecessors. Production designer Barbara Ling wanted a new look for all of Batman's vehicles and gadgets.

This production illustration, labeled "Gotham City 3," depicts an even wilder city than was created for the two previous Batman films.

Tommy Lee Jones brought sardonic humor to Two-Face in the 1995 film *Batman Forever*.

Jim Carrey, the hottest new comedian in films, was cast as the Riddler. "He's enormously gifted physically and emotionally," Schumacher says. "He can do so many things that it's amazing." Oscar winner Tommy Lee Jones got the role of Two-Face, a grim figure to be presented in this less sinister version of the Batman saga. "I think Tommy Lee was the first person signed," says Schumacher. "Who else can be this wicked and this funny at the same time?" The fantastic makeup that Jones wears, built around five key pieces of foam latex, was designed by another Oscar winner, Rick Baker.

The script blames Two-Face for killing the family of a young circus acrobat named Dick Grayson (Chris O'Donnell). This motivation for the origin of Robin echoes the original 1989 *Batman* feature, in which another major bad guy, the Joker, takes on the blame for turning a kid named Bruce Wayne into a crime-fighter. The introduction of Robin is also a significant factor in softening the harder edges of the film series, with the young partner functioning much the way he did in the comics more than half a century ago. Change is the hallmark of *Batman*

Forever, which also introduces Batman's third romantic interest (Nicole Kidman) in as many movies. But, as actor Michael Gough observes, his character of Alfred the butler is "set in cement."

Of course, the most important figure in the film is Batman, and for that role Joel Schumacher chose Val Kilmer, whom he calls "a very interesting, complex actor." Kilmer has made something of a specialty out of characters driven by demons, including rock star Jim Morrison in *The Doors* (1991) and tubercular gunfighter Doc Holliday in *Tombstone* (1993). "In terms of acting," says Kilmer, "there is some sort of pattern with Jim Morrison and Doc Holliday and even Bruce Wayne, in that they are identified as heroes but there's something personal about what they're seeking." Part of it is the fascination with "the gray area between good and evil," he suggests. "There's something fascinating" about Batman, but also something "bizarre," Kilmer says. What finally impresses the actor most is the impact his costume has on his young daughter and her friends. "Just to see their eyes, and their total satisfaction with the image. I didn't have to do anything," he admits. "Batman does it."

Rubber-faced Jim Carrey, who has skyrocketed to success in recent years, was a perfect choice to embody a cartoon character like the Riddler.

"*What I love about* DC *is that we're not a one-note business. We can be on-liñe, we can be* CD-ROM, *we can be video games and interactive toys, or we can be movies, television, animation. So the opportunities technology brings are all open to us, and each one of those different areas helps all the others— as long as we never lose sight of the fact that the comics made all these other things possible.*"

Jenette Kahn,
PRESIDENT,
DC COMICS

Painting by Alex Ross

INDEX

Page references in lightface are to the text; references in boldface are to the captions of the illustrations. Titles in italics without qualification are names of comic books, e.g. "*Batman.*" All other titles are qualified, e.g. "*Batman* (movie)." Fictional characters are listed first name first, e.g. "Bruce Wayne." Alternative identities for super heroes are cross-referenced to the super hero's name, e.g. "Bruce Wayne. *See also* Batman."

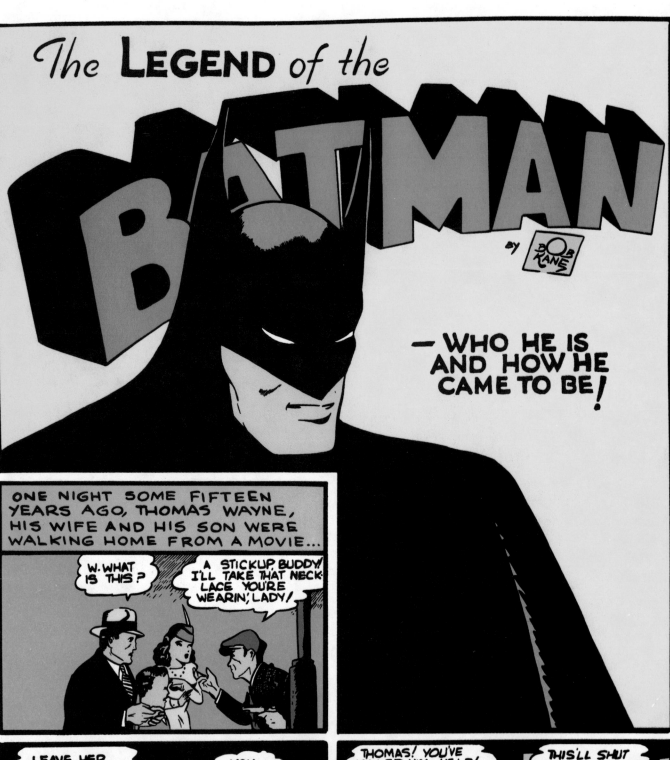
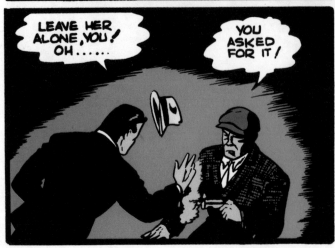
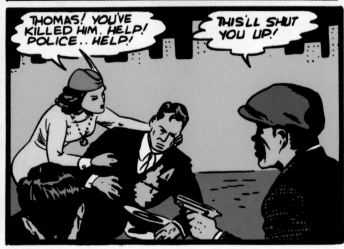